Interpreting the Images of Greek Myths

From the age of Homer until late antiquity the culture of ancient Greece and Rome was permeated by images of Greek myths. Gods and heroes were represented as statues, on vase and wall paintings, on temples, on sarcophagi, as well as in other media. This book provides a concise introduction to the interpretation of the images of Greek myths. Its main aim is to make the pictorial versions of the myths comprehensible on their own terms. Ancient artists were well aware of the potential – but also the limitations – of these 'silent' images and of the strategies that made them 'speak' to the audience/viewer. The book explains the theoretical and methodological issues at stake and discusses in detail a number of case studies. It will be useful and stimulating for all undergraduate and graduate students taking courses in classical mythology and ancient art.

KLAUS JUNKER is Professor of Classical Archaeology at Mainz University. He has published extensively on ancient Greek sculpture, architecture and mythological imagery, as well as on the history of Classical archaeology.

Interpreting the Images of Greek Myths

An Introduction

KLAUS JUNKER

Translated by
ANNEMARIE KÜNZL-SNODGRASS
and
ANTHONY SNODGRASS

CAMBRIDGE
UNIVERSITY PRESS

CAMBRIDGE UNIVERSITY PRESS
Cambridge, New York, Melbourne, Madrid, Cape Town,
Singapore, São Paulo, Delhi, Tokyo, Mexico City

Cambridge University Press
The Edinburgh Building, Cambridge CB2 8RU, UK

Published in the United States of America by Cambridge University Press, New York

www.cambridge.org
Information on this title: www.cambridge.org/9780521720076

Original German language edition: Klaus Junker, *Griechische Mythenbilder: Eine Einführung
in ihre Interpretation* published by J. B. Metzlersche Verlagsbuchhandlung und Carl Ernst Poeschel
Verlag GmbH Stuttgart, Germany. © 2005.

This English translation © Cambridge University Press 2012

First published 2012

Printed in the United Kingdom at the University Press, Cambridge

A catalogue record for this publication is available from the British Library

Library of Congress Cataloguing in Publication data
Junker, Klaus.
[Griechische Mythenbilder. English]
Interpreting the images of Greek myths : an introduction / Klaus Junker ; translated by
Annemarie Künzl-Snodgrass and Anthony Snodgrass.
 p. cm.
Originally published: Griechische Mythenbilder : Eine Einführung in ihre Interpretation.
Stuttgart : J. B. Metzlersche Verlagsbuchhandlung und Carl Ernst Poeschel Verlag, c2005.
ISBN 978-0-521-89582-8 (hardback)
1. Mythology, Greek, in art. 2. Image (Philosophy) I. Title.
N7760.J7813 2012
704.9′489213–dc22

 2011013188

ISBN 978-0-521-89582-8 Hardback
ISBN 978-0-521-72007-6 Paperback

Contents

List of illustrations [*page* vi]
Preface [xi]

1 Achilles and Patroclus in the Trojan War: An introductory
 case study [1]

2 Definitions: myth and mythological image [19]

3 The production of myths and of mythological
 images – stages in the historical development [64]

4 Types of monument and fields of function [96]

5 Methods [120]

6 Content and intention [159]

Guide to further reading [197]
Index [222]

Illustrations

1 Achilles tends the wounded Patroclus. Attic red-figure cup, signed by the potter Sosias, interior, *c.* 500 BC. Berlin, Staatliche Museen, Antikensammlung (F 2278). Photo: bpk / Antikensammlung SMB (U. Jung). [*page* 2]

2 Heracles takes his place among the gods on Mount Olympus. Exterior of the cup shown in Fig. 1. Photo: bpk / Antikensammlung, SMB (U. Jung). [4]

3 Fighting before Troy: Sthenelos tends the wounded Diomedes. 'Chalcidian' amphora (drawing), *c.* 540 BC. Whereabouts unknown; formerly Pembroke Hope collection. After A. Rumpf, *Chalkidische Vasen* (Berlin/Leipzig 1927), pl. 12. [9]

4 Peleus and Thetis. Attic red-figure cup, signed by the painter Peithinos, *c.* 500 BC. Berlin, Staatliche Museen, Antikensammlung (F 2279). Photo: bpk / Antikensammlung, SMB. [13]

5 Warrior's departure. Attic black-figure amphora, side A, *c.* 540 BC. Whereabouts unknown, formerly Berlin, Staatliche Museen, Antikensammlung (F 1718). Photo: bpk / Antikensammlung, SMB (Ant 5592). [14]

6 Warrior carrying a fallen comrade. Side B of the amphora shown in Fig. 5. Photo: bpk / Antikensammlung, SMB (Ant 5588). [15]

7 Heracles and the Nemean lion. Olympia, Marble metope from the temple of Zeus, *c.* 460 BC. Olympia, Museum. Photo: DAI Athens (Hege 731). [17]

8 Oedipus and the Sphinx. Attic red-figure cup, *c.* 460 BC. Vatican Museums (16541). Mainz University, Institute for Classical Archaeology, photo collection. [23]

9 Contest between Athena and Poseidon over the patronage of Attica. Athens, west pediment of the Parthenon, *c.* 435 BC. Drawing by Jacques Carrey (?), 1674. Paris, Bibliothèque Nationale. After F. Brommer, *Die Skulpturen der Parthenon-Giebel* (Mainz 1963), pl. 64. [26]

10 Odysseus in Polyphemus' cave. From John Flaxman, *The Odyssey of
 Homer* . . . (London 1805), pl. 14. After R. Essick and J. La Belle (eds.),
 Flaxman's Illustrations to Homer (New York 1977), pl. 14
 (reprint). [31]

11 The ransom of Hector (Priam before Achilles). Attic red-figure
 skyphos (drawing), *c.* 490 BC. Vienna, Kunsthistorisches Museum
 (8710). After FR, pl. 84. [34]

12 Ariadne, Theseus, the Minotaur and King Minos. South-Italian
 (Lucanian) bell-krater, *c.* 430 BC. Berlin, Staatliche Museen,
 Antikensammlung (1993–243). Photo: bpk / Antikensammlung,
 SMB (J. Laurentius). [41]

13 Medea in Corinth. Sarcophagus, Rome, *c.* AD 150. Rome, Museo
 Nazionale Romano (75248). Photo: DAI Rome (63.545). [43]

14 Sleeping satyr, so-called Barberini Faun, *c.* 250–200 BC. Munich,
 Staatliche Antikensammlung und Glyptothek (218). Photo: Renate
 Kühling [47]

15 Satyrs molesting a sleeping maenad. Attic red-figure cup, *c.* 430 BC.
 Mainz, Institute for Classical Archaeology (104). Photo: Mainz
 University, Institute for Classical Archaeology (G. Pöhlein). [49]

16 Ajax carrying the body of Achilles. Attic black-figure volute-krater
 by the painter Kleitias and the potter Ergotimos (so-called
 François Krater), *c.* 670 BC. Florence, Museo Archeologico (4209).
 Mainz University, Institute for Classical Archaeology, photo
 collection. [54]

17 Hypnos and Thanatos carrying the body of Sarpedon. Attic red-figure
 kalyx-krater, signed by the painter Euphronios, side A, *c.* 510 BC.
 Formerly New York, Metropolitan Museum of Art (1972.11.0);
 restituted 2008 to the Italian State, now in Rome, Museo Nazionale
 Etrusco di Villa Giulia. Photo: Metropolitan Museum, New York
 (198428 TF). [56]

18 Arming scene (projection), side B of the kalyx-krater shown
 in Fig. 17. Photo: Metropolitan Museum, New York
 (198497 B). [57]

19 Shipwreck. Attic Geometric jug (projection), *c.* 720 BC. Munich,
 Staatliche Antikensammlung und Glyptothek (8696). Photo:
 Museum. [75]

20 Odysseus and his companions blinding Polyphemus; Perseus killing
 the Gorgon Medusa. Proto-Attic amphora, *c.* 670 BC. Eleusis,
 Archaeological Museum. Photo: DAI Athens (Eleusis 544). [76]

21 Perseus killing the Gorgon Medusa. Drawing (detail) of the amphora
 shown in fig. 20. After G. Mylonas, *O protoattikos amphoreus tes
 Eleusinos* (Athens 1957), pl. 10. [77]

22 The Gorgon Medusa and Perseus. Corfu, west pediment of the
 temple of Artemis, *c.* 580 BC. Corfu, Archaeological Museum.
 Photo: DAI Athen (Hege 2214). [82]

23 Zeus in combat with a Giant (as Fig. 22). Photo: DAI Athens
 (Hege 2161). [83]

24 Battle between Lapiths and centaurs. Olympia, west pediment of the
 Temple of Zeus (drawing), *c.* 460 BC. Olympia, Museum.
 © Copyright A. F. Stewart and Candace Smith. [84]

25 Scenes from the sack of Troy (Ilioupersis; so-called Vivenzio Hydria).
 Attic red-figure hydria (drawing), *c.* 480 BC. Naples, Museo
 Archeologico Nazionale (2242). After FR, pl. 34. [85]

26 Menelaus and Helen of Troy. Attic red-figure jug (drawing), *c.* 430
 BC. Vatican Museums (16535). After FR, pl. 170,1. [89]

27 Artemis has Actaeon killed by his own hounds. Selinous, metope
 from the temple of Hera (drawing), *c.* 460 BC. Palermo, Museo
 Archeologico Regionale A. Salinas (3921 C). After D. Lo Faso
 Pietrasanta Duca di Serradifalco, *Antichità della Sicilia* II. *Selinunte*
 (Palermo 1834), pl. 31 [91]

28 Zeus and Hera. Selinous, metope from the temple of Hera
 (drawing), *c.* 460 BC. Palermo, Museo Archeologico Regionale
 A. Salinas (3921 B). After D. Lo Faso Pietrasanta Duca di
 Serradifalco, *Antichità della Sicilia* II. *Selinunte* (Palermo 1834),
 pl. 33 [93]

29 Symposium (*symposion*). Attic red-figure stamnos, *c.* 430 BC.
 Munich, Staatliche Antikensammlung und Glyptothek (2410).
 Photo: Museum. [100]

30 Funeral. Attic black-figure jug, *c.* 500 BC. Bowdoin College
 Museum of Art, Brunswick, Maine (1984.023). Photo:
 Museum. [102]

31 Ariadne helping Theseus to overcome the Minotaur. Pompeii,
 Casa della Caccia Antica (drawing), *c.* AD 70. After P. M. Allison
 and F. B. Sear, *Casa della Caccia Antica. Häuser in Pompeji* 11
 (Munich 2002), fig. 106 (drawing Judith Sellers). [112]

32 Companions of Odysseus in the land of Laestrygonians. Rome,
 wall painting in a villa on the Esquiline (watercolour), *c.* 30 BC.
 After R. Biering, *Die Odysseefresken vom Esquilin* (Munich 1995),
 pl. 1. [115]

33 Rome, so-called Tomba della Medusa, photo montage of the
 sarcophagi, *c*. AD 140. Photo collage: R. Bielfeldt (cf.
 R. Bielfeldt, *Orestes auf römischen Sarkophagen* [Berlin 2005] 311,
 fig. 87). [118]

34 Death of Laocoön and his sons, *c*. 30 BC. Vatican Museums (1059;
 1064; 1067). Photo: DAI Rom (64.900). [130]

35 Myron's Athena. Roman copy of a Greek original of *c*. 450 BC.
 Frankfurt, Liebieghaus 195. Photo: Museum. [133]

36 Myron's Marsyas. Roman copy of a Greek original of *c*. 450 BC.
 Vatican Museums (9974). Photo: Cologne, Forschungsarchiv für
 Antike Plastik (1788–08). [134]

37 Reconstruction of the Athena-Marsyas group by Myron. Drawing:
 I. Nalepa after K. Junker. [136]

38 Head of Athena shown in Fig. 35. Photo: Museum. [138]

39 Cast of a satyr play. Attic red-figure dinos, *c*. 430 BC. Athens,
 National Museum (13027). Photo: DAI Athen (NM 4703). [145]

40 Athena playing the *aulos*, Heracles playing the lyre. Attic black-figure
 amphora, *c*. 500 BC. Germany, private collection. Photo: D. Widmer,
 Basle (5991). [156]

41 Athena notices the distortion of her face when playing the *aulos*.
 South-Italian (Apulian) bell-krater, *c*. 370 BC. Boston, Museum of
 Fine Arts (Henry Lillie Pierce Fund, Inv. 00.348). Photo:
 Museum. [157]

42 Adonis and Aphrodite. Sarcophagus, Rome, *c*. AD 220. Vatican
 Museums (10409). Photo: DAI Rom (71.1762). [165]

43 Portrait heads of Adonis and Aphrodite as shown in Fig. 42. Photo:
 DAI Rom (71.1762). [166]

44 Dionysus with his circle and the sleeping Ariadne. Sarcophagus,
 Rome, *c*. AD 220. Hever Castle. Photo: DAI Rome (78.2084) [167]

45 Scene of sacrifice. Attic red-figure bell-krater, *c*. 440 BC. Frankfurt,
 Archäologisches Museum (Vf b 413). Photo: Museum. [173]

46 Wedding procession. Attic red-figure loutrophoros (drawing), *c*. 430
 BC. Berlin, Staatliche Museen, Antikensammlung (F 2372). After
 A. Furtwängler, *Die Sammlung Sabouroff* (Berlin 1883), pl. 58. [179]

47 The battle of the gods and giants (Gigantomachy). Great Altar of
 Pergamon, *c*. 170 BC. Berlin, Staatliche Museen, Antikensammlung.
 Photo: bpk / Antikensammlung, SMB. [185]

48 Achilles and Ajax playing board game. Attic black-figure amphora, signed by the painter Exekias (drawing), *c.* 530 BC. Vatican Museums (344). After FR, pl. 131. [193]

FR A. Furtwängler and K. Reichhold, *Griechische Vasenmalerei. Auswahl hervorragender Vasenbilder* (Munich 1902–32)

DAI Deutsches Archäologisches Institut

Preface

The stories from Greek mythology offer the most popular route of access to the world of Classical antiquity. Great events of myth such as the Trojan War and outstanding figures like Heracles, Oedipus, Medea or the great Olympian Gods have a firm place in the cultural consciousness of the present day. At the same time, the Greek myths play a prominent role in the study of the Classical world. That such a wide range of disciplines – Classical philology, ancient history, Classical archaeology, and philosophy – draw on these myths for their research has much do with the fact that, in antiquity, myths and their content were present in so many facets of human existence. They were narrated in various literary genres, performed for the general public in festive productions, given pictorial form for centuries on end. In practically every field of life, men and women were continually confronted by the stories of the gods and heroes.

Here we are already addressing a central issue of any engagement with ancient myth: the relation between language and image. Through their process of origin, Greek myths, no less than German saga and fairytales, are a matter of language. They were first shaped as oral narratives, passed on from one generation to the next and, at the same time, subject to continuous change. In the case of Greek culture, however, the process of putting the stories into written form began very early on. Thus a fleeting form of oral presentation was replaced by a written text, something that could be communicated, in virtually unchanged form, across great distances of space and time. What the bards of Archaic Greece sang about the great Achilles to their audiences, we can reconstruct word for word, more than two and a half millennia later.

Having collected together the literary records of the Greek myths, the text-based disciplines, above all Classical philology, study them as testimony for the development of ancient poetry and drama, the history of ideas, early religion or the analysis of historical processes. For a long time and for a simple reason, the pictorial versions of mythological subjects found little place in this research. It is an old and basic principle that thought formation lies primarily or exclusively in language. Unquestioned acceptance of this means accepting that only the verbal form provides access to the ideas

contained within the myths; pictorial versions are degraded to a secondary role as the result of simple transference from one medium to another. A depiction on a temple or a vase is thus relegated to the status of a mere visual illustration of a literary account of a myth.

A consequence of this 'philological' study of ancient mythology is that, in essence, pictorial representations are only used when an image can help 'complete' a literary account that is preserved solely in fragmentary form. Interestingly, the approach also characterises the early archaeological study of myths. The founder of this school, Carl Robert, was the first to systematically investigate the peculiarities of the pictorial medium in his two great works, *Bild und Lied. Archäologische Beiträge zur Geschichte der griechischen Heldensage* (Berlin 1881) and *Archäologische Hermeneutik* (Berlin 1919), yet he did not address the question of the degree to which the visual representations of Greek myths convey a meaning and significance of their own, one that is distinct from the literary versions.

Since then, however, there has been a fundamental change of perspective. In recent research on the forms and effects of communication, it is now commonly accepted that in addition to verbally conducted discourse, there is also a 'discourse of images', meaning that in every field of human activity – cultural, political or economic – different types of expression and message are closely bound to a complex use of visual media. This is as true for antiquity as it is today. The best example is Greek drama. One may analyse a tragedy by Sophocles or Euripides solely on the basis of the preserved text. The audience at a production in Classical Athens, however, did not engage just with the pure text and its intellectual possibilities; but rather subjected themselves to a whole range of additional acoustic and visual effects, with whose help the (almost exclusively mythological) subject-matter was performed.

The study of the ancient imagery of Greek myths has also benefited from the general tendency towards a holistic approach to ancient culture. That the scholarly study of images of Greek myths is, however, still striving to reach a consensus on basic methodological principles is evident from three recent publications. Susan Woodford's *Images of Myths in Classical Antiquity* (Cambridge 2003) is an elementary account of the various manifestations of Greek mythological imagery which demonstrates that the task Carl Robert set himself is as topical as ever. *The Parallel Worlds of Classical Art and Text* by Jocelyn Penny Small (Cambridge 2003) essentially analyses the 'divergences' between the literary and visual representations of a myth, and concludes that authors and artists worked in largely separate worlds. Luca Giuliani, by contrast, pursues a constructive concept in his *Bild und*

Mythos. Geschichte der Bilderzählung in der griechischen Kunst (Munich 2003). Taking as his point of departure the fact that a mythological image and a verbally constructed narrative *must* differ from each other because language is subject to formative laws different from those of a visual image, Giuliani demonstrates, in a broadly drawn historical outline, what different paths artists followed in order to create a pictorial form from a verbal narrative.

This present introductory text is the first to focus solely on the contextual meaning of images of Greeks myths. It thus complements not only the publications just cited, but also the various works of reference which categorise myths in chronological or cyclic order so as to provide an over-view of the surviving representations in the various types of monuments (see the Guide to further reading). Like any introduction to a broad field of research in the humanities, this book cannot claim to deal exhaustively with every aspect of its subject. The main concern is to set out the basic means of interpretation, and at the same time to describe actual research practices. The text is structured so that more strictly theoretical passages alternate with case studies, the choice of which reflect both personal preferences and the focus of my own research, hopefully to the reader's benefit. It seemed to me necessary to interpret the succinct title *Interpreting the Images of Greek Myths* in the broader sense of 'ancient images of Greek myths'. Not only is the tendency to make a strict distinction between Greek and Roman art somewhat artificial, but in this special instance there is the added factor that Roman sarcophagi testify to a vigorous engagement with the subject-matter of Greek myth, and that research into this particular group of monuments continually provides substantial methodological impulses that further our understanding of earlier images of Greek myth.

The book is divided into six chapters, which to a certain extent build upon each other and are also linked by cross-references; each can, however, also be read on its own. The case study presented in the first chapter is designed to highlight the potential, but also the problems, of interpreting mytholog-ical images. Next, defining 'myth' and 'mythological image' involves raising the fundamental question of how exactly mythical narratives were given visual form in Classical antiquity. The third chapter changes perspective by giving a brief historical outline of the shaping of myths in language and in image, while the fourth is devoted to the most important types of monu-ment and their historical setting. The 'methodology' chapter is divided into a shorter first part, which explains the hermeneutic theory of images, and a longer second part which uses a complex case study to demonstrate its application. The sixth and final chapter looks at the possible results of

archaeological interpretation of myths, and suggests which aspects of content and intention were communicated by such images to contemporary viewers.

During the preparation of this book I have enjoyed valuable support on many sides. A sabbatical from my teaching position at the Johannes Gutenberg University in Mainz made concentrated work on the manuscript possible. Frank Bernstein, Fiona Healy, Brigitte Lowis and Kirsten Simon read part or all of the text and gave critical and useful comments. I am grateful to the staff of the relevant museums for providing photographic material, and also to Angelika Schurzig, photographer at the Institute for Classical Archaeology in Mainz. I am indebted to Annemarie Künzl-Snodgrass and Anthony Snodgrass, who undertook the difficult task of translating my text into English, and to Oliver Schütze in Stuttgart and Michael Sharp in Cambridge for their editorial work. My warmest thanks to all those named.

1 | Achilles and Patroclus in the Trojan War: An introductory case study

From early times, the use of the bow and arrow formed a part of Greek military practice, as a dangerous long-range weapon. If the arrow had not struck an immediately fatal blow, it could still be the cause of insidious wounds. If the arrowhead had become completely embedded in the body and perhaps, in the heat of the battle, broken off from the shaft, then the removal of the metal would cause acute pain and, in certain circumstances, cause further damage to the tissues surrounding the wound. In the detailed battle descriptions of the *Iliad*, wounds caused by arrows are mentioned on various occasions. When the Greek Menelaus has just been struck by an arrow, his initial fear gives way to relief that the binding, which attaches the arrowhead to the shaft, is still visible (4, 150–1): the wound cannot be deep and the damage is therefore slight. So too in the picture that will now be used as a test case for interpretation (Fig. 1), the warrior has been lucky in his misfortune. The arrow portrayed in beautiful detail in the left foreground, so as to put the cause of the wound in his arm beyond all doubt, is still complete and, at the most, slightly bent at the tip, unless the small irregularity in the drawing is unintentional. Yet the abrupt turn away of the head and the open mouth, with the teeth visible and coated in added white, convey something of the pain that the man feels, as his comrade-in-arms applies the bandage to his arm. But the fact that neither man has taken off his armour – the helper still wears his helmet and his companion's cuirass is only partially unfastened – gives an obvious impression that the wound can be treated there and then, and that the two warriors will probably return immediately to the fray. Thus an unpleasant incident, admittedly, but not a catastrophe: a passing event on the edge of the battlefield, where nothing in the image would lead a viewer to think that the arrow-shot would have fatal consequences for the wounded man. So why, then, was an event of such obviously transient significance seen as a theme deserving of representation?

If one were to confine oneself exclusively to what is shown in the image itself, then the question could only be answered speculatively. So-called 'iconography', the verbal recording of all the visual elements in an image, cannot on its own supply any indication of the significance of the content. A symbol of friendship and solidarity, of the dangers of war or, conversely,

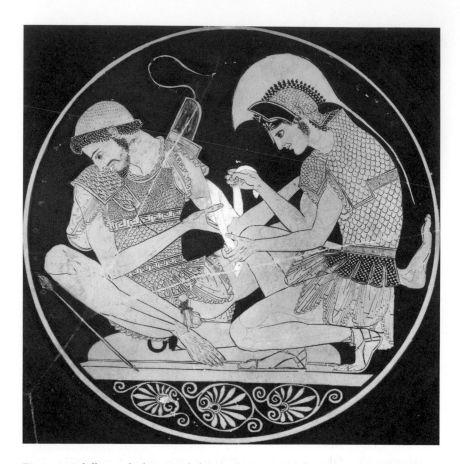

Figure 1 Achilles tends the wounded Patroclus. Attic red-figure cup, signed by the potter Sosias, interior, *c.* 500 BC

of the obligation to defend one's country? Each of these is equally justified as an off-the-cuff idea, with an equally free choice between them, since in the end it is only the spontaneous reaction of a present-day viewer that is being put into words. The path to be followed in a careful interpretation, by contrast, has a clear, yet never wholly attainable, intermediate goal: to recover the cognitive horizons of the people for whom this image was made. 'Context' is the term used for the sum of those aspects which could have been fundamental to the contemporary understanding of an image or an object. Often the context of an image can be deduced only very incompletely, but in the present case the circumstances are relatively favourable. Enough clues are available, whether provided by the picture itself or taken from external sources, to form the basis for an interpretation. Some of the circumstantial evidence, derived from various fields of context, will be

examined presently. The fundamentals of contextual research will be dealt with in the methodological chapter.

In antiquity, no one ever saw the image in the isolated form in which it appears in our illustration. The scene with the two male figures decorates the interior of a large terracotta drinking-cup. The image has a diameter of 17.5 cm.; the bowl of the cup, one of 32 cm. Since the broad outer ring is coated in a lustrous, deep black, the effect is one of looking at the image through an opening. This artistic trick – that is, the decision not to extend the figured scene over the entire surface available – emphasises the somewhat miniaturist character of the execution, but also has the effect of focusing attention on the events depicted.

The high level of artistic craftsmanship represented by the cup can be directly grasped by anyone who goes to see the original in the Department of Antiquities of the Berlin Museums. The vessel dates from the years around 500 BC: in historical terms, to the period of transition from the Archaic to the Classical period in Greece. The piece is one of the undisputed masterpieces among the painted vases produced in Athens. The term 'vase', introduced here, should be understood not as an indication of function, but as a purely conventional expression to convey the sense of a luxury vessel. The contribution of the potter is the first feature to display high quality. The wide-splaying bowl of the cup, very thin-walled in proportion to its extent, sits perched on a slender foot in such a way that the contour of the vessel runs in an elegant, unbroken curve all the way from the round foot to the outer rim of the bowl. Two handles provided the means of holding, at the same time enlivening the shape of the cup. The potter has added his name, Sosias, on the edge of the foot. The painter (assuming that he was not the same person as the potter) has not signed his work. Since no name is found, either, on other vessels which on the basis of style could be identified as works by the same hand, the painter is known by the alias or substitute name of the 'Sosias Painter'. Even though his *oeuvre* and his artistic development are no longer accessible to us, it is beyond question that he was not just a master of the technique of vase painting, but also an innovator within it. For the first time in the history, already centuries long, of Greek vase painting and two-dimensional art in general, we have on the Sosias cup (as it is called in the technical jargon) profile figures whose eyes are also shown in profile. By comparison with the pictorial convention followed hitherto, with the eyes shown in frontal view, an exceptional gain was achieved in the accuracy and vividness of the portrayal of the human figure. One can also see just how innovatory this type of rendering was, from the fact that the same vase painter did not employ it for the scenes on the outside of the same

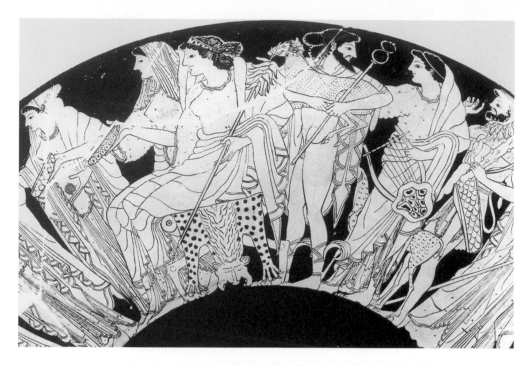

Figure 2 Heracles takes his place among the gods on Mount Olympus. Exterior of the cup shown in Fig. 1

cup (Fig. 2). In connection with the issue of meaning and interpretation, this stylistic detail deserves attention for showing that, with an artist who shows himself an innovator in terms of formal technique, innovation in the thematic field may also be expected.

Painted vessels like the cup by the Sosias Painter are luxury ware, as will be discussed in greater detail in chapter 4. Here it will be enough to give a brief indication of the three main areas of use of pottery, particularly that from Athens. First, to furnish the symposium (*symposion*), the men's evening entertainment, accompanied by wine drinking; secondly, for use in association with the honouring of the dead, as props for the celebration of the funeral or for interment as grave goods; and thirdly, to function as votive offerings in sanctuaries, in gratitude to the gods. In principle, each of these three possible uses must be reckoned with in the case of every vessel. In particular cases, a find-spot, the traces of use or even the subject-matter of representations can help to restrict the range of purposes that the vase painter had in mind at the time of the vessel's making. But in every case we are dealing with prestige objects, whose use goes beyond the sphere of ordinary everyday business. In the case of vases like that by the Sosias

Painter, which can in all aspects lay claim to a special artistic status, such products will also have had a price, as luxury goods valued by those in 'high society' for their beauty, but also for the distinction which their ownership conferred.

This also speaks indirectly for the historical situation. In the decades at the transition from the sixth to the fifth centuries BC, Athens found herself in political upheaval. In the year 507, radical reforms were introduced which, by a very dynamic process, were to replace an aristocratic structure with the first democratic constitution in European history. In 490, the Persians first advanced as far as mainland Greece; in 480, the Persian Wars reached their dramatic climax with the triumph of the Greeks at the battle of Salamis. As far as the picture on the cup is concerned, a first point of interest is that the great political revolutions of these years did not immediately alter the status and self-perception of the ruling class. They kept in their hands, *de facto*, the power of decision in all important social questions; their lifestyle, too, in which the display of material wealth played a certain part, survived for a time. On the other hand, the principle that defence of the city's territory should be in the hands of 'citizen soldiers' remained unchanged. Instead of a professional army, or of mercenaries, it was precisely the better-off male inhabitants who, in the case of conflict, took on the task of the armed defence of their own land. Every citizen had a potential role in warfare, and was trained and equipped accordingly. To that extent, a picture showing two men in a war setting, however idealised the image might be, was always something that could get across a message about one's own existence.

A very inconspicuous detail of the picture, but one that is of exceptional importance for understanding it, has so far been left out of account: each man has his name inscribed beside him. The wounded man is identified as Patroclus, his helper as Achilles. The picture, then, is meant to reproduce not a typical scene of war, such as would repeatedly occur in this or much the same form, but a scene from the world of myth. Achilles and Patroclus are among the most outstanding Greek warriors and well-known figures in the saga of the Trojan War. Homer raised their literary monument in the *Iliad*, which exerted a powerful influence already in antiquity, certainly including the late Archaic period to which the Sosias cup belongs.

All the same, no ancient text that tells anything about an arrow-wound to Patroclus or his tending by Achilles has come down to us. Recognition of the names does not allow us to say, in consequence, whether the scene reproduced in the picture represents a specific moment in the life story of the two heroes or, if so, which. In the *Iliad*, Patroclus takes the field as a

warrior at one point only, in a longish passage of Book 16, but his powerful intervention there is immediately followed by his death. Yet the names which the vase painter has added are anything but valueless. Even if the written sources give no direct hint of the event depicted here, there is no shortage of indirect testimonies giving information about the special features of the two men and their mutual relations. We can with some certainty reconstruct the idea of the legendary warriors Achilles and Patroclus that an Athenian of the years around 500 BC would have.

Achilles was, by tradition, indisputably the mightiest warrior in the Greek army at Troy. To his legendary wrath, arising from a quarrel with his leader Agamemnon, he gave full expression by withdrawing from the war and thereby placing his comrades in dire straits. Only when he returns to the battlefield does the tide turn and the Trojans go on the retreat. Yet Achilles is not just the terrifying warrior, whose sword and spear bring destruction to countless enemies, but also a healer. He learned this skill from the centaur Chiron who, as Homer already recounts, took part in his upbringing. So there is no mystery about Achilles, in the vase painting, treating the wound and doing so with the same confidence and decisiveness that typifies his movements on the battefield.

This notion of outstanding military ability is not equally closely associated with Patroclus. The prime role which the mythological tradition assigns to him is as the friend of Achilles. They were brought up together and set out for Troy together, Achilles as leader of his contingent, Patroclus as his first comrade in arms; together, too – so says Achilles according to Homer (*Iliad* 18, 80–2; 24, 574–5) – they would one day be buried. Patroclus is the elder of the two: in the picture, he is shown bearded and in this way contrasted with the more strikingly youthful Achilles. That one of them should look after the other, therefore, when an injury necessitates skilled first aid, fully conforms to the established understanding of the contemporary viewer. But yet another aspect of the biography of Achilles and Patroclus was certainly also present to that viewer, though it is one to which the picture makes no direct reference: both men are doomed to fall, in the tragic linkage of their destinies, even before the Greeks capture Troy in the tenth year of the war. When Achilles, out of anger at the conduct of Agamemnon, stayed away from the fighting, Patroclus begged him to provide at least some indirect support by putting at his own disposal his exceptionally fine armour and weapons. Reluctantly, Achilles agreed and let Patroclus go off into battle, where he fought with outstanding success and might have brought lasting ascendancy to the Greeks, had not a god invisibly joined in the fray. Apollo leaps to the aid of the Trojans and sees

to it that Patroclus loses his armour, making it easy for his enemies to destroy him. Patroclus himself takes note of what is happening to him: he would, he says in his dying words, have left the battlefield in triumph, had he had only mortal opponents to contend with.

The notion of such direct forms of divine intervention in the affairs of mortals was deeply embedded in the religious feelings of early Greeks. Achilles, likewise, does not meet his end entirely through the power of his human opponents. The arrow-shot by Paris, one of the sons of King Priam of Troy, that strikes Achilles in the heel, has won proverbial fame. According to a later refashioning of the myth, this was the only part of his body where he could be wounded; originally, and still at the time when the Sosias cup was created, Achilles was thought of as fully mortal, and the wound in the heel represents no more than an assumption that Achilles could no longer defend himself and was thus doomed. Independently of this detail, however, it is part of the earliest form of the legend that it was an intervention by Apollo, once again, that sealed Achilles' fate. He could be mightier than any one of his enemies on the battlefield, but even he could do nothing against the power of a god who directed a hostile arrow into his heel.

The contemporaries of the Sosias Painter certainly needed no such reconstruction of the biographical background to the two participants in the vase painting since they were familiar with the context. On such a basis as this, the first, very generally worded question of the interpretation of the scene can be formulated in a more complex form. One thesis (it has long been the prevailing interpretation in research) runs like this: it is friendship and humanity that are at issue here, qualities that showed themselves precisely in a situation of crisis, but which are also linked with the ideal of unconditional commitment to war service: even a wound can only briefly keep men from the battlefield. The alternative view can be developed out of the aspect handled just now. Notwithstanding the exceptional military prowess of both men, reflected in the picture by their imposing physique and the presence of the weapons, Achilles and Patroclus will not return in triumph from the war, but will meet early deaths. Only in the knowledge of this does the motif – in itself unspectacular – of the treatment of an arrow-wound acquire its full force of drama: in the wound, there is indicated the possibility of total failure. What is depicted is the positive situation, in which one man helps the other and restores his body for a return to battle. But this very scene calls up their later fate for the viewer to recollect, and to realise that, if gods intervene, there can be no rescue. On this initial explanation, confrontation with the inescapability

of death, and perhaps with the brutality of war, become the central cues to interpretation.

From what has been said so far, this second, more complex interpretation of the scene gains preference over the other explanation. It takes into account a much wider range, both of the features inherent in the picture (that is, the indications given by the representation itself) and of the background knowledge that the vase painter's contemporaries possessed. If, then, a basis has been given for saying that one of the two lines of interpretation can lay claim, at least provisionally, to far greater probability, then from this a clear proposition has crystallised which can now be tested. How far will a closer examination of the context in which the image was produced provide a confirmation? Or will it rather result in serious counterarguments?

So far, we have considered the vase painting more or less in isolation, as if it stood entirely alone in the ancient iconographic tradition and there were no other representations offering similar motifs and thus parallel interpretations. Unlike many other new iconographic devices of this period, the tondo of the Sosias cup is not in fact linked to a long tradition of motifs. Its specific peculiarities are uncommon. Scenes from the edge of the battlefield are exceptionally rare, apart from the theme of the rescue of the body of a fallen comrade. Yet there is one representation which can be called closely related in its motif. It is found on a so-called Chalcidian amphora, produced some forty years earlier than the cup by Sosias (Fig. 3). The term 'Chalcidian' is used for a class of vases which is in many respects close to Athenian vessels. The inscriptions on many of these vases point, by their letter-forms, to a dialect that was spoken in the Euboean city of Chalcis, but in other places too; in reality, the Chalcidian vases were probably produced in southern Italy, and specifically in the Greek city of Rhegion (today, Reggio Calabria). The amphora is decorated with a long frieze of figures, a battle-scene which once again includes, among others, Achilles; but this time he lies dead on the ground, pierced by two arrows. The fierce battle over his corpse means that his comrades and enemies are fighting over his body, with the aim of dragging it from the battlefield on to their own side. The Goddess Athena, only symbolically present, stands towards the left-hand edge of the scene, acting as a protecting authority for the Greek warriors.

Somewhat withdrawn from the crowded tumult of battle, one can see two warriors, one of whom is binding the other's wounded index finger. These two figures, named as Diomedes and Sthenelos, again represent a pair of friends. The *Iliad* relates how Diomedes is at one point wounded in the

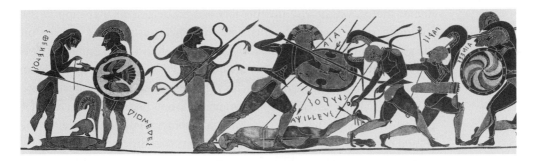

Figure 3 Fighting before Troy: Sthenelos tends the wounded Diomedes. 'Chalcidian' amphora (drawing), *c.* 540 BC

shoulder, and how Sthenelos assists him by pulling the arrow out of the wound (5, 111–13). But the vase painter, if he took his inspiration from the epic at all, has given himself the freedom to exploit not the letter, but the spirit of the legendary tradition. The rendering of the treatment of the wound emphasises the momentary, enforced suspension of the fight and the considerate aid given by one warrior to the other. As on the Sosias cup, both men are armed, fully in Diomedes' case, while Sthenelos has put down his helmet and shield. Even if it represents an isolated work within the tradition, the testimony of the scene on the amphora is still of no little value. It shows that the introduction of the motif of the treatment of the wound, and its use to express something extending far beyond the incident immediately shown, was no new invention of Sosias' time. In one case as in the other, the iconography makes it clear beyond all doubt that the men's injury will not prevent them from returning to the battle. And in each case, the temporary disablement hints at the fundamental vulnerability and mortality of even the greatest heroes. On the amphora, this is directly expressed through the dead Achilles; on the Sosias Painter's cup, it is done by the indirect means already mentioned. Thus the later work contributes no real innovation. But by expressing visually the two elements, 'military prowess' and 'mortality', in one and the same image, instead of doing so cumulatively in two separate scenes, as on the amphora, it displays both greater conceptual elegance and a more discriminating creativity. In any case, the consideration of both representations together has produced added circumstantial evidence for the soundness of the thesis advanced earlier.

An important component of this thesis is that the Sosias Painter's picture has a prophetic quality. It is created by the tension between what is actually depicted, and the knowledge of the further destiny of the two men, of their approaching death. This interpretation cannot be, in the strictest sense,

demonstrated, yet there are further iconographic elements that support the legitimacy of the thesis. Patroclus, while he is being attended to, sits not on the ground but on a shield. The device on the shield is just recognisable. It is an (only partly visible) tripod, the attribute of Apollo. So: the very god who will set in train the killing of Patroclus is brought, if only symbolically, into the picture. But, as already explained, it is not only Patroclus, but Achilles too who will perish before Troy through the intervention of Apollo. One should not, however, judge the device, without reservation, as an unambiguous 'speaking sign', for the tripod occurs very widely as a shield-device in late Archaic vase painting, and does so in a variety of types of mythical scene. Yet analogies nevertheless exist for the referential function suggested here, as for instance when giants, in their struggle against the Olympian gods, carry on their shield a device which relates to the divinity who is their opponent.

In the *Iliad*, the headlong downfall of Patroclus is described in a dramatic sequence (16, 698–867). Apollo first knocks the helmet from his head, then breaks his spear; his shield falls to the ground and finally his cuirass is undone, so that the warrior stands unprotected on the battlefield, to be struck first by the rather unimportant Euphorbus, then by Hector, the greatest warrior in the Trojan ranks. The question arises: is it possible that certain details of the picture, not directly connected with the theme of the treatment of the wound, might establish an associative link with the concrete circumstances of Patroclus' death? In contrast to Achilles, he is not wearing a helmet, but has only the cap-shaped lining on his head; the cuirass is untied not only on the side of the wounded arm, the left, but on the right too – its lacing cord is clearly visible. Both features fit in with the initial stages of his destruction, as the Homeric epic describes them. His posture, too, seated with splayed legs, should not be put down to his circumstances, as has often been supposed: it was seen as a momentary loss of composure, a way of bringing the hero down to a human level. Patroclus' body-armour, and the block-like unity of Achilles' pose, stand in marked contrast to the bare, widely spread legs and unprotected genitals. The exact words of the *Iliad*, to describe where the fatal spear-thrust of Hector struck him, are 'Low down, in the flank' (16, 820–1).

At first, it may perhaps appear too risky to assume such a close correspondence as this, between the verbal version of a myth and the visual representation of Patroclus. But the doubts disperse when one takes account of the fact that regular, festive public recitations of the Homeric epics *Iliad* and *Odyssey* were taking place in Athens at the period when the cup was made. In an age when there was nothing to compare with the present-day

flood of images and texts, one may assume that audiences had a highly developed receptivity, even for small narrative details and even single, telling phrases. Besides, other visual images testify to a knowledge that extended to the details, not just of the subject-matter of myth, but of specific versions of these myths. Vase paintings which relate to recondite, seldom represented episodes in the Homeric narratives can only be understood if the producer, as well as the viewer, was thoroughly acquainted with the legends in their poetic form. Such familiarity further embodies an assumption that people with the vessel in front of them were capable of fully appreciating an independent visual innovation like that of the Sosias Painter.

Another part of the context of the picture of Achilles and Patroclus, one more closely related than some of the aspects so far discussed, is the representation on the outside of the cup (Fig. 2). It offers, yet again, important clues for identifying the meaning contained in the scene with which our examination began, as will shortly be revealed. There is no narrative connection with the scene in the interior, but rather an intellectual one. The theme chosen is the introduction of Heracles to Olympus and his reception there by the gods. Heracles was the issue of the union of Zeus, in one of his many affairs, with Alcmene. Like his mother, Heracles too was of mortal birth. What distinguished him, however, was a physical strength that belonged in the sphere of the miraculous. His extraordinary deeds – the slaying of the Nemean lion (Fig. 7) and the capture of Cerberus the dog of the Underworld, among many others – made him into one of the best-known figures of Greek myth. His popularity found expression in the visual arts as well: no figure of legend is represented as often as he. Yet it would be a mistake to assume that Heracles was, for the ancient Greeks, merely the epitome of physical energy and near-effortless success. His deeds often required of him the utmost extremes; what is more, virtually none of them were 'adventures' undertaken just out of hunger for experience, but tasks which he fulfilled under contract to others and under duress. Already in Homer he is described, for this reason, as someone who must achieve the exceptional and whose life was, above all, one of almost unbearable troubles.

According to the version of the legend that was commonest in the time of Sosias, Heracles is endowed with immortality at the end of his life, as an expression of the gods' esteem for the sufferings he had borne. He takes a place among the gods. Just this situation, the transition from a laborious life on earth to the sphere of the gods, is portrayed on the exterior of the cup, in a long frieze interrupted only by the two handles. Whether the impression of a certain hesitancy on the part of Heracles – as a reflection of his unfamiliarity with his new environment – corresponds to the vase painter's

intention remains to be seen. No less than seventeen gods have assembled in this heavenly setting, on the side with Heracles mostly standing, on the other side mostly seated. Their movements and looks centre on Zeus, who sits on a fine throne beside his consort Hera. The words 'My greeting, Zeus!' are written, as if in a speech-bubble, beside Heracles' mouth. So it is to Zeus that he is making his way, past many other divinities, so leaving the viewer in no doubt as to the source of the favour to which he owes the gift of eternal life.

From this point on, it is obvious how the inner and outer pictures on the cup are tied together by a contrast. Physical prowess and, as a result, a place in human memory, are common to all of them, Achilles, Patroclus and Heracles. But while the last named was admitted to a place among the gods, the wounding of Patroclus in the other instance indicates that these two heroes will not receive the privilege of immortality, albeit Achilles at least is descended from a deity. The contrast with the daunting but, in the end, extremely fortunate destiny of Heracles makes the legendary biography of Achilles and Patroclus into an invitation for the (male) viewer of the vase painting to identify with them: they too might win honour through their supreme military achievements, but they must be conscious at every moment that this striving for fame may bring them death, if external factors (or, in religious language, the will of the gods) so dictate.

So the pictures on the Sosias cup relate to different cycles of saga, yet their content and meaning merge them together into a creation that is positively programmatic. Such a result is nothing unusual for the epoch in question. As evidence that it is a phenomenon typical of its time one may quote, as a striking parallel, another Athenian cup in Berlin of the same period and the same artistic quality. The painter signed his vessel with the name 'Peithinos', very probably not his real one but a stage name that in this case could be understood as meaning much the same as 'the seducer'. For the images, once again both inside and outside, are entirely concerned with the bringing about of love affairs. In both the external pictures nameless men, to be understood as contemporaries, make advances, in one case to women, in the other to enticing boys. In the internal picture, the confrontation is raised to a different plane, for we find ourselves in the sphere of myth and divine love (Fig. 4). The Sea Goddess Thetis, best known as the mother of Achilles, sets out to resist her abduction by the mortal Peleus, whom she is nevertheless later to marry in a magnificent ceremony. The intertwinings of motif and content are thus as comparable with the cup of Sosias, as is the further conceptual idea of letting the world of the gods appear as a remote point of reference for the affairs of mortals.

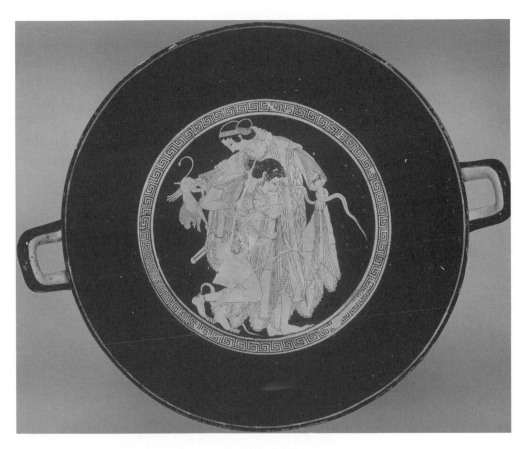

Figure 4 Peleus and Thetis. Attic red-figure cup, signed by the painter Peithinos,
c. 500 BC

The starting point for every interpretation of a Greek mythological image
is the information contained in the picture itself. When we add to this the
tradition handed down by the literary sources about the actions and char-
acters shown, and in addition take account (as has been possible with our
example) of the other motifs that appear on the same vessel, then a wealth of
circumstantial evidence will usually be at our disposal, on which to base
quite a far-reaching interpretation. The critical and quite justified objection
can be advanced, that this procedure resembles a game whose object is to
arrange the different pieces of evidence in as convincing a way as possible, so
as to produce an intellectual scheme that is as free from internal contra-
diction as it can be. In more openly technical terminology, this would
be called something like 'combinatory iconography'. The doubts that can
undercut the results reached by this type of procedure are directed at the
question: is the final result convincing mainly because it is in harmony with

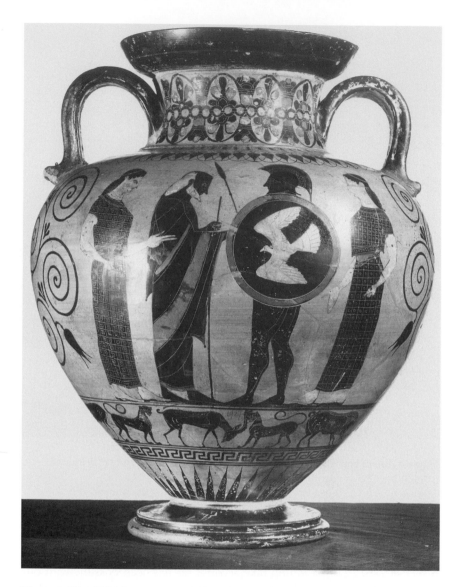

Figure 5 Warrior's departure. Attic black-figure amphora, side A, *c.* 540 BC

the convictions and intellectual positions of the modern interpreter's own day? An interpretation of an image, if not as openly anti-war, then as a challenge to reflection over military action, may owe some of its credibility to the fact that *we*, according to the dominant standards of today, find a treatment that expresses such feelings sympathetic and, as a consequence, convincing as well. The study of ancient images, mythological or otherwise, may benefit from close association with the theoretical frameworks of the present, and can continually draw on them to formulate new questions; but

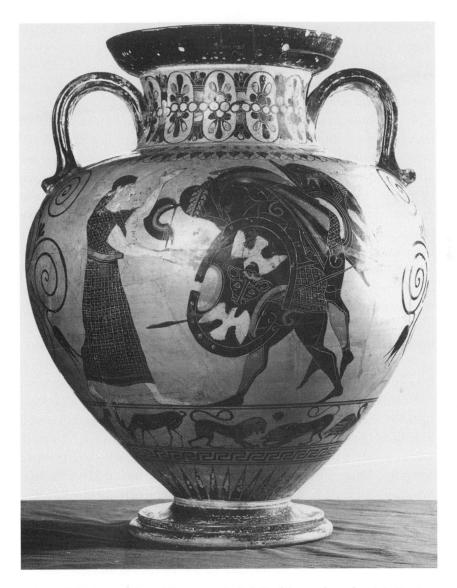

Figure 6 Warrior carrying a fallen comrade. Side B of the amphora shown in Fig. 5

at the same time it is exposed, to a much greater degree than something like the study of Greek architecture, to the danger of discovering in the images only what one's own intellectual disposition inclines one to accept.

For that reason, too, this risk cannot be entirely averted; but it can be reduced by the further widening of the basis, still relatively narrow, from which the result is elaborated. The first question must then be whether the interpretation, resulting from the combination of the iconographic

elements, can also be seen as historically plausible: can it be convincingly shown that open debate, on both the good and the bad consequences of war, was something within the intellectual horizons of the age? And can one assume that the great heroes of legend had become ambivalent figures, not merely men of action, but subject to weaknesses as well?

As such questions intimate, investigating the historical probability of an interpretation often takes one far beyond what is directly addressed in the image to be interpreted. Some of these external aspects, which locate the Sosias Painter's vase painting in a wider context, have already been sketched in the preceding pages. They include the practice of Homeric recitation at that time, the religious notion of the intervention of the gods in human affairs, and the indication that programmes of imagery, of comparable complexity, exist on other vases of the time. In what follows, in keeping with the illustrative character of this text, we shall deal briefly with just two of the many possible aspects, typical of the age, both of them belonging to the context of the visual arts.

No one will question that the image, with Achilles tending Patroclus, invites reflection on friendship and solidarity between warriors. Even some-one who knows nothing of mythology and for whom the inscribed names have no associations will immediately confirm this. But anyone who is not only familiar with the two characters but also capable of 'reading' additional signs like the shield device will, according to the interpretation advocated here, think of the impending death of the two men and thus extract a more specific meaning from the image. The claim that war is not – or at any rate not only – being glorified here, but is being treated as a theme with fatal consequences, finds abundant confirmation in the repertoire of imagery in Archaic Athenian vase painting. Already in the early sixth century BC it is relatively common to portray, not just success in battle but also defeat, with the rescue of a corpse from the battlefield being shown. A few decades later (and thus relatively close to the date of our cup), this motif appears in combination with another theme. A series of vessels shows, on one side, a young man in armour saying goodbye to his family, as he leaves his house to go to war (Fig. 5). Our example is a work that can be attributed to the painter Exekias, famous for his inventive imagery. On the reverse side of this vase, made around 530 BC in Athens, another man in armour can be seen, this time fallen in action and being carried away by a comrade (Fig. 6). Unlike the case of an isolated representation of the rescue of a dead man from the battlefield, here there can be no doubt as to how the picture and its pendant are to be understood: first the departure to war, then the tragic ending with death in battle. Athenians evidently did not avert their gaze from the

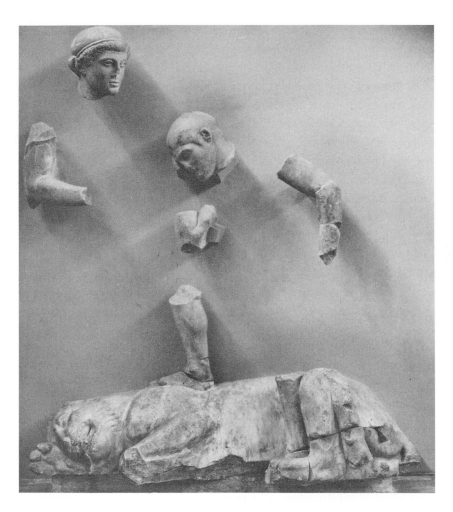

Figure 7 Heracles and the Nemean lion. Olympia, Marble metope from the temple of Zeus, *c.* 460 BC

disastrous consequences of war, something by no means self-evident for other cultures with a comparably developed visual imagery. This is where the Sosias Painter fits in. But, as has already been said in connection with the Chalcidian amphora (Fig. 3), he shows his especial mastery in the way that he encompasses both the greatness and the downfall of the warriors, if only by suggestion, in one and the same picture.

According to our interpretation, the image presents a complex view of humanity, for it does not simply ask of the individual that he set out undeterred to war and fulfil his duty to his country. Instead, Achilles and Patroclus appear in certain respects as unheroic heroes, who are vulnerable and need protection. Of the spectrum of human emotions, it is the aspect of

weakness and anxiety that is uppermost here. That such an understanding of the picture can claim historical probability will once again be demonstrated by an abundance of images from this period, which deal in an analogous way with the everyday and apparently irrelevant topics from the lives of the great mythical heroes. There are pictures of Heracles, showing him reclining at table and living the good life with food and wine. The Greek warriors before Troy, an especially favourite theme of the time of Sosias, will be depicted, not fighting but sitting down together to pass the time with a game of dice (Fig. 48). In such a scene, too, whatever its detailed interpretation may be, there is a 'cut' away from the battlefield and the figures of legend turn into complex characters. This interest in the human aspects reaches a peak when an archetypal figure of tirelessness like Heracles is shown on the Temple of Zeus at Olympia (*c.* 460 BC) as a young man supporting himself, as if exhausted, after achieving his first great deed, the conquest of the lion (Fig. 7). 'It could have turned out otherwise' is the viewer's instinctive response; 'Even a hero who is later to join the gods has his limits.'

In this introductory chapter, an unusual and artistically ambitious mythological image has served as a concrete example for a first, detailed insight into the practical interpretation of imagery. In order to achieve a maximum of clarity, we have gone into matters of general principle only so far as was absolutely necessary for understanding each step, from the description of the picture to its analysis and interpretation. In the next chapter, it is instead the fundamental questions, especially the problems of definition, which come to the fore, and examples will be produced, case by case, for their explanation.

2 | Definitions: myth and mythological image

The attempt to define 'myth', or the basic character of Greek mythology, can start out either from the original meaning of the word *mythos*, or from the modern engagement with the subject-matter of myth. Consideration of the ancient term calls for certain prior assumptions as to its content, and should therefore be postponed for the moment (see below, pp. 69–70). True, we do not find any definition that could be said to command general acceptance, in the scholarly disciplines which are concerned with ancient myth, from Classical philology, through the history of religion, to philosophy, ancient history and, not least, Classical archaeology. Some kind of consensus in the handling of the subject has nevertheless developed in the course of research. At the most basic level, there is at least agreement as to what belongs to the category of 'myth'.

Accordingly, Greek myth can be classified as 'a traditional tale with secondary, partial reference to something of collective importance', to quote the apt formulation of Walter Burkert. In the course of this chapter, the individual components of this definition will be discussed in detail and brought to life by examples. For the moment, this basic point is enough: that myths tell stories and that the characters involved in them belong to a sphere which, potentially at least, lies beyond the world of human experience. Heracles who will be accepted into Olympus (Fig. 2), or Achilles who is born of a goddess and instructed in the art of healing by a centaur (Fig. 1), are especially prominent figures from this mythical sphere. In these stories, there is much that bears the mark of fairytale, but much else that conforms to conventional human patterns of behaviour, as in the case of military confrontations between figures of myth, of intrigues or of fateful chains of events. Many of these stories are, from their characteristic turns of plot, decidedly memorable and fulfil every condition for exciting and entertaining their public. To grasp the effectiveness of this subject-matter in antiquity, it is perfectly legitimate to call to mind one of the film versions of the adventures of Odysseus, in which the viewer is carried, spellbound, from one fantastic backdrop to the next. Across the gap of the centuries, the myths have always had the power to speak directly to an audience (we have already mentioned the recitations of Homer in Archaic times, above,

pp. 10–11) or to the spectators in a theatre, and to encourage them to witness the events.

The second basic component is concerned with the fact that the narratives of the myths were never meant solely to entertain, but always possessed a meaningful content, the 'significance' just referred to. If the narratives have the capacity to grip the emotions of those listening to the stories, then this effect can also be used to fulfil the conditions for confronting their public with the content of the ideas round which the myths revolve. The discussion of the vase painting in the opening chapter already had the aim of going beyond the recording of its narrative content to consider its meaning and, in the course of the treatment, to identify this with ever greater precision. If Greek myths were constructed purely of action (as in 'action film'), if they contained no intellectually stimulating element, they would certainly not exercise the full hold that they do today, but would have become merely material for specialist research.

There is another justification, too, for establishing the connection between Greek legend and our own times. The pictorial rendering of fictional subjects is something which probably enjoys even higher regard in modern western societies than it did in Classical antiquity. Today however the pictures that surround us are no longer static, as remained the case in the Middle Ages and until far into the modern age, but moving ones: cinema and television. Whether one takes the television soap programmes of the early evening or the prime-time film showings, the popular blockbusters of the latest cinema or famous productions of the past, all alike, in differing degrees and in a variety of ways, have something in common both with each other and with ancient mythological images: they use the stories that they tell to entertain, yet they also exercise an effect that goes beyond the moment, by taking abstractions like wishes, ideas and fears and giving them visible and concrete form. To engage emotionally, by identifying with the heroes and heroines of a film or sharing in the trivial conflicts that are the stuff of television serials, always means crossing the boundary between one's own range of experience and those of an imaginary world of performance. Fictional subjects, turned into film, can thus make a contribution to coping with one's own life. They set off a wide variety of effects, ranging from momentary distraction or diversion to intense intellectual engagement with what has been experienced. Thus in the course of time each individual builds, out of the characters and narratives that have left a special mark on their consciousness, a kind of private mythology. This is made up differently for each individual yet, because of the special popularity of certain films and characters, it also contains many things that are shared

with others. But its function is always the same. Invented stories and characters are juxtaposed, and contrasted, with situations from one's own experience and with one's personal ego. Consciously or otherwise, to a certain extent one takes one's bearings from them, whether in imitation or in differentiation. The universe of stories and ideas that is represented in the Greek myths (and mythological imagery) serves the same purpose: a challenge to widen the limited field of one's own experiences and conflicts, by engaging with figures and their contexts that belong to a world that is only imagined.

From what has been said so far, Greek myths, for all the substantial role that the gods play in them, seem to be at the same time a purely 'secular' phenomenon. One of the major themes in the history of ancient religion is indeed this question of how we should imagine the relationship between religion and myth in Greece. An especially controversial debate has long been directed at the problem of finding a reliable model for the origins of myth in early, prehistoric times: did religious rituals lead to the invention of 'appropriate' myths to go with them or did mythical stories, conversely, contribute to the establishment of cults? For the historical period, from which all the mythological images come, these problems of origin have little significance. What is indisputable, however, is that for the entire duration of Greek civilisation, myths were linked with religious beliefs and with religious practices too. Every legendary narrative in which gods appear as participants also contains a message as to how mortals imagined the workings of these transcendental beings. As regards ritual practices, one must take as a starting point that, as part of the main festivals in many sanctuaries, myths were performed in the form of hymns or ritual dramas, in which the deities being worshipped there at the time were the centre of attention. This gives the gods a certain biographical substance and, at the same time, the festive celebration of their outstanding deeds on each occasion supplied a renewed legitimation for honouring them in cult. Clear traces of the myths performed in a ritual context have seldom survived, so that an analysis in detail is scarcely possible.

The recitation of narrative material in the course of religious ritual might seem to offer a parallel with the practice of divine service in the Christian faith. In fact, though, this comparison between Greek myths and Biblical texts leads in the first instance to a serious discrepancy. Sacred texts, whose wording is fixed and whose messages have a binding character, play only a minor role in Greek religion. If Homer in his epics, or a tragedian in his dramas, presents the gods in a certain way, if even a hymn performed at a religious festival glorifies the gods, then this is not the expression of

an 'official' view. Rather, it represents a contemporary approach to the question of how one envisages the peculiarities and workings of the gods. As the content of the myths undergoes constant change, so the view of the gods who appear in them changes with it. In general, there is no way that Greek mythology as a whole can be assigned to the sphere of religion, because the legends about the gods cannot be clearly differentiated from the mythical stories which deal with mortal figures, whether or not they have contact with the gods. One thinks, for instance, of Heracles who completes his famous labours, who at times enjoys the aid of Athena when conditions are difficult and who, at the end of his life, will be accepted among the gods as an immortal. The hero as model for human energy and suffering becomes, in the course of his life, a figure offering some kind of promise of religious salvation.

Just as the language versions of the myths are not binding religious texts, so the mythological images cannot be treated as religious representations. In the same way, to anticipate briefly at this point the commentary on the different classes of monuments (chapter 4), a comparison between the Greek temple and the Christian church would bring to light more differences than common features. The images in temples and treasuries translate narratives and abstract ideas into visual form, just as do the statues and reliefs in Christian churches; yet they have little to do with an illustrated Bible, which uses an easily accessible medium to popularise firmly held religious positions.

Myths as traditional tales

Of the three components of the definition of myth cited at the outset, the key word 'tale' demands at least some explanation. In the same sense in which this expression is used to refer to a literary form, it indicates that myths, on the one hand, consist of a sequence of events or episodes and on the other, that the participants in its action are specific, non-interchangeable persons. The stories do not, as many fairytales do, deal in anonymous representatives of a class – a king, a shoemaker, an orphaned child. Instead, myths are about individual figures, known by name, and with these in turn are linked specific deeds and occurrences.

The legend of Oedipus can serve as a typical example. The story, if its more distant antecedents are left out of account, is composed of a number of central episodes: when it is foretold to King Laius of Thebes that his son will kill him and usurp his rule, and when Oedipus is born, he has his feet

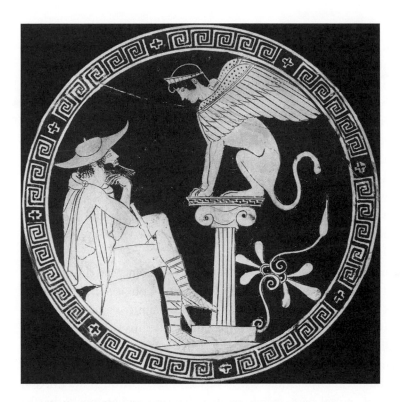

Figure 8 Oedipus and the Sphinx. Attic red-figure cup, *c.* 460 BC

pierced through (*Oidipous:* Greek 'club-foot') and maroons him in the wilds; he will not incur the guilt of the murder himself and in this way exposes his son to supposedly certain death. Yet Oedipus survives and, when he has grown to manhood, kills his (unidentified) father as a result of an unfortunate chain of circumstances. Unaware of his own identity and unrecognised by others, he finds his way back to his native town and there solves the riddle of the Sphinx, who squats before the city gates and has brought great disaster to the inhabitants (Fig. 8). In gratitude, he receives in marriage the widow of the king – his own mother, Jocasta. In the end, to the horror of the participants, the blood-guilt is revealed. In the commonest version of the legend, Oedipus thereupon puts out his eyes and Jocasta hangs herself.

The example can be considered typical, insofar as the Oedipus myth deals, not with a single, isolated deed but with a chain of events that are in part causally linked together. The actions that Oedipus himself takes – that is, that he unknowingly kills his father and marries his mother – have a past history, the oracle given to Laius, and a consequence, the extreme tragedy of

Oedipus: mutilated and exposed in childhood, he ends his life in disgrace. This tight and indissoluble chain of single episodes in the legend means that a pictorial representation or oral narration of the meeting of the hero with the Sphinx will also put the mythically informed viewer or listener in mind of what has gone before this episode and what will follow later. What the fourth-century BC comic poet Antiphanes says (fragment 191) about myth as material for the stage, holds good in a closely similar way for the visual arts: '. . . the public knows all about the content, before even the first word is spoken. A poet has only to remind the public. I need only say "Oedipus" and they know all the rest – Laius the father, Jocasta the mother, the sons and the daughters; what he will suffer; what he has done'. In a single moment from the narrative of a legend are often contained all the other elements that belong to the story in question.

A peculiarity of Greek mythical narratives, one that will spring to the mind of non-specialists more strongly than that of experts, must be mentioned at this point: the exceptionally drastic nature of many of their themes. In innumerable cases, conflicts are pursued to the extreme point of the killing of one of the adversaries; gods change themselves into beings of a different form; heroes fight with monsters. A definite trait of the myths seems to be the intensification of the events, whether through the extreme behaviour of mortal participants, or in the form of phenomena that lie beyond the limits of the empirical world. In dramatic terms, the Oedipus myth is a real *tour de force*, leaving virtually no time for reflection: the mutilation and exposure of the child, his killing of his own father, his conquest of the monstrous Sphinx, his sexual union with his own mother.

In a famous passage of his *Poetics* (1449b27–8) Aristotle speaks of how tragedies performed on stage, nearly all of them made up of mythical subjects, served the purpose of entertainment, but also of *katharsis*, or inner purification. The purifying effect was achieved through terror and pity, as they arise from the performance of dramas. This statement can in its essence be transferred to Greek myths in their entirety, their visual representations included. The intensification of the action sets up emotional reactions in the listener or viewer. This brings about a sharper attentiveness than would be the case with events taken from our own world of experience. At the same time, these mythical events do not have their origin in pure fantasy. The basic narrative elements without exception relate to fundamental aspects of life experience: for example, the relations between the sexes and between generations, the confrontation with external threats, the relationship between god and man. Thus a peculiar balance is created: the exaggeration in the character of the narrative serves to step up the

intensity of the intellectual engagement with the ideas behind it. The frank improbability which is characteristic of Greek myths – as of the legend and fairytale narratives of many other cultures – is to some extent neutralised by the truth content that only becomes fully apparent through the exaggeration.

A second component in our initial definition of myth also demands some explanation. 'Traditional' has a double meaning. Legendary material of this kind, first of all, has no individual author, but is the anonymous possession of a cultural community, one which is transmitted and kept alive in that community over a long period. Certainly, specific formulations of mythical narratives were linked in Classical times with the names of Homer and Hesiod. Yet there is no legendary material of importance that was held to be an entirely new creation on the part of an author known by name, and that was then passed on from one generation to another as the work of this creator. It was of no advantage, for the status and consequent effect of an invented myth, for it to have an author: on the contrary. Anything which is patently man made and devised by an individual is open to the criticism of being subjective, and thus without any claim to universal validity. The myth with no author, by contrast, when represented as something which is simply 'there', possesses a certain quality of more than personal authoritativeness, whose truth cannot be readily questioned.

There are numerous Greek myths that were, demonstrably, not generated in some timeless 'dim and distant past', but which arose only at an advanced stage of history and were then integrated into the existing body of legend, thereby becoming 'traditional'. To such narratives, the myth of the contest between the Gods Athena and Poseidon for the land of Attica can very probably be assigned. Each of the two deities had, according to the myth, laid claim to the role of protecting authority for Athens and its territory Attica. To bring about a decision they entered into a contest, as to which could give the more persuasive proof of their powers. Because of the incomplete nature of the tradition, it is no longer possible to reconstruct every detail of the narrative. In any event, both deities gave vivid demonstrations of their power. Athena caused an olive tree to sprout from the rocky citadel of the town, the Acropolis; Poseidon, in the same high-lying locality, created a salt lake. Both acts were meant not only to cause amazement, but to recall the wider potency of the deities. Athena was seen as the bringer of culture whose olive tree here represented one of the most important plants for exploitation and fundamental subsistence: Poseidon's marvel alludes to his status as ruler of the elements, in this case specifically the sea.

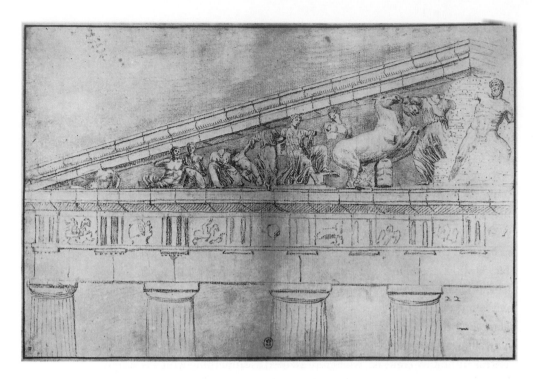

Figure 9 Contest between Athena and Poseidon over the patronage of Attica. Athens, west pediment of the Parthenon (drawing), *c.* 435 BC

The earliest evidence for the existence of this story consists of a succinct passage in the *Histories* of Herodotus and the sculptured group in the west pediment of the Temple of Athena Parthenos on the Athenian Acropolis, known as the Parthenon (Fig. 9). Herodotus merely tells us briefly that by one of the temples on the Acropolis, there was '. . . an olive tree and a salt-pool, which (as the Athenians say) were set there by Poseidon and Athene as tokens of their contention for the land' (8, 55; trans. A. D. Godley). The pedimental group was designed and executed in the years around 435 BC and Herodotus' history also belongs to about this time. But the assumption that the myth was actually only very new at this time is not based merely on the lack of earlier evidence. Countless dedications have been found on the Acropolis, set up there by private donors. Chronologically, the votives to Athena extend far back into the earlier Archaic period, but not those to Poseidon: none of these can be placed before 480 BC. In general, Poseidon seems to have been honoured with worship in Athens on a wider scale only in the sequel of the battle of Salamis in the year 480. After the Greek fleet, with decisive Athenian participation, had won a victory as overwhelming

as it was unexpected over the Persians, gratitude towards the sea god found expression in the establishment of new cults. Poseidon rose in the religious life of the city to the status of a protecting deity and, as such, found himself side by side with Athena who had from time immemorial been acknowledged in this role. But to fix in the consciousness of the population this new status for the god, arresting images and myths were needed. Thus the idea was born of inventing a story of a competition between the two deities, with each trying to outbid the other to be of service to mortals.

No doubt this myth was at first presented orally, perhaps in the form of a hymn performed at religious festivals. But in order to give credibility and a measure of authority to the newly created divine myth, visual narratives were also commissioned at considerable expense. The pedimental group was a relatively conventional response to this aim. A drawing made in 1674 (Fig. 9) shows it still in fairly good condition, shortly before the building and its sculptures underwent severe damage. The two adversaries occupy the centre of the pediment: Athena and Poseidon appear to be recoiling from each other after a forceful initial clash. The (mostly not securely identifiable) figures beside them are probably to be seen as spectators and as judges of the contest. With the quasi-documentary visualisation of this mythical event in the pedimental space was associated the arrangement of the actual site on the Acropolis where Poseidon was supposed to have performed his action. In a temple known as the Erechtheion, newly erected at this same period, a clear space was left on the floor at the spot where Poseidon's trident was supposed to have cleft the ground and released the salt-water spring. And to give free play to the visitor's imagining of the mythical happening, a hole was left in the roof of the building, exactly over the place where the trident had been driven into the ground. The overall effect was one of the respectful preservation of a time-honoured site of divine epiphany; yet the likely truth is that all this was merely a device, to give a new myth the appearance of a traditional story.

The 'importance' of myths

According to the second part of our definition cited at the outset, Greek myths possess, in addition to their function as entertaining narratives, a 'collective importance'. The tale just discussed, of the contest between Athena and Poseidon, just like the cup by the Sosias Painter considered in the first chapter, has demonstrated, by a concrete example, how we must imagine the transmission of 'meaning'. In the one case, it was a matter of

furnishing a new cult with credibility and authority; in the other, the tension that exists between the winning of military glory and the danger of individual failure became the theme. Fundamentally – and this is the decisive point – Greek myths were produced in order to fulfil a specific purpose, something well over and above the need for entertainment and distraction or, more precisely, lying beyond it. They contribute towards making complex facts more readily intelligible than would be possible in a direct, abrupt explanation. A myth is thus, to cite Walter Burkert once again, always an 'application' or a 'tale applied' – and this in the fully active sense of this word. A myth's content is not just passively conveyed: on the contrary, it constitutes the real impulse by which the particular content is generated, with its multiple characters and specific plot.

The modern interpreters were not the first to issue the methodological challenge of distinguishing clearly between the narrative material on the one hand, and a deeper significance of the content on the other; it is something as old as the very first thoughtful involvement with Greek myth. A famous passage of Plato's *Republic* discusses the value of mythical narratives for education. By the fourth century BC, it went without saying among intellectuals that the traditional myths about gods and heroes, with their unreal happenings, were without exception to be classified as untrue, as simple stories which had been used by people in earlier times to try to make sense of certain aspects of the world in which they lived. Yet, says Plato, these tales are not to be entirely rejected. What they communicate about universal ideas and imaginings may perfectly well contain truths that may, with advantage, be inserted into the framework for the intellectual training of the young. Plato speaks in this connection of the *hyponoia*, the deeper meaning of myths. In order to achieve the right effect, however, the choice of material and the activities of the *mythopoioi*, the creators of the myths, are to be very closely monitored. The critical attitude towards the traditional transmission of legend, which is expressed in this position, will be the subject of renewed discussion in the next chapter.

For what Plato called the *hyponoia*, all manner of terms have been tried out as equivalents: the 'symbolic', 'metaphorical' or 'allegorical' level in the case of a (literary) image, or the distinction between the literal and the transferred sense. It need not be a source of irritation that no consensus has developed, in professional practice, on how these terms should be used, so long as the nature of the case is clearly understood. To speak of the 'significance' or 'meaning' of a piece of imagery is the least awkward solution, because of the neutral character of these terms. The expression 'allegory' may also be used, with the added advantage that

it was already employed for similar phenomena in Greek and Roman antiquity. 'Allegory' means literally 'talking in an other way' or 'talking of something other than what is apparent': that is, conveying a message, but doing so not immediately but by indirect means. The picture on the interior of the Sosias cup (Fig. 1) could in this way be understood as an allegorical message about warrior status and outlooks on life. Yet in our context, 'allegory' too cannot be used quite without reservations. In the first place the expression, at least in its literal sense ('talking in another way') relates to verbal formations, not images; and it is an essential precondition for understanding the means by which mythological images achieve their effects, to make a clear distinction between the rules of communication in the medium of language and in the medium of the image. Secondly, allegory involves active and conscious treatment of the two levels. The expression therefore relates, in the first instance, to the outlook of the producer. In archaeological research, however, the investigation of the allegorical meaning of a mythological image also embraces, in equal measure, those aspects of the content which express typical contemporary attitudes, without these necessarily having their origin entirely in the intentions of the artist. The interpretation of the pictures on the Sosias cup that was developed in the first chapter is not to be seen without qualification as a reconstruction of the thought-processes of the vase painter; rather, it seeks to determine what meaning the viewers of the image could have applied to it. The viewpoint that we wish to reconstruct is fundamentally that of the recipient.

In the variability of the few cases that we have considered so far, there is an intimation of a fundamental peculiarity of Greek myth. There is hardly an aspect of human life that is not in some way touched upon by one myth or another and by its meaning. The legendary tales deal with the whole range of life and experience in which conflicts can arise, be they psychological, religious or ethical in nature, for the individual or for a social community. Phenomena that defy any conclusive rational analysis are, so to say, translated into stories in which the participants, as proxies, live through certain basic situations. The phrase 'mythical thinking' has rightly been used, to characterise this function of mythical narratives as a means of explaining the world. Even if, collectively, they present no structure that is systematically built up, it remains beyond question that Greek myths express an intensive intellectual engagement with the world around us in all its manifestations. Instead of developing abstract principles, in the manner of the logico-deductive method, mythical thinking transposes the examination of its subject-matter entirely from the standpoint of its narrated stories.

Every author who tries to put into words this quality of Greek myth will end up with different formulations and partially differing choices of emphasis. Walter Burkert for example, whom we have already cited, said this on the matter, that the tale is often 'the first and fundamental verbalisation of complex reality, the primary way to speak about many-sided problems'; and further that myth 'in its application, creates a system of coordinates to cope with the present or even with the future'. The unpredictability and unintelligibility of natural phenomena, for instance, is embodied in the figure of Poseidon, who causes a salt spring to bubble up on a rocky height; the story of Athena putting the olive and its fruit at the disposal of humanity provides an 'explanation' for why the earth readily offers a basis of subsistence for thousands of people. To grasp in a succinct formula the peculiarity of Greek myth, Fritz Graf's formulation was that it has '... cultural relevance. A myth makes a valid statement about the origins of the world, of society and its institutions, about the gods and their relationship with mortals, in short, about everything on which human existence depends'.

But a further result of this claim to unlimited authority, on the part of traditional myth as a whole, is that no narrow and clear-cut definition of 'the' Greek myth can be given. Yet certain areas can be recognised in which myths, whether verbally or pictorially expressed, came strongly into operation, for instance to define and redefine continuously the relationship between god and man. As compared with such special 'applications', however, the universally serviceable character of traditional mythical narrative must be called the more distinctive characteristic. This has a clear consequence for interpretation: an individual myth, even when it offers a recurrent narrative pattern, can only be fairly treated by a very careful and often time-consuming investigation of all its components.

The changeability of myths

In the year 1838 appeared the first of the three volumes of what is still the best-known retelling of Greek myths in Germany, the *Tales from Classical Antiquity*. With this compilation, Gustav Schwab made a contribution that is impossible to overrate in the popularisation of this material. With the drawings of, among others, John Flaxman (1755–1826), first appearing as a series of engravings in 1793, the tales of the great heroes and of the doings of the gods made a firm visual impression, too, on many readers (Fig. 10). To make the content of the original ancient texts accessible and easily readable, however, Schwab eliminated one important peculiarity of Greek myths,

Figure 10 Odysseus in Polyphemus' cave. Drawing by John Flaxman (1793)

their great changeability. In Schwab, the myths of Classical antiquity are given an apparently definitive shape, not unlike the authoritative form in which the events are set down in the Old Testament and the Gospels. On the course of events involving Moses or the life of Jesus Christ, the Bible and, at least for the devout Christian, only the Bible can inform us. What is written in the Old or New Testament demands to be taken as valid, in the formulation there present, and cannot be remodelled according to choice, or even modified in any important point. This also gives a firm basis to the occupation of illustrating Biblical events. True, the present-day interpreter of the sculptural decoration of a medieval cathedral does not see these works with the same eyes as those of the medieval sculptor, but they both refer to exactly the same text, one for the carving of the sculptures, the other for their intellectual analysis.

In this respect, the Greek myths could not differ more strongly. Regardless of their content, there is never one 'valid' version, to be preferred to all others. Instead, the hallmark of the dealings of the Greeks with their mythical tradition is their constant alteration and reformulation of the traditional tales. That different versions should exist of the same myth is not a source of 'contradiction'. Thus, to take the best-known field for the regeneration *of* myths, the great Athenian tragedians Aeschylus, Sophocles and Euripides almost never entirely invented new themes and characters, but fundamentally reworked already familiar tales. In this way, stories with anonymous origins were freshly formulated by individual authors. The

narrative core of the myth meanwhile remained inescapably unchanged. Anyone introducing imported figures from mythology to appear in a drama must, to avoid confusion, at least stick to the basic outlines of the fate of these characters, as fixed in the audience's consciousness. So, for example, the figures of Agamemnon and Clytaemnestra are firmly tied to the narrative theme of a murdered husband. After ten years' absence Agamemnon, commander of the Greeks in the Trojan War, returns to his palace; but since he had sacrificed his daughter Iphigeneia after offending the goddess Artemis and as his wife had in the meantime taken up with another man, he is lured into a trap and killed. But whereas in Homer the rival lover and pretender to the throne, Aegisthus, is given the leading role in the murder, Aeschylus in his *Oresteia*, first performed in 458 BC, puts Clytaemnestra in the foreground as the active party. The starting point and the outcome of the events remain the same, yet a shift of emphasis in the content has taken place. Every drama contains a wealth of such changes, and of greater and smaller alterations in the setting, which together result in the specific character of a new version of the myth.

This process and, with it, the situation for the audience has close parallels in the modern handling of fictional themes. Anyone who attends for the first time a production of Shakespeare's *Merchant of Venice*, of Goethe's *Faust* or (to take a current example) of Wolfgang Petersen's film *Troy*, and who knows older versions of these themes, will not be irritated by the 'deviations' but will, on the contrary, follow the version of the play or film with added excitement deriving precisely from the new elements. For antiquity, too, one should not assume that the invention of new versions of myths put difficulties of comprehension into the path of their audiences. One reason for not expecting this is that the traditional legendary tales were updated through constant changes and thereby made accessible in a way appropriate to the audience. A woman who behaved in the active way that Clytaemnestra does would have seemed outlandish to an audience in the age of Homer but, on the other hand, this does not hold for the time of Aeschylus. Later on in the course of the *Oresteia*, when the chain of events leads to the death of the murderess Clytaemnestra at the hands of her own son Orestes, and a judgement is to be passed on the degree of guilt that he has incurred, Aeschylus carries the 'updating' very much further still. Fundamental principles, intensively discussed in his day, of decision-making in the democratically organised city of Athens, are slipped into the development of the mythical narrative: as in the contemporary politics of his day where, differently from those societies under authoritarian rule, rigorous debate took place and, in cases of disagreement, consensus was

sought by taking a vote, the same procedure is followed in the mythical events of the drama. Gods and mortals debate against each other, as to which points tip the scales in the assessment of guilt. From the viewpoint of the dramatist, the deed of Orestes and the moral and legal judgement of his case, even though set on the level of myth, are seen as a test case for the workings of political committees in the world inhabited by the spectators.

If one takes the entire chronological sequence of versions of the mythical tradition, then this 'mythical thinking', with its constant change, constitutes an access to the intellectual history of ancient Greece that is entirely its own. The fact that the versions of myths, newly 'updated' at each stage, do not explicitly betray their engagement with the surrounding world, but always achieve their message only by indirect means, makes the study of these questions – most of them only approximately answerable – into a complex and fascinating task.

Myths in language and image

At first glance, it might not seem an urgently necessary task to make an explicit distinction between the literary and pictorial versions of myths. The fact is that a long and still continuing tradition exists in archaeological research of taking the myths, as shaped in the two media, directly side by side. Much-used compilations give the impression that the images are, as a rule, the direct counterparts of pre-existing legendary tales, fixed in verbal form, and that the main thing asked of the producer of such images was to furnish illustrations for texts. But 'illustration', to clear up this misapprehension straight away, is a term that cannot be used for the greater part of Greek antiquity, simply because the images were not conceived as an addition to a text (which is what 'illustration' means), but had to stand alone and achieve their effect independently. Yet the idea of the 'illustration' lives on precisely in popular editions of ancient texts, when for example an edition of Homer's *Odyssey* has a series of Greek vase paintings added to it, giving the impression that these too, in their day, were produced as explanatory illustrations for the text.

There can, however, be no doubting the necessity of investigating the pictorial representations of myths in their own right, as a field independent of their literary form. For the pictorial medium, in our own age especially, there are fundamentally different formal laws and potential effects from those of the medium of language. In what follows, the issue will be that of examining carefully the differences and the points in common, and of

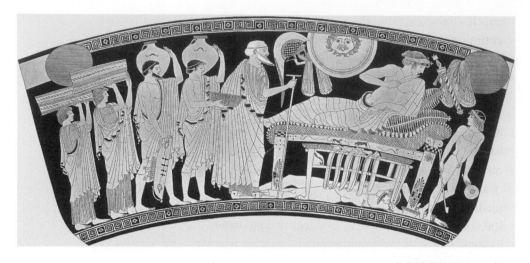

Figure 11 The ransom of Hector (Priam before Achilles). Attic red-figure skyphos (drawing), *c*. 490 BC

identifying the consequences for the interpretation of the images which arise from these. These points can be well illustrated with the help of a story that is fully attested both in literary and in visual form.

Acknowledged as the mightiest hero in the Greek army, Achilles takes part in the Trojan War. In the tenth year of the war, he kills his opposite number on the Trojan side, the king's son Hector and thereupon, in an excess of rage, drags his opponent's body along the ground behind his chariot; yet later gives back the dead man's body to his father, Priam, to enable him to give it an honourable burial and thereby find some comfort for his grief over the loss of his son. The 24th book of Homer's *Iliad* narrates this last episode in great detail: how Priam leaves Troy by night with a cart full of precious objects as a ransom; how he is briefed on the way by Hermes, the god of roads, on how to gain access to the Greek camp and to the tent of Achilles; and how Achilles finally fulfils his request. This episode in the story is also frequently represented in art. The most elaborate version is found on an Athenian luxury vessel of the early fifth century BC (Fig. 11). In a comparison with the description of the events in the *Iliad*, the different possibilities that exist in the two media stand out:

1 For all its wealth of detail, the pictorial image still assumes in the viewer a knowledge of the content of the myth. Someone who knows nothing of Priam, Achilles and Hector may admittedly recognise certain relationships in the portrayal – that the dignified old man is leading a procession and that he is in the act of approaching the young man reclining on a

couch. But what the naked body on the ground is about and, with it, the entire context in which the characters are set, remains mysterious without additional knowledge. Even the addition of name-inscriptions, which are often found on such pictures, would do nothing to alter the fact that something further, something not contained in the image, is needed to decipher its content.

2 A narrative consists not only of a single event, but always of a sequence of happenings: first Priam resolves to venture on the mission to the enemy camp, then he equips himself for this, and only right at the end, after the conversation with Achilles, comes the recovery of his son's body. In the medium of language, almost any number of the episodes which a mythical narrative incorporates can be strung together. The reader is led, step by step, from the starting point of the action, through various intermediate stages, to the conclusion. To the image, by contrast, the unfolding of such sequences is denied. In our example, from the long chain of single events a window of time has been chosen, one lasting only a brief moment: the arrival of the king, just before Achilles becomes aware of his presence. The vessel is not provided with other pictures, showing other scenes from the overall course of events. If one takes both these points together, a clear result is reached: an image is not in a position to narrate, in the strict sense of the term. If specific episodes of the myth are to be represented, then it requires in principle the knowledgeable viewer. How the visual artists handled these limitations of their medium by comparison with language, and did so highly productively, will be the object of closer investigation in the sections that follow.

3 The third and last point shows the pictorial medium as, once again, the less powerful of the two in its effects. A writer can himself explain the 'significance' (to revert to our initial definition) of the events that he portrays. In the Homeric epic, not only are the happenings narrated in detail, but the intentions behind the actions of the participants are also explained: Priam's grief and his hope of perhaps being able, against all expectations, to ransom his son nevertheless; Achilles' readiness, out of respect for the old man's justified request, to overcome his hatred for his dead enemy. By allowing the legendary characters to voice their own motives, the author not only explains the logic of the individual actions but, on top of that, can comment on the meaning of the mythical episodes (without necessarily overstepping the boundaries of fictional narrative by adopting first-person narration). The story of Priam and Achilles unambiguously stands as an example for the elemental challenges to humanitarian values, which must arise in just such an extreme situation as warfare and the fight between man and man.

An image cannot directly 'express' any of all this. If there is to be sympathy with Priam's pain or the unexpected leniency of Achilles, then this is once again a property of the viewer's knowledge of the myth. On the other side, the pictorial representation (with which we shall be dealing in greater detail from now on) is capable of directing our perception of the scene at specific targets and as a result placing special emphasis, by its own means, on certain psychological factors and intellectual aspects. Thus the high status of King Priam is very effectively made intelligible by the procession accompanying him, which can easily be imagined as extending further still (in the *Iliad*, there is only one person accompanying him into the camp of the Greeks). The contrast, too, between the solemnity and seriousness of the Trojan delegation and the relaxed, carefree attitude of Achilles, of whom in the next instant a decision of great moral significance will be demanded, is more effectively shared with us than it would be by any words, however well chosen.

When one compares a visual with a literary version of the same subject, then the image will appear clearly the more limited medium, in respect of the forms of the narrative and the communication of spiritual aspects, even though at the end we touched on some of that potential which is specifically its own. The fact that, in the creation of a myth, the literary version is as a rule determined first, and only then will the methods of the visual arts be explored, might induce us to classify the literary as fundamentally the primary, the visual as a secondary and merely derivative medium. But this would be to ignore a seminal peculiarity of all mythical narrative, one so far only indirectly addressed: a Greek myth, regardless of the literary genre in which it is performed, is an eminently graphic creation. From the earliest evidence of myth creation onwards, the stories depend on the fact that what the poet has recited or written takes a vivid and detailed visual shape in the consciousness of the listener (or, later, the reader). This is already unequivocally true of Homer's *Iliad*. Regardless of whether it is a question of battle-scenes, with their repetitive courses, or of unique events that one follows excitedly over the individual steps in the narrative, like the mission of Priam to Achilles, great store is set on maximising the vividness and immediacy of the scene-setting. The visual richness of the language reaches a peak of development in the so-called Homeric similes. When Sarpedon, one of the adversaries of the Greeks in the Trojan War, is killed in the fighting, the poet develops the following image (16, 482–6; trans. A. T. Murray):

And he fell as an oak falls, or a poplar,
or a tall pine, that among the mountains shipwrights

fell with whetted axes to be a ship's timber;
even so before his horses and chariot he lay outstretched,
moaning aloud and clutching at the bloody dust.

With such a simile, the poet evokes for the listener familiar situations from the world of real experience, thus leading him to use the visual impressions received in his own experiences and so develop an 'illustration', as subtly differentiated as possible, for the fictional world of the heroic tales. Everyone knows of the mute fall of a tree and the bulkiness of its trunk: by the insertion of the simile, the story of the death of an important warrior becomes far removed from a bare report and gains the maximum of vividness and conciseness. In this way, the graphic quality that anyway distinguishes the epic narrative is even further intensified. The passage cited is directly followed by a second simile for the killing of Sarpedon, the savaging of a bull by a lion; only after that does the original action continue.

With the rise of the genre of drama, which first reaches a developed stage in the late sixth century BC and experiences its full flowering in the fifth, the visual potential of myth creation attains a new quality. Instead of translating what they hear into vivid scenes by using their own powers of imagination, the spectators in the theatre (the Greek *theatron* means a place of spectacle, not an auditorium) see the characters and setting of the mythical events directly before them. The texts of the plays of Aeschylus (died 456) already leave no room for doubt that the poets went beyond the verbal shaping of the plot, to rely heavily on the visual effects that the action on stage was capable of displaying. This is shown by an arrangement like the so-called *deus ex machina*: the sudden appearance, achieved by sophisticated stage technique, of a god who intervenes in the human affairs of the play. The tendency towards a powerful graphic effect also emerges from many single scenes, perhaps most impressively in the situation at the beginning of Aeschylus' *Eumenides*, the concluding part of the *Oresteia* trilogy. Unsuspecting, the priestess enters the Temple of Apollo at Delphi, to recoil in real shock from the sight that presents itself within. She hurries out again into the open air and describes to the crowd how, in there, a young man is besieged by women, unknown to her and hideous in appearance. She seeks an explanation of who these women might be and, to make herself understood, even compares the unfamiliar sight that had presented itself inside the temple with works of art (lines 46–54; trans. H. W. Smyth):

Before this man there sat asleep on thrones
a wondrous throng of women.

No! women they were surely not, Gorgons I rather call them
Nor yet can I liken them to forms of Gorgons either.
Once ere this I saw some pictured creatures carrying off
the feast of Phineus – but these are wingless,
sable, and altogether detestable;
Their snorting nostrils blow forth fearsome blasts,
and from their eyes oozes a loathly rheum.

For the audience at the performance, the terrifying picture of these shock-ingly repulsive goddesses of vengeance (that is their true identity) is at first communicated only through the report of the priestess. Initially, the audi-ence can perceive only her words and gestures. In this way, they are compelled to picture the scene with their mind's eye and so visualise it. Only in the scene that follows can they, already in a state of intense excite-ment, see the repellent sight with their own eyes when the temple doors open, and receive a measure of confirmation for what had already hitherto existed in their imagination. Ancient testimonies record for us the success with which Aeschylus brought off this *coup de théâtre*. Vase paintings of somewhat later date, showing Orestes and the goddesses of vengeance inside the temple, provide a distant echo to document the exceptional visual effectiveness of the opening scene of the play.

So the production of myth, in the sense of the verbalisation of stories, is linked very closely with the shaping of a visual representation of the action, as these two examples have demonstrated – and this is true from the very outset. But this also makes it necessary to modify the statement that the verbal version of a myth always precedes its pictorial form in time. Simultaneously with the invention of a myth or the reworking of an already familiar subject, a visualisation in the consciousness of the listener takes place. One could speak of 'virtual imagery'. Therefore, when an artist creates a real, concrete mythological image, then he is not merely transferring a verbal version of a myth into a pictorial one. Rather, he is giving the already visualised version of the myth a visible form.

Forms of visual narrative

Explicit scenes of action

An indispensable property of myth is narration, that is, the stringing together of single episodes from which a plot is made up. As explained in

the previous section, the medium of imagery is in this respect inferior to that of language. An action is something essentially dynamic, an image, by contrast, static. A pictorial representation inevitably holds its figures firmly in a set position and so is not capable of reproducing, in appropriate form, the aspect of movement and process which belongs to a narrative, of whatever type. The methods that were adopted by the artists to meet these difficulties have been thoroughly discussed in the course of research. Yet such 'narratological' investigations have not produced wholly satisfactory results. They repeatedly employ different expressions to identify the same phenomenon. The multiple expressions thus generated form an easy diversion, preventing the establishment of a fundamental classification from which all finer subdivisions – insofar as they make sense at all – can be derived. A mythological image is either devised as a kind of snapshot or, on the contrary, it contains *no* unity of time: that is, an attempt is made instead to imagine different stages of the action as present in one and the same image.

The picture on the cup with Oedipus and the Sphinx, made in Athens around 460 BC and briefly discussed earlier (Fig. 8), can serve as an example of the basic category of 'snapshot' representation. Oedipus is shown as an already mature man with a beard. The rock on which he sits, together with the hero's equipment of a wide-brimmed traveller's hat, light cloak, knotted stick and high-fastening sandals inform us, independently of the wider context of the picture, that the man is engaged on a journey. The figure facing him, the Sphinx sitting on a column crowned by a capital, then makes clear how we are to understand the exact situation. Oedipus has just had put to him the famous riddling question, which had brought disaster to all his predecessors and cost them their lives, and begins to ponder it: 'Which creature at first goes on four, then on two, then on three legs?' – 'Man'. The inscriptions added to the picture give, besides the name of Oedipus, the last two words of the question. An isolated moment has thus been reproduced from a mythical narrative rich in episodes. Our attention is directed entirely at the critical instant which will decide whether Oedipus will succeed in finding the answer, so as to set the city free from the monster and save his own life.

The momentary character of the representation tempts us to see in this a kind of literal illustration of a mythical action, comparable to a picture of the set of a theatre production. On closer inspection, however, several details stand in the way of this assumption. Oedipus is shown naked apart from his cloak, an artistic convention behind which lies the attempt to indicate fineness in a man's outward appearance, even when it does not

'fit' the situation. The Sphinx crouches, not in a wild landscape but on an elaborately carved architectural element, as if she were a venerable monument. The beauty of her head, additionally adorned with a diadem, takes this line of thought a step further. In this way, the monstrousness of the Sphinx is made relative; the bloody menace to passers-by seems to have been replaced by a well-mannered intellectual contest. My suggestions for interpretation are meant to show one thing only: the representation can be counted as a momentary snapshot only to the extent that unity of time is preserved, and that nothing points directly to earlier or later episodes in the life story of the hero. But, in the interests of characterising the content of the scene, the picture also shows dissonant elements that can be classed as 'ideal' or 'idealising', and thus distances itself from the status of a simple transfer of a verbally shaped narrative into the pictorial medium.

At least since the invention and wide diffusion of photography, more than a hundred years ago, it has seemed to us the normal thing that a picture is a *reproduction* of a specific, concrete situation. A photograph reproduces, at least as a rule, what is exposed to the lens at a given moment. For all the artistic interventions carried out by photographers or visual artists, the overwhelming majority of the photographs that surround us in the western world respect the fundamental unity of time and space: only what is present at the same time and in the same place turns out to be shown together too. The illustration by John Flaxman for the scene in which Odysseus makes the giant Polyphemus drunk in his cave, while his companions wait in the background (Fig. 10), can serve as an example taken from the sphere of graphic art. For large areas of ancient art, however – and also for a good part of non-western art in modern times – this rule of simultaneous representation does not hold. In the Oedipus picture just discussed, there were merely individual attributes that were incorporated, in defiance of the setting. Very often, however, the representations are much further removed from the illustrative character of a conventional photograph, and put together figures who belong at different stages in time and in different places.

A picture on a bell krater, produced around 430 BC in one of the Greek cities of southern Italy, can serve as an illustration (Fig. 12). Of the four figures, the two central ones take on the main action while the other two figures, almost symmetrically arranged in mirror-image, are to some extent brought into the frame. Even though this time there are no name inscriptions, the identification of the scene presents no difficulties whatsoever. It gives itself away in the half-human, half-animal form of the figure who is under attack, as well as by the ball (of wool) which the woman holds in one hand: the Minotaur is being overcome by Theseus. Because of a transgression on their

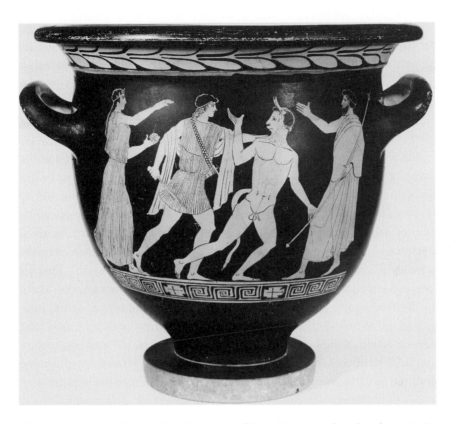

Figure 12 Ariadne, Theseus, the Minotaur and King Minos. South-Italian (Lucanian) bell-krater, *c.* 430 BC

part, the Athenians were obliged to send, every ninth year, seven youths and seven girls to Crete, where they were sacrificed in the legendary labyrinth of King Minos, to the Minotaur who had his lair there. Theseus brought the cruel ritual to an end by killing the monster. What is more, he succeeded by a trick in finding his way out of the labyrinth again. The daughter of the Cretan king had given him a skein of wool to take with him, the thread of Ariadne that became proverbial, which he unravelled as he penetrated into the building and which served him as a dependable guide for the return journey.

As far as the visual narrative is concerned, the first point to establish is one of a radical simplification by comparison with the verbal form of the story: of the labyrinth as a structure, although it plays a substantial part in the course of events, not the smallest indication is given. The reason for this is obvious. Had the painter added walls, or the like, to identify the location, it would not have been possible to arrange the decisive moment of the struggle between the two protagonists so effectively. A comprehensible depiction of

the labyrinth would, besides, have called for something wholly foreign to Greek art of this period, a bird's eye view. Other visual artists helped themselves along by providing an entrance to a building as a makeshift reference to the labyrinth but then, in return for this dubious gain in pictorial accuracy, had to sacrifice the dramatic moment of the fight and instead show the situation before the building was entered (Fig. 31), or the victorious Theseus with the Minotaur already slain.

But even in our picture the labyrinth is present, not only through the viewer's knowledge of the myth but also through a direct hint, the ball of wool in Ariadne's hand. In time, though, the presenting of this aid to Theseus belongs to an earlier stage in the events. In contrast, the gesticulation of Minos, standing at the far right and recognisable by his dignified appearance and especially by his sceptre, makes the best sense *after* the successful conclusion of the fight when, against expectation, Theseus comes back alive out of the labyrinth, as conqueror of the monster. Much as the four figures present themselves as being, in the formal sense, integrated, in no way do they represent a unity of setting or time. Around the central action of the fight, time is, as it were, stretched out and past history (Ariadne's aid) and outcome (the amazement of King Minos) are integrated into the pictorial representation and thereby brought into the present. This mode of representation can be called 'complementary' or 'synoptic'.

This freedom to switch between phases in time and places of action, which can be observed here in very obvious form, was applied in various ways and forms to Greek mythological images. One would look in vain for firm rules behind these practices of visual narrative. The variations in the practices, to which we shall return again and again in reviewing the case studies, are as diverse as are the artistic intentions of the artists. The decisive point consists in realising how efficiently the breakdown of the time-phases can be employed to serve as a medium of pictorial language – and in not looking for a moment in the action (still less, for an otherwise unknown version of the myth) in which, to stay with the Minotaur picture, all four persons could be understood as acting together.

The integrating process just described, in which sequences of events are reproduced in one picture, stands in contrast with a very much simpler one, which is familiar from our own everyday culture: a number of pictures set directly side by side, in the chronological order of the events – a procedure like that found in comics and cartoons, or indeed in so-called graphic literature such as Manga. Within the history of Greek art, we come across this narrative method only very late, in later Hellenistic times (second century BC). In Roman art, by contrast, it is very widely distributed and,

Figure 13 Medea in Corinth. Sarcophagus, Rome, *c*. 150 AD

for that reason, a Greek myth in a representation of Imperial date suggests itself as an example for more detailed commentary.

For the decoration of the front of a sarcophagus dating to around AD 150, the patron chose the story of Medea's revenge on her former husband Jason (Fig. 13). The relief panel, just over 2 metres long and 55 cm. high, is densely filled with no less than sixteen figures, who make up a frieze that is compositionally animated, complex and, at first glance, bewilderingly rich. The story of the notorious child-murderess unfolds in four separate scenes, which are not however separated by clear breaks. Medea, daughter of King Aëtes who ruled at Colchis on the Black Sea and endowed with magical powers, helped the Greek hero Jason to steal the famous Golden Fleece, taken from a miraculous specimen of a ram. A whole series of deadly dangers had then to be overcome before the pair – by now lovers – could return together to Greece. After an intermediate stop, during which they become the parents of two children, they reach Corinth. There Jason falls in love with Creusa, the daughter of the regent, and consequently abandons the 'barbarian-born' wife to whom he owed so much. Medea is out for revenge and will pursue this course to the ultimate resolution.

It is at this point in the story that the visual narrative on the body of the sarcophagus, unrolling from left to right, fits in (the representation on the lid does not relate to the Medea story). Jason, leaning on a pillar, and his new bride, seated on a fine chair, form the frame for the first scene; between them are two figures of secondary importance. The two putto-like children in front of them are, so it appears, bringing wedding gifts; in fact, they are being used by Medea for a horrific murder attempt. The garment held by the

child in front is soaked in poison which will consume Creusa's body. This is exactly what is taking place in the next scene that takes up almost the exact centre of the sarcophagus front and whose setting is to be thought of as the bedchamber of the bride. She writhes in pain, flames flicker upwards from her hair and Creon, the father who rushes to her rescue, will also perish. Strangely detached, as if separated by an invisible wall, two men stand next to the scene. The remaining two scenes take up far less space than the first two. The renewed change of scene is inconspicuously signalled with the aid of the cloth stretched out in the background, which ends at this point. Medea looks down at her two children, already holding the powerful weapon in her hand. The contrast between her murderous intention and the innocence of their childish games could not be greater. In the last scene, she has already done the deed; one dead child lies over her shoulder; a leg of the other is visible below Medea's knee. In the serpent-drawn vehicle, she will evade pursuit.

The description of the sarcophagus front has brought out the points in common with, and the differences from, the two modes of representation sketched before (for its interpretation, see pages 163–4). A sequence of events is not, as in the example with Theseus and the Minotaur, integrated into a single picture, but spread out over several. Taken singly, the individual scenes do not represent anything qualitatively new by comparison with the one of Oedipus and the Sphinx (Fig. 8). What takes place within a scene is to be understood, as there, as happening simultaneously. The difference lies solely in the arrangement of several such 'snapshots' within a larger pictorial frame, in this case the front of a sarcophagus. As a consequence of this process, several participants are represented twice or more; in this specific instance, these are Creusa in the first and second scenes, Medea in the third and fourth, and the two children in the first, third and fourth. Since the individual scenes, unlike those in a comic, are largely merged into each other without a break and one must, so to speak, mentally supply the dividing lines oneself, one and the same figure can appear duplicated. Medea contemplating the murder stands almost directly beside Medea in flight. Because of the blurred transitions, with at the same time a repetition of the participants, this mode of narrative has been aptly named the 'continuous'.

This process represents the maximal solution when the aim is to show, in the image too, as much as possible of the narrative wealth that the verbal form of a myth is able to deploy. The summary description given here, whose primary aim was to find some way around a frieze that is crammed with figures, could end up very much more comprehensive, if every

thematic detail were noted, the numerous props as well as the specific gestures of the figures. What is achieved in a comic, to take up this revealing comparison for one last time, through the commentary on the place and time of the action ('the year is 50 BC ... a small village of indomitable Gauls ...'), and especially through the dialogue of the characters placed in speech-bubbles, must in the case of the sarcophagus relief be achieved by the viewers themselves. Thus for any shared decoding of the reliefs, on the one hand the gaps in time must be filled ('after the presentation of the gifts, Creusa went to her bedchamber and there put on the poisoned garment') and on the other a visual narrative, as multiform and dramatic as a full textual version of the story, can be created by this means. Through the analysis of the details, which will be studied more closely in the final chapter, one can also gain access to the significance of the subject as a decoration for a funerary monument.

Any consideration of the forms of visual presentation of myths must centre on the tension between the extension of time that belongs, as a matter of course, to a verbal narrative, and the determination of a single moment that is a necessary property of an image. Both the two representational processes so far described seek in different ways to compensate for the disadvantage of the visual medium: the 'complementary' by the fact that figures belonging to different phases in the story can appear within one and the same image, the 'continuous' by constructing a series of images, in each of which the figures are acting simultaneously. Since both processes demonstrate how figures interact with each other, one can speak of explicit scenes of action. But in every case, the visual artist relies on the viewer's ample knowledge of the subject. With the Minotaur krater (Fig. 12), it is not only the 'missing' labyrinth that one must imagine as added in, in order to sort out the representation. Anyone expecting unity of time, as in a photograph, will feel that the Ariadne figure is at least odd, even faulty. She hurries over as if she wished to present Theseus with the ball of wool at that moment. In reality, one should imagine a dividing line, as on the sarcophagus relief, running between Ariadne and the central group (another line would divide off King Minos). Her initiative in helping the hero through the device of the thread belongs to an earlier time-phase. As the gesture of Minos, too, is best understood as a cry of surprise *after* the killing of the monster, we are basically dealing with three scenes. It thus becomes evident that the 'complementary' and the 'continuous' methods do not represent fundamentally different ways of making visible the passage of time. What is realised in a condensed form in the one case, appears broken up into single scenes in the other.

Implicit scenes of action

The example of the Minotaur krater enables us to discern yet another important peculiarity of Greek mythological images. The figure of Ariadne, who merely appears to be hurrying towards the fighting Theseus, clearly represents in its own right an episode in the story, the handing over of the ball of wool. Viewers who know their mythology can in addition 'see', as it were, the missing elements: Theseus as recipient of the thread, the walls of the labyrinth. Accordingly, even a single figure can be the carrier of an action, to which other invisible characters in the episode also belong. This potential narrative self-sufficiency of the single figure – the term 'hieroglyphic' has been applied, if not too aptly, to the technique (N. Himmelmann) – does not, however, exist only within multi-figured representations such as the Minotaur krater. By comparison with the Ariadne in the vase painting, there is a difference only in degree, not in principle, from the case of a single figure portrayed in its own right, with no further human context, which is given the function of recalling a mythical event.

A simple example, and one familiar from recent art history, is presented by statues of Heracles with his club and lion-skin. One might be tempted to see the portrayal of the hero as a splendid athletic figure and the presence of his weapon as purely symbolic, as a signal indication of bodily strength and consequential superiority to any conceivable opponent – something which also made Heracles / Hercules into a figure with whom many rulers of antiquity and later times sought to identify themselves. Yet the club already and inescapably puts one in mind of the fact that it was the specific deeds of Heracles, carried out with the aid of a weapon, that made of him an important symbolic figure. This applies even more strongly to his habitual defensive protection, the lion's skin incorporating its head, which Heracles in many representations transforms into a helmet. This prop, which belongs only to him, represents the trophy from his first great triumph, the over-coming of the Nemean Lion with his bare hands (Fig. 7). At this point, one can go a stage further and state that even a statue of Heracles, peace-fully standing, belongs to the imagery of myth. Action may not indeed be constituted as interaction, as it is in innumerable vase paintings whose subject is the fight with the lion; yet it is present in the consciousness of the viewer. The designation 'implicit scenes of action' will take into account this characteristic.

The potential effectiveness of such images can be better brought out by another, far more complex work. The Barberini Faun (so called from the location at which it was formerly kept, the Palazzo Barberini in Rome) has

Figure 14 Sleeping satyr, so-called Barberini Faun, *c.* 250–200 BC

since 1820 been one of the great showpieces of the Glyptothek in Munich (Fig. 14). The life-sized, or slightly over life-sized, statue can be dated to the third century BC, on grounds of stylistic indications. Not only in modern times, but in antiquity too it seems to have changed its locations. The statue was very probably created for exhibition in a Greek sanctuary of Dionysus, most likely as a spectacular offering by a private individual. It must have reached its place of discovery, Rome, as looted or traded property, like so many other statues: a clear indication of its high valuation in antiquity, irrespective of how one should imagine the detailed circumstances of this transferral.

On the analogy of other sculptures of the Hellenistic age, the statue was probably one that people could recognise from far away. As we can reconstruct this experience in the museum today too, so at first one can make out only certain essential qualities of the figure portrayed: the nakedness of the athletic man, his resting and, as can then be confirmed, sleeping posture, the nonetheless forceful physical presence, which derives especially from the widely parted legs and has something near-animal about it. This very impression is reinforced as one approaches more closely. The rocky seat and the animal skin serving as an underlay become visible; then peculiarities in the figure's outward appearance, such as the slightly open mouth, the face somewhat broader than the norm, and finally more inconspicuous details like the hair falling in firm tufts towards the back, the single strands that spread out further into the middle of the forehead, then the vine-leaves in the hair and two final, clinching attributes of the figure: the sharply pointed ears and the horse's tail whose end lies on the animal-skin, to the viewer's right side. Only now does all become clear: the resting man is no mortal, but a satyr, a figure from the retinue of Dionysus, the Greek god who brings among other things, wine, sensual pleasure and with it redemption too. With this identification that can be made only at close quarters, one is transported directly into the sphere of myth.

Yet the sculptor was not merely concerned with achieving a charming effect, with this apparent shift in the identity of the figure shown. Such bafflement is not the real point of the artist's conception, but merely an aid that is part of a strategy which will lead to the viewer's becoming, so to speak, a participant in the action. Satyrs were imagined as wild fellows, at home in the open air of nature, far from civilisation and its constraining conventions. They deviated from the norm above all in their strong sensual urges. Vase paintings show them as passionate dancers and musicians, drinkers and creatures of extraordinary sexual avidity. With this supporting knowledge, the specific theme of the Barberini Faun (Latin *faunus* roughly corresponds with Greek *satyros*) is revealed. The vine-leaves in the hair establish him as a reveller, the open-mouthed sleep, in a markedly uncomfortable posture, is explained as exhaustion after heavy sensual indulgence.

For the person who stands in front of the mythical figure and has recognised him as a sleeping satyr, this gives rise to a double irritation. Fanciful reports told of how this or that person had once seen a satyr in the flesh, even though the quintessence of these creatures' lifestyle was remoteness from humanity. The sight of the satyr in marble seemed to dispel this remoteness in an astonishing way, and the deceptively realistic likeness does everything possible to set up the illusion of an actual meeting with the

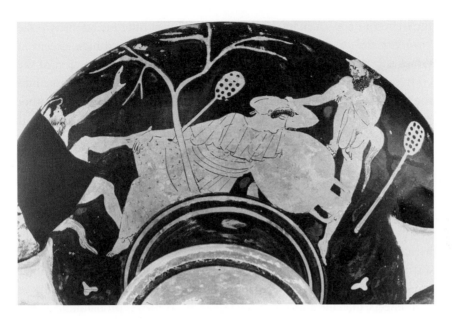

Figure 15 Satyrs molesting a sleeping maenad. Attic red-figure cup, *c*. 430 BC

nature-demon. But the simulation into which the viewer is transported goes a step further still. What would happen if the satyr awoke from his light sleep? The immensely lewd posture with the genitals exposed as if on display, leaves us in no doubt that bodily lust, belonging as it does to the satyr's nature, will drive him once again as soon as his momentary fatigue is gone. Women above all, his favourite objects of desire, could suddenly exchange the active role of the viewer for the passive one of the victim of pursuit. That these are not modern fantasies, stimulated by the ubiquity of erotic pictures in our own world, emerges – quite apart from the 'talking' posture of the sleeping figure – from the pictorial tradition.

Vase paintings of the Classical period often show satyrs molesting sleeping maenads – the female counterparts in the entourage of Dionysus (Fig. 15). Like the visitors to the sanctuary where the statue of the Barberini Faun was set up, the satyrs have approached a sleeping figure. On our example, the maenad is sleeping equally uncomfortably, with a wine-jar as a pillow. She too seems to have abandoned a celebration for a moment's enforced rest. The satyr to the right of her recalls in his own way the Barberini Faun, with the splaying of his legs; in other pictures the satyrs give, by their erect members, an atmospheric pointer to the direction in which things are going. By comparison with the conventional motif on the vases, the statue shows a double switch in roles. It is not the satyr who makes

the lecherous approach, but he is himself an object of erotic curiosity – the beauty of the young male body, as is well known, enjoyed high esteem in Greek society, for men too. But, more than anything else, the effect of the conception of the Faun is to draw the person standing before the statue into the process described, as a participant. With the vase paintings on the other hand, which are by comparison 'complete' and self-sufficient, the viewer is distanced and this effect could not happen.

One could contest the appropriateness of the expression 'image', and especially 'mythological image', to a work like the Munich Satyr. In common practice, 'mythological image' is equated with 'image of action': so, a representation in which an event is reproduced, containing as a rule at least two participants, in which furthermore specific, individualised figures from legend appear. The scientific need for clear systematisation may make such distinctions appear attractive. When, however, one takes as a starting point the peculiarities of the representations and the ways in which they achieve their effects, then the drawing of such boundaries proves problematic. In the representation of Oedipus and the Sphinx (Fig. 8), the action comes across only through the viewer's knowledge – and through the non-pictorial means of the 'balloon' in front of the Sphinx's mouth. In the case of a work like the Barberini Faun, if one takes into account not just the directly visible elements but the visual strategy whereby the viewers of the statue are led to take part in an intellectual interaction then, as a scene of action and in terms of its narrative potential, it can almost be placed above the vase painting: the sequence of momentary experiences in which the viewer is involved, begins already when he or she has only just spied the statue from a distance. Maybe the satyr even had a name, in the tradition of the locality where it was exhibited (personal names for satyrs and maenads are not uncommon even in vase paintings); if so, even the last part of the conventional definition given just now would be fulfilled. Against the background of these considerations, the distinction between explicit and implicit scenes of action emerges as no more than a helpful construct, which should not disguise the fluid nature of the transitions between the separate forms of visual narrative.

The mythological image and the 'lifeworld'

This same fundamental statement would apply to the drawing of another boundary, that between images concerned with mythical narrative, and those whose themes are of the 'lifeworld'. The expression 'Lebenswelt',

which as a philosophical term plays an important role in the writings of Edmund Husserl, has in more recent years become established in Germany as a general term for the entire scope of the world as experienced by the senses: that is, for all the phenomena that we can perceive in the world around us, in contrast with the world of myth with its persons, places and events that are only imagined. The 'real world' is perhaps an acceptable equivalent in English. The older terminology has the disadvantage of being less comprehensive, and so of privileging one specific aspect at the expense of another. Thus the once much-used phrase 'scene from everyday life' is too suggestive of the 'everyday' in the modern sense, that is the realm of the world of work, as against festive or prestigious occasions. 'Genre scene', as a term for non-mythological representations, cannot be detached from its use in modern art history, where 'genre' means that category of painting which devotes itself to 'lowly' subjects, once again especially from the world of work and the everyday – one thinks of the scenes of inns in Dutch painting. 'Genre' here stands in contrast to those categories long considered more elevated, such as the portrait or the historical painting. In the field of ancient art, however, such a hierarchical distinction makes no sense.

Archaeological research into figurative scenes, and vase paintings in particular, has long neglected the issue of the reality content and (to simplify somewhat) has divided the images as far as possible into two clearly separated categories, the mythological and the non-mythological. The conviction that this does justice to the ancient pictures coincided with a definite focus on the acquisition of knowledge. From this viewpoint, the mythological pictures enjoyed the status of source material, making possible the recovery of lost mythical narratives, or versions of myths that were only incompletely preserved in ancient literature. The non-mythological representations on the other hand, according to this once widespread attitude, offer authentic insights into the everyday life of the Greeks. Thus the study of *Realia* acquired an almost inexhaustible source, where precise evidence could be found for fields of activity such as craftsmanship, warfare, marriage, the care of the dead and much else.

Since the 1960s, in the course of a fundamental reorientation of art historical subjects, the conviction has gradually begun to win acceptance, in ancient studies too, that the notion of the image as a reproduction is untenable and is an obstacle to the fruitful examination of the subject. Images are an independent medium of communication, an instrument for conveying not only information, but also ideas and all sorts of abstract concepts, regardless of whether these are transmitted consciously, as 'messages', or not. The portrait of a Roman emperor, to take a simple example,

will always aim first and foremost to represent him as someone who embodies certain ideals, such as that of the military commander in resolute action or the calm ruler governing. The 'construction' of such a portrait, to use a favourite expression of recent theoretical debates, will certainly make use of features in the ruler's actual appearance, if only to make the sitter recognisable, but will reshape and amplify these in such a way that the viewers make the associations that the patron intends. Images, thus understood, do not complement language, but constitute a 'discourse' of their own, which operates according to specific rules and, in the same way as texts and words, shapes the individual's perception of the world around.

The renunciation of the idea of the image as a reproduction is of fundamental importance for interpreting mythological representations. Taking a mythological image as a copy, that is as the transference of a story from one medium to another, is an expression of the (mostly unspoken) principle of philologically oriented scholarship of conventional type. Accordingly, it directs its attention first and foremost at the correspondences between text and image, seeking to prove that the differences are, for various reasons, irrelevant. In reality, however, the differences are so numerous and substantial as to compel the adoption of a different viewpoint on the subject. Once one frees oneself from the shackles of believing that the images were produced as illustrations and thus as something derivative, and instead sees in them a means of giving visual form to abstract concepts, then *all* elements of a representation can, in equal measure, be taken seriously. Among the most prominent of them, in this context, is the freedom that the visual artists allowed themselves to combine together mythical figures and props with non-mythical ones, thus giving the image a special meaning. The mingling of the two spheres, as practised by the visual artists, actually goes so far as to prove that the comfortable distinction, between the categories of 'mythological image' and 'scene from real life', is often illusionary. Two examples should illustrate this.

The representations of warriors on a vessel by the Athenian vase painter Exekias from the time around 540 BC (Figs. 5, 6) were briefly discussed already in the first chapter. The two pictures, by their scale and care of execution, are given equal importance; neither stands out as being the front or main side of the vase. In one of the scenes, four figures compose a group motif whose frequent occurrence has earned it the standard name of 'warrior's departure'. An old man extends his hand to a young man, who is equipped with helmet, spear, a splendid shield and greaves. Two women wearing the long woollen garment, the *peplos*, frame the two men. The gestures of their hands express the emotions to which they are subject. From

the analogy of other, more readily 'legible' representations, it emerges that a departure for war is intended and that the relations, evidently aware of the menacing danger, are taking their farewells. The two women will be understood as the mother and, in the slimmer figure on the right, a sister of the warrior.

The interpretation as a scene of anxious farewell can be supported not only by the arrangement and gestures of the figures, but also by the combination on the *amphora* of the two subjects. The picture on the other side shows the body of a dead warrior being carried by a comrade. The depiction of a woman signifies that the scene is enacted, not at the edge of the battlefield, but back on home ground. The warrior returns, fallen in action, to be received by the relation who rushes, gesticulating animatedly, towards him. The anxiety of the parents was justified; whether the wreath that surrounds the helmet of the fallen man, as a badge of honour, is to be taken to indicate a positive view of the outcome – a glorious service to the fatherland – is difficult to decide.

The objections to a purely lifeworld understanding of the two pictures, on the lines just presented, lie on two levels. First, there are 'contradictions' with reality: the warrior once has a round shield and once (as can be made out even in side view) the so-called Boeotian shield, with lateral openings; the forms of helmet crest and the designs of the greaves also differ. Yet these objections are not weighty ones. We should not expect a detailed extract from an individual biography anyway. By the conventions of the time, it is instead the exemplary character of the events portrayed, which can befall *any* man at arms, that is specially emphasised. Just as some of the people living in the house that the warrior is leaving stand in for it, so the picture on the other side picks out what is typical, the fact of death in battle and the sorrow of the family, indicated by the woman's gestures. The idealising element in the pictures also emerges from small details: the predator's head on the shield in Fig. 6 repeats, on a larger scale, one of the heads in the animal frieze in the bottom register on the other side of the vessel (Fig. 5), and the frieze as a whole, with its predators and their potential victims, seems to give a faint echo of the sometimes peaceful, sometimes hostile human encounters, which are pointedly thematised in the two warrior scenes.

The stronger argument for a mythological interpretation of the scenes, in place of a 'real world' one, is provided not by these themselves, but by a series of comparable representations. Among the pictorial versions of the recovery of a body, there are some from the Archaic period in which the presence of name inscriptions by the figures indicates, beyond any doubt,

Figure 16 Ajax carrying the body of Achilles. Attic black-figure volute-krater by the painter Kleitias and the potter Ergotimos (so-called François Krater), *c.* 670 BC

that they are characters from myth. What is shown is a striking episode from the Trojan War. When Achilles, just as was prophesied to him, has fallen even before the sack of Troy, Ajax rescues his body (Fig. 16). He thus prevents the enemy from seizing his armour, and makes possible an honourable burial, something of exceptional importance in Greek society.

Since the name inscriptions, whenever they occur, regularly name Achilles and Ajax, this mythical event must have held the status of an exemplary action in the consciousness of contemporaries. But does it follow from this that the picture on the Exekias amphora (and with it many other uninscribed examples) can be recognised with certainty as a representation of the rescue of Achilles? The woman on the left-hand side could then be recognised as Thetis, the hero's divine mother (cf. Fig. 4) who had sought to spare him from his fate (the departure scene on the other side of the vessel would be disregarded in these reflections). In respect of the amphora, one could answer the question with an emphatic 'no', since direct grounds for classifying it as an image from myth are missing. Besides, this vase painter quite frequently made use of personal names in other cases (Fig. 48).

Here, he has avoided doing so, thus consciously leaving the image with its generalising character.

And yet those writers who have labelled the scene 'Ajax with the body of Achilles' are not entirely mistaken. Just as representations of the rescue of Achilles could evoke in the viewer corresponding episodes from the world of his own experience, so conversely the image of the rescue of an anonymous soldier has the potential of calling to mind the events of myth; the scene by Exekias, even without any kind of explicit pointer, may have triggered an association with Ajax and Achilles. Such a mental connection would be encouraged by the resemblance in the formal arrangement of the motifs and by the idealising elements, already described, in the anonymous scene of the recovery. In other words: the widespread and, in most cases, sensible archaeological striving for rigorous classification this time leads one astray. A strict separation of lifeworld and mythological images is unfair to the object itself. The merging of the two spheres in this image presents us with an important assumption, that myths should be perceived as something which stimulates an intense intellectual examination of the phenomena of the world around us. This gives a mythical setting special potential for conferring an exemplary quality on the events portrayed, while the elements from real life have the function of building a bridge over to the recipients of these messages.

How hard the visual artists in fact worked, in individual cases, towards bridging the boundaries between myth and the real world, so as to emphasise the connection between the legendary stories and life, the following finding will show: once again from Athenian vase painting of the Late Archaic period, about a generation later than Exekias, now in the red-figure instead of the black-figure technique, and yet again the work of an outstanding painter. Euphronios put his artist's signature, around 510 BC, on a large kalyx-krater. The splendid vase formed, for more than three decades, a showpiece of the antiquities collection of the Metropolitan Museum in New York, but was given back to the Italian state in 2008, because it had been unearthed in a clandestine excavation at the Etruscan city of Vulci. Once again, the subject of the vase painting is departure for war and death in battle, and once more, the narrative context is the Trojan War. On side A of the vessel (the striking subject and artistic elaboration make it clear that this is the main scene), the rescue of another hero of the Trojan War is shown (Fig. 17). Sarpedon was the leader of the contingent from the tribe of the Lycians, which took the Trojan side in the ten-year war. His end is described, in great detail, in Book 16 of Homer's *Iliad*. Because of the high esteem enjoyed by the epic at the time when the krater was made,

Figure 17 Hypnos and Thanatos carrying the body of Sarpedon. Attic red-figure kalyx-krater, signed by the painter Euphronios, side A, *c.* 510 BC

the Homeric version of the story can be assumed to have been widely familiar. Patroclus, Achilles' friend (Fig. 1), succeeds in overcoming Sarpedon in a dramatic struggle. The picture or 'simile' that Homer uses to illustrate the collapse of this outstanding warrior has already been cited (pp. 36–7). Sarpedon has advocates among the gods, who did not prevent his death, but are now concerned to see that he receives a worthy burial. For this purpose, they dispatch two divine beings who, unnoticed by the participants in the still continuing battle, lift the body from the ground and bring it to its homeland. Hypnos (left) and Thanatos, literally Sleep and Death, are now carrying out these instructions. In the epic, it is Apollo who supervises this operation. In the picture, Hermes appears in his place, a substitution that is in keeping with his function as divine escort, especially for the dead.

The central group of four figures thus appears to be a mythological scene pure and simple and, were it not for the substitution of roles between Apollo and Hermes, one might be tempted to speak of an illustration of the passage in the Homeric epic. Yet however 'fabulous' the intervention of the two

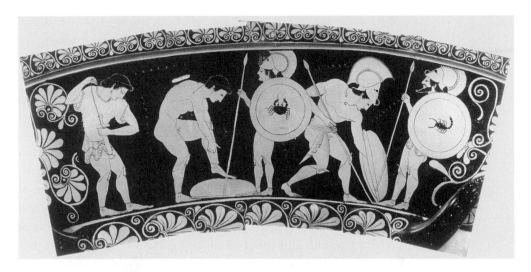

Figure 18 Arming scene (projection), side B of the kalyx-krater shown in Fig. 17

divine winged figures may be, it was evidently just as important for the vase painter to make an isolated but close connection with the world of human experience. If Hypnos and Thanatos did not have their wings, they would be in no way distinguishable from the common depictions of mortal warriors on Athenian vases. With the two figures at the sides of the scene, one can put the example to the test. Helmet, leather corslet, richly creased cloak and greaves together make up the standard equipment.

 In the two spear-carriers who flank the scene of the rescue, the blurring of the boundary between myth and real world then becomes recognisable as a system. In exact mirror image, not recognisably stirring, as if they were merely sentries sent out on watch, they seem to be looking at the astonishing event that is taking place in front of them. The attempt has been made to salvage a unified, mythological reading of the scene on this side of the vessel, by explaining the two men as comrades in arms of Sarpedon, who are not reacting simply because the rescue is being carried out, through divine intervention, in artificial darkness. But quite apart from the fact that there is no support for such a version of the legend, the exact repetition of one of the supposed sentries on the other side of the vessel (Fig. 18) also speaks decisively against an involvement in the mythical narrative. Such figures, clothed and equipped like contemporaries, often appear in mythological scenes of this period. The spectators, as they are simply called in the technical jargon, are to some extent viewers of the action in the centre of the image in the same way as the person holding the vessel in his hands. The formula, 'The viewer is part of the image,' applies quite literally here.

On the reverse side of the vessel, the deliberate mixing of the mythical sphere with that of the lifeworld continues. A group of men is arming for battle. Three of them are already at the stage of taking up their weapons. The two men standing quietly in the middle and on the right are as much like the two spear-carriers on the front side as two peas in a pod. By this small artistic trick, the two sides of the vessel are bracketed together, in form and content. But can one say anything more specific about the identity of the men? Since both pictures on the krater deal with war, an expectation arises of a shared – which means a shared mythical – action, with a trial identification of the five men either as comrades in arms of the dead Sarpedon, or alternatively as a homogeneous group of warriors on the opposing Greek side. Yet one will find no support for these inferences in the composition of the picture: the actions and attributes of the figures are too unspecific. But even this has not yet completed the list of the image's components. Unlike Exekias on the amphora discussed earlier (Figs. 5, 6), Euphronios has made full use of the possibility of amplifying the picture with writing. Study of the names leads to a surprising result. The vase painter has expressly avoided giving the soldiers the names of Trojan or Greek warriors throughout, and thus establishing a specific connection with the scene on the front. Only some of the names are known from the *Iliad*; others take us far away from Troy; they evidently relate to contemporary Athens, and thus quite directly to the world of the viewer. The representation cannot therefore be understood as a narrative complement of the rescue of Sarpedon: on the contrary. In the warriors, caught as if in a snapshot in the middle of an everyday performance, preparing themselves for action, those contemporary ancient Athenians who were capable of bearing arms could recognise themselves.

In retrospect, the relation between the sphere of myth and that of the real world in the two representations appears as a transition, carried out step by step. The central group of the main picture represents – with only minor qualifications – a direct visualisation of a traditional legendary tale, while the two spectators framing it have, at best, only an indirect connection with the mythical event in the centre of the picture; and with the five warriors on the reverse side, the representation distances itself not only from that specifically identifiable mythical episode, but from the world of myth as a whole.

According to this reconstruction of his procedures with the language of images, the artist is here unfolding a challenging game with the levels of reality, and perhaps a bewildering one for us today. The examples of a representation taking on a status between the two spheres, being neither purely images of myth nor exclusively related to the world of human

experience, could be multiplied at will. This result is confirmed by the statements already made: in just the same way as the mythical and the real worlds are combined in the field of the image, so the viewer too should understand the two spheres as a unity. If on the Euphronios krater a great hero of myth can form a pictorial unity with a group of ordinary warriors of the present day, then a suggestive assertion of an objective connection between the two apparently heterogeneous motifs is being made. It could be reduced to the formula: 'The fate of Sarpedon is to some degree the business of everyone who goes to war' – whatever is the message communicated by its content, whether about glory won through military ability, warning of deadly danger, understanding of the necessity of divine protection, or yet other things. Thus the exemplary event, the death and rescuing of the mythical personage, enters into a close relationship with that area of human life, and with the people, to whom the example is addressed.

What is a mythological image?

If, in conclusion, we try to put together the separate observations and statements into a definition of 'mythological image', then the relation between language and image must take centre stage. The traditional perspective, even today still frequently to be found in research, amounts to seeing a clear and comprehensive relationship of dependence between the literary and the pictorial versions of myth: a poet develops a mythical narrative, which is distributed in either oral or written form, the visual artist reacts to it and gives visual shape to the verbal creation. With this, a position is adopted at the same time with regard to the creative share in these processes. The role of the inventor is, on this view, virtually exclusively played by the author, while the visual artist works primarily in a creatively secondary capacity. It was no accident that the term 'illustration' was long used as a matter of course, although in many cases, as the examples discussed in this chapter have shown, even a fleeting acquaintance with the images leads one to recognise the determination with which they follow laws of their own, in achieving the effective presentation of the subjects of myth.

In fact, an understanding of the distinctive features of mythological images is only possible if the fundamental differences between the two media, language and image, are fully recognised and observed. Each form of representation has its own possibilities and limitations. Beyond doubt, many ancient writers and artists were fully aware of the particular

characteristics of their own medium and understood how to make carefully considered use of its advantages. On the limitations of visual representations, already discussed in detail above (pp. 33–6), it will suffice to make some summary observations; their advantages, on the other hand, require somewhat more detailed discussion.

A Every designer of mythological images must have an eye to the viewers' knowledge of the subject-matter. They need to know something of Oedipus or Sarpedon, otherwise the representations will remain mysterious. To this extent language really is the primary medium of communication from the point of view of the creative process, while the image builds on an already existing premise.

B The image, as a static medium, lacks the capacity to reproduce a narrative of events. Its figures are, as it were, inevitably held fast in a momentary situation, while the narrator can describe a plot as something ongoing, at whatever length he chooses. Under the makeshift headings of 'explicit and implicit scenes of action', the processes were discussed whereby the visual artists at least partially neutralised this limitation.

C The verbal version speaks to the listener or reader, the image on the other hand remains silent: it cannot explain itself. In the literary version of a myth, not only can it be made clear what motives lie behind the actions of the individual participants, why Medea acts as she does, how she does so. A writer like, for example, Euripides in his tragedy *Medea* is also in a position to speak evaluatively of the actions of the main figures. In the form of on-stage dialogue, conflicting discussion of the conduct of the child murderess Medea takes place and the problem of the justification of her action is raised. Thus the spectators of the production are given simultaneously a performance of the mythical action and also clearly formulated suggestions for its interpretation.

Yet, in these same three fields, the pictorial versions of myths also possess advantages over their textual counterparts:

A *Verbalising – visualising – imaging.* A verbal formation undoubtedly stands at the beginning of the creation of a new myth, whether in the form of a literary work or of a popular tale, and whether the originator is a writer known by name or the source is anonymous. Yet from the first beginnings that we can follow historically, the distinctive literary shaping of a mythical narrative goes hand in hand with lively visualisation. The Homeric epics, to an important degree, gain their rich vitality from a narrative style that is, in the strict sense of the word, pictorial in effect.

To characterise an event or a situation appropriately, the poet often incorporates descriptions taken from the everyday world of the listeners, the so-called similes, and thus makes the illustration of the mythical action more intense. Imaging therefore means, in certain respects, no more than the continuation and carrying over into permanent form of this eminently visual quality of the mythical narratives. What was hitherto visualised only in the mind now acquires a *visible* pictorial form. With it goes an immediacy of effect that no literary work can ever achieve. The representation on the Euphronios krater (Fig. 17), in which the blood flows from Sarpedon's wounds like little rivulets, while the otherwise unblemished body at the same time directs our attention to the mighty warrior, offers an especially vivid example of this quality of the medium of imagery.

B *Condensation of narrative.* To the advantage that a literary narrative has, in its ability to put together sequences of events, there is also a drawback. Language not merely can, but must proceed sequentially. It requires a certain duration or extent of time, in order to present a myth as a narrative unity. With an image, on the other hand, the possibility exists of representing together what belongs together in the narrative, and furthermore of achieving a focus of attention by the omission of unimportant details – always assuming the viewers' knowledge of the myth. On the Minotaur krater (Fig. 12), three phases of the action are shown, strongly condensed, in what one at first glance perceives as a 'snapshot' picture: the central episode of the killing of the monster, the assistance which Ariadne had earlier provided, and the astonishment of the king at Theseus' success in making his way out again from the (unseen) labyrinth. What is in fact a causal chain of events in the plot of the myth, the image too can declare to be just that, at least to some extent, by presenting the individual events in apparent simultaneity: with the rendering of Ariadne and her thread, indispensable for the survival of Theseus, we are not merely given a neutral piece of information about the sequence of the stages of the action in the story; we also have an explanation of *why* Theseus was successful. True, the process of condensing the visual narratives does have its limits. They arise from the nature of the object which carries the image and are subject to the then prevailing conventions for its design. Vase paintings, to stick to our example, most often contain only a few figures, because the size of the field does not allow for anything else, if a miniaturist treatment is to be avoided. A more important factor is that the human eye and sensory processes ('apperception') can only within limits register a group of figures as a connected unity,

joined together by a common action. On the densely populated frieze of the sarcophagus with the Medea legend (Fig. 13), the wealth of action can only be handled because the relief zone is divided into four individual scenes, each with a maximum of six figures. The sequence of mythological scenes, each self-contained, on one and the same monument thus approximates to the sequential process of language.

c *Deviations and associations*. If the image is silent and cannot explain itself, as just established, then how is it at all capable of communicating something like the meaning of its content? This point brings us directly to the methodology of interpreting representations of myth and will be addressed here, therefore, only in the form of a brief suggestion. The stereotyped form of answer runs, that many images of myth are capable of generating a field of intellectual tension, and that the unavoidable 'frankness' of the visual as against the conventional form of narrative is thereby transformed into an advantage. Emphases and deviations, by comparison with the conventional form of a story or a character, serve as a means of reaching this result. The detailed discussion of our test case in the first chapter has already outlined the mechanisms of this process of association. The picture on the inside of the Sosias cup (Fig. 1) shows heroes whose build and equipment, it is true, are commensurate with their famous names, but who are nevertheless shown at a moment of weakness and threatened failure. They remind contemporaries of the fame that can be won as a soldier if one emulates Achilles and Patroclus, and at the same time warn of the dangers of military action. Two contrasting associations are called up simultaneously. In the same thematic area but with different motifs, the Sarpedon krater (Figs. 17, 18) also provokes intellectual debate. The seemingly almost cheerful preparation for war on one side of the vessel – on the shield of the central figure, there is a crab playing a double flute – stands in extremely sharp contrast to the removal of the dead body, bleeding from its gaping wounds, of the king of the Lycians. The more ambitious among the visual artists knew how to exploit these possibilities for the intensification of motifs and ideas, which the medium of language cannot offer in the same way.

To define means to set boundaries, to separate what belongs from what does not, and so to make an attempt to determine the nature of a thing. At the outset of any discussion of the question of what a mythological image is, must be placed the question of the nature of the mythical narrative in textual form. This leads on to another problematic: what are the fundamental

differences between language and image in the shaping of mythical material? The numerous individual points that were to be addressed in this context have collectively shown that 'myth' is much easier to define (which does not mean to 'explain') than is 'image of myth'. While different authors have arrived at broadly concurrent answers to the question of what constitutes a myth, the difficult task of achieving a comprehensive definition of what constitutes a mythological image has only recently been given due attention by scholars. The central elements in the definition of 'myth' cannot, or can only with substantial qualifications, be transferred to images: let us recall here the category of 'narrative – action' and the oscillation, in many representations, between the mythical sphere and that of the lifeworld. The 'open-ended' definition that results from the nature of the medium of image is not necessarily an obstacle to a practical engagement with images of myth. The effects of this circumstance, especially in all efforts at interpretation, can be perceived at every stage.

3 | The production of myths and of mythological images – stages in the historical development

Central to the previous chapter were the definition and determination of what constitutes myth and mythological image. This and the following chapter will focus more closely on the aspect of the production of myth. Once more, this means looking at the relationship between language and image. To begin with, a brief outline will serve to describe some essential aspects of the changing literary accounts of myths over the course of time. This includes the question, what attitude the Greeks and Romans themselves took towards the stories of myth. Here, there emerges a curious co-existence of criticism on the one hand, and lively reception and continuous development of the traditional subjects of legend on the other, a phenomenon which undoubtedly has certain parallels in the world of today's media. Although the use of film and television in the present day is intensive, it is matched by the repeated and emphatic criticism of all manner of 'excesses' in the visual media, not least because of the fear of negative effects on adolescents – this again a point familiar from ancient discourse. The next question is, in what way the work of the visual artists was affected by the changes in the field of literary production of myth. In the following outline, only a few aspects of the long and complex history of the production of mythological images can be discussed: the beginnings, the path from the single image to the creation of whole cycles, as well as the tendency towards the dissolution of the conventional image of the legend, as the Greek myths began to lose their time-honoured binding force. The next chapter links up directly with this, presenting the most important kinds of monument on which mythological images can be found, with their fields of function.

The production of myth in language

Homer and the beginnings

Homer stands at the beginning of literary tradition; he does not, however, mark the beginning of the Greek production of myth. When the *Iliad* was created, roughly in the period between 750 and 700 BC, the traditions of this

kind of heroic poetry already reached back several centuries. The *Iliad* and the *Odyssey*, presumably created a few decades later, belong to the literary genre called epic. This genre is defined, on the one hand by the strict rules of its language, the use of verse made up of hexameters (six stresses to the line) and, on the other, by its choice of subject-matter, usually the stories of gods and heroes, which therefore exceed the normal scope of human experience, but which can at the same time claim to have an exemplary character for human affairs. Take for example Achilles, the central character in the *Iliad*, whose status as son of the Goddess Thetis is distinct from that of ordinary mortals but who, precisely because of this, can take on the role of a figure with whom the (male) listeners of the epic can identify, as an outstanding warrior. That the *Iliad* and *Odyssey* cannot stand at the beginning of epic poetry is, for two reasons, indisputable. First, they show a degree of perfection which could never have been developed from scratch, as the achievement of a single poet. Rather, with both the epics, something that had been practised for generations exclusively in the oral tradition, but with a growing complexity in terms of language and content, was then fixed in written form. The second reason is that extensive philological research has shown how the poet of the *Iliad* and *Odyssey* uses, in various ways, material from older legends. For example, he talks about the expedition of the Argonauts in a way which presupposes listeners were familiar with the details of the story. Thus we can grasp, at least at certain points, the historical tradition to which the oldest surviving epics presumably belong.

There is good reason for speaking of 'the poet of the *Iliad*' in vague terms. 'Homer', as the name of the creator of the *Iliad* and the *Odyssey*, is not authenticated in historical terms; besides, rather than being a proper name, it is more an indication of status. The personalisation of the authorship is derived from a later, decidedly legendary, attribution. In addition to that, it is as good as certain that the poet of the *Iliad* and of the *Odyssey* are not one and the same person, which is why the personified Homer evaporates even further – yet is nevertheless retained, for ease of comprehension, in the practice of research. Of the many questions of detail on the history of the origins of the two Homeric epics, one will concern us in greater detail here. When, in the decades around 700 BC, the *Iliad* and *Odyssey* reached a fixed and, in all probability, a written form, opening a new phase in the history of the treatment of traditional legend, what effects does this have on the visual engagement with these subjects?

The events depicted in the two epics represent only a small excerpt from the entirety of the mythical tales circulating in Homeric times. The *Iliad* spans no more than fifty-one days of the Trojan War, which went on for ten

years in all, and the core of the action is further restricted to a mere six days. In the ninth year of the war, Achilles has withdrawn from battle because of an argument with his leader Agamemnon over the distribution of booty. Only when his friend Patroclus falls does he take up arms again, supporting the Greeks, by now in extreme difficulties, with great success. Finally, he also kills his arch-enemy Hector, son of the Trojan king and leader of the Trojans. The last 'picture' in the epic shows the handing over of Hector's body to his father Priam (Fig. 11).

In the *Odyssey*, the narrative material is much more varied. The story begins long after the fall of Troy and has as its central theme the return of one of the Greek chieftains, Odysseus, to his homeland, Ithaca. We first learn of the difficult situation that has arisen on his home territory because of the long absence of its ruler. After the ten years of war, another ten years have passed in uncertainty over his fate. His wife, Penelope, is put under pressure to marry again and so let a new ruler take the place of her husband. Only now does the epic turn to the hero himself. He is with the Phaeaceans, a people who have granted him a warm welcome, and he recounts to them the obstacles he has encountered during his voyage home, the famous adventures and the loss of all his comrades. In a closing episode full of suspense, we hear about his perilous return home and resumption of power.

The two works recorded under the name of Homer represent both a climax and a turning-point in the entirety of epic literature of Classical antiquity. The fact that all later epic poetry, right down to Ovid's *Metamorphoses* and Virgil's *Aeneid*, was created in dialogue with Homer, clearly demonstrates their ranking in antiquity. But if the oldest surviving examples of the epic genre set the standard from which other poets took their bearings, right down to the end of antiquity, this was only possible because the earlier epics, standing in the oral tradition and therefore subject to continuous alteration, had reached a very high level. In the field of epic literature dedicated to mythical subject-matter, a strong tendency can be observed, in the period after Homer, to give full literary form to the various cycles of Greek myth. Such legends as those about Heracles, Theseus, or the Theban lineage around Oedipus, are rendered in epic form, which will invariably also tend to exempt them from the free play of continuous reformulation.

This need for a thorough rendering of the mythical tradition into a homogeneous poetic form is especially clearly demonstrated by the so-called Epic Cycle. This term refers to a cycle of epics (Greek *kyklos*, circle), which had as its subject a seamless sequence of all the events connected with the Trojan War, from the earliest causes of strife between Greeks and

Trojans, to the sacking of the city by means of the trick of the Trojan Horse and beyond that to the return of all the heroes to Greece. Almost nothing of this remains; only summary retellings inform us of the content of the individual parts of the story. This state of affairs in the transmission has less to do with the unfortunate fate of the manuscripts in the Middle Ages than with a value judgement reached during antiquity itself. In terms of their literary value, the various authors contributing to the cycle were all evidently ranked far below Homer.

One of Homer's contemporaries amongst the epic poets, Hesiod, deserves to be mentioned separately. At least two works, *Theogony* and *Works and Days*, can be attributed to him by name. We do not need to discuss here whether these works follow after Homer's epics in time, or whether they precede them, as a minority of ancient as well as contemporary scholars hold. In terms of historical development, however, they can undoubtedly be seen to have progressive characteristics. The wealth of the body of myths, continuously on the increase in the Greek world, led inevitably to a situation where the individual versions of the stories, created at different times and in different places, contradicted each other. A particular problem could arise here when it came to the question as to how to imagine the gods, their deeds and their lineage, if these gods also were worshipped in cult. When the *Theogony*, Hesiod's epic about 'The origin of the gods', sets out a detailed table of the individual generations, this is to be seen as an intervention aimed at creating order, by applying a systematic approach to the world of the gods and thereby making their world a convincing one. A collection of isolated myths is replaced by a mythology.

From the fact that Hesiod talks about the figure of Pandora in both epics, we can gain a direct insight into the workings of Hesiod's mind in connection with myth. Pandora stands, so to speak, at the interface between gods and humans. Created by the blacksmith God Hephaestus, on the orders of Zeus and with the involvement of other gods, as a kind of first woman, she brings joy and ruin to mortal men at the same time. In what became a proverbial expression, she is called 'Beautiful Evil' (*kalon kakon*) by Hesiod. The two versions of the story resemble each other in all essential points, but the fuller version in *Works and Days* more strongly sharpens the contradictions that characterise Pandora and, with her, the female sex as a whole. Besides Athena, who makes Pandora's external appearance attractive, the God Hermes also furnishes the new creation with characteristics, most prominently deviousness. On the other hand, in comparison with the *Theogony*, greater weight is given to the positive characteristics in the *Works and Days*: Athena passes on to Pandora the art of weaving, invented by her;

Pandora, in turn, does not just wear beautiful clothes but is very skilled in making them.

There is a pointer to the future, by comparison with Homer, which is at the same time a first hint of the distance between the poet as author and the material he shapes. Hesiod presents himself as a man with special talents. Only to him and men like him, the poets, have the Muses given the ability to say something about such a subject as the lineage of the gods and their relationship with humans. But this pronouncement, so proudly put, has an unspoken reverse side. It allows us to detect a consciousness that a mythical narrative does not just exist, but has been created by individuals – and is therefore in need of legitimation. The beautiful fiction of the kiss of the Muses as the font of divine inspiration would not have been developed, if the individual myth-maker did not know that, besides his own view of the world of gods and heroes, other views might be possible.

This last point deserves more pressing attention. The question, 'Did the Greeks believe in their myths?' (asked by Paul Veyne in the title of his book) can be answered, for Homer, Hesiod and their contemporaries, with an unequivocal 'yes'. The image of gods who are vested with supernatural powers and intervene in various ways in the individual fate of humans, corresponds in essence with the beliefs of the time and is not a mere product of poetic imagination. But this does not mean that the early Greeks' treatment of their myths could be taken as evidence of a naïve and, to some degree, pre-logical system of thought. The conviction, expressed in the title of a seminal book (Wilhelm Nestle's *Vom Mythos zum Logos*), of a gradual upward development from myth to logic has long ago been revealed as misleading. In fact, we can trace an intellectual engagement with myths as far back in time as we can the production of myths themselves. In this way, Hesiod's determination to systematise the genealogy of the gods is to be seen as a symptom of a critical handling of the traditional material of legends; while in the Homeric epics the similes (see pp. 36–7), that is to say the frequent intermingling of the levels of myth and of real life, are only the most obvious proof that the poet is working on myth in a reflective way.

The critique of myth

The relationship of the early epic poets with myth can be seen as critical only in the general sense of targeted selection and reflective reworking of the traditional material of legends; we find no indications of scepticism towards the content of the stories themselves. This was to change fundamentally two centuries later, with the blossoming of philosophy during the sixth century BC.

The natural philosophers of the movement called 'Ionian', after the region of origin of its most prominent representatives (the west coast of Asia Minor), established it as one of their methodological principles to evaluate the truth content of a statement by the strict standard of what can be verified by one's own critical judgement. As a result, not only natural phenomena, but also religion and myth became the object of incisive intellectual approaches. For such a 'scientific' world-view, the old legends were on two counts objectionable.

Religiously motivated criticism is the first facet of this phenomenon. Its most famous representative is Xenophanes of Colophon, who lived and worked in the decades around 500. His objections were mainly directed against the ideas, spread through Homer over the whole Greek world, as to how the gods were to be imagined: what are we to think, for example, of a Zeus who on the one hand appears in many situations to be a just god, but who is also capable of deceit and selfish behaviour? What is the reason, so the basic argument runs, to worship gods who resemble humans in all their weaknesses and vices and differ from them only by their greater power? To demonstrate the absurdity of this whole edifice, Xenophanes uses the image that animals, were they themselves capable of giving visual form to the gods, would give them the shape, respectively, of horses, cattle or lions. Yet Xenophanes was no 'atheist'. His criticism is not directed against the worship of divine authority as such, quite the contrary. The aim of his polemics is to expose the stories told about the gods as lies and thus to purify them, so to speak, and open up a new way of access to them.

Secondly, a critique of myth developed which can be called rationalist. It was sparked off mainly by the countless elements of fantasy in the legends which, seen from the point of view of strictly empirical thought, naturally show elements of the ridiculous and can lay no claim whatsoever to authority. Who would take it literally that Oedipus meets a creature half human, half animal, which then turns round and asks him questions? In the principles of methodology which Herodotus weaves into his *Histories*, it becomes evident how pioneering it still was, in the middle decades of the fifth century, to distinguish between belief and knowledge, between 'stories' which we tell each other, but which cannot lay claim to credibility, and knowledge which has been gained by means of our own experience and intellectual scrutiny. The first type of statements Herodotus places into the category of what he himself calls *mythos* (2, 23; 2, 45, 1). As a result, the concept of the 'mythical' has a negative connotation in Herodotus' work; it becomes a collective term for those unreliable accounts from which every serious author must distance himself. This methodological assertion runs

ahead of its practical fulfilment, as all true innovation does; it must not be used as a reproach against the early historians. Even Thucydides, writing a generation later, although still more critical of everything 'mythical' relates in his *History of the Peloponnesian War* that amongst the original inhabitants of Sicily there had been the gigantic Cyclopes (6, 2, 1), creatures therefore who belong to the myth of the wanderings of Odysseus.

The rationalist critique of myth also incorporates a constructive initiative. It differentiates between the core and the surface, between the meaning and the narrative material of myths: even if the monsters with whom Heracles fights, or the metamorphoses which Zeus brings about for his amours, have to be accepted as pure invention, such stories may still have an element of truth in them. The eponymous representative of this type of critique of myth, Euhemeros of Messene (active in the early third century BC), took the view that the Olympian gods had originally been mortal humans who were worshipped because they had achieved extraordinary things for society, to receive, in the course of time, the status of gods. This form of scholarly analysis of Greek beliefs about myths and gods (Euhemerism) was widespread in antiquity and, two millennia later, the philosophy of the European Enlightenment carries it on. The very title of Bernard de Fontenelle's Treatise *Of the Origin of Fables* (1724), with its use of the term 'fables' instead of the more neutral 'myths', makes clear the parallel with Herodotus and the sceptics of myth who followed him. Fontenelle does, however, make new sense out of the fabulous stories of the ancient Greeks. In accordance with the belief of his own epoch in progress, the Greek myths for him bear testimony to an early phase in the development of humankind, when the instruments of reason were not available. This evolutionist view has, even today, not yet disappeared from the interpretations of myths and their images.

The production of myth in times critical of myth

The critics did not manage to banish myths from Greek everyday life. At the same time as Xenophanes was castigating belief in the Homeric gods as simple-minded, Homeric poetry was being recited in front of large audiences in the context of religious festivals. Drama, which developed as a literary genre only in the later sixth century BC, reached its full flowering in the fifth. The vast majority of the tragedies by Aeschylus, Euripides and Sophocles, as well as those of authors whose works we know by name only, occupy themselves with mythical subjects. But the relationship with myth has lost its earlier straightforwardness. In the dramas of the great tragedians,

narrative as such distinctly fades in importance. Not only because of the restrictions in what could be performed on stage, the most striking parts of the plot are often put into a messenger's report: a character comes on stage and relates the dramatic events that have taken place immediately beforehand, indoors or in another invisible place. Controversial issues, on the other hand, are especially brought out on stage and ethical conflicts handled in detail in alternating speeches, with a particularly explosive topicality for the audience, as we have already seen in the context of Aeschylus' *Oresteia* (pp. 31–3). The exemplary character of the myths, which had been only implicit in the Homeric epics, takes precedence in the dramas over the narrative potential of the material.

From this, it is only a small step to the 'philosophers' myths' as handed down by Prodicus or Plato, new creations like the parable of the Choice of Heracles. The exemplary element in myth, which in the theatre is veiled by the fictitious action on stage, is openly declared by the philosophers as their reason for occupying themselves with these stories. For them, myths are a 'didactic instrument' (Fritz Graf) which is pointedly used in cases where mythical thought, because of its greater accessibility, is preferable to the more usual procedure of systematic and rational argumentation.

As a concrete example of the creation and processing of myth during the epoch of Greek enlightenment, a victory ode by the poet Pindar will serve to bring the genre of lyric poetry into consideration, beside those of epic and drama. The history of Greek lyric can be traced back to Homeric times; the oldest surviving texts come from the years around 650 BC. In Archaic and Classical times, lyric poetry was not something to be read quietly for personal edification, or to be recited for a small circle, as in modern times. It was overwhelmingly performed in a festive cultic context and recited not by an individual but by a chorus, always to the accompaniment of music. During the fifth century, the celebrations for the victors of great athletic competitions, at Olympia for example, offered the opportunity to perform choral songs of a very refined character. From Pindar, whose creative period spans the entire first half of the fifth century, there survive a large number of such victory songs (also referred to as Odes or Epinicians). The poet was a well-known and much sought-after person throughout the entire Hellenic world; some of the most powerful political figures of the day, who had won prizes at the prestigious horse- and chariot-races, commissioned works by him. One of them is Hieron, ruler (*tyrannos*) of Syracuse, who asked Pindar to compose a prize song for him, as victor in the horse race of 476 BC. In the corpus of Pindar's works, this is registered as the *1st Olympian Ode*.

We have already looked in detail at the purposeful dissolution of the boundary between myth and the 'real world' (or lifeworld), in the context of the definition of the 'mythological image'. On the literary level, Pindar uses a closely comparable procedure in his poem. This ode, a good hundred lines long, repeatedly changes locations and the levels of reality, in a manner typical of this genre. A brief introductory *priamel* is followed by praise for the victor, his home town and the location of his sporting triumph, Olympia. The mention of the legendary founder of the Olympic games, Pelops, is used as a kind of hinge, to transport the listener from the plane of life on to that of myth. In ornate formulations, Pindar narrates two episodes from Pelops' life story: how Poseidon took a liking to and abducted him; and how Pelops, returning to the world of mortals, won as his bride Hippodameia, whom her father would give away only to whoever could beat him in a chariot-race. After thirteen suitors had already paid with their lives for daring to enter the contest, Pelops mastered the task, thanks to Poseidon's support. The key word 'chariot-race' takes the listener back to the time in which victor and poet live. May Hieron, so the ending runs, follow the example of the mythical victor by also winning the prize in this most prestigious of all Olympian disciplines.

The poem presents a beautiful example of the task that was assigned to myth, even at a time when it was critically viewed. Every representation of a mythological subject, whether it follows the traditional narrative line or whether it adds new elements to the story, represents an 'application' for a certain purpose. In the case of the victory ode, the poet Pindar praises the victor Hieron by describing him as a second Pelops who, as Poseidon's favourite, was in turn closely connected with the sphere of the gods. In the field of the visual media, such a direct linkage of the mythical sphere to human experience can be seen, for example, on the Sarpedon krater (Figs. 17, 18). Here, the legendary scene of the retrieval of the body of the Lycian leader, slightly altered from Homer's version, changes seamlessly into a representation of everyday people preparing for war by the simple addition of flanking figures. The exemplary character of the myth becomes immediately evident, because the real world is present, whether in the image on the vase or in the victory ode.

The *1st Olympian Ode* holds a special status within Pindar's work: not however for the use of traditional legendary material that has been described, but because the poet himself gives a commentary on his own procedure. What has been told hitherto about Pelops and his father Tantalus, he says, is false, for it shows the gods in a bad light. Tantalus, so the traditional version runs, had killed his son and served him up as a meal

to the gods, to find out whether they would notice; they did indeed fail to notice it immediately, but afterwards they put the sacrificial victim back together again. Such stories, however, presenting the gods as potential cannibals, are denounced by the story-teller Pindar as the lies of other story-tellers. Himself a user of myths, he stands out as a decided critic of myth – a clear sign of a radical change taking place in this field in the early fifth century.

One theme which played only a minor part in antiquity (and of which no image exists!), but which has since the Middle Ages received close attention from scholars and artists alike, brings us finally into the sphere of the purely didactic use of myth: the parable of Heracles at the Crossroads. It is the invention – if we allow ourselves to believe his own statement – of the philosopher Prodicus of Ceos, who lived and worked in the late fifth century. Rather than the original version, we have only a somewhat later rendering by the author Xenophon (*Memorabilia* 2, 1, 21–34); but this very probably reproduces Prodicus' creation faithfully in all essential features. According to this, Heracles meets two divine women at a place where the path divides. The two women approach him and offer him something, just as the three goddesses do in the much older story of the Judgement of Paris, wanting to know which of them is the most beautiful. The two women whom Heracles meets are not portrayed as individual beings, but as abstractions, that is to say as the embodiments of the morally good and the morally bad life (*aretē* and *kakia*). The latter offers to the hero Heracles, who is to be imagined as a still young man at the threshold of adulthood, the advantages of the comfortable way of pleasure and vice; the former, equally emphatically, offers the happiness he can win on the path of virtue, but which in turn would mean taking on great labours. As we know, the hero decides on the second alternative.

We cannot really talk of a narrative here, even if the parable is set on a mythical level. Admittedly, the legendary figure of Heracles plays a prominent role, and the meeting of the three figures constitutes something like a narrative situation. But the mere fact that instead of proper names the women are simply called 'Virtue' and 'Vice', hints strongly at the author's intention: he wants to communicate a certain philosophical and pedagogical position and, to illustrate this, he thinly veils his message in myth. Accordingly, this 'myth' does not consist of a series of single events, but of a kind of programmatic test, with Heracles doing nothing but listening to the arguments for one and then the other way of life, and then taking a decision. For the contemporaries of the radical thinker Socrates, the element of truth in the traditional legends had become strongly relativised. At the same time,

they worked sporadically with the formal patterns of myth, as is the practice of Prodicus in our example, insofar as this was useful for the communication of abstract concepts. But they wanted no more of story-telling.

Philosophical thinking, committed wholly to reason and to one's own experience, certainly shook the credibility of myths, within and beyond the circles of intellectual exchange; but the attraction of the implausible, which belongs to myth, remained untouched by this. If Pindar's words put into the mind of the ruler Hieron that, with his abilities, he might come close to one of the mythical figures loved by the gods; if those who look at the Sarpedon image (Fig. 17) are shown how Hypnos and Thanatos, almost like two guardian angels, intervene in human affairs at least to the extent of making possible an honourable burial for the dead warrior, then this offers a positive value which goes beyond the question of factual truth. Myths had lost much of their earlier importance as a means of explaining the world. But their function as a surface on which to project immaterial concepts – fears, wishes, ideals of society and utopias – was not questioned to the same degree. The imaginative potential of myth made them into tools, offering a counterpart to the visible world in something that was only imagined, and so satisfying the need for transcendence. It was this which secured for myths, whether in verbal or in visual form, a place in human consciousness throughout antiquity.

Myth production through images

The beginnings

We can only imagine how the literary production of myth began in the Greek world. When our oldest surviving testimony emerges with the *Iliad* in the eighth century, this marks a beginning only insofar as the art of oral story-telling, developed over many generations, was carried over into a fixed form which could be passed on. By comparison, we can draw a much more precise picture of the first beginnings of myth production through *images*. The rich sequence of painted vessels, surviving from Homeric times and even from the preceding epochs, allows us to observe, step by step, the development of another type of representation: the imagery of myth.

Until about 800 BC, Greek ceramics are decorated almost exclusively with non-figural motifs. In subsequent decades, in line with the perfecting of the potter's art and the refinement of decorating systems, animal friezes are increasingly taken into the repertoire, but they are so schematically and

repetitively formed (see, as a late example, the animal frieze in Figs. 5, 6) that they hardly stand out from the décor of the vessels which is still dominated by Geometric motifs. Around 770 BC, this process of change accelerates considerably. The simple repetition of apparently decorative figures gives way to groups of human figures interacting with one another. In accordance with the frequent use of these vessels as grave monuments and grave goods (see chapter 4), funerary scenes dominate: the laying out of the dead and the solemn funerary procession are amongst the most popular subjects.

Again, one or two generations later, towards the end of the eighth century, the first images of myth are created, depictions which refer to specific episodes in a mythical narrative. An amphora, no less than 1.42 metres high, from Eleusis near Athens and belonging in the time around 670 BC, though admittedly not one of the very first examples, is a particularly impressive and instructive one (Figs. 20, 21). The killing of the Gorgon Medusa is shown on the body of the vessel: in the centre of the picture the two sisters of the decapitated Medusa move towards the Goddess Athena, while Perseus runs away to the right. The image on the neck of the

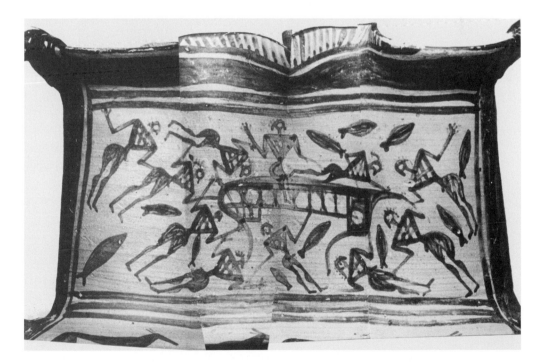

Figure 19 Shipwreck. Attic Geometric jug (projection), *c.* 720 BC

Figure 20 Odysseus and his companions blinding Polyphemus; Perseus killing the Gorgon Medusa. Proto-Attic amphora, *c.* 670 BC

Figure 21 Perseus killing the Gorgon Medusa. Drawing (detail) of the amphora shown in fig. 20

amphora shows Odysseus and his comrades blinding Polyphemus – we shall go more closely into this type of representation in what follows.

The literary consolidation of the traditional mythical narratives as epic poems and their visual consolidation in imagery are thus more or less contemporaneous. This is certainly no coincidence, but the expression of a markedly intensified engagement with the traditional stories. This development takes place during a very dynamic epoch within the Greek world, which has even been called a 'Renaissance': the institution of the Olympic Games, the beginnings of colonisation in Sicily and south Italy, as well as a significant strengthening of the political and religious infrastructure – these are but a few of the key terms that arise in this context. But it by no means follows that, because the earliest mythological images coincide with the beginning of the creation of written versions of myth, the images were in great part directly dependent on the epics and other – surviving – works of early literature. Even if the Homeric poems had already achieved a wide diffusion in Archaic times, it is beyond question that the creation of mythical images was also extensively stimulated by works now lost and, above all, by the stories handed down in the oral tradition.

The description of the developmental process which led to the first depictions of myths must be stated more precisely, at least in one point. This can once again contribute something to the definition of the concept of the mythological image, this time from the historical perspective. A strict dichotomy, solely between the non-mythological scenes of action (for example, funeral processions) and the (developmentally later) depictions unequivocally relating to myth, does not do justice to the historical development, in that images exist which must be placed between the two categories. At times, men can be seen fighting with a lion on vases of

this epoch. It is as good as certain that these images do not derive from actual contemporary hunting adventures, or from resistance to predators threatening cattle, since the assumption that there had been lions in eighth-century Greece is extremely unlikely. These representations therefore have a fictitious character; they must be understood in allegorical terms, as a symbolic representation of 'lion-like' courage, or of a danger equal to that of fighting with a predatory animal. This does not yet take us into the world of myth, but it does come close to the world of mythical thinking, since the idea of a lion attacking a herd of cattle is one of the most popular 'Homeric similes'. Just as the poetic image in the epic serves to illustrate extreme physical danger in, for example, a battle setting, so in the art of the pictorial image, the motif of the lion is used to characterise a situation or a person of the real world, through the connection with a fictitious occurrence.

The next, and more complex, example demonstrates how the path to the mythological image passed through a mixture of the world of real experience and the sphere of myth. The basic motif of the picture on a jug from the time around 720 BC (Fig. 19) can be clearly recognised. The ship which is shown with its keel up, the men who are distributed all around the image and, last not least, the fish – all of these together make sense only if the meaning is that of the shipwreck. The fact that the eleven men – in almost every case identified as such by their penis – are also naked, should not however be seen as an indication of the situation they are in: it conforms to an artistic convention typical for that period and independent of the action it depicts. Those with an optimistic perspective will identify the figure sitting conspicuously astride the keel and centrally placed in the picture as Odysseus, of whom we hear in Book 12 of the *Odyssey* that he was the only survivor of a storm which robbed him of all his companions at the end of his wanderings (lines 405–25). The way in which the other men drift around in different directions amongst the fish seems to confirm this view. The image on the jug would then be one of the earliest preserved images of myth in Greek art, originating at the latest at the same time as the Homeric *Odyssey*, if not preceding it. The sceptics underpin their view with two arguments. One is that the picture does not, or at least not unequivocally, distinguish between the one survivor and his companions who all without exception perish. All men in the water are still alive, for they are hanging on to the ship or on to each other; one of them, also still alive, even lies along the keel. The second thing to ponder is the fact that depictions of shipwreck or, even more frequently, battles at sea with heavy losses, are relatively common during those years. Seen in this light, the picture may quite reasonably be interpreted as one amongst many variants of a basic motif typical for the time.

In the previous chapter we discussed what constitutes an essential aspect in a definition of the mythological image, that is the ready transition between the world of life and the image of myth: we can see this here, as it were, *in statu nascendi*. Insistence on drawing a sharp line between a descriptive (shipwreck) and a narrative (shipwreck of Odysseus) interpretation would mean denying the associative potential and, with it, one of the central characteristics of the medium of imagery. Since the subject-matter of the *Odyssey* was well known at this period, independently of its shaping by Homer, and since the picture on the jug quite pointedly designates the man sitting on the keel as the main character, in contrast with his many companions drifting in the water, the tragic hero Odysseus may perfectly well have swum into the minds of those viewers familiar with the myths. The inconsistencies in the action do not represent an obstacle worth mentioning: we can easily imagine the sailors as still alive, but dying. If the vase painter, by adding the name 'Odysseus', had explicitly sought to depict a theme from the life of the hero, no changes in the representation would have been needed.

To speak of 'inconsistencies' is in any case misleading, since we cannot expect the pictorial version of a myth to reproduce faithfully that of its written form. The specific laws of representation give the visual artist only limited possibilities, by comparison with a poet, of representing action in a comprehensible way or even of 'illustrating' a mythical narrative – this too was discussed extensively as an aspect of the definitions. To go back to the theme of shipwreck, it is possible, within the artistic means of the image, to denote visually the state of being alive and that of being dead, but not that of the process of dying (if indeed this applies to Odysseus' companions). The same problems, if in another form, occur with the depiction of Polyphemus (Fig. 20) which belongs to the first generation of unequivocal images of myth. All deviations from the text of the *Odyssey* can be explained without difficulty by reference to the laws of the medium and the formal conventions of the time. Odysseus had, first of all, made the Giant drunk with wine and put him into a deep sleep in order that next, with the support of five of his companions, he could ram a wooden stake with a red hot tip into the one eye of the sleeping Giant. In conflict with the situation, but justifiably in terms of the story, the vase painter has given Polyphemus a cup to hold in one hand, although the decisive attack is already under way – a trick of the trade, well suited for recalling to the viewer the precondition for the deed. The remaining 'deviations' are all to do with the laws of representation – as a counter-example, it is worth taking a look at Flaxman's drawing of the same story (Fig. 10).

In order to achieve a monumental effect within the rectangular panel which is determined by the shape of a vase, the number of the companions was reduced to two and since in Attic vase painting of that epoch figures did not overlap in depth, but were arranged on the principle of a frieze, it was the most practical solution to show Polyphemus in a crouching position instead of a lying one, and to set the stake in a horizontal instead of a vertical direction. What emerges from this analysis of the picture of Polyphemus may be judged to have an exemplary value. From the very beginnings of such imagery, there is on the one hand a close relationship with a written version of the myth that is known to us, yet on the other hand the pictures do more than just illustrate: they go their own way.

It is not just the arrangement of the representations themselves, but also the choice of subject-matter that affords a proof for this statement. Mythological subjects spread only haltingly in vase painting and in various genres of the minor arts. From the first hundred years in the history of Greek mythological imagery, that is from around 700 to 600 BC, no more than about one hundred examples survive; by comparison with the sixth and fifth centuries, this is an almost insignificant number. Geographically, the early images were spread over a wide area, from the Greek settlements in Italy to the eastern coast of the Aegean. As with epic literature, whose reception spans the whole of the Greek world, so giving visual shape to the subject-matter is also a Panhellenic phenomenon. About half of the early images refer to the cycle of legends from the Trojan War, beginning with the Judgement of Paris, then on to the events of the war itself and finally to the return of the heroes. Other themes are taken from other areas of mythology, for example, the deeds of Heracles or of Perseus (Fig. 21).

A comparison between, on the one hand, the *Iliad* and the *Odyssey* and, on the other, the images showing episodes from both the epics, yields some remarkable results. Only few episodes from either of the works were considered worthy of an image. With the *Odyssey* in particular, the visual artists seem to have proceeded very selectively. Until the end of the seventh century, we know of images only of the blinding of Polyphemus and of another moment during that adventure, the flight from the cave. In this context, it is above all the negative aspect of this result that deserves attention: that the vast majority of episodes from the *Iliad* and the *Odyssey* were *not* illustrated by images. If the main purpose of the images had been the transposition of the subject-matter from one medium to the other, we should have a more even spread of subjects. Far from merely illustrating, the representations obviously had, from their very beginnings,

purposes of their own, which can be analysed only by means of a careful interpretation of image and context.

Narrative cycles: maximising the pictorial image

The amphora from Eleusis (Figs. 20, 21) is a striking example of how powerful and inspired is the imagery of myth, especially in this, its first phase. In the main field of the vessel the sisters of the Gorgon Medusa, killed by Perseus, could hardly have been rendered more expressively, with their long naked legs, spindly arms and globular heads. They convey, more effectively than words could, the disturbingly alien aspect of these half-human creatures. Yet one thing was clearly not important to the vase painter, although he evidently had considerable conceptual powers at his disposal. He did not turn this magnificent vessel, which stands out as altogether exceptional in the ceramic output, into an 'Odysseus' or 'Perseus vase'. There would have been no technical obstacle to using, on the neck and belly zones of the vase, images from one and the same cycle of stories: to show, for example, besides the blinding of the Giant, the subsequent flight from the cave; or alternatively to depict another of Odysseus' adventures. The additive character of the actual scenes is further intensified by placing the scene of fighting animals in between the two mythological images. So there was no requirement, then, to achieve narrative coherence within the decoration of an object – neither on this amphora nor on other monuments decorated with multiple scenes. But we need not therefore call the combination of the three subjects arbitrary. If there is no connection on the narrative level, there may yet be one on the level of meaning. Since the only external hint is the fact that the vessel was used as a burial urn, much caution needs to be exercised here. The two mythological images could be linked with each other as symbols for averting death, or for heroic courage in a seemingly hopeless situation.

Even in the clearly defined space of a pediment of a temple, images were put which, in terms of narrative, are as little connected with each other as the two scenes on the amphora of Eleusis. A gigantic Gorgon Medusa takes up the central space of the pediment in the temple of Artemis on Corfu (Greek Kerkyra); the figure of Perseus at her side, who seems to be almost in miniature (Fig. 22), identifies her as only a part of a scene. Towards the corners of the pediment are shown two battle scenes, Zeus as victor against an opponent, most likely a Giant (Fig. 23), as well as probably an event from the Trojan War, the killing of King Priam. The divergence between the themes is further heightened by two big felines, positioned between the

Figure 22 The Gorgon Medusa and Perseus. Corfu, west pediment of the temple of Artemis, *c.* 580 BC

group in the middle and the two battle-scenes, a combination which compares with the one found on the Eleusis amphora. As there, so too on the Corfu pediment, the meaning that contemporaries read into the sequence of motifs must remain a matter of speculation; whether they perceived any dominant idea at all or whether, instead, they 'read' the individual representations one after the other and never even asked the question, which seems to us a matter of course, about the possible coherence of the content.

Only from two generations later, around the middle of the sixth century onwards, are monuments widely found that carry images connected by their narrative content. The additive principle, however, is not then pushed aside: quantitatively, it remains the dominant one. But the tendency towards thematic unity has to be understood as the indicator of a generally changed attitude towards mythical narrative, even if this cannot be easily explained historically. This striking innovation can be observed not only in vase

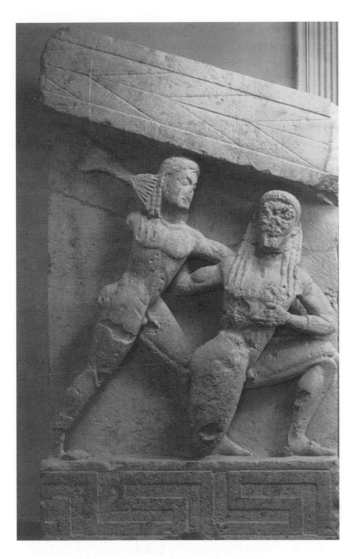

Figure 23 Zeus in combat with a Giant (as Fig. 22)

painting but also in the sculptural decoration of religious buildings, where thematic unity more or less replaced diversity as the norm. In the west pediment of the Parthenon on the Acropolis in Athens (Fig. 9), to quote an example already cited, the group of the two warring deities, Athena and Poseidon, takes up the centre. The numerous other figures in the composition in the pediment do not intervene actively in the quarrel, yet they take part in it as witnesses and judges, so forming a unity with the two gods. But much more frequently found in architectural sculpture than such part-static, part-dynamic conceptions are the battle-scenes with multiple figures.

Figure 24 Battle between Lapiths and centaurs. Olympia, west pediment of the temple of Zeus (drawing), *c.* 460 BC

In formal terms not least, they can be realised to advantage both within the stretched-out triangular shape of the pediment, and on friezes and metopes, the series of reliefs on the entablature of buildings in the Doric order (compare Figs. 7, 24, 27, 28). The war between the gods and Giants, as well as the battles of certain groups of Greeks against the Amazons and centaurs, are among the most popular themes in architectural sculpture of the sixth and fifth centuries BC.

The west pediment of the Temple of Zeus at Olympia (Fig. 24), created towards 460 BC, has as its theme the so-called Centauromachy, a very popular myth at the time. The scene of action is the palace of Peirithoos, the king of the Lapiths whose homeland is Thessaly, a region of northern Greece. Peirithoos is marrying Hippodameia and invites the centaurs, with whom the Lapiths had friendly relations although they were half-human, half-horse, to the celebrations as well. The animal nature of the centaurs breaks through after too much enjoyment of alcoholic drink. They lay hands on the bride and the guests of the wedding party and so provoke a bloody conflict. In the pediment sculptures, aggression and defence are depicted in an unusually realistic manner. The centaurs have attacked both men and women, and they fight with all available means. One centaur bites into a boy's arm, another tears a woman's hair; their opponents defend themselves with bare hands, swords and knives. Despite the chaos within the individual battle groups, the pediment composition as a whole follows a strict idea of order. From the middle outwards, a group of three is followed by a group of two and then again a group of three, with two Lapith women in the corners of the pediment. The centre is occupied by a figure of Apollo, who should be imagined as the invisibly present divine helper of the Lapiths. This clear organisation gives the

Figure 25 Scenes from the Sack of Troy (Ilioupersis; so-called Vivenzio Hydria). Attic red-figure hydria (drawing), *c.* 480 BC

viewer the help necessary to grasp the meaning of the ensemble with its twenty-one figures.

In vase painting, the tendency to compress themes emerges equally clearly. On the Euphronios krater, the arming scene (Fig. 18) represents, as it were, the events leading up to the death of Sarpedon (Fig. 17). On the amphora by Exekias, a warrior's leave-taking (Fig. 5) was combined with the scene of the fallen soldier being brought back home. The last example takes us away from the field of mythological images; but among vessels with unambiguously legendary images, too, there are numerous cases of the type of composition with separate scenes that together form one action. A significant example of the tendency to achieve a maximum of narrative coherence in a picture is the frieze on the Vivenzio Hydria (Fig. 25), named after a previous owner. The vessel, in its plain, unadorned form used for carrying water, was created in Athens around 480 BC and is attributed to the

oeuvre of the Kleophrades Painter. After the images of events during the Trojan War itself (Figs. 3, 11, 16, 17) and the journey home of the Greek ruler Odysseus (Fig. 20), we now arrive at the climax and turning point of the enterprise: the sack of the city after a ten-year siege.

On the frieze, which occupies almost the whole circuit of the shoulder of the vessel, five individual episodes from the night of the sack of Troy (Greek, *Ilioupersis*) are arranged next to each other. The scenes are not ordered in a temporal sequence, but must in principle be imagined as taking place simultaneously. The structuring principle is one of content: the overall theme of war is fanned out into the sequence of three basic situations: destruction, battle and salvation. In the centre of the frieze a real slaughter is taking place. On an altar normally used for the sacrifice of animals, where every act of violence against humans represents sacrilege, Neoptolemus the son of Achilles butchers the old and defenceless King Priam, on whose lap his grandson Astyanax lies, already killed. Immediately to the right, the fight between an anonymous Trojan woman wielding a pestle as an improvised weapon, and a kneeling Greek man, seems still undecided, but the constellation of the two combatants leaves us in no doubt as to who will win in the end. In the corresponding scene on the left, it is a woman who is kneeling, the Trojan priestess and seer Cassandra who clings, seeking protection, to the cult image of Athena, but to no avail. Her nakedness, heightened by her short cloak, gives the viewer the unambiguous message that (the Lesser) Ajax, who is already grasping her head, also means to attack her sexually. Towards the two sides of the frieze, the scene lightens. On the left we see how the Trojan Aeneas succeeds in escaping with his son, and with his father laboriously carried on his shoulders; at the far right we see how Aethra, Theseus' mother who had come to Troy in the context of the Rape of Helen, is saved.

We can best appreciate the peculiar nature of this frieze if we compare it with a version of the narrative of the same events in verbal form. For if a viewer successively analyses the dense sequence of figures and scenes for himself, he may well arrive at a similar result as from reading or listening to a text (which might run as follows): 'During the night of Troy's fall, Priam was brutally killed, although he had fled to the altar; in another place, Ajax pulled the priestess Cassandra away from the cult image of Athena; but during the tumult Aeneas succeeded in escaping, together with his father and his son . . . [and so on]'. The picture, though created as a visual unit and depicting simultaneous action, inevitably dissolves into a sequence of individual events which have to be understood one after the other, corresponding with the always linear structure of a text which develops from one point

to the next. But its evident programmatic quality also links the picture with a verbal version of the myth. Even though the frieze conveys the impression that during that night arbitrary, raging forces came down on Troy, there is an equally emphatic effort, through the planned order of the five scenes, to get beyond a pure description of individual situation and individual fate. The mirrored arrangement, with the destruction of Priam at the central axis and the battle and rescue scenes on either side, constitutes an attempt to give the viewer something like a set of instructions for interpretation: 'war is first and foremost destruction, and only by lucky chance can the (civilian) population escape the catastrophe' – that is the direction taken by the message of this cycle of images.

Signs of disintegration

There is something very ambivalent in the fact that, when a pictorial representation approximates to a verbal version of the myth, as in the example discussed above, it does so by narrating in detail and then commenting on the action. This can be seen as a sign of progress, but at the same time it has to be judged a symptom of crisis. One medium coming closer to another serves only to bring out, in the sharpest focus, the limitations that apply to the mythological narrative image. It is precisely when we take in the numerous 'speaking' motifs on the Vivenzio Hydria (Fig. 25) one by one, for example Priam putting his hands on his head by a reflex action but completely ineffectively, or the contrast between Ajax's unwavering action and the exposure of Cassandra's body, that we feel that the image will always fall far short of the kind of completeness of narrative that is possible in language. The more wide ranging the picture, the more comprehensive and specialised knowledge of myth it requires of the viewer. In our case, the viewer must not only have knowledge of the individual episodes of the *Ilioupersis*, but also of the settings and chronology of its actions, in order to be able to translate the differentiated tableau of the pictorial frieze, down to the smallest detail, accurately into the action of the myth.

The limitations of the mythological image are even more strongly detectable in terms of content and message. The structuring of these five scenes, clear almost to the point of being pedantic, obviously expresses a firm determination to mark out the way to the understanding of the representation. But this artistic trick cannot do more, even for the contemporary viewer, than point to the *approximate* direction for an interpretation. Whether, for example, the polarised arrangement of the frieze, laying such emphasis on the scene of destruction, is also meant to contain an element of

moral denunciation of war, cannot simply be decided by just looking at the picture. An objection would be that this was a much less open question for contemporary viewers than for the modern interpreter, because of their familiarity with the allegorical valency of the *Ilioupersis* motif from other contexts, drama performances for example. This objection, however, precisely underlines our crucial finding: in a text, a few lines suffice to make explicit statements about a myth's content of meaning, something which, in contrast, is never possible with a pictorial version.

The intention, detectable in the pictures on the Vivenzio Hydria and many other images, not only to tell a tale in detail but also to give explanations, can bring about the desired results only within narrow limits. It is therefore hardly surprising when, at this period of transition from Archaic to Classical times, counter-tendencies develop, and radically different ways are pursued to bring the picture closer to the text and to explore its potential for conveying a message. We can observe not only a striking reduction in narrative substance, but also a new internal organisation of the images. A conspicuous phenomenon in this context is found in the so-called personifications. These are figures whose form is human or close to human, but who embody abstract values and concepts. We have already met Hypnos and Thanatos, the personified demons of sleep and death, on the Sarpedon krater of Euphronios (Fig. 17). The name-inscriptions, as additional, text-related elements, secure the identifications. Compositionally, the picture on the krater possesses relatively little independence, for in essence the recovery scene corresponds exactly with the wording in the *Iliad*.

Another example may be able to illustrate more clearly the extent to which the use of personifications and other comparable figures is symptomatic of a fundamental change in the conception of the mythological images. We turn once more to the *Ilioupersis* and to a situation of great dramatic depth (Fig. 26). The abduction of the beautiful Helen, the wife of the king of Sparta, had been the cause of the Trojan War. After ten years of fighting which had cost many men their lives, during the night of the sack of the city, Menelaus again meets Helen who in the meantime, and not at all against her own will, has become the lover of her abductor, Paris, the king's son. On an Attic jug from the years around 430 BC, Menelaus storms like a runner towards his former wife who, like Cassandra before her, has fled to the cult image of Athena, and whose whole body signals inner defence and distance. Her appearance, however, radiates an extraordinary beauty which, in the truest sense of the word, disarms Menelaus. He is overwhelmed by the sight of Helen and, for that reason, the sword with which he had meant to kill his adulterous wife slides from his hand. The two women on either side

Figure 26 Menelaus and Helen of Troy. Attic red-figure jug (drawing), *c.* 430 BC

of him would be taken to be the servants of Helen or similar figures, but for the names inscribed besides all the figures. On the far left stands Peitho, personification of persuasion, who seems to turn away a little from the action. With her, a kind of explanation of the scene is written into the picture. As if by writing under the picture 'Persuasion through the senses has conquered the furious man,' the addition of Peitho does away with any potential uncertainty of interpretation. On our example, already quite late in the history of personifications in Greek imagery, this trend manifests itself in a particularly pronounced form. The majestic figure between Menelaus and Helen, calmly rearranging her dress, is Aphrodite, the Goddess of love who is invisibly present. The whole atmosphere is heavily charged in an erotic way, as is further made clear by the flying Eros who, on grounds of his name ('Love, Desire') and his character alike, belongs more to the group of personified abstract concepts than to one of mythical beings with their own biography.

The fifth century is, as outlined above, a period of the constructive criticism of myth. The credibility of the traditional narratives – in the sense that they were held to be true – is doubted, but this at the same time clears the way for the function of the legends to be openly discussed and put to thoughtful use. Pindar's *Odes* are an illuminating example from the field of literature for the tendency, typical for the time, of the unabashed instru-mentalisation of myths (see pp. 71–4). The poet uses the imaginative potential of the legendary narratives and yet, through the manner and

style with which he uses them as examples in his victory odes, keeps a certain distance from them. In the picture of Menelaus and Helen, there is a comparable balance between the care and consistency with which the mythical action is translated into an image, and the weightiness of the additional explanatory figures. Once the viewer is made fully aware of the fact that Peitho, Aphrodite and Eros do not belong in the narrative, Menelaus and Helen almost inevitably come across like stage performers: two very committed actors who, in performing a specific legend as a concrete example, present the universal topic of 'The Power of Beauty'.

The personifications, integrated for their explanatory power, change the character of the image of myth fundamentally. The balance between the advantages and disadvantages of imagery as a medium, by comparison with a myth expressed in language, has shifted. The gain from the point of view of explanation of content goes hand in hand with a loss in respect of narrative fiction; the four adult figures in the Helen picture are not the moving forces in a common action, but belong to different levels of reality. Such signs of disintegration in the mythological image can, once the relationship towards myth has become a critical one, be observed in very different forms are difficult to systematise in a meaningful way. One of these developments consists of once again abandoning the achievement of thematic unity in cycles of images of myth, and instead linking up the individual representations with each other solely on the level of abstract allegory. A striking example of this tendency is given by the relief metopes on the Temple of Hera in Selinous, erected around 460 BC. Selinous, the westernmost outpost of the Greek world on the southern coast of Sicily, demonstrated the great wealth which the city had acquired since its foundation in the seventh century by an unusually high number of magnificent temple buildings. The temple of Hera was furnished with twelve metopes of around 1.60 metres in height. Two groups, with six in each of them, formed a frieze in an alternating sequence with undecorated members above the entrance to the temple interior, as well as in the corresponding place at the back of the building.

Of the five preserved relief slabs, one shows the death of Actaeon (Fig. 27). Like Oedipus, Actaeon comes from the royal house of Thebes. The story of his end found its most famous form in Ovid's *Metamorphoses*. The poet belonged to a celebrated circle of literati in Rome at the time of the Emperor Augustus, until he was banished, in the year AD 8, to a provincial place on the Black Sea, as a potential accessory to a political intrigue. As the author of the *Metamorphoses*, he is a late successor to Homer and Hesiod, as Virgil had been a few decades before him, with his *Aeneid*, the epic about

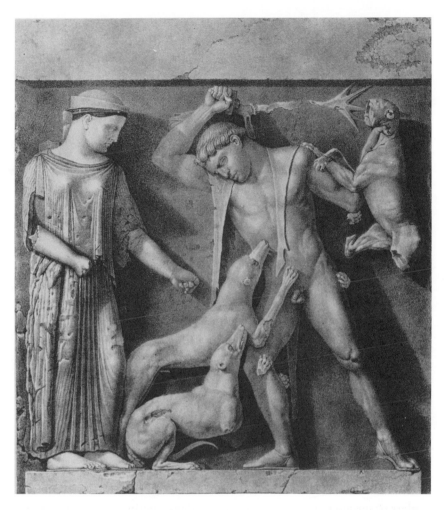

Figure 27 Artemis has Actaeon killed by his own hounds. Selinous, metope from the temple of Hera (drawing), *c.* 460 BC

Aeneas the legendary founder of Rome. Ovid establishes a particular link with Hesiod's *Theogony*, by setting the individual stories of the *Metamorphoses* in the context of a great chronicle of the world, beginning with the creation and ending with his own lifetime. His distanced, organising attitude towards traditional myths is expressed more strongly still in the fact that he looks at these stories from a single point of view, presenting them all, in accordance with the title of his work, as transformations. The idea of transformation as a driving force in all human activity is a philosophical maxim, which dominates the conception of this sizeable work. As with Xenophanes 500 years earlier, the philosophical approach also includes

criticism of many actions of the gods of Greek mythology. At one point, there is talk of *celestia crimina*, the abominable deeds of the gods (6, 131) which, as well as the amours with mortal women achieved by force, refers to the immeasurable cruelty of the gods towards humans. Niobe, for boasting of having many more children than the Goddess Leto, is turned into a figure of stone as a punishment (6, 146–312), and the satyr Marsyas is skinned alive on the orders of Apollo whom he had beaten in a musical competition, and so turned into a living anatomical model (6, 382–400).

The hunter Actaeon happened upon a place in a remote area where the Goddess Artemis used to bathe. Ovid tells us at length, how she undresses, how first her attendants and then the goddess herself notice Actaeon watching, and how he is thereupon subjected to a magic spell (3, 131–252). As a punishment for the fact that he has come, even unwittingly, too close to a divinity, she sprinkles him with water to transform him from a human being into the outward form of a deer. As a result, he becomes the defenceless victim of his own hounds, which set upon and dismember him.

The metope, in a number of details, does not go exactly with the story as told by the Roman poet. Some of this is connected with the conventions of the image as a medium and its conformity to pictorial laws. The bow which was drawn by Artemis with her hands, now broken off, should probably be primarily seen as a means of recognition. Most of the differences, however, very probably arise from the fact that in Classical times, when the metope was made, a different version of the course of the action was current. Because we have this only in fragmentary form, it is possible to reconstruct it only in broad outline. According to this, to set the dogs on to the hunter himself, it was enough to throw the hide of a stag over him – the hide and antlers of the animal can be made out on the relief. In the view of the fifth century, a further reason for Actaeon's downfall was his passion for a mistress of Zeus or, on the other hand, his arrogance in thinking himself a better hunter than Artemis. The motif of voyeurism, which takes centre stage in Ovid's version and gives the story an insinuated erotic slant, seems only to have been developed considerably later.

But the context of the representation in the relief is more interesting than the change in the narrative of the myth. None of the other four surviving metopes is in any way connected, in narrative terms, with the legend of Actaeon, nor are there other narrative links between the four representations themselves. They depict Heracles killing an Amazon, Athena conquering a giant, the Gods Zeus and Hera as lovers (Fig. 28), and a man, most probably Apollo, pursuing a woman – five different motifs therefore, five myths standing independently from each other in the sequence of images

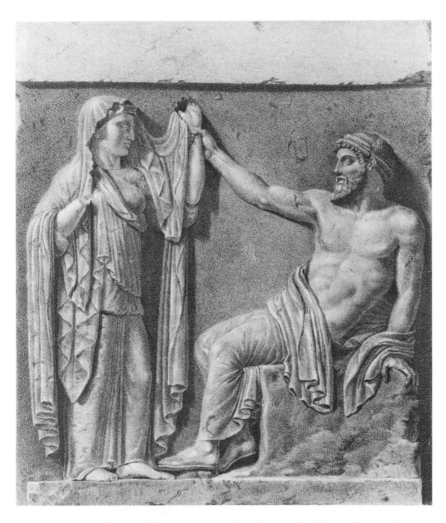

Figure 28 Zeus and Hera. Selinous, metope from the temple of Hera (drawing), *c.* 460 BC

which decorated the temple. The seven lost metopes confirm this result as far as they can, to judge from the preserved traces. The divergence in the subjects steers our attention towards the existence of connective patterns, not on a narrative but on a conceptual level. Thus at least one deity appears on each slab, if we include Heracles, who is accepted into Olympus later, and each of these deities gives a taste of their power. If the ancient observers went through the cycle of twice times six reliefs, then they had before them a community of gods, each of them introduced by a characteristic deed. The relief which, exceptionally, shows two deities also fits in, for it documents the high status of the temple's owner Hera, as bride and wife of the chief of

the gods, Zeus (Fig. 28). Each individual image of a myth is thus given a clearly defined function as a building block within an overriding concept. To put it more concretely: the fate of poor Actaeon is not told for its own sake, but as a message about the merciless operations of the Goddess Artemis.

This tendency is confirmed by a further pattern, in relation to the choice of the members of the 'cast'. On each of the preserved reliefs, a man and a woman are portrayed. This must have been a characteristic structural feature of the whole cycle, as can be understood from a number of clues: amongst others, the unusual fact that the female figures are distinguished from the male by the use of white marble for the face and unclothed parts of the body. Thus the relationship between the sexes is played through, as it were, with a series of contrasting 'couples', ranging from deadly mutual conflict, as with Artemis and Actaeon, to the celestial marriage of the two highest Olympians. What was realised here, with the help of images, can be compared with texts of various kinds: a hymn, which addresses the various gods worshipped in a city; and a treatise which discusses, by way of individual examples, the complex relationship between the sexes. But precisely from this, we can see how far the representations, for all their realism of execution, have become vehicles, put to thoughtful use with a view to communicating abstract ideas. As with the representation of the personification of Peitho (Fig. 26), here too it is true that the more intensively a mythological image or sequence of images explains its own content, and seeks to do away with that element of associative openness which in principle belongs to the image as medium, the more sharply, in compensation, the narrative substance and credibility of the representations are, in relative terms, reduced.

This section is entitled 'Signs of Disintegration' and in it 'symptoms of crisis' have been discussed; but this does not mean that the production of myth and mythological images in the fifth century had fallen into a general crisis. In fact, the engagement with legends old and new, by means of word and image, continues in a lively form in both throughout Hellenistic and Roman times; some examples of this we have already discussed. But if, from the later sixth century onwards, there is a tendency to push back the boundaries of the image, by comparison with language, as far as possible, then this is a clear sign that these very restrictions were pondered and perhaps even understood to be a problem. The attempt to recall as much of the narrative as possible in the picture (see pp. 85–7), as well as the endeavour to integrate in it as much explanation of its content as could be achieved (see pp. 88–90), make fully visible the limitations of the visual medium. From a positive point of view, the two poles are now identified,

between which the further development of the Greek mythological image, including the versions in Roman art, takes place. At one end of the spectrum, there are works with a large measure of narrative content and factual interpretation – the Ilioupersis cycle on the Attic hydria (Fig. 25) and the sequence of images on the Medea sarcophagus (Fig. 13) from the Imperial period must in this respect be put side by side, despite the distance of time between them. The other end of the scale is marked by such highly imaginative works as the Barberini Faun (Fig. 14), or indeed the image on the interior of the bowl by the Sosias Painter (Fig. 1). They are hardly explicit in terms of narrative material, but instead they set off associations, in a manner all the more targeted at directing the perceptions of the viewer thereby.

4 | Types of monument and fields of function

The types of archaeological monuments used for the visual representation of myth in Greek and Roman antiquity are very diverse. The spectrum ranges from the miniaturist frieze of figures on a vessel, at times only a few centimetres high, to the decoration on a sarcophagus and on to sculptural groups of almost colossal dimensions. Because of these strong divergences, many of the questions of central importance for the interpretation of the images find widely differing answers: who commissioned the work and to whom is it directed? What function does a work of art decorated with a mythological image fulfil for those around it? And in what way does the formal representation of a myth depend on the type of object or monument on which the image occurs? In good part, these questions can be quite reliably answered; yet a number of points, essential for interpreting the images, have to remain open. In this chapter the four groups of monument which are most important for our subject are introduced in the chronological order of their emergence.

Vase painting

The idea that ceramics are a characteristic heritage from most ancient cultures is one familiar even to the non-specialist. Every archaeological museum exhibits terracotta pots and pans in various shapes; every film about archaeological excavations has a scene with assistants hard at work scrubbing sherds. But what is distinctive for Greek ceramics over several centuries is not just its high technological standard, but also a real passion for elaborate decoration. Further, a certain beauty in the shaping of the vessels and the general artistic 'excess' of the potter's workmanship, elevate ceramics above the status of purely utilitarian objects. But through the painting of the objects and, in particular, through the creation of mythical and non-mythical scenes of action, the element of prestige (as the domain beyond the practical necessities of use can be labelled) comes even more strongly to the fore. Regardless of what function the prestige element in Greek pottery fulfils in detail, ranging from the satisfaction of aesthetic

needs to the pictorial representation of values central to society, then on to its use as a demonstration of individual status: painted pottery is not only an artistic, but always an eminently social phenomenon too.

Already in the Minoan-Mycenaean culture of the second millennium BC, with its palaces on Crete and the Greek mainland, vase painting had developed to the level of a major art. The so-called Dark Ages around the turn of the first millennium brought a striking regression, both in terms of social organisation and in terms of practical life skills. The potter's art and the technique of vase painting also fell back to a lower level. But already by the ninth century, this branch of craft had again reached an artistic level, which presupposes a society in which such tasks are entrusted to a specialist and where there is a pronounced demand for vessels as instruments of prestige. In the Homeric period, from about the middle of the eighth century onwards, magnificent specimens of vessels are produced in Athens, showing a level of perfection which was intermittently reached again, but never surpassed, in later periods (Fig. 20).

Down to the end of the history of Greek fine pottery, around 300 BC, the production of painted vessels remained, to a high degree, a craft for specialists which was far from being practised in every region. In the seventh and early sixth centuries, the potteries in Corinth were prominent in terms of the quality and scope of their output; in the sixth and fifth centuries, the potters and painters of Athens gained the leading position, to the point of a temporary monopoly until, from about 440 to the end of the fourth century, Greek producers in Sicily and, above all, in southern Italy (Figs. 12, 41) brought about a new flowering in vase painting. Even though the importance of painted vases as objects of trade has so far eluded exact analysis, there are a number of indications that strong competition existed between workshops in various Greek centres. Among the arguments for this are the fact that vessels were, at times, marketed over great distances; the changes in control over certain points of sale; and the development of individual artistic characteristics which served the production of what might be called 'branded' articles. Attic vases of the later sixth and early fifth centuries could obviously command, in some parts of the ancient world, the kind of appreciation which is shown to some of the 'labels' in modern marketing. Even Celtic chieftains north of the Alps must have had some idea of the worth of Attic vases; some specimens were found as grave gifts with burials.

Amongst the types of monument used in Classical antiquity for the portrayal of myths, painted pottery represents not only the earliest, but also by far the biggest and most varied category. Textbooks about Greek mythological representations are full of photographs and drawings of Attic,

Corinthian and south Italian vases. The representations of figures such as Heracles, or of the major Olympian gods, are numbered in thousands. Yet not only the popular, but also many of the more unusual subjects are found on the vessels, so that vase paintings represent a practically inexhaustible source for anyone studying Greek mythology and its historical background. Vase painting is therefore also a kind of primary field for the methodology of the analysis of Greek mythological imagery.

We can argue about whether vase paintings should be judged to be works of art or, more modestly, craftwork. One thesis that is, if with qualifications, completely misguided, even goes so far as to say that much of the fine pottery, with its paintings, served only as a cheap replacement for precious metals. It is true that – if only because of their material value – gold and silver vessels were naturally held in much higher esteem, at all periods, than mass-produced ceramics. But already the exceptional variety of the mythical subjects and single motifs is a decisive argument against the claim that vase painting commonly merely repeated what had been developed in another artistic genre. For all the tendency to repeat popular motifs, which is real enough, the pictures on Greek vases stand out for their continuous search for new subjects; and for their equally continuous modification of the already existing images of myth. Irrespective of the question of what value the Greeks – and their neighbours – put on the painted vases as 'works of art', it is unquestionably true that the creative powers of the vase painters deliver clear proof of the Greeks' preoccupation with mythology, reaching far into everyday life.

Research into vase painting has not been equally fruitful in all areas. As far as questions of art historical development are concerned, by now hardly any essential question remains open. The attribution of the surviving vessels to the various pottery workshops can be regarded as generally settled, as can the chronology. For Athens, as for all the other notable centres of production, there is consensus over the development of style and, with it, over the dating of individual pieces too. On top of that, art historical analysis has succeeded in setting up a system, hardly ever contested by specialists, to attribute a high proportion of the known vessels to the work of individual artists. Where, as in the vast majority of cases, artists' signatures with their original names (for example, Exekias, Fig. 48, or Euphronios, Figs. 17 and 18) are missing, improvised names or aliases are used. They are derived from the potter's signature, as for example with the 'Kleophrades Painter' (Fig. 25), or from a distinctive subject (the 'Sisyphus Painter'), or from the place where a significant piece was found or is kept (the 'Berlin Painter').

Much less clear-cut is the situation for identifying the function of Greek vases, a point of specific importance when it comes to the interpretation of the images of myth. A certain embarrassment can already be detected in the – internationally accepted – use of the term 'vase'. The Greek vessels have next to nothing to do with flower vases. Yet the term 'vase' is not completely unsuitable since, thanks to its prestigious character already discussed, a painted terracotta vessel is not so far removed from a modern ornamental vase which is appreciated for its beautiful outward shape.

The study of the terminology for the various shapes of vessels brings us closer to the core of the problem. In the course of time, a plethora of different shapes was developed in the pottery workshops, as a reaction to the range of functions the vessels had to fulfil. For example, a water container of standard form, the hydria, had a large volume, a broad mouth and three handles, two horizontal ones for lifting and carrying, and a vertical one for tipping. By contrast, an oil storage vessel, the lekythos, is tall and slim, has a small opening and a relatively small volume. In order to distinguish them from each other clearly, the individual shapes of vessels have, in research practice, been given certain names. Only a few of them, however, such as hydria, are directly authentic, that is to say that the ancient linguistic usage coincides with the modern terminology. In other cases, there is at least an approximate correspondence. In Greek antiquity, lekythos was a collective term for oil containers, but it is used today only for a particular type of vessel. Other modern names, however, used when clues to the ancient names are entirely absent, are inevitably purely fictitious, for example stamnos (Fig. 29).

The uncertainty over the ancient names does not seriously hinder the analysis of vases and the images on them, but it is symptomatic of an important deficiency. It is precisely for the Attic vases of the sixth and fifth century, with their images of myth by the thousand, that reliable knowledge of their forms of use is scarce. In the surviving ancient literature, one looks in vain for statements on the practical uses of fine ceramics; their use was obviously too self-evident to have ever received coherent description. But even the indirect hints, above all from the context in which they were found and from the portrayal of vases as props in contemporary pictures, fall far short of answering all the questions. To understand these difficulties and their consequences for the interpretation of images, we must first give an outline of the undisputed fields of use of Greek pottery. A complete discussion of this theme would also need to pay attention to the fact that Attic vases were exported in great numbers to Etruria. It can by no means be excluded that vase painters, when selecting motifs and manners of

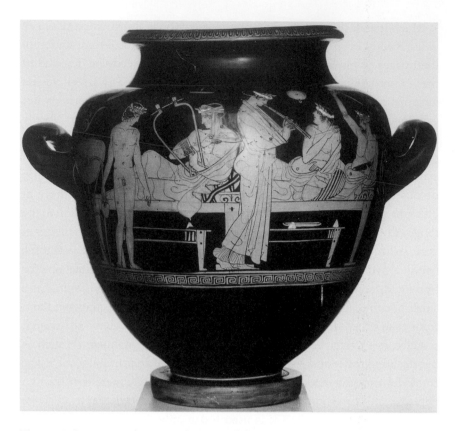

Figure 29 Symposium (*symposion*). Attic red-figure stamnos, *c.* 430 BC

artistic execution, in some cases took into consideration their overseas customers who were knowledgeable about myth.

House, sanctuary and grave – with these three key terms, the areas of use of Greek fine pottery can be outlined in a concise formula. For domestic use, two aspects are prominent. One important impulse for the development of ever newer forms and motifs is the requirement of luxury vessels for the symposium (*symposion*). At a symposium, literally 'drinking together', a group of men came together in the evening in a private house both for enjoyment of the senses and for intellectual exchange. The stamnos from the time around 430 BC captures some of a symposium's characteristic elements (Fig. 29). The men have made themselves comfortable on reclining couches (*klinai*), they listen to the girl playing the aulos, they make music themselves, drink wine which is poured for them by a cupbearer and, as their lively gestures suggest, they find enjoyment in companionship. Erotic pleasures were also part of a symposium; this is intimated by the nakedness of the boy and the physical beauty, accentuated by her closely fitting dress,

of the woman. Thus the use of drinking cups of elegant shape and rich decoration fits into the larger frame of a festive, yet everyday culture. The men hold and use – no easy art! – extremely shallow drinking cups. On a stand to the left is a pot containing water mixed with wine; the boy has just scooped drink from it with his jug, to refill the cups of the symposiasts. The paintings on their cups, not least, could offer them food for thought. Pictures such as the one on the Sarpedon krater (Fig. 17, also a vessel for mixing water and wine) must have posed an intellectual challenge to the participants in the banquet – at least, one would suppose so.

In line with the division of social roles, women too had their province in the house and its surroundings, and their own specific needs for beautiful pots. To this category belong the lekythos already mentioned as a container for oils and perfumes, the pyxis (compare the German *Büchse*, English 'box') for the safe-keeping of jewellery and ointments, as well as types of vases connected with the wedding, the event of supreme importance in a Greek woman's life. As with the shapes, so with the motifs there were gender-specific points of emphasis, such as battle and war for men, while on the vessels produced for the women's domain, scenes are often found which refer to the relationship between the sexes (see pp. 173–9).

In a Greek sanctuary, painted vases belong among the innumerable objects which were dedicated by the devout as a personal gift to a deity, to give thanks or to pray for help; the spectrum of such votives reaches from statues, indeed even whole buildings, down to donations of food. There are pronounced local differences in the shapes of the favourite pots for donation; but it was widespread practice to deposit in a sanctuary prestigious crockery from the symposium, which could previously have had normal use. Among the uses of painted pottery in religious contexts, there also belongs its employment at certain feasts and rituals, for which individual shapes and pictorial motifs were at times developed.

There is also both a permanent and a temporary use for painted ceramics in the field of the grave cult and burial. Just as the private donations in a sanctuary remained indefinitely in place, so in certain regions and epochs decorated vessels were likewise deposited as grave gifts; in early Greece, there was also at times the practice of putting them as markers and adornments on top of the grave. Besides this, fine ceramics could be used in the context of the funeral ceremony, for ritual acts at the grave and as showpieces in the procession or the wake, as a way of demonstrating to the community of mourners and the general public the social position of the deceased. Proof for such practices can be found in scattered written sources and a few scarce pieces of pictorial evidence. On one side of an Attic jug of

Figure 30 Funeral. Attic black-figure jug, *c.* 500 BC

around 500 BC, there is a scene which shows a dead man being laid in the coffin, while on the other side a group of mourners is getting ready for the procession to the grave (Fig. 30). A female figure is carrying a series of lekythoi, at that time very widespread as grave gifts. Two of the youths, on the other hand, have shouldered a large cauldron and a hydria. Vessels of this type and shape, whether made of clay or metal, are hardly ever found in the graves of this period in Athens and its surroundings. The pieces in this funerary scene were therefore most probably used for the festivities at the

grave, to be carried home again afterwards, as is explicitly prescribed in a law about funerary luxury.

Reliable as may be the general statements which we can make about the different fields of function of Greek fine pottery, it is often difficult to determine the context for which an individual pot was produced and for which the images on it were planned. These difficulties can be attributed to two factors above all. The first point is the fact that the various practices in the use of painted pottery are not precisely reflected in the archaeological findings. Vases that in antiquity had already been deposited in a place, whether as a votive in a sanctuary or as an object in a grave, have a relatively slight risk of destruction and dispersal and have therefore survived in large numbers. Finds from settlements, on the other hand, fall far short in quantity, which must have primarily to do with the fact that, although houses of Archaic and Classical date are repeatedly excavated, either their continuity of use or their destruction means that the inventory of these houses has been as good as lost forever. The other, temporary types of use are even more elusive to archaeological documentation. Whilst in sanctuaries certain types of pot, produced solely for ritual purposes, are occasionally found, it is practically impossible to identify vessels which were used in the cult of the dead but were afterwards taken back to the settlement. The number of vases specifically produced for this latter purpose may nevertheless have been quite high, if one takes into account that it was repeatedly found necessary to pass laws which restricted expenditure in connection with funerals and the honouring of the dead. But it is not only the statistical data of finds that come with imponderable factors attached. It is frequently impossible to decide whether a vase, used as a grave gift or votive object, was also produced by the workshop beforehand for this specific purpose and decorated with 'suitable' pictures. For there is a real possibility that the vessel was first employed in the household, to receive a secondary later use because of its particular, non-material value.

The second factor is connected with the difference, already touched on, between functional and artistic form. From the Middle Ages and the early modern period onwards, we know of the practice that the king's goblet resembles the poor man's beaker, or a work of courtly silverware the simple serving-bowl for food. The demands of practical use determine the basic shapes of the vessels; but out of this, in a socially differentiated society, forms of art are developed which additionally, or even exclusively, serve the purposes of prestige. In Greek culture, this phenomenon was developed to an unparalleled degree. In its simple form, this means that containers used for drinking or for the storage of wine, water, oil and other substances were

shaped to a degree which reached far beyond the practical requirements –
and this in more than one respect: production of elegantly shaped vases,
intensification of the quality, decoration with figural painting. Without
exception, this can be said of the vases used as examples in this book.

In the intensified form of this phenomenon, the object is detached to a
large extent from the purpose for which, to judge by its basic shape, it
was created. Many objects which we neutrally class as 'vessels' and which,
in terms of their outer shape, are exactly that, never in reality served as
containers, or only for a single ritual use. Instead, they are objects of
prestige, which were given the shape of a drinking cup or an amphora.
With this, their artistic quality, as it were, takes precedence over their
functional form.

The first great peak of this genre in the eighth century already shows the
phenomenon fully formed. The magnificent vases of the 'Geometric' epoch,
which takes its name from the typical decoration of the time, were used
almost exclusively for burial purposes, as a 'monument' placed on a grave
tumulus or, more frequently still, as a grave gift. This custom continued,
with pronounced local differences, when legendary images began to appear
on the pots. The monumental amphora from Eleusis near Athens (Fig. 20),
which was created around 670 BC, was brought to light in a cemetery and
contained the remains of the skeleton of an approximately ten-year-old
child. The sheer size of the amphora, together with its ornate design and
filled-in handles, exclude the practical use of this pot as a container. As a
result, the clear contextual reference to burial must also determine the angle
from which we interpret the images of the blinding of Polyphemus and the
killing of the Medusa.

At the other end of the long history of Greek vase painting, the situation is
not at all dissimilar. Both the late Attic vases and those originating from the
bigger output of Sicily and southern Italy in the fifth and fourth centuries
were mostly used in the context of burial rites and as grave goods. For the
interpretation of the rich corpus of the South Italian images of myth we
should therefore, in principle, once again keep in mind the funerary frame
of reference. What was interesting about the fate of Theseus who, against all
expectations, kills the Minotaur (Fig. 12), was presumably less the exem-
plary bravery of the hero than his deliverance from what was thought to be
certain death.

While for the two epochs discussed above, this form of use for fine pottery
as a resource for prestige is uncontested, the situation is far more difficult
with Attic vase production of the sixth and fifth centuries – and, with that,
for an enormous number of mythological images. The development of the

symposium into a festive institution, which took place during the Archaic period, set in motion new developments in the design of drinking vessels and their decoration. The dominant practice in research is to take each cup and krater for what their shape proclaims them to be – a fine drinking utensil and a container for the mixing of water and wine, placed in the room in which the symposium takes place – and then to use this context as a starting point for the interpretation of the images: as reflections of the subjects and issues which were normal topics of debate among the symposiasts. But the situation is not quite so clear-cut. In particular, it is not easy to draw boundaries between vessels and their pictorial representations which really were meant to be used at a symposium, and those which were devised for the funerary sphere.

Let us take an example to illustrate this point. Amphorae, so the textbook description goes, are bulk storage containers with two handles for ease of operation. As potential containers for wine, they are usually included in the category of pots used at a symposium. But how are we to imagine the practical use of an amphora such as the one by Exekias (Figs. 5, 6)? We know from pictures of feasts (Fig. 29) that, at best, it was possible to put amphorae into a side room, which however meant that the pictures could not be given any attention – in sharp contrast with the krater, which was the central prop of the symposium. Furthermore, it was customary to line up storage vessels very closely next to each other; but then the delicate surface would have quickly been exposed to damage. To seek out the prestige function of such vessels, we must therefore look to another field. If we take the images on them as a starting point, it appears plausible, in the particular case of the Exekias amphora, that it was meant to be used in funerary ritual (and it was in a grave, after all, that it was found). In that case, the scenes with the anxious leave-taking of a warrior and the recovery of a fallen combatant (Achilles and Ajax?) need no specific explanation. But if this amphora was originally meant to be used at a symposium, the scenes of a warrior's total undoing would form an extraordinary subject, and one needing interpretation.

If the issue of the function of the vessels long remained an area of marginal interest in scholarship, this was not solely to do with the long domination of Greek vase painting studies by the art historical interest. Doubtless the fact that, over many fields in this subject area, it is very difficult to achieve any certainty, has also helped to keep it in the background. That is why there is also a tendency in research to leave out the issue of the functional context altogether when analysing the pictures and to treat the Attic vases, of the sixth and fifth centuries especially, in an all-inclusive manner as part of the 'World

of Greek Images'. If the difference between functional and artistic form is carefully taken into account, and if one reckons with the possibility that a supposed storage vessel (to cite once more the example of the Exekias amphora) was in reality created to furnish a funeral ceremony, the interpretation of the images will gain something, if not in every case, then in a great many.

Architectural and free-standing sculpture

The practice of applying images of myth to buildings reaches almost as far back in time as the history of Greek monumental architecture itself. From the first half of the seventh century onwards, temple buildings begin to be set apart from domestic architecture, both in terms of their dimensions and of their artistic claims. In the decades around 600, the dominant type of building in Greek architecture, the temple, usually stone-built with rows of columns on all four sides, has already developed a form which remained essentially unchanged for centuries. Its features also included an internal arrangement that followed certain rules. The Doric and Ionian 'order' each represent a differentiated system of design which also determines where, in the sequence of individual components of the building, sculptural decoration in the form of figural representations can be placed. The subjects for these come almost exclusively from myth.

With a few exceptions, such decoration in Greek architecture remained restricted to sacred buildings; but in the immediate cultural vicinity of the Greeks, it can also frequently be found on grave monuments. Apart from the temples, the so-called treasuries can also be counted as sacred structures; they were smaller, but often richly furnished buildings, built within sanctuaries for the storage of precious offerings. In the delicate Ionian architecture, decoration in the form of sculpture played a relatively small part; narrative images were mainly put into the friezes in the entablature of the building. Much more elaborately decorated were, in many cases, temples and treasuries of the 'more severe', Doric order, if not in every region and epoch. The two pediments offer space for large groups of figures (Figs. 9, 22–4), the metopes in the entablature were often furnished with a series of images in relief. The limitations and possibilities of artistic design were obvious in both cases. The triangle of the pediment, which on the Temple of Zeus at Olympia and the Parthenon in Athens measures over 3 metres in height and more than 25 metres in length, needs spaciously designed compositions with an internal arrangement which makes it possible for

the viewer, by drawing successively on the images, to grasp the coherence of the different parts. By contrast, the fields of the metopes are particularly suitable for subjects which can be divided into sequences of two- and three-figure images, the deeds of Heracles, a series of pairs of combatants, and similar themes. Buildings of the Doric order occasionally had images of myth put even on to their roofs, in the form of statues above the corners of the pediments.

In contrast with the case of vase painting, the functions of the buildings and their communicative qualities pose no mysteries; nor do such questions arise in the context of the free-standing statuary either. Temples and treasuries stood in sanctuaries; the images that adorned them thus addressed a wide circle and were not directed at a narrowly defined group within the population. The public character of the buildings is also shown by the fact that, as a rule, the responsibility for these buildings was corporate and not individual. The decision as to whether a temple was to be erected and what its furnishings should be, lay with the committee of management of a sanctuary or a state. Only in autocratic regimes did individuals, in their role as rulers, take on the role of client for whom the temple or treasury was built. When the name of Eumenes II (who ruled 197–159 BC) appeared as donor on the Great Altar of Pergamon (Fig. 47), he was, as king, acting as it were on behalf of his state.

The difficult question of the relationship between myth and religion has already been raised (pp. 21–2). In this respect there are important differences from Christian practice. Myths, even if they are about the gods, are not sacred texts and Greek temples are not churches in which a community held a service. The most important ritual act, the communal sacrifice of an animal, took place at the altar in the open air. The fundamental function of the temple was as a place where the cult statue of the respective deity was kept, which led to the assumption that, at least at certain times, the deity was actually present in that place, for example while festivities were being held in their honour. But the dimensions of the Greek temples – the Temple of Zeus at Olympia is 64 metres long, and the biggest examples of this type of building reach more than 100 metres – cannot be explained by the practical requirements, but only by a desire to create a monumental impression. Here, the religious and the political categories merge into an indissoluble unity. According to its official status, the temple is a religious foundation. The community, or a ruler as a representative of his state, prove their respect for the gods through constructing and taking care of a temple, just as the individual visitor to a sanctuary dedicated a statuette or a painted vase as a private gift to a deity, as a token of piety. There was also mutual

competitiveness, at least to the same degree as is true of medieval cathedrals, between those who commissioned the temples, taking matters away from religious concerns. A magnificent new temple often represented a demonstration of economic power and, at the same time, a political investment.

This brings us to an essential point for the interpretation of the images. The mythical subjects which were given visual form in the pediments, on the friezes and the metopes of the temples and treasuries, often but by no means always display a close link with the divine occupant of the building or the sanctuary. On the Parthenon in Athens, the sculptural groups in both pediments make statements about the goddess to whom the temple is dedicated. Both the account of Athena's birth from the head of the father of the gods, Zeus (east pediment), and the legend of the contest between Athena and Poseidon for the status of protector of Athens (Fig. 9), represent a confirmation of her divine powers, presented in mythical form. By contrast, the series of metopes on the same building, showing Greeks fighting Amazons and centaurs, can no longer be directly connected to Athena.

This is also true for the west pediment of the Temple of Zeus in Olympia (Fig. 24), which again recalls a battle against the centaurs. Here, the immediate spatial context delivers no clue as to the interpretation of the content. Instead of a direct reference to Zeus, there is only an indirect one. In the same way as the latter appears as the decisive authority in a contest in the east pediment, Apollo intervenes in the west pediment and acts as the defender of order. What was the symbolism of the quarrel between the Greek tribe of Lapiths and the centaurs, friends with them yet so very alien, remains a matter of contention despite a long debate. One line of thought takes the design of the pedimental composition as an allegory of the Persian Wars which had been brought to a successful end a few years previously, and so could represent the ethical and political superiority of Greek culture, or on the other hand as a symbol of the necessity of settlement in internal Greek conflicts. Since the message in both pediments is about an attempt to obstruct a mythical marriage, ethical principles, as distinct from or in place of political positions, might also be a subject of discussion here. In any event, its meaning has to be looked for outside the strictly religious sphere and the ensemble of figures, placed in a prominent position in a sanctuary of more than just regional importance, served to represent common concepts of values which were of concern to the social community.

In free-standing statuary, mythological subjects are a relatively late phenomenon. In the Archaic epoch, it is the two types of the male and the female standing statue – *kouroi* and *korai* – that hold a prominent position.

Only when, at the turn of the Classical epoch, movement becomes a major theme in sculpture, does an interest develop in using single statues or group compositions to create mythological images. In the fifth and fourth centuries, if surviving sculpture can be seen as representative, such works of sculpture remained relatively rare and very heterogeneous in terms of artistic individuality. To take some examples, from Olympia we know a terracotta figure of Zeus abducting the beautiful youth Ganymede; several Roman copies attest to a lost bronze figure of Diomedes who, after the sack of Troy, is carrying the cult image of Athena (the Palladion) from the burning city; and, as representative of an ambitious sculptural group, Myron's Athena and Marsyas (Figs. 35–8), to be discussed extensively in the next chapter, can be cited. As a mythical figure in a broader sense, the Barberini Faun (Fig. 14) should also be mentioned.

It is unnecessary to explain that compositions of two or more figures are far better placed to give visual form to a narrative action than is a single figure. Despite this, the so-called mythological group reached its full development only in Hellenistic times. The Laocoön group, excavated in the early sixteenth century in Rome (Fig. 34), is only the best-known representative of a whole series of works of conceptually outstanding ambition, created between the third and the first centuries BC. Life-sized, three-dimensional figures have an incomparably greater potential to reproduce, as it were, a mythical action in a dramatically heightened form, so as to generate a strong emotional reaction in the viewer.

But what was the purpose of mythological statues? We can answer this question only in approximate terms, because we have little secure knowledge about those who commissioned the works and their motives. One essential point however emerges clearly: almost all the single Greek statues and groups whose original place of display is known were located in sanctuaries. As a rule, the initiative for the execution and public presentation of the work will have come from individual citizens. During Hellenistic times, as with the endowment of buildings, this will increasingly have meant that kings and other political rulers acted as initiators; but it was probably exceptional, even for them, to have the works they had commissioned displayed in palaces or other places with restricted access. In terms of their relationship with the general public, therefore, mythological statues do not differ fundamentally from the representations of legends which adorned religious buildings. With statues too, praise of the gods and the self-praise of the donor form an indissoluble unity. While the ensembles of figures in architectural sculpture tend to express collective values, in line with the function of temples and treasuries, in free-standing sculpture, in

many cases conceptually more original and in addition mainly paid for by individual donors, a more personal element often surfaces. The Barberini Faun can be seen as a characteristic example. By the indirect route of portraying, with striking realism, a disturbingly sensuous satyr, the statue celebrates the power of the God Dionysus (see pp. 46–50). But the attention which the Faun doubtless drew to himself through the novelty and audacity of his composition, at the same time promoted the image of donor and artist, whose names were presumably communicated to the observer by an inscription.

From Greece to Rome

There are several good reasons to extend research on 'Greek mythological images' beyond Greek works of art to those of Roman date. The first of these arises from the fact that drawing a clear boundary between the two fields would not correspond with the historical realities. Many cultural practices, developed in the Greek world, continued seamlessly when the Greek and the Hellenised regions were politically integrated into the Imperium Romanum in the second and first centuries BC. In terms of its date of origin, the Vatican Laocoön is Roman or, better, belongs to Roman times but in terms of the artistic tradition in which it is rooted, it is undoubtedly Greek.

This sculptural group (Fig. 34) is therefore prominent testimony of the lively reception, both of the subject-matter of Greek myth and of Greek mythological images, in Roman times. In the Roman Imperial age, the members of the educated classes were also familiar with the works of the great authors of Greek literature who dealt in myths, from Homer to the tragedians and the late epic poets of Hellenistic date. And we should know little of the mythological statues and groups of Greek times, had the Romans not made copies of many of them; for the originals, insofar as they were made of bronze, were almost all melted down after the end of antiquity. To some degree, the contemporary interpreter of Greek mythological images has in any case to look at them through Roman eyes. The great interest the Romans showed in Greek myth is additionally made clear by the fact that genuinely Roman myths play a rather minor part in art; this is evidently not just because there are far fewer of them, but also because they were seen to be much less suited to allegorical narrative.

The practice of archaeological research, already discussed, puts together images of Greek myths from Greek and from Roman times – and this not solely for reasons to do with the technicalities of transmission. As in other

fields of Classical archaeology, patterns of explanation and methods of analysis used for works of Roman date can also be gainfully applied to Greek works, and vice versa. The large group of Roman mythological sarcophagi offers a prime example of how the interpretation of the images, long and intensively studied, can have fruitful effects on the study of Greek works (see pp. 161–9).

To concentrate the focus of this account, several smaller categories have been set aside in the discussion of mythological images from Greek times. Depictions of myths can occasionally be found on coins and gemstones and, in Archaic times, rather more often on pieces of equipment, that is to say on objects which, at least by their basic form, belong to the sphere of everyday use. These include for example shields, to which were attached metal bands with images on them and which were dedicated as votive offerings in sanctuaries, along with the large tripods also occasionally decorated with reliefs. The production of mythological images in Roman art, even more so than in Greece, is concentrated into a few areas. These can be designated by the key words house and grave. In dwelling houses, mythical themes represented popular subjects for the paintings on the walls (Fig. 31) and the mosaics on the floors. In the funerary use of depictions of myth, relief sarcophagi far exceed, in numbers as well as in originality, all other sub-categories of sepulchral art, such as urns for the ashes or wall paintings.

In the types of object used for their imagery, therefore, and in their respective fields of application, Greek and Roman images of myth have a more or less complementary relationship with each other. In the predominantly private sphere of house and grave, portable objects such as painted vases are preferred in the Greek world until the end of the Classical epoch. In the Roman world, by contrast, immovable furnishings such as wall paintings and mosaics, or at least permanent ones such as sarcophagi, predominate. For Greek sculpture displayed in public places, there are counterparts from Roman times only in a modified form. To a certain extent, admittedly, mythological statues formed part of the furnishings of the villas of the rich and also of temples, baths and other publicly accessible places. Yet the creation of new images, as a means of giving visual shape to collective values, clearly has a much less important part to play than in the Greek world. The mythological statues displayed in public places are, as a rule, either copies of Greek works or even – in the city of Rome especially – originals transported there from Greece. A comparison of the pedimental compositions on temples also gives a symptomatic result. Instead of complex scenes of action which communicate their content indirectly, simple arrays of divine figures or personifications are often found on Roman

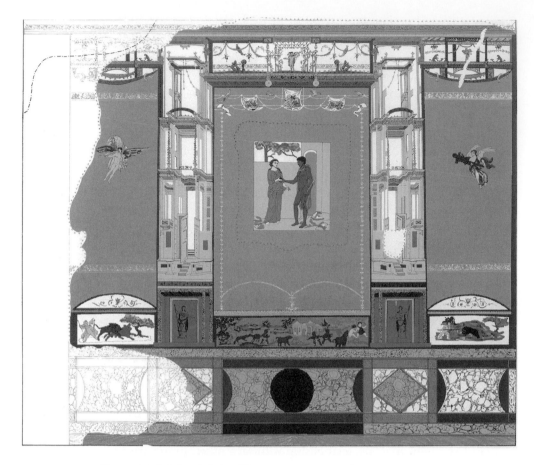

Figure 31 Ariadne helping Theseus to overcome the Minotaur. Pompeii, Casa della Caccia Antica (drawing), *c.* AD 70

religious buildings, pinning the viewer quite narrowly down to a particular understanding of the image.

Myths in the Roman house: painting and mosaics

With the representation of myth in painting, we find a situation that is paradoxical. While the outstanding works of Greek art described by ancient authors have, without exception, been lost, the Roman works which survive in relatively large numbers seem for the most to be repertoire pieces executed by well-trained muralists. The fact that, along with famous statues, Greek panel paintings were also shipped in large numbers from Greece to Rome, to be displayed in public and private galleries, does tell us something

about the exceptional quality of the paintings of Classical and Hellenistic times. Yet without the eruption of Vesuvius in AD 79, which preserved the towns of Pompeii, Herculaneum and many single villas in this region, Roman wall painting would be more or less *terra incognita* for us. We have relatively few finds which tell us anything substantial from other places, the capital city of Rome included, and for the period after the catastrophic eruption the tradition is generally scanty.

As soon as technology had advanced far enough, in early Classical times, to make possible work on a large scale, mythological pictures formed one of the most important genres in painting. Some sacred or communal buildings won fame solely through the paintings with which they were decorated; in private dwelling houses, by contrast, wall or panel paintings apparently played no significant role as decoration in the Greek world before Hellenistic times. To cite a concrete example from the fifth century: the sacred precinct for the 'national' hero Theseus, situated in the centre of Athens, contained three paintings. According to the account of Pausanias (1, 17, 2–6), the pictures show important events in the life of Theseus, his aid to the Lapiths in their battle against the centaurs (compare Fig. 24), his participation in the battle against the Amazons, and the story of how Theseus, on his way to Crete, dived into the depths of the sea to retrieve a ring from the bottom and so prove his divine lineage. Not least because of their ability to produce work of deceptive realism, the great painters of this epoch seem to have attained something of a cult status of international standing.

The attempts at a partial recreation of these mythological paintings, by identifying reflections of them in Greek vase painting and copies in Pompeian wall painting, have not produced results that command a consensus. At best, we can guess that certain individual paintings in Roman houses are based on famous models from Classical or Hellenistic times. The correspondences between the presumed copy and the lost original known only from literary descriptions are hardly ever so close that such a connection could be seen as proven. But we are on a safer footing in stating that the display of panel paintings, originally in a museum context, had some effect on the composition of Roman wall paintings. In some of the houses in the towns around Mount Vesuvius, there are even painted reproductions of picture galleries, complete with little shutters for covering the precious panels. Much more widespread, however, is a more integrated treatment of mythological images. In Roman private houses of the first century BC, it became standard practice to paint the walls, from floor to ceiling, with sophisticatedly planned compositions – the contrast with the plain wall layout that prevails in the western world of today could hardly be greater.

Where there were images of myth, they were normally placed in the central area of the wall. With appropriate contrasts in colour and tone from the framing background, the impression could once more arise that the images were independent paintings. In the last few years before the destruction of Pompeii, the paintings in the Casa della Caccia Antica (Fig. 31), a typical private house in the Campanian provincial town, were executed. In the *tablinum*, a kind of salon and in any case the most elegant room, one of the two wall surfaces is covered by a system of decoration characteristic of the time. With architectural vistas and an imitation stone panelling at the base, illusionist effects are achieved. Into this is fitted, as though hung on the wall, a mythological picture showing Theseus and Ariadne at the moment when the thread is handed over – we have already become acquainted with a Greek pictorial version of the legend (Fig. 12).

So far, scholarship has not been much concerned with the question of the meaning of the mythical scenes in Roman wall decoration. In the choice of subjects displayed in a room and the way they are designed, only in exceptional cases is there any sign of an ambitious conception of the content. Frequently the arrangement of the pictures seems rather to conform to external aspects: correlations in composition, for example, such as a theatrical posing of the figures; or repetitions of certain basic motifs, such as tragic forms of love. In our example, there is a certain biographical, but no narrative correlation with the painting on the opposite wall of the *tablinum*; this shows an episode in the life of Ariadne's mother Pasiphaë. The particular popularity of the worlds of Aphrodite and Dionysus also reminds us to exercise restraint in interpreting the content of the mythological images in Roman houses. Stories of happy or unhappy love, along with pairs of divine and heroic lovers, take first place in terms of popularity. Helped by the sometimes complete integration of the viewer, through the elaborate decorative settings of the walls, the mythological pictures play their part in creating a kind of idealised visual world, as a counterpart to the real world of experience. The exceptions confirm the rule. The so-called *Odyssey* landscapes, executed in a villa in Rome in the last decades before the Christian era and today in the possession of the Vatican, unfold before us, in large-scale pictures which dominate the room, a cycle of the deeds of Odysseus. The panel shown here (Fig. 32) refers to the situation when the companions of Odysseus reach the land of the gigantic Laestrygonians as described in Book 10 of the *Odyssey*. The illusionist technique of painting brings the viewer even closer. But to a great extent, the intention of the clients seems not to have gone beyond this same aim, to present the subject of a famous Greek myth in as 'authentic' a way as possible. So far, research has not

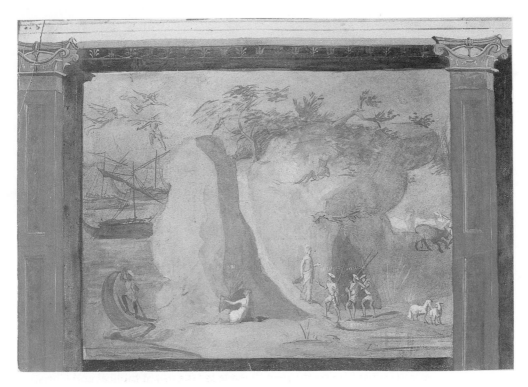

Figure 32 Companions of Odysseus in the land of Laestrygonians. Rome, wall painting in a villa on the Esquiline (watercolour), *c.* 30 BC

succeeded in interpreting the cycle as evidence of an intensive intellectual engagement with the story of Odysseus.

Other considerations that lead in a similar direction are that the choice of myth, as the subject for prestigious wall painting and mosaic, was linked not least with the demonstration of social status. Pictures of a Medea killing her children, or scenes of the Fall of Troy, require knowledge of myths, and thus a certain degree of education. But this was at the disposal only of those who had the money and leisure to occupy themselves with Greek literature and art. So, to furnish one's home in a way that was not only lavish but also learned became a sign of belonging to a certain class in society.

Myths at the grave: Roman sarcophagi

Sarcophagi decorated with reliefs constitute the most important group of monuments in the field of Roman sepulchral art. Mythological themes can

also be found elsewhere: paintings and stucco reliefs on the walls of sepulchral buildings, as well as marble urns for the ashes and sepulchral altars with figural decoration. But, in terms of wealth of motifs and the sophistication of execution, the sarcophagi take precedence over all other forms of Roman sepulchral art. The key word 'sophistication' also justifies narrowing down our treatment to the sarcophagi from Rome itself. It is true that sarcophagi with mythological imagery were also produced in two other centres of production, primarily in Athens and, to a lesser extent, in the historically insignificant city of Dokimeion (near the Turkish town of Afyon, in ancient Phrygia). But the examples classed as 'metropolitan' prove to be especially interesting; the fundamental statements that can be made about their functions are also, in essence, valid for the sarcophagi from the other centres.

In Roman Republican and early Imperial times sarcophagi, whether plain or relief-decorated, are used only in isolated cases; later, their popularity increases from the beginning of the second century AD onwards, soon becoming the dominant form of costly burial. This remains the custom until late antiquity and early Christendom. After the new religion had established itself in the early fourth century AD, this familiar type of monument is taken over by the new clientele for the use of Biblical and Christian motifs. It is difficult to determine how exclusive was the use of sarcophagi during Imperial times, as it is not known what proportion of the entire production the surviving examples represent. But because of the high expenditure in material and execution, such luxury cannot have been accessible to more than just a small part of the population. So far, the reasons for the quite sudden and lasting popularity of this type of monument have remained equally puzzling. There is obviously a connection with the change in burial rite which takes place in the middle Imperial period, from cremation to inhumation. But at best this gives us only half the answer: for on the one hand, the change in burial practice itself cannot be explained succinctly and, on the other, the change to inhumation gives rise to a need for coffins, but not for relief-decorated sarcophagi.

The term 'mythological sarcophagi' is commonly used with a restriction that also applies to other groups of monument. The term is used only for examples which have as their central theme the portrayal of specific, unique episodes from Greek mythology. Representations of a mythical character, but including no mythical action, are not counted here, even if they contain allusions to a specific story: for example, the figure of Ariadne set in the midst of a colourful bustle of Dionysiac figures, after her abandonment by Theseus and now her rediscovery by the god himself (Fig. 44).

The representations on the sarcophagi have a lot in common with the mythical scenes in houses despite the differences in media and functional context. In both cases, we are dealing with monuments which belong to the sphere of what is called private representation. Seen in the widest context, they are a mirror reflecting conditions in society and the world of imagination of individuals. As personal wealth may be reflected by the lavishness of the furnishings in a house, so in sepulchral space the same is true of the splendour of the sarcophagi and in the decoration of their walls and ceilings We have little secure knowledge of the way in which the sarcophagi were set up. But the few cases where the original arrangements are documented at least tell us that the sarcophagi normally stood quite close to each other and were badly lit; this explains the plain backs and the often rather neglected short sides. But this was not a reason for hiding away the sarcophagi with their elaborate reliefs. At the burial ceremony, first of all, the light of a torch will have allowed examination of the images; and, assuming the grave monument was finished a while after the death, there would presumably have been ample opportunity to look closely at the scenes before the sarcophagus was placed into the sepulchral chamber. We must remember the practice in Archaic and Classical Greece to parade vases with mythological scenes as show-pieces before the community of mourners, before they were placed in the tomb as grave gifts.

A further parallel to the mythological scenes in houses is found in the fact that the sarcophagi placed together in a sepulchral chamber likewise did not normally amount to a 'programme' in the stricter sense of the word. To judge from the few secure find contexts that we have, diversity of themes seems to have been actually preferred to any close connection in narrative or content. In the years around AD 140, three very different sarcophagi were placed in a sepulchral building on one of the routes leading out of ancient Rome (the so-called Medusa grave), one decorated with garlands and two mythological ones (Fig. 33): one of these portrays Orestes taking revenge on his father's murderers (see pp. 32–3), the other the punishment of Niobe for her arrogance towards the gods. A unifying bond might be detected in the punishment, in both cases capital; but in character, the two mythical episodes are very different indeed. This divergence can be seen as a sign that, in the funerary context too, the need for social distinction was at any rate one of the reasons to make visual use of mythical narratives.

The elements in common between the mythological images in the house and those in the grave are explained by their complementary function within the general concept of private prestige: the houses of the living, like those of the dead and of the bereaved, serve the purpose of demonstrating social status, but

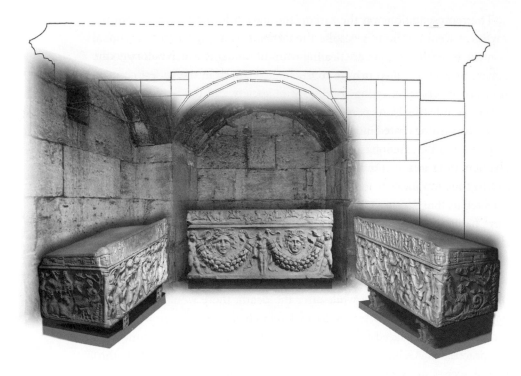

Figure 33 Rome, so-called Tomba della Medusa, photo montage of the sarcophagi, *c*. AD 140

also to raise discussion about general questions of human existence. It is hardly surprising that this latter element is incomparably more prominent in the grave. In fact, the reliefs on sarcophagi show a decidedly freer and more creative handling of the established mythical subjects. As sepulchral memorials, they have certain tasks to fulfil: to give comfort when a person was snatched away early in life; to make, indirectly, a positive statement about the deceased by the choice of appropriate legendary material; or, as well, to show ideas about the afterlife in visual form, whether as Elysium or as a vision of horror. This will be dealt with more thoroughly in the closing chapter.

On the sarcophagus with the narrative of Medea in Corinth (Fig. 13), the two most important artistic tricks by which the Greek myths were adapted to particular specifications were put to use. The two episodes which have a particular symbolic value occupy decidedly more space than the remaining ones. The wedding and death of Creusa are depicted spaciously, for they stand as a mythical analogy for two high points in the life of the deceased person, presumably a woman, who was buried in the sarcophagus. By contrast, the two episodes with Medea before and after the murder of her

children appear compressed almost to the level of the bare essentials; and it is presumably for more than purely technical reasons in terms of narrative that, in the closing scene, Medea's 'assumption' in the snake-drawn cart attracts more attention than the corpses of the two little ones whom she also takes along with her. To prevent the mythical events from being perceived as actions in a faraway magic world, the designer – this is the second artistic trick – has incorporated in his image a whole series of props from the world of Roman life. Contemporary furniture, clothes, weapons are only the most elementary means by which the mythical sphere and that of everyday life are linked together for the contemporary viewer and the events in the legend thus made relevant for the present. On sarcophagi of later date, this merely implicit fusion of the two worlds was at times replaced by bracketing them unambiguously together, and individual protagonists in the myth were given portrait heads typical of the time (Fig. 43). The narrative fiction is more or less suspended, as if an actor in a film told us his name in the middle of it; but the message is at the same time emphatically expressed, that the fate of unfortunate Creusa is everyone's concern.

But it is not only these forms of artistic adaptation that give proof of an intensive engagement with the material of Greek myths. The choice of mythological subjects, too, gives interesting insights into the thought-processes. Many of the narratives portrayed on the sarcophagi are – hardly surprisingly – concerned with tragic accidents or miraculous rescue from death. Some of this was abandoned again soon enough, evidently because the allegorical meaning was felt to be too deeply encoded. Sarcophagi with the crude story of Medea's revenge on her husband Jason's new wife are few in number and occur only in the years between about 130 and 200. About ten times as frequent, with over a hundred examples, are reliefs with the story of Endymion. The eternal sleep into which the moon Goddess Selene puts the handsome shepherd Endymion, is an extremely tangible and easily comprehended symbol for the desire to avoid not just the troubles of old age, but death itself. The basic motif of someone in the intermediary state of death-like sleep lives on, at the end of pagan antiquity, on Christian sarcophagi with the image of Jonah in the gourd.

5 | Methods

Theory of interpretation

The basic characteristics and limitations
of the hermeneutic approach

Whereas the natural sciences occupy themselves with investigating unchangeable natural 'laws', the arts concern themselves with cultural phenomena and consequently with subject-matter whose analysis involves the determination of truth and untruth only to a much lesser degree. Whether a philologist is examining a text, an archaeologist a picture, or an ethnologist the social structures of a village community, the basic relation will always be shaped by the distance that exists between the researcher and the object of the research. This distance is the result of a temporal or cultural difference or, in most cases, of both. Admittedly, an economic historian investigating the economic conditions in fifteenth-century Florence will have many individual aspects to deal with which, in related form, exist in the present day as well. Yet exactly how these aspects were perceived by Early Modern society will never be fully accessible to the historian rooted in his or her own culture. An ethnologist, analysing the living conditions of an African community largely untouched by western lifestyles, will not have to overcome a distance in time, yet will experience the way of life of the people under study as something which can be described, but hardly entirely comprehended as a system.

To recognise this distance from the object of research and the consequent strangeness of the latter, is a fundamental precondition for the thoughtful handling of a subject for research. Now it is the objective of hermeneutics to overcome this distance as far as it can. The term itself gives expression to the fact that this is never possible beyond the level of approximation. It is derived from the Greek *hermeneuo*, meaning in essence simply 'to interpret, explain' – not 'to prove'. Despite this, hermeneutics is no mere discursive discipline, something differing in all essential points from the 'exact' sciences. Its propositions, like theirs, are based on evidence, and it presents its findings in a testable form. At the end of the hermeneutic process stands, not an interpretation in the accepted sense of a more or less subjective

opinion, but a result representing a claim, even if only in relative terms, to truth.

The maximal objective of a hermeneutic examination is that of opening up the cultural horizons of the subjects or phenomena to be analysed and of perceiving them, as it were, through the senses of those in whose world they originated. A process that has this aim will always begin with the definition of the context. In the introductory chapter of this book, we have already talked of the context of a mythological image, with extensive discussion of an example. 'Context' is a Latin term and, in its basic sense, means no more than 'connection'. The noun *contextus* comes from the verb *contexo*, to connect, to tie together, or quite literally to weave together. In specialist usage, the context constitutes the entirety of the factors which – in our specific case – have had an effect on the production and perception of a mythological image, ranging from the workmanship of the artist to the visual experiences of the viewer and the cultural conditions of his upbringing. The modern word 'textile' derives from the same basic root: context can be understood as the cultural fabric into which the visual image is woven.

To stay for a moment with the intellectual image of context as 'fabric': the material at our disposal will always have too many gaps for us to be able to reconstruct a truly complete picture of its historical setting; and at the same time, it will be too comprehensive for us to be able to take account of *every* aspect in a hermeneutic study. Wherever we engage with historical epochs, the evidence needed for the interpretation of the period in question has always survived only in part. For example, to cite a central point for the specific case of Greek mythological images, the only versions of the relevant subject in literary form that we know are often very much older or substantially later; or else we lack them altogether, as in the case of the depiction of Achilles and Patroclus (Fig. 1). And self-reference on the part of the artist, which in later art history can represent an important building block of hermeneutic examination, is entirely absent.

It is not just the gaps in historical tradition, however, that cause difficulties for the practice of research but, at the opposite extreme, the mass of data at our disposal has the same effect. The context is not just many sided; it is, strictly speaking, infinite. To make good the claim to reconstitute the perspective of a contemporary viewer of an image, one would simply have to look into *all* the factors which were of importance for the perception and world-view of the ancients. But research, unlike context, cannot be infinite. The time constraint of the researcher is as limited as is the size of the text that a reader can reasonably be expected to tackle. In the case of the cup by Sosias, the following aspects of its context were discussed: the function of

the vessel, the biography of the two mythical figures, images that are related in terms of motif, as well as the ethos of the contemporary warrior. But, so as to maintain the illustrative character of this text, all this was done only in the form of brief approaches. It would not be at all out of place to write a whole book to outline the meaning of the image, and to do so without digressing into far-off fields.

But, aside from the question of how the opening up of the context is handled in practical terms, the collection of data and acquisition of knowledge on their own cannot make possible an understanding of the object of study. An element of quality must be added to that of quantity. The context of a picture, as is true of every artefact, constitutes a vital element of its epoch. For the contemporaries of the Sosias Painter who drew the picture of Achilles and Patroclus, all those aspects which, in a sober scientific approach, we bring together to form the framework of a historical reconstruction, were taken for granted as components of the world around them. Already as children they had heard at home of the heroes of the Trojan War; as adults, they were able to participate in recitations of Homer; while the warrior ethos, to which the vase painting refers, had been transmitted to them in many forms from their early youth onwards and later became part of their self-perception as free citizens in a community. Much of what was important for an Athenian living around 500 BC can be identified, even from the very distant perspective that we have on this culture. Texts and images tell us what people's concerns were and what made up their identity. But how these aspects had their specific effect, what was the influence of this vital system on the life experience of men and women, masters and slaves – these are things that cannot be reconstructed and appreciated in detail, however refined the methodology. For not only did we not grow up in that world; we have, besides, vital interests of our own, a particular relationship of our own with essential aspects of life, such as love, enmity, work, parenthood, sensuality. Especially with a subject such as Greek mythology, which was used as a canvas for engaging with these same categories, it is inevitable that the interpreter's own convictions will to some extent interfere with the analysis. Thus an epoch which sees war as predominantly a legitimate political means will develop a different view of the warlike episodes in the world of Greek legend, from that of a time which is much more ready to refuse legitimacy to military action.

But this does not mean that interpretations must therefore be arbitrary: quite the contrary. As long as there is a clear consciousness of how strongly earlier and current approaches to interpretation are a reflection of their time, each generation can, on the basis of their own convictions, develop

new and additional perspectives in the study of long-standing academic subjects, without having wholly to abandon the results of older research. But there will always be something paradoxical about the method of using one's own vital interests and experience as a kind of bridge into a different, alien world: the impulses that we receive from our own contemporary world are an indispensable instrument of knowledge but, at the same time, their inevitably subjective character means that they also need to be continuously and strictly controlled.

To 'contextualise' a mythological image in the way described, that is to bring together all potentially relevant aspects in the analysis, seems something that should go without saying. In archaeological research on myth, however, this approach is only now beginning to take a full hold. This is evident if we look at one form of scholarly study still widespread today, the monograph concentrating on the exhaustive analysis of the images of a single figure or episode from legend. Such a study, for example on the entire visual material for the fall of Troy, certainly has a neatly defined subject and seems thereby to acquire sufficient legitimation. But historically speaking, it will not be an adequate study of the topic unless it takes into account the wider context – for example, battle-scenes with protagonists from other myths, or real-life images of Greeks and Orientals.

Pioneers of contextual research

Classical archaeology did not itself develop the principle of such a holistic form of investigation, but took it over – relatively recently – from neighbouring disciplines. Amongst the early pioneers must be counted the art historian and cultural anthropologist Aby Warburg (1866–1929), whose works however began to have a broader influence only after 1945. The method of contextual research was first systematically shaped in ethnology. In the twenties of the last century, Bronislaw Malinowski (1884–1942) formulated the principle of 'participant observation' for the examination of indigenous societies, which in essence coincides with what is called contextual research in other cultural disciplines. It demanded from the ethnologist that he should not just take into account individual aspects, already identified by him as important but, in the course of a longer stay, should also register, from the closest range possible, *all* expressions of life, so as to proceed to an analysis on a comprehensive empirical basis. Historians, whichever period they study, can no longer participate and observe. They must employ the aid of *re*-constructing the cultural conditions. But Malinowski's ideal is also relevant for archaeologists (with the change of

one word): 'to understand the point of view of the native and his connection with life, and to imagine his view of his world'.

The methodological suggestions presented in 'discourse analysis', connected above all with the name of the French philosopher Michel Foucault (1926–84), have a stronger presence today. In a comprehensive way, 'discourse' refers to all statements or, in general, all the objectively relevant conditions of an area of life. To examine a particular discourse demands a consideration, as complete as possible, of all the aspects that constitute it. For the Classical epoch of Greek culture, we can for example speak of a religious discourse, which consists of concrete cultic rituals as well as of discussion, both everyday and philosophical, about the gods; but also of pictorial representations of these gods which define their outward appearance in a contemporary way. We can speak of a musical discourse which, as we shall see, plays a part in the example that follows presently. It in turn consists of actual musical performances, of talk about them, of the practice of music teaching for the young, of pictures of musicians, and so on. From the vantage-point of discourse analysis, the single image of myth that is to be interpreted is, as it were, located at the crossroads of all discourses of which it is itself a part.

The methodological reflections on the difference between iconography and iconology by the art historian Erwin Panofsky (1892–1968) bring us closer to the practice of archaeological research into myth. Iconography literally means describing a picture (Greek *eikon*, image and *grapho*, to write); more broadly, it is the verbal recording of all elements which contribute something to the definition of the picture's content. Applied to the tondo with Achilles and Patroclus (Fig. 1) presented in the introductory chapter, this means that the basic motif is composed of the two warriors, with one tending to the wounds of the other; in addition, there are a large number of details which all serve to characterise the situation more closely; finally, there are the inscriptions identifying the two warriors. Thus the gestures of the figures and the conclusions which, without premature evaluation, can be drawn from them are part of the iconographic examination of an image. In this way, we can infer from Patroclus' abrupt turn of his head, his open mouth and the process of having a bandage put on his wounds, that the wounded man is at that moment shouting out in pain, or at least fighting against the pain. Things are not always as clear as with this example. If a representation has not survived intact, but also if the identity of figures or the meaning of objects or gestures remain unclear, then even the iconographic description can already be fraught with considerable difficulties.

In his introduction to the terms 'Iconography and Iconology', Panofsky makes a distinction between a pre-iconographic and an iconographic step in the analysis. The pre-iconographic step is restricted to the elements of representation as such, that is to say anything that can be said without consideration or knowledge of proper names. In the iconographic examination proper, the identity of the figures in the picture is taken into consideration. Two anonymous warriors turn into the two friends, Achilles and Patroclus, and the situation becomes one within a certain mythical episode, the Trojan War. Panofsky developed these fundamental terms in the context of his study of Christian art. Only with considerable qualifications can this distinction be transferred to the study of images of Greek myth. In Christian art the figures, whether shown singly or as part of an action, usually possess a clearly defined identity: this is true for the figures of the Old and New Testaments, as well as of the Saints. The motif 'woman with wheel' and St Catherine can, as descriptive categories, be clearly distinguished. This applies much less to the pagan world, where the areas of myth and real life are blurred in the visual media (see pp. 50–9). We cannot reach a reliable decision as to whether Fig. 6 represents Achilles and Ajax or two anonymous warriors, and presumably this was not clearly determined for the ancient viewer either.

Panofsky's concept of iconology, too, can be applied only in a very limited way to the study of ancient images of myth. 'Iconology' means literally 'picture text' or, more fully, 'speech, or systematic treatise, expressed by pictures'. This concept can be applied quite easily to Christian art, insofar as its representations refer to beliefs whose content is to a large extent fixed and which, additionally, are founded on a text, the Bible, which is unchangeable even in terms of wording. In a representation of the Sacrifice of Isaac, the freedom of the artist stops short of any departure from the account in the Old Testament. If he were to transgress that boundary, it would amount to a violation of religious principles.

While Christian art in large part serves to extend the preoccupation with religious doctrines into a different medium, the ancient images of myth are much less tied to such *logoi*. Since the Greek narratives of myth are not religious texts and the pictures are not their illustrations and since in general the element of dogma is largely missing from the sphere of Greek mythology, the ancient artists have incomparably more freedom in dealing with their subject-matter, be that in relation to motifs or the messages that they want to convey. Instead of seeking to put into visual form clearly defined positions, many pictures of myth look to unsettled questions and conflicts and, in this way, invite the viewers to deal associatively with what they see.

The intellectual potential of this will be better served by a hermeneutic approach, which does not exclude any aspect, than by iconology which inevitably brings up the association with a 'theory of images', as if it were possible to 'read' every visual representation like a text, as long as certain rules are sensibly obeyed.

The hermeneutic spiral

After this excursion into the methods of some pioneers of the theoretical engagement with the hermeneutic method and its practical application, let us return to a description of the method itself. As explained above, it is the context that forms the basis, in data and in knowledge, for every investigation, while one's own vital capacities are the bridge to the understanding of the objects or phenomena to be investigated. The two factors together allow something qualitatively new to develop, a kind of inner familiarity with the context of an image. The interpreter, taking as a starting point a perhaps still barely articulated empathy with the historical circumstances, finally develops theses, which amount to no more than taking a decision as to which of the various contextual fields may be most relevant for the meaning. In the case of the scene on the interior of the Sosias cup (Fig. 1) it is possible, if we look only at the picture, to think that the scene represents an allegory of unbounded readiness for sacrifice in war, or for its opposite, a denunciation of the horrors of war. In the course of a careful involvement with the context, it is then to be expected that one or the other of the initial thoughts, or perhaps a possibility not thought of at the beginning, will condense into a theory.

This process has been given different names. Panofsky for example uses the term 'synthetic intuition', which he himself found a little awkward. He uses 'synthetic' because the formation of a thesis and the longer path to a result are dependent on an overview of a multitude of contextual aspects; 'intuition', because this element in the interpretative process basically lies outside the field of learnable technique, and in addition contains a subjective element. Either an idea develops, on the basis of an adequate talent for combination and the individual's growing familiarity with the particular subject, or the approach to it remains closed, despite all the erudition. This formulation of a thesis, led by intuition, is entirely comparable with the inspiration of the poet or the artist (Latin, *divinatio*). Without a certain measure of divinatory ability – and the self-confidence that enables one to stay nonetheless within the scholarly framework – it is impossible to

develop, from an almost endless quantity of particles of knowledge, any idea of how they hang together.

The methodological process which can make possible a balance between the formulation of a thesis led by intuition, and the check imposed on it by a learned grasp of the context, is the so called hermeneutic spiral. It is not so well known as its negative counterpart, the hermeneutic circle, colloquially called the circular argument (Latin, *circulus vitiosus*). This term relates to a procedure (known in many areas other than scholarship) whereby, after enunciating a thesis, the interpreter takes into account, from a varied range of contextual aspects, only those which serve to confirm the already assumed and desired outcome. To take a simple example, if the picture with the dead soldier and his companion (Fig. 6) is to be used globally as a symbol of the beauty of dying for your fatherland, then the argument will run as follows: the figure of the dead man who, strictly in terms of the picture, is anonymous, would have to be Achilles, the quintessential positive figure with whom a warrior could identify, while the rich clothes and equipment of both men alike show that this picture was not about misery and destruction, but only about glory gained in war. The starting point for the circle is represented by the formulation of the initial thesis, and it is closed again after the deployment of exclusively supportive arguments. The picture on the opposite side (Fig. 5), which as a companion piece heightens the aspect of the loss of a human life, as well as the fact that images of warriors taking leave of their families are widespread in this epoch, are by contrast omitted, since they call the whole thesis into question.

The hermeneutic spiral requires a greater expenditure of method and argument. The metaphor of the geometric figure of a spiral hints at the central point. With this procedure too, we return again and again to the starting point, that of the initial idea or thesis; not however in the expectation of confirming it outright, but of modifying it on a higher level after the discussion of the individual parts of its context; or, if necessary, of abandoning a good part of it. Just as a spiral has several turns, so the procedure of scrutinising a thesis and stating it more precisely requires, as a rule, several circuits. Each aspect of the context which is to be integrated into the assumed outcome represents, as it were, one turn in the spiral; and the more numerous the turns, the more secure and refined the *final* result.

The point of the comparison of the process of interpretation with a spiral and with the gradual ascent from one level to the next, is to describe in abstract form the intellectual structure of the procedure. In its practical execution interpretation, like any primarily text-based argumentation, comes in the outward form of a strictly linear construct. Sentence follows

sentence, paragraph follows paragraph, and so on; intermediate résumés, showing the level that has been reached, step by step, in refining the initial question, may – to stay within the image – mark the end of a circuit.

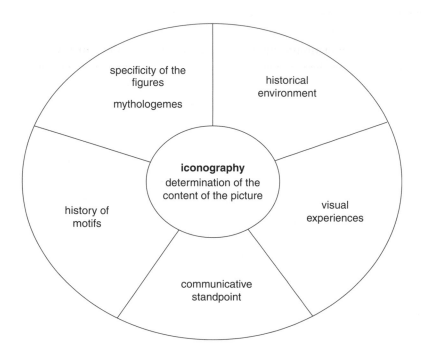

If the contextual scheme were to be illustrated with a schematic plan, the 'texture' of the individual aspects would be best represented by a diagram such as this. We take once more as an example the picture on the interior of the Sosias cup. Everything which belongs to iconography – that is, the basic situation that one warrior bandages the wound of the other, the identity of each of them as secured by inscriptions, as well as various significant individual motifs such as the arrow in the foreground or the device on the shield – is located in the centre. The circle of fields grouped around the centre corresponds to the contextual elements that are significant for the interpretation of the picture presented here. Other authors would add different or further fields and group them differently, along the lines of their own understanding of the scene. But even this diagram, with its clear dividing lines, has strong idealising characteristics: the separation of the central and the outer fields, especially, should be imagined as a very permeable line. For study of one part of the context invariably sharpens anew one's eye for the meaning, whether of a specific detail or of the picture

as a whole. To cite only the most striking point in our example: only by taking into account the picture on the outside of the cup, which shows Heracles on his way to becoming immortal, do we understand why the vase painter has made the rare motif of a wounding into the independent subject of a picture – and also that these heroes strive in vain for physical restoration.

There are certain minimum requirements when it comes to the interpretation of a Greek image of myth. If the context cannot be woven together into a network (as opposed to its literal meaning) and if it therefore has no fundamental existence, then all interpretation is lost in arbitrariness. It is true that a thesis can be formulated to fit more or less any outcome of study of an image. But if there is no adequate context and therefore no possibility of testing it, then we cannot talk of interpretation but, at best, of pure speculation. As things stand at the moment many works, and in particular some very famous ones amongst these, are *de facto* not open to interpretation. Let us illustrate this with a few remarks on the Laocoön group in the Vatican.

The sculptural group in Rome is probably the most famous representation of a myth that has survived from antiquity (Fig. 34). It has exercised a great effect on the visual arts since the Renaissance and, to this day, invites intensive scholarly engagement. Immediately on its discovery in 1506, observers well informed about antiquity were able to name the scene. A passage in Pliny the Elder (*Naturalis Historia* 36, 37) tells us that three sculptors from Rhodes had created the statuary group of Laocoön and his two sons. Laocoön plays an important part at the fall of Troy. In the most widely known version of the legend, that of Virgil's *Aeneid*, Laocoön warns the Trojans, in his role as priest, against bringing into the city the Wooden Horse, which the Greeks had left behind on the beach before appearing to sail away (2, 40–56 and 199–245). When two large snakes attack and kill Laocoön and his two sons, this is taken as a divine hint to disregard his warning. During the following night the fate of Troy is sealed, in the tenth year of the war, after the Greeks hiding inside the horse have opened the city gates to their returning comrades.

Although the identification of the sculptural group is clear and its effect on the observer immediate, its interpretation, despite numerous suggestions, remains open. The reason for this is our lack of knowledge about the context of the Laocoön group. Apart from the names of the artists, the ancient sources tell us only about the location of its display, in the palace of the Emperor Titus (who ruled AD 79–81) in Rome, but this is certainly not the place where the group originally stood. The artists named by Pliny were

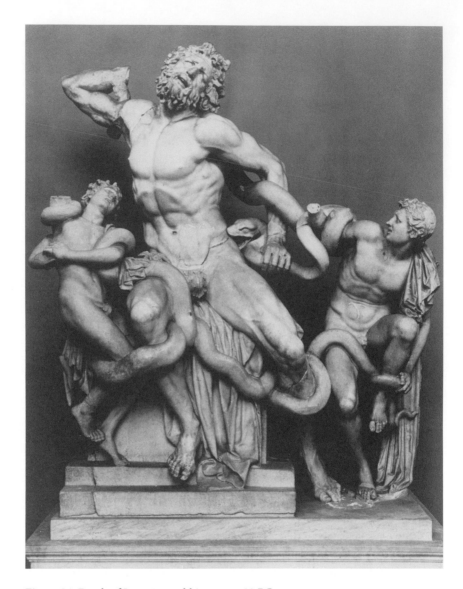

Figure 34 Death of Laocoön and his sons, *c.* 30 BC

very probably active in the first century BC; but a (rather unconvincing) theory holds that what they had created was not an original work, but only a copy of an older group now lost. But even if we take the traditional position, that the Vatican Laocoön was an original design executed by Greek artists in late Republican Rome, for fact, we gain little in its interpretation. It is possible that the Laocoön was a political memorial: his death was a precondition for the fall of Troy and consequently, for the flight of Aeneas (compare Fig. 25) to whom legend assigned a vital role in the foundation of

Rome. Or was the fate of the Trojan and his sons seen as a symbol of man's dependence on the will of the gods? Or is the group of statues, executed with such virtuosity, 'only' a testimony, like other works of its epoch, for the enthusiasm for Homeric and other early legendary subjects on the part of Romans with a feeling for art? The list of suggestions could easily be lengthened, but the methodological problem remains unchanged. The securely attested historical context for the Laocoön group is so full of gaps that an interpretation in terms of the content cannot reach beyond conjecture, even if some of the theses presented from time to time are given the appearance of fact.

The practice of interpretation: iconographical definition

The hermeneutic method, working through its steps one at a time, can be applied in many branches of cultural studies, regardless of whether these disciplines deal primarily with texts, as in philological studies; social structures, as in ethnology; or images and other testimony of material culture, as in art history and Classical archaeology. Its practical implementation, however, differs considerably according to the particular nature of the subject in question. In the further course of this chapter, we shall discuss aspects of the historical and cultural context that are fundamental to the particular field of archaeological research on myth. To illustrate the process of interpretation, a sculptural group will be used which, by comparison with the example used in the first chapter, yields far more complex results; and which can therefore serve to demonstrate, in a much more comprehensive way, the method of approach to an interpretation of its content. Mere clarification of the question, what the group in detail represents, costs some effort. There is also the opportunity to go into an essential problem of almost every analysis of a mythological image, that is, the difference between the literary and the visual tradition. The more demanding nature of the interpretation of this statuary group, finally, allows us to deal with the contextual areas only cursorily addressed in the first chapter, in a more strongly systematic form. General statements, developed on the basis of this individual case, will therefore be the more readily transferable to any other image.

The synthesis of written and visual sources

The so-called Athena-Marsyas group is a work particularly apt for demonstrating the long interpretative route, from iconographic identification to

hermeneutic analysis with its possibilities and problems. On the one hand, the process of interpretation has to start, as it were, from square one, since the original group of statues has not survived, but can be reconstructed with the help of a number of written and visual ancient sources. On the other, the density of the context makes it possible to come up with a rather far-reaching interpretation.

Two brief passages, from Pliny the Elder and Pausanias, who both wrote in Roman Imperial times, yield the following basic information: in the years around 450 BC the sculptor Myron, today known above all for his statue of a discus thrower, created a statuary group comprising the Goddess Athena and the satyr Marsyas, a figure from the retinue of the God Dionysus. In both authors' reports, the theme gives a rather enigmatic impression. Athena has thrown to the ground a musical instrument, the so-called double flute; Marsyas picks it up again, according to Pausanias against Athena's will. The ensemble, made of bronze, was displayed on the Acropolis at Athens. The original, which was melted down in post-antique times, survives nonetheless in marble copies, on the same scale but in every case incomplete, and all made in Roman Imperial times for the decoration of public buildings and the gardens of wealthy citizens (Figs. 35, 36), in line with a widespread practice of the time. Besides the short notices in ancient literature, some more or less faithful copies in the minor arts contribute to a reliable reconstruction of the group, at least in its basic outlines. The drawing in Figure 37 is meant to give an idea of how the two figures were related to each other in the composition.

Precise investigation of the incomplete Roman marble copies does not, however, lead inevitably to the reconstruction shown in the illustration; on the contrary, this is already the product of an interpretation. What was stated at the beginning of this chapter, on the theory of a clear distinction between iconography and hermeneutics, or between thesis and context, are inevitably rather abstract principles and, in practice, need to be implemented with flexibility. More concretely: *what* we see in an image depends mainly on *how* we understand it. In accordance with the principle of the hermeneutic spiral it is inevitable that there should be, even at this early stage of the process while we are trying to grasp the meaning of the situation represented, a continuous alternation between description and interpretation. These problems arise especially clearly in a task which has to be tackled in practically every analysis of a Greek mythological image, that is the use of the written sources and their combination with an archaeological object.

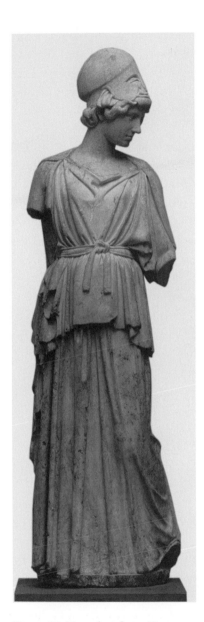

Figure 35 Myron's Athena. Roman copy of a Greek original of *c*. 450 BC

For the sequence of events, the versions of the myth in the ancient texts, put into visual form by Myron, tell us the following. Athena, the patron goddess of the arts, was regarded as the inventor of the *aulos* ('double flute', in Greek a plural form), consisting of two tubes with a sound similar to a modern oboe. Because playing the *aulos* puffed out her cheeks and thus

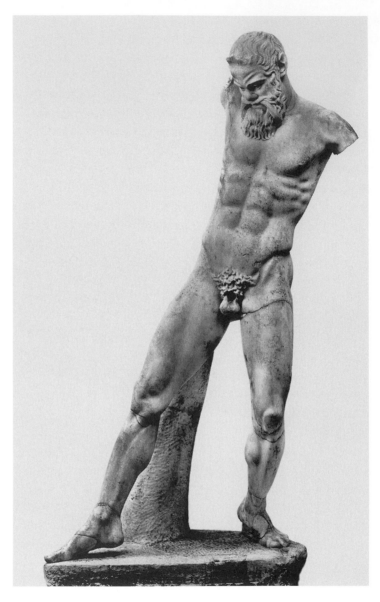

Figure 36 Myron's Marsyas. Roman copy of a Greek original of *c*. 450 BC

disfigured her face, Athena threw the instrument down. By chance Marsyas finds it, takes it for himself and becomes not only a virtuoso player but also, for posterity, a teacher and imparter of *aulos*-playing. This myth originated very probably only in the fifth century, not very long before the group was created. In its rudimentary meaning, the story therefore has a negative and a

positive element: on the one hand, Athena's refusal to play the instrument herself; on the other, the practice of this art by Marsyas, only made possible through Athena's act. Which of these two elements is decisive for the interpretation of the group?

At this point, a phenomenon already addressed under the heading 'changeability of myths' (in chapter 2) must be taken into consideration. The question just posed was given a wide variety of answers in antiquity. Roughly speaking, the evaluation of the mythical event in Greek and Roman authors shifts successively from positive to negative. While in the texts which are closer in time to Myron's group, it is not the playing of the *aulos* itself which is thought in some way to lack beauty, but only its execution by the Goddess Athena, the later sources pass over to presenting both the instrument and Marsyas himself as contemptible. It goes without saying that the early versions of the myth are to be preferred to the later ones: to work towards a fitting interpretation of the sculptural group, only the understanding which prevailed at the time may be used as a basis.

This methodological principle, though really self-evident, is frequently disregarded in the practice of research, and for a simple reason. Quite often, thanks to the chances of transmission, the sources that survive from the time of origin of the mythological image are non-existent or only incomplete, while extensive textual versions exist from another, usually later, epoch. In this context, the myth of Actaeon and Artemis (see pp. 90–2) should be remembered. It is only from Hellenistic times that we have proof of the existence of the story, which is easy to grasp as well as conforming to modern taste, whereby the hunter had chanced to see the goddess bathing naked in the forest and for that reason had to die. This version of the legend may not therefore be used as a basis of interpretation of earlier pictures of Actaeon (Fig. 27), even if many comments in the secondary literature suggest the opposite. In Classical times, the motivation for Actaeon's death was apparently different.

The situation is similar in the case of the Athena-Marsyas group. One of the comments in later literature, which assumes a 'bad' Marsyas, has played an unreasonably large part in the discussion. Pausanias, who saw the sculptural group on the Acropolis, talks of Athena beating Marsyas with her spear because he wants to pick up the *aulos* from the floor where she has thrown them (1, 24, 1). But this is unthinkable, for a start because Athena is the goddess of the *art* of war and would never use her weapon as a cudgel. Other arguments can be added. A check through the whole literary tradition for the Athena-Marsyas story makes it clear that the two figures in reality

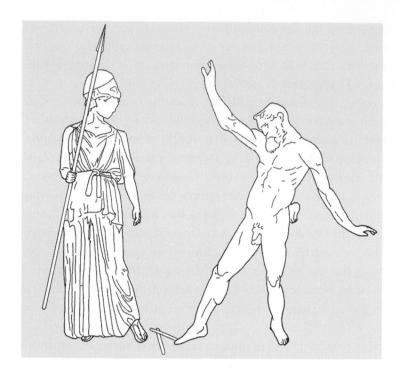

Figure 37 Reconstruction of the Athena-Marsyas group by Myron

never meet. The discarding of the instrument and its recovery represent two different moments in time. No direct interaction takes place between Athena and Marsyas. Myron alone has pulled the two characters together in one 'image', because as a visual artist he cannot represent the individual actions as one coming after the other – a procedure to which the modern viewer is unaccustomed, but which for the Classical Greeks was unproblematic (compare pp. 38–43), the more so because, unlike us, they were familiar with the narrative. In the following section we will concentrate on how the artist proceeded in order to create, in a unified image, what in reality takes place in sequence.

Now, too, a more precise reconstruction of the group can be established (Fig. 37). Athena has just thrown down the *aulos*, and looks back once more to the spot that she is about to leave; the position of her left leg indicates clearly that her direction of departure is to the left. She was carrying a spear, without using it, clear of her body and in a such a way that Pausanias could misinterpret this posture as 'beating'. Despite how it appears to us, Marsyas reacts not to Athena, but only to the musical instrument; he prances inquisitively up and shows his surprise by waving his arms in a hectic way.

Paying tribute to form

A commonly heard view, and perhaps not a mistaken one, holds that people in the western world have never been as densely surrounded by images as they are today, but that they lack mastery in handling them. For in school education as well as in vocational training, the preoccupation with language dominates, while engagement with the creation and effect of images plays an utterly subordinate role. There is only one great exception, commercial advertising design. When our attention is to be drawn to products and services and when economic success is at stake, great effort is put into even the smallest details of presentation through images and their effect on the recipient is very carefully weighed.

But on the level of scholarly research, too, imbalances of this kind can be discerned. In the universities and beyond them, history of art, archaeology, ethnology and other academic subjects dealing with 'monuments' and 'images' at present enjoy great popularity. Attention to the formal quality of visual representation, however, has not kept up with this trend. Engagement with the stylistic character of a work or with its design in general, until recently taken for granted, is today receding more and more into the background. An explanation for this is hinted at in the terminology by which the allegedly modern ways of interpretation conduct their trade. We have already talked about 'iconology' as a method which claims to be able to make images readable as if they were texts. The practice, inspired by French structuralism, of understanding images as elements of a 'discourse' goes in the same direction. Discourse (*discours*), at least according to its original meaning, corresponds fairly exactly with the Greek *logos*: 'spcech', 'systematic discussion'. To speak of a systematic 'discourse of images' leads easily to the expectation that one could directly 'translate' the intended message of a visual creation into a content that can be expressed in words.

Iconology and the concept of a 'discourse of images' represent a form of progress, insofar as they understand pictorial representations as an intellectually effective field, which communicates its content to the addressees according to its own rules. Like vocabulary and syntax in language, motifs and their combinations serve to call to mind abstract subject-matter. Yet these methodological approaches prove problematic in many of their applications, because of their scant interest in the formal aspects of an image. To simplify, they ask primarily 'What is represented?', and seldom 'How is it represented?'. This is to undervalue not one, but two points. First, a detailed examination of formal characteristics frequently results in essential information about the meaning, especially with works that are artistically discriminating and sophisticated in content. Secondly, only formal analysis

Figure 38 Head of Athena shown in Fig. 35

affords a degree of familiarity with the phenomenon that a pictorial repre-
sentation cannot as a rule be entirely smoothly broken down into specific
elements of content. Rather, it is precisely the complex works that exercise
their effect through the thought-associations which they trigger in the
viewer, and which stimulate open discussion (see pp. 59–63).

When applied to the subject of ancient mythological images, this means
confronting as comprehensively as possible the design of an image, in terms
of motif and form, with the version of the mythical narrative that is
accessible for the period concerned. To pick up on an old formulation,
this is about 'emphases and deviations' on the part of the visual, by compar-
ison with the verbal, form of the myth.

Let us view the Athena-Marsyas group once more, from this perspective.
We see nothing of the 'quarrel' between the two figures that later ancient
sources – and many modern interpreters – have sought. In terms of facial
expression, Athena's face appears neutral (Fig. 38), nor does the pose of her

body show any sign of excitement (Fig. 35). The figure's 'civic' character is further emphasised by her youthfulness and her restrained armour. As a rule, in Classical times the goddess of warfare presents herself as a grown-up woman equipped, besides helmet and spear, with a protective magic hide (*aegis*) on her breast too, but that is missing here. Nor does the figure of Marsyas correspond in every respect with the accepted form of a satyr (Fig. 36). It is true that the grotesque features of his face, as well as the long ears and the horsetail on his back, betray the part-animal nature of a satellite of Dionysus. But already the ordered hair of his head and beard, and even more the shape of the torso, with its perfect play of muscles, present Marsyas as an idealised figure, conforming to the norm. The physique of his body would be no different if he were a victorious athlete. The apparently twisted way in which he holds himself, with the right leg pushed right forward and the left leg at a sharp angle, is linked with the immediate situation, but also with something typical of all satyrs: they are curious and timid at the same time; thus Marsyas wants to know what lies on the ground in front of him, but at the same time recoils because it is something unknown to him.

Looking at the characteristics of the design allows us to make two statements, which are equally important for the question of the meaning of the group. On the one hand, there is confirmation of what the written sources have already told us about the course of the narrative: even if the two figures were placed on the same base, they do not react to each other, but the attention of each is directed at the instrument lying between them. The clearly downward direction of the satyr's glance, above all, allows no doubt of this. Taken as a whole, this is basically a 'continuous representation' (pp. 42–5): that is to say, we must not read the group as the image of one simultaneous action, but from left to right, as a sequence of moments – first Athena throwing away the instrument, then Marsyas recovering it. Thus both figures are, as it were, independent carriers of the action, and together they embody one sequence of events. On the other hand, certain of the formal elements also serve to illuminate the particular characteristics of the protagonists. Myron's Athena, with her girlish figure and subdued armament, self-controlled in expression and posture, is anything but a typical combative goddess, and she also shows no sign of aggression towards the satyr whose presence is only virtual. The satyr, in turn, represents a deviation from the norm of the impulsive creature of nature through his idealised outer form. On this view the sculptor, with this figure as well, has held back from creating a contrast between two figures who are, in terms of their basic characters, very different.

Thesis

In this idealised outline of the interpretation process, and on the basis of the aspects discussed so far, a thesis for the interpretation of the content of the Athena-Marsyas group can be formulated. It makes use of the following points:

1 The invention of a musical instrument, the *aulos* ('double flute') was in the fifth century attributed to Athena, patroness of the arts.
2 In the same period, the satyr Marsyas was given the role of virtuoso and teacher of this instrument.
3 A myth, probably only created in the fifth century, brings the two figures together. According to this, Athena refused to play in the instrument that she herself had invented, because it distorted her face. This task then fell to the satyr.
4 The virginal, youthful-looking Athena and the satyr who belongs to the lascivious group of followers of Dionysus are considerably different in character, a difference which, however, is not emphasised but weakened by the composition of the group.

Sculptural group and myth, according to the idea developed from these points, seek to deliver an explanation for how *aulos*-playing was transmitted to mankind. The starting point for this was the mythical idea according to which this important branch of musical life had a divine origin. The new myth completes this notion through the fiction that a musical satyr in some way took over the instrument from the goddess and, after he had learned the technique, became the communicator of this art to humankind. Seen from the point of view of this sequence, Athena and Marsyas are something like mutually unknown partners; and for this reason they do not appear in the sculptural group as figures of contrast, still less of enmity.

The practice of interpretation: contextual fields

The remarks on the formulation of a thesis have deliberately been kept very brief. To develop an idea or a thesis is, to say it again with Panofsky, a thing of intuition and to this extent it cannot be learned according to firm rules. On the other hand, in most cases a precondition for it is a good knowledge of the historical context; but here, for clarity of presentation, this is discussed in its widest implications only *after* the thesis has been reviewed. The point of this schematic procedure, as described here, is to scrutinise the

thesis and then establish distinctions in the content of the outcome. The five areas of content discussed in the following section have in most cases to be taken into consideration, in one form or another, for a circumspect interpretation of images of Greek myth. As before, general discussion of methodology will alternate with explanation of its application to the model example of the Athena-Marsyas group.

Specificity of mythical figures – mythologemes

Mythical narratives, along with their visual counterparts, are about certain unique events. In our search for the meaning of a plot, we shall direct our attention first to the immediate associations of the event and, from this, try to draw conclusions for the underlying viewpoint of the content. Athena rejects playing the *aulos* for herself but, by not destroying the instrument and instead just throwing it away, she makes it possible for another person to retrieve it. This course of events alone gives a clear hint that the topic of 'transmission of an art' must be one of the central elements in the meaning of this myth. But this interpretation gains in plausibility only through aspects which, at first glance, are neither present in Myron's sculptural group, nor belong directly to the Athena-Marsyas story.

With the statement that, according to tradition, both figures are connected with the arts, we have already crossed over into the context of the image and incorporated into our study something that can be called a definite specificity of the figures. Every mythical character who is linked to a specific action represents a set of unchanging characteristics, independent of the changing situation in which they appear at any moment. The figure may well appear in very different narrative contexts, yet carries these specifics, as it were, within itself. This gives an advantage, both in the conception of a mythological image and for the viewer's grasp of its meaning, in that certain elements of content are always present in clearly defined form, even if they are not made explicitly visible. We have already seen more than once how effective this can be in practice, as an aid to understanding. To see, in the picture of the wounded Patroclus (Fig. 1), only the solidarity between friends in war, would mean leaving out of account what the ancient viewer inevitably connected with the two men. They would think, as a matter of course, of the early death of both heroes as well as the outstanding military prowess of Achilles. In the picture of the dead Sarpedon (Fig. 17), it is the God Hermes, appearing behind the dead warrior, who is clearly valuable for communication even though, according to the literary versions of the narrative, he has no part in the action at all. Escorting the dead was

one of his characteristics or powers. In the mythological image then, the point is not that he should be doing a specific thing. His presence alone is of relevance: it signals divine protection and underlines the fulfilment of the wish to arrange an honourable burial for the Lycian king.

In the case of the Athena-Marsyas group, the characteristics of the two figures that are relevant for their interpretation go decidedly further than what has been said so far. It has already been stated that Athena's unwarlike and girlish appearance brings to the fore her role as representative of the liberal arts. Besides this responsibility for a certain area of everyday human life, Myron's contemporaries doubtless also called to mind another of her characteristics. She appears in many mythical contexts as the helper of the heroes. Perseus, Theseus, Heracles – in the careers of all these heroes we encounter the motif of the necessity for divine support, which they then receive from Athena (compare Fig. 7). The close connection of the goddess with mythical figures who are mortal, and thus close to ourselves, also lends credibility to the interplay with Marsyas: the satyr sees to it that Athena's invention of a musical instrument is passed on to mankind.

As far as Marsyas is concerned, as a satellite of Dionysus, like the (for us) nameless Barberini Faun (Fig. 14), he represents sensuality, with a special field in *aulos* music. For the understanding of the figure of Marsyas, as already stated, his role as teacher and communicator of an art is important. His influence reaches far beyond that of a performing musician. But with this figure, too, the ancient viewer connected specific aspects that lead beyond the immediate subject of the statuary group. Marsyas' life ended in a spectacular way. A narrative, probably considerably older than the story of the handing on of the *aulos*, tells us of a competition between the satyr-musician and the god of the Muses, Apollo. The latter was playing on his characteristic instrument, the *kithara*, while Marsyas played the *aulos*. The god was awarded the victory, and with it the right to deal with the loser as he chose. Marsyas was tied to a tree and skinned alive. The 'skin of Marsyas the Silenus' was already a fixed term for the historian Herodotus (*Histories* 7, 26, 3). Many modern authors have assumed that Marsyas, as challenger of a god and victim of cruel punishment, was generally seen as a morally inferior figure in Greek antiquity and that, in taking the instrument rejected by Athena, his reprehensible nature, as well as that of the music played by him, once more showed themselves.

But this moralising perspective disregards a structural element that needs to be taken into account for the interpretation of the legend and of the sculptural group. There is a whole range of mythical figures who pass inventions on to mankind and who die violently in the context of their

act. Prometheus, who brings fire to humans against the will of the gods, is a typical representative of this group. As a punishment he is chained to the Caucasus mountains and each day an eagle pecks out his liver from his body. Two other such conveyers of innovation are closer to Marsyas. Orpheus, in legend the first poet and singer, is – in the most widespread version of the legend – killed by a group of women who tear him into pieces. A less well-known myth tells us how the God Dionysus brought wine to mankind and how a man named Icarius was used by him as an intermediary. But the first mortals to drink of this as yet unknown substance were very frightened by its effects, and killed Icarius.

All the examples cited, Marsyas' fate included, follow a basic pattern of motifs which is the same as that for heroes dependent on divine support. To the recurrent mythical element of action, the so-called mythologeme, there corresponds an element of content that is, at its core, unchanging. The inventors and intermediaries cited above, who are in direct or indirect touch with the gods, act as benefactors of human beings to whom they bring innovations enriching their lives, but in return they are nevertheless punished or fall victims to a cruel death. They are, to borrow a term from Christian culture, something like martyrs. They die for a cause which is later recognised as good but which, at the time of its introduction, is categorised by contemporaries as potentially dangerous and to be resisted. The fate of the mythical participants obviously reflects, in a concrete way, the experience that inventions, even if their usefulness is soon beyond question, are felt in the first instance to be something risky and forcible, because of the breach with existing tradition.

The connection of the individual mythical figures with certain basic patterns restricts the narrative framework within which they can move – Marsyas is and remains a sensually talented child of nature. For that reason, he appears only in those legendary contexts that are structured accordingly. The fact that the figures are relatively tied to specific characteristics, however, proves to be of great advantage if viewers are to be given access to new myths, or to myths told in a new form, be that in a verbal or pictorial version. For the concrete example of Myron's group, this means that anyone who is familiar with Athena as the inventor of a musical instrument, and who also knows of the role of Marsyas as a martyr for his cause, the diffusion of music, has at his disposal the essential prerequisites for understanding allegorically the myth of the handing over, by the goddess to the satyr, of the art of playing the *aulos*. The same is true for Myron's sculptural group, whose particular form gives it a somewhat aloof effect. The specifics, whose meaning the modern observer must first of all grasp, were part of common

knowledge for the sculptor's contemporaries, and they create a framework of content which confined the possible meaning of the image to a quite narrowly defined range.

The historical environment

All mythical narration, whether in verbal or pictorial form, represents an engagement with critical aspects of the sphere of human life. Therefore, as we have just now seen, study of the character of individual mythical figures always includes an examination of their relationship with their historical environment. To describe Athena as patroness of the arts already contains a message about the importance of the arts in Greek society, and reference to her role as helper of the heroes in emergency touches on an aspect of religious history, the relationship of mankind to the gods. What was only in the margins of the discussion in the previous section now comes to the fore, namely the question how far our thesis, that the myth of Athena and Marsyas sought to take as its theme the transfer of one of the arts from the gods to mankind, is supported by the conditions of the time. Our concern is therefore with the so-called historical probability of the proposed interpretation: to what extent can what we have postulated as the real topic of the Athena-Marsyas group be regarded as something which, at the time of the group's creation, was actually of great importance for people?

What was said earlier about the infinity of context has a uniquely valid application to this particular sector of it. The historical setting for the representation of a mythical story is composed of an almost limitless spectrum of aspects which, however – not least for practical reasons – cannot all be taken into consideration. For example, the key term sexuality which, in view of the grouping of the figures, would definitely deserve attention, has not been taken into account. Athena, born from the head of Zeus and never joined to a male partner, is remote from all sexual desire – which conversely is one of the outstanding characteristics of the satyrs. The military context, too, as in countless other images of Greek myths, belongs in a broader sense to the sculptural group, since war is one of the numerous domains of the goddess, whilst Marsyas has no connection with this sphere. In what follows, I want to take a closer look at an aspect of cultural history and then at one of the history of religion, both of which serve to widen the basis for an interpretation of the myth and the group of statues.

One might perhaps raise the objection: is not making music with the *aulos* rather too minor a facet of the everyday world in Classical Greece, to receive the rather lavish honour of a large sculptural group? It is in fact not

Figure 39 Cast of a satyr play. Attic red-figure dinos, *c.* 430 BC

at all easy to find another monument to set beside Myron's work, paying homage in a comparably emphatic way to a branch of musical creativity. Yet the question just raised can certainly be answered in the negative. That it is raised at all is primarily the result of factors to do with transmission. The surviving texts give us exhaustive information on the Greeks' achievements in literature and philosophy. For the various fields of the fine arts we have a no less overwhelming tradition. Musical life, by comparison, has left only scant direct traces: finds of actual instruments, first and foremost, must be mentioned here, among them a sizeable number of bronze *auloi*.

But indirect evidence has survived all the more densely. Countless passages in Greek literature and, in addition hundreds of pictorial representations, inform us that everyday life was absolutely permeated by music and that its performance was by no means something for a limited circle of connoisseurs only. At religious festivities, theatre performances (Fig. 39), funerals, private gatherings (Fig. 29), music, instrumental and vocal, was at home everywhere. The earliest poetry and the earliest representations of figures already bring proof of this. Part of Homer's characterisation of

Achilles is the detail that, after the capture of a city, the warrior had taken as booty not material goods or slaves, but a musical instrument which he used to accompany his own singing in the military camp before Troy (*Iliad* 9, 186–9). Music practice was part of young people's school education, as a number of vase paintings, among other things, show. For amateurs the *auloi*, apparently because of the high technical expertise needed to play them, took a less prominent place than did string instruments. On the other hand, thanks to their very serviceable tone, they were used in force at all activities where the citizens came together as a collective and experienced themselves as a community, such as in the theatre and at a sanctuary – so that there is nothing surprising in the conspicuous honour paid to this instrument or in the mythical fiction of its divine origins.

The second aspect, to do with the history of religion, has also already been touched on in the previous section. That gods should invent things belongs just as much to the category of mythologemes as does the motif of the 'punished' intermediaries of these inventions, or that of the great heroes who in critical situations depend on divine support. Many achievements of civilisations have, in the course of time, been attributed to a divine inventor. We have already heard about Dionysus and wine. Grain, according to mythical imagination, was received by mankind from Demeter and its diffusion taken on by the hero Triptolemus who was linked with the goddess. Another basic source of nutrition, oil, was according to an Athenian legend 'invented' by Athena, who caused the first olive tree to grow. In a prominent position – and within sight of the Athena-Marsyas group! – this subject was given monumental exposure. In the west pediment of the Parthenon (Fig. 9) are shown the Gods Athena and Poseidon, as they compete with miraculous deeds for the patronage of the territory of Athens.

Athena often stands out as the creator of innovations in general. The invention of weaving, and of the loom required for it, is attributed to her along with ship-building, another technical achievement with far-reaching consequences. But it is not just the inventor, but the invention itself that forms part of a wider context. The second important musical instrument of Greek culture, the *kithara* and the slightly differently designed *lyra*, also has an inventor from the circle of the gods. The inventive Hermes is said to have accomplished this when he was only just born. As with the distribution of roles between Marsyas and Athena, so here inventor and performer are not identical. The instrument passed immediately from Hermes to Apollo and became a symbol for this god. So the Athena-Marsyas group, whose topic at first glance seems to be a little recondite, is on the contrary placed at the intersection of a large and important group of myths.

Mythological images do not give visual form to sacred texts (see pp. 21–2). But each picture that shows a divinity as a personage in action contains a statement about how the relationship between gods and humans was seen at the time in question. What the gods display through the innovations they create is not primarily intellectual or technical competence. Rather, the role in which they are seen is much more that of the bringers of culture and thus, of benefactors. They provide humans with basic things indispensable for life, from the primary safeguarding of existence through foodstuffs, right through to the sensual and emotional enrichment through the experience of music. In an ode by Pindar, composed in 490 BC, not only is the occasion described when Athena thought of the idea of carving the *aulos* from two tubes, but the poet also explains the goddess' motives for her action: she had, as we are explicitly told, made her invention for the sake of 'mortal humans' (*12th Pythian*, line 22).

The fact that myths following this pattern became especially popular in the fifth century can be taken as a clue for a change in the relationship with the gods. The Homeric idea of direct intervention in human affairs recedes, in favour of the conviction that the gods on the one hand create the essential conditions, but that humans, on the other, have to appropriate and perfect this technology in order to be able to cope with their own existence. It is this very thought which the Athena-Marsyas group immediately transforms into fashioned form: if Athena turns away from the place where she has left behind the *aulos*, she does it not to signal her rejection of the instrument, but because with the invention she has fulfilled her part in the process of establishing one of the arts. Unaware of her presence, in accordance with the concept of keeping tasks separate, the mortal Marsyas picks up from the ground the instrument passed on by her and teaches himself how to play the *aulos* so that, as a teacher, he can see to its wider distribution.

Visual experiences

Arriving at a context-orientated interpretation consists essentially in the attempt to grasp the meaning of the thought-processes set in motion by what the viewer has immediately before him. For the case study of the group by Myron, some aspects of the content were identifed in the two preceding sections. But in the same way as every reader registers the content not only of the pages lying open before him but also, consciously or subconsciously, that of earlier reading experiences; so a single object in principle also evokes in the viewer earlier visual experiences. For example, visitors to the Athenian Acropolis saw Athena as inventor before them not once but twice,

in Myron's sculptural group and in the west pediment of the Parthenon (Fig. 9). Inevitably, the effect on the viewer's perception of the first ensemble was maintained while he was looking at the second – assuming that he had a good understanding of the representations. But with this also comes an indication of a necessary reversal. The phenomenon has not only a receptive but also a productive side. An author – or, for the early Greek period, a narrator – can take it for granted that his readers or listeners have knowledge of certain texts and, in the creative process of drawing up a new text, he takes this prior knowledge into consideration. If a Greek dramatic poet in the fifth century worked on subject-matter already shaped by Homer, he could rely on the fact that many of the visitors to the performance were familiar with Homer's version, even word for word. This prior knowledge may possibly allow him to do without a detailed explanation of the action and instead to call it to mind by hints only. But above all an author can, by deviating in certain points from an older version familiar to the audience, steer the thought-processes of the audience. Precisely because the listeners come to the performance with an idea of the course of the legend already articulated in their minds, they will register and work through the differences with particular intensity.

Philology uses the term 'intertextuality' for the various forms of a calculated literary recourse to other texts. It is only logical that, at a recent conference on (post-antique) discourse in imagery, the term 'interpicturality' (from Latin, *pictura*, painting) was coined and its use recommended, to emphasise that the literary elements described do have a counterpart on the level of imagery. An artist, too, when creating an image of a myth, can take the visual experiences of the viewers into consideration and so direct their perceptions. Three areas need to be distinguished from each other here. The first is the tradition of motifs to which the individual representation belongs, that is to say earlier, or in any way related, images of the same subject that could be known to the observer. Second, the artist develops each image for a specific spatial context, for example that of a sanctuary, where the individual objects relate to each other reciprocally. Finally, however, the designer of a myth-representation is also likely to make use of visual versions which stem, not from the sphere of the arts, but from the wider context of the viewers' world.

In many cases we have quite good information about the history of the motifs and the communicative standpoint of a mythological image and these will be given sections of their own in the explanations that follow. Finds made in the soil, above all vases and sculpture from graves and sanctuaries, as well as statements in the ancient literature, can often supply

very reliable information here. But to grasp the meaning of visual experiences from the everyday world of the viewer is only intermittently possible, because much that was part of the self-evident and recurrent situations did not form the subject of any kind of artistic or literary treatment. Some central areas of life hardly found an echo in the surviving pictorial evidence. Common gainful employment falls under this head, along with actions that form part of what is called the festival culture, for example the communal sacrificial meal at major religious ceremonies. But it was precisely because certain situations recurred regularly over the months and years that they and their special elements must have impressed themselves, in the fullest sense of the word, in the collective consciousness. In the case of Myron's Athena-Marsyas group, as an exceptional case, we can follow in detail how the artist utilises the visual experiences of his audience productively, so as to give them easier access to a complex representation of myth.

The Marsyas of the group represents, in terms of motif, an ambiguous figure. The way he holds his body is, on the one hand, explained by the mythical action. He cautiously approaches the instrument lying on the ground with his right leg, but at the same time he recedes, because satyrs are timid fellows. But there is something else besides: Marsyas is dancing. To be able to reconstruct this we need, first of all, to restore the satyr's arms. Both were held away from the body, the left one downwards, the right, energetically upwards. Together with the legs, which are turned at right angles to each other, the result is a composition of the satyr's body such that his limbs seem to rush away in all imaginable directions (Figs. 36, 37). As the mythical event can only be a partial motive for these movements, so they can be even better explained as the dance-steps characteristic of a certain type of satyr.

The Athenians knew satyrs not only as figures in legend, but also from their own social environment. In Myron's day, part of the programme for the great dramatic competitions, performed in honour of Dionysus, was the so-called satyr play. As with its 'serious' counterpart, tragedy, the subjects were taken mostly from myth and the characters on stage consisted of individual actors and a chorus. This chorus was invariably composed of men in satyr costume. Vase paintings of the time (Fig. 39), together with ancient literature, give us a good idea of the action on stage. The chorus members had two characteristic props: first, a tightly fitting loincloth which hints at the satyrs' strong growth of pubic hair, and whose genitalia signalise (perhaps with an element of irony) permanent sexual appetite with the erect penis (*phallos*); secondly, a mask with all the physiognomic characteristics of the satyrs, long ears, receding hair, snub nose, shaggy beard. In line

with a widespread pictorial convention, the mask cannot here be recognised as such – the actor seems to have merged perfectly into his role.

Even if the mask is not detectable, because the aim is to present the effect of the change and not the prop, our vase painting, which can be matched with related depictions, can lay claim to a high degree of realism. For the understanding of the Athena-Marsyas group, this is of interest in two respects. In the central part of the picture we see a professional *aulos* player, a figure to be seen in every performance of a satyr play. The man in his professional costume of a long, brightly coloured gown produced the music to which the satyrs executed their dances during the performance. And the figure to his right demonstrates how a dance movement, perhaps a standard one, of the stage satyr looked – it coincides in all important points with those of the Marsyas in the statuary group: the outstretched right leg, the tilted posture of the upper body, the arm held far away from the torso. The appearance of the Marsyas figure thus records a visual impression regularly made on thousands of theatre-goers during the performances.

This has important consequences for the interpretation of the statuary group and the understanding of its conception as a 'medium'. Looking at Myron's Marsyas, the viewer is instinctively reminded of the real experience of the dancing satyrs on stage. Through this play on different levels of reality, visitors to the Acropolis get a clear hint as to what idea is meant to be embodied by the Marsyas in the group. It recalls sensual pleasure, which contemporaries knew as an occurrence in the world of their own experience. Once we are aware of this artistic move, then it is beyond question that Myron's Marsyas must have been a figure seen, at the time, in a positive light – not, for example, the uncultured counterpart to Athena, but the personification of pleasure in music and dance. Another aspect, too, can be added here. As already said, Marsyas in the myth takes on the role of intermediary, who passes on to mankind the art invented by Athena. One could not give shape to this idea more convincingly than is done here: the statue imitates stage satyrs, who in turn are nothing but people, normal fellow citizens, in disguise (at this time there were as yet no professional actors). Thus visitors to the Acropolis saw themselves, so to speak, as the recipients of Athena's art, through the Marsyas in the statuary group.

Of all contextual areas, the one most difficult to comprehend is how a visual artist made use of the everyday visual experiences of the viewer, in the conception of a mythological image. In the case of our model example, conditions were favourable, and we therefore get a good idea of the efficiency of a procedure which, for that reason, was surely often used. The procedure also makes a substantial contribution, in guiding the viewer of

the group reliably to the message conveyed by its content, whereas scholarly interpretation attempts, by a laboured and never more than partially successful process, to understand how contemporaries perceived an image.

Communicative viewpoint

This admittedly somewhat modernistic title aims to convey, in one brief phrase, those aspects of the context of a mythological representation that relate to the status of the person who commissioned the work, the function of the object, the place where it was displayed or used and, as a result of all these points, the way it was perceived by the viewers. In chapter 4, important basic principles for the consideration of this group of issues have been discussed. Earlier research paid little attention to the relationship between image and viewer and tended to see the representations as evidence for the history of ancient thought and mentality, largely independent of their context and regardless of whether they were vase paintings, statues or sarcophagus reliefs. More recent scholarship has taken on all the more intensively the task of uncovering the perspective of the viewer wherever possible – the term 'viewer' has become indispensable in research, and not only on mythological images.

We have already seen various examples of how this method has become standard practice in archaeological research, and the problems it may generate. The greatest uncertainties exist with the largest category of monuments, vase painting. Even the term 'vase', used for want of something more appropriate, gives a hint of the difficulties in defining how exactly the individual vessels were used and where, as a consequence, they exercised their effects. A cup which, by its outer shape, can be classed with certainty as a drinking utensil may equally have been produced by the workshop for use as a votive or funerary object. This has considerable consequences for the interpretation of the mythological images on the vessels.

The Sarpedon krater of Euphronios (Fig. 17) is a good example for this. Judged by its shape, it is a vessel for mixing water and wine, scooped from it at feasts to fill the bowls and beakers of symposiasts. But a series of clues, in particular the context in which many of these kraters were found, forces us to accept a further primary use as an object of burial cult. There are very different bases for the respective interpretations, according to purpose and place of use. If the vessel and the image on it were designed for the symposium, then one would need to consider whether Sarpedon, killed in battle but given an honourable burial through divine intervention, is mainly meant to invite the viewer's absolute commitment to military service,

because only in this field can lasting honour be gained. But if, on the other hand, the vessel is an object for burial cult, the picture will be 'read' more directly and those elements that refer to death and burial will be taken as a basis for interpretation.

The statue of the Barberini Faun (Fig. 14) is a vivid example of how an art appreciation that was initially, so to speak, 'absolute', has more recently been replaced by a context-oriented examination, and how the emphases of the interpretation of its content have shifted. One view, still common until a few decades ago, can be traced back to Johann Joachim Winckelmann, the founder of Classical archaeology as a scholarly discipline. It was his idea that the figure of the sleeping satyr was virtually nothing more than a study of nature. Winckelmann (1764) sees in it 'an image of simple nature left to itself'; Adolf Furtwängler (1900) recognises as the essence of the representation the 'thoughtless loss of self-control on the part of an ignoble, common being'; and Ludger Alscher (1957) too restricts his interpretation to seeing the satyr as embodying a balance 'between elemental powers of nature and the sphere of intelligent humanity'. None of these sensitive characterisations can be rejected as a failure. But the fact that none of the authors asks at all how the display of the statue is to be imagined and what consequences this has for its interpretation, on its own constitutes grounds for taking a critical view. According to the unanimous view of contemporary research the statue, with its large format that demands free space for display, must have been placed in a sanctuary of Dionysus. This spatial and functional context therefore gives us a clear framework within which the Faun is to be interpreted. Whichever aspect of detail we wish to bring to the fore, only those interpretations which convey an understanding of the satyr as a symbol of the liberating effect of Dionysus can be apposite.

Corresponding reflections can take a more precise form in the case of the Athena-Marsyas group, for which the sanctuary as place of display is a matter, not of conjecture but of secure knowledge. Beyond the trivial statement that the statue of a deity must say something positive about that deity, we can deduce from the unusual iconography of the ensemble that it is meant to emphasise a special aspect within Athena's 'sphere of competence'. For the visitor to the Athenian Acropolis, the holy precinct of the city's patron deity, Myron's Athena represented only one among several images of that figure. We have seen her as the opponent of Poseidon in the west pediment of the temple (Fig. 9); in the east pediment she is the one born from the head of Zeus; in the interior of the temple stood Phidias' gigantic cult statue of gold and ivory; on the open ground of the sanctuary area a colossal statue of Athena was placed beside many other figures, by motif a

so-called *promachos*, also a creation of Phidias. The two last-named works, above all, present emphatically the warrior aspect of the goddess, a figure in full armour and of shattering power, because the scale of the statues is several times life size.

These statues and the experiences mediated by them are part of the communicative network within which moved the viewer who, in the years around 430 BC, walked through the sanctuary of the goddess and reached the Athena-Marsyas group. Characteristics such as the girlish appearance of Myron's Athena or her subdued armament, which we objectively register as elements of her outer shape, are obviously meant to set up a contrast with the image of the deity that was dominant in that place and to communicate unequivocally, even for those who knew little of the content of the myth, the fundamentally civilian nature of her appearance in the group. Myron's Athena is thus defined in part by what is around her, and not only by the characteristics detectable on the figure itself. With the figure of Marsyas, we have already established a similar way of proceeding. He evokes in the viewer the memory of the dances of the human satyrs on stage and, in that way, calls to mind the recipients of Athens' art.

The point about the 'status of the client', touched on at the beginning of this section, should not be wholly left aside, even if in this particular case we have no secure knowledge. By analogy to other statuary in Classical Greek sanctuaries, it is as good as certain that it is a private votive offering which, following a widespread practice, links the worship of the deity with the self-representation of the person, almost certainly once known by name, who commissioned and financed the sculptural ensemble. The donor, male or female, need not have had a close connection with the musical life of the city of Athens. Because music was so highly ranked in society and because Myron's group celebrates Athena as benefactress in a comprehensive way, any member of the citizenry of Athens is conceivable as client, provided they had sufficient means and attached value to making a dedication that would have an impact on the general public.

History of motifs

The central idea of contextual analysis is to see mythological images as historical testimonials of *their own* time, so as to determine on this basis the meaning of their content in as discriminating a way as possible. No matter which, or how many, aspects are separately dealt with, this always involves collecting together all relevant points for a certain historical time – the time of origin, or the period of immediate impact, of the representation being

interpreted. Accordingly, the main perspective is the examination of a cross-section of history: how did a visitor to the Acropolis in the years around 450 come to an understanding about the meaning of a work such as the Athena-Marsyas group, when encountered? The sections above were to give an idea of the range of visual and intellectual experiences that had effect on the viewers of the group.

Like every strict methodological challenge in the field of hermeneutics, the demand for a logically consistent synchronic analysis of the context of the image also has something exemplary about it. If the attempt is made to collect together everything that the contemporary viewer brought to it, so to speak, from the outside, then the interpreter must inevitably look back into the past. The knowledge and experience of the ancient viewers were formed over their whole lifetime and were further built on traditions which may have reached back far in time. The historical cross-section therefore also contains an element reaching beyond the horizons of the period in question. Thus, in most cases a diachronic examination is also an explicit task and one of the indispensable steps in the interpretation of the mythological image. Examination of the predecessors, and also the successors, of the motifs in question forms the most important part of the contextual field. The tradition from which the individual image comes and the history of its impact alike may give us essential information about the meaning of its content.

Two monuments already discussed can instructively illustrate how an examination of the history of motifs helps with the understanding of the genesis, and with it the meaning, of a mythological representation. The singular image on the inside of the Sosias cup (Fig. 1) does not represent a complete novelty in terms of motif, but has predecessors in depictions such as that of Diomedes tended by another warrior (Fig. 3). Comparing the two does not, however, lessen the creative achievement of the Sosias Painter; on the contrary, it enables us to measure fully the upward leap in the quality of the design. But, more than anything else, we gain in this way valuable insights into the intellectual context of the Achilles-Patroclus picture. The earlier image links together basic situations of warrior activity in an additive, and also interactive, way: fighting, being wounded, dying – and in this way gives a hint of the causal connection between them. The existence of this picture gives important support for the interpretation whereby the picture by Sosias is essentially directed at the same idea, only its visual realisation takes a compressed and partially indirect form. Fighting and being wounded are now recalled in one and the same image; the painter could assume knowledge of the early death of these famous men, even in moderately

informed viewers. Here, the history of motif presents itself as a process of condensation.

By contrast, a reversal in terms of motif could be observed in the creation of the Barberini Faun (Fig. 14) – in this case, too, with consequences for its interpretation. Earlier Greek art knows sleeping maenads, who are spied upon and molested by satyrs, as a theme for imagery (Fig. 15). The connection, in terms of motif, to the statue of the satyr finds a parallel in terms of content. In analogy to female, the topic this time is that of male erotic charisma, perhaps in slightly distorted ironical form. On top of that, the link with the earlier images entitles us to infer that the Faun himself requires someone else, who takes advantage of his sleeping state to approach him, but that that person now is not a figure in the image itself but the viewers, female or male, themselves.

Like the two representations discussed above, the Athena-Marsyas group does not stand in a tradition of motif in a narrower sense: that is, we know of no earlier monuments that reflect the same legendary event. Here, too, the lack of predecessors is unlikely to be explained by gaps in the tradition; rather, all three monuments most probably represent genuine new inventions in terms of motif. But the ensemble created by Myron is also not entirely without a usable earlier history. A representation on an Attic amphora, which precedes the sculptural group by about fifty years, shows Athena as an active *aulos* player together with Heracles who is also making music (Fig. 40); each is about to set their foot on to a victor's rostrum. This scene, unique so far in Greek art, supports a central point in our interpretation. It delivers definitive proof that, according to traditional view, Athena has a perfectly positive relationship to playing the *aulos* and does not radically reject the art after the invention of the instrument.

Just as the predecessors of a mythological representation are part of the history of motifs, so too are its successors; they convey information about the meaning of the representation from the opposite perspective, that is, from its impact. In the case of Myron's group of statues they are quite sparse, but not without value. In the first instance, it is essential to note that no single representation of the Athena-Marsyas story is older than Myron's group itself. Together with the literary testimony, also very scattered, they support the thesis that this myth was in fact developed only in the course of the fifth century, to extend the narrative of the invention of the *aulos* by Athena.

Further information on how the course of development in the literary version should be imagined, can be gained from a picture on a vessel from southern Italy in Boston, from the middle of the fourth century BC (Fig. 41).

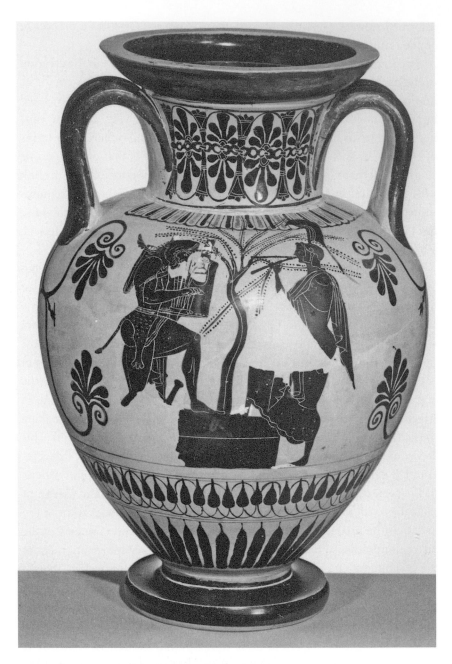

Figure 40 Athena playing the *aulos*, Heracles playing the lyre. Attic black-figure amphora, *c.* 500 BC

Figure 41 Athena notices the distortion of her face when playing the *aulos*. South-Italian (Apulian) bell-krater, *c.* 370 BC

It was possibly in a stage play, specifically a satyr play, that the myth was formulated and, at the same time, also first given visual form. Apart from the humorous element of a majestic goddess suddenly made aware of the disfiguring effects on her face, the other figures on the Boston vessel, among other things, also support this view: special attention should be paid to the satyr in the left centre of the picture, who is not directly involved in the action. The vase painting also tells how Athena found out that playing the *aulos* puffed up her cheeks: a youth holds a mirror up before her face. According to later ancient texts, this scene may not be taken entirely literally and the young man be understood as the personification of a stretch of water whose surface reflects Athena's face. The pose and connection to the content of the satyr at the top right also need some explanation. The basic motif, with the raised arm and the body tensed all over, is strongly reminiscent of the satyr in the statuary group and supports his identification as Marsyas. The course of the narrative is presented in one picture here, as is typical not only of vase paintings, so the satyr would have to be seen as

belonging to another level in time, when what is shown in the scene with the mirror has already happened – a horrified Athena throws down the instrument and walks away.

In a passage in Aristotle's *Politics*, we are told about the use of certain instruments in the context of education (1339a–1342b). The strict theoretician of pedagogy takes a very critical attitude towards the *aulos*, whereas he has no reservations about the use of string instruments in education. In this context, Aristotle comes round to discussing the myth of Athena and Marsyas. Athena's refusal to play the instrument herself, he says, was traditionally attributed to the distortion of her features. But for the philosopher, arguing entirely within the tradition of an ethical critique of myth (see pp. 68–9), the imputation of vanity to Athena is hardly convincing. So he offers his own interpretation. The real reason why Athena had turned her back on this art was the fact that playing the *aulos* produced tones alone, and could therefore only have an impact on the emotions, while it was possible to sing while playing a string instrument, that is to say, use language and in this way promote the intellect.

We do not need to discuss here the question how far Aristotle's interpretation of this myth, which implicitly claims to hold also for the ensemble of statues by Myron, won acceptance from his contemporaries. Another point is more important. It is obvious that already Aristotle, writing barely a hundred years after the creation of the myth, could no longer have recourse to an established interpretation of that narrative (the motif of Athena's vanity, moreover, offers an explanation only for the course of the narrative, not for its meaning). So he develops an *ad hoc* argument, which amounts to processing the myth as an illustration for his theory of education. Put differently: even for Aristotle, the original context of the legend of Athena and Marsyas was so remote that it was anything but natural for him to take as given a specific interpretation of the material. On the one hand, in modern Classical studies it is perhaps possible to collect more knowledge of the time of Myron, in certain fields, than Aristotle had at his disposal. But the problems of interpretation, already present for the ancient commentator, represent a serious warning for the modern interpreter. Despite every effort to consider the historical context as comprehensively as possible, any view developed today on the meaning of a mythological image is in good part dependent on the interpreter's own horizons of knowledge and experience.

6 | Content and intention

To try to discuss the content of Greek mythological images in a summary fashion presents a fundamental paradox. The range covered in the subject-matter of the myths is practically infinite. There is no field of human activity, from the relationship of mankind with the gods, to the legitimation of claims to rulership and on to individual role conflicts, which could not have led to the creation of myths. Thus it will not be possible to assign the case studies so far discussed in this book to a small circle of areas of life, nor even to reduce them to a common denominator. It is not by chance that generalising treatises on Greek myth place emphasis on their comprehensive claim to explanatory power. Wherever in a society there were open questions about life that could not be subjected to a definitive order by law or convention, mythical thinking served a function precisely as a form of intellectual engagement with these problems. A comprehensive account of the issues that form the subjects of Greek myth and mythological images would thus be tantamount to a history of problems of Greek civilisation.

But within the wide range of themes addressed by the countless myths, the main focus does centre on certain points. This arises directly from historical change. To take one example, the role of the sexes as a theme is not to be expected in the Homeric age, with its largely prescribed positions for men and women in society. The situation had become quite different by Classical times where all the elements of state organisation, ranging from the family as smallest social unit to legislative political bodies, had become a subject of public discussion. To generalise, just as each epoch has its spectrum of pressing questions, so it seeks, on the level of myth, the materials which can reflect these topics.

There are, besides, focal points in the visual representation of Greek myths that result from the function of the type of monument traditionally used for the purpose (Chapter 4). At the level of the literary production of myths, the forms of presentation follow each other from Homeric times onwards, and each takes its audience and the societal framework into consideration: first, the rhapsodes and the lyricists as single performers before a limited circle of listeners; then, from Late Archaic and especially Classical times, the performances in the theatre before a large audience;

finally the versions of myths created for circulation in written form, whose radius is potentially limitless.

In an analogous way, the fields of representation for the visual versions of myth change and, with them, the interest in the content that they communicate. The heyday of the art of Greek temple building is in the sixth and fifth centuries BC. This span of time sees a change from aristocratic to democratic types of constitutional rule, a development that is not without effect on the mythological sculpture which adorned the buildings. In Classical Greek houses, to cite a second example, lavish furnishing was not customary; whereas in the Roman world, wealthy citizens for centuries laid great emphasis on living areas and grave-buildings fitted out with precious materials. This specific need actually serves as the decisive precondition for the fact that Greek myth once again enjoyed a phase of markedly vigorous visual presentation. Thus two strands run parallel in the history of the production of mythological images: on one side, the inner relationship of the viewer to the narratives, subject to continuous modification according to the changes in 'mentalities'; on the other, the *outer* form of communication of Greek myths by image, that is to say the various types of monument with their respective functions, each of which existed only for limited periods of time within the great historical span from early Greece to Late Antiquity.

And there is yet a third element which contributes to the fact that representations of myth give priority to certain aspects. The image as medium is not equally suitable for every statement and, above all, not for every class of statement. The strength of literary representation, as explained when laying the basis of definition (Chapter 2), lies in the extensive spread of narrative action and in the possibility of developing a rational argument through the speeches and counter-speeches of the participants. The visually formulated versions of myth, by contrast, work inevitably towards steering the viewer of an image towards certain associations. What consequences – positive ones included – result from these restrictions of the medium for communicating content, will be discussed in the last section of this chapter. But first comes the question, in relation to three large classes of monument, as to which ideas were pursued in the images realised in these monuments. It is possible to do this relatively comprehensively for Greek vase painting and Roman sarcophagi; for Greek architectural sculpture, much more by means of examples. The group of monuments which comes latest in time will be discussed at the beginning, because of the part played by the study of sarcophagi in leading the way for the methodology of the analysis of ancient mythological images as a whole.

Greek myths on Roman sarcophagi

Early research of the imagery of Greek myths, not only in the area of sarcophagi, is strongly philologically oriented. To simplify a little, the literary tradition from Homer down to the adaptations of Greek myths by authors of Roman Imperial times was seen as the primary or original version of the narratives, the visual versions as a reaction and as a transposition from one medium to another. To that extent, it was only logical for nineteenth-century research to relate the pictorial versions of a myth as far as possible to certain texts; and especially to go a step further again, by attempting to reconstruct with the help of pictures the lost textual versions of a myth; for example, dramas of the Greek tragedians for which we only know the title. In research on sarcophagi in particular, this approach has for long played an important part.

One practice, inherited from the philological perspective and already critically commented on above, is to direct attention in the first instance to individual mythical subjects and the historical change that they undergo. But it is only possible to do justice to the individual subject if it is analysed in its context of recurrent basic narrative patterns (mythologemes). With the example of the Athena-Marsyas group, we can readily reconstruct how an individual myth, however distinctive its action may at first appear, can be fitted into the system of Greek mythology (pp. 141–4).

These preferences in research have led to a contradictory situation in publication practice also. In 1884, the first of several volumes appeared of a lexicon, logically ordered in terms of individual figures, which drew on the entire mythical tradition of Classical antiquity and, to a certain extent, also took the pictorial evidence into consideration. For almost a hundred years, Wilhelm Heinrich Roscher's *Das ausführliche Lexikon der griechischen und römischen Mythologie* ('Roscher' for short in professional jargon) remained internationally the only reference work of its kind. In 1981, however, publication began of the *Lexicon Iconographicum Mythologiae Classicae* (*LIMC* for short), completed since then by the production of the eighth volume. It is entirely dedicated to the visual representations, supplemented by brief information on the literary evidence, and can claim to give access to them in a form that, if not complete, takes into consideration all the important aspects. This monumental iconographic lexicon, with its illustrations running into the thousands, has taken over from its predecessor its strict arrangement by mythical figures – with all the disadvantages, as well as the great advantages, which this brings. Visual phenomena which do

not fit the template of the lexicon are passed over. To name but the most serious point: the blurring of the boundaries between myth and real life, so characteristic of the visual representations, is scarcely ever noted, or is even obscured, in *LIMC*. For example, under the rubric 'Ajax rescuing Achilles' body' are listed not only depictions inscribed with the two names (Fig. 16), but also the anonymous pair of warriors as in Figure 6, in contrast to the obvious complexity with which the ancient artists operated.

For the special field of the pictures of Greek myths on Roman sarcophagi, there is a separate, again lexically arranged publication, called the *Corpus der antiken Sarkophagreliefs* (*ASR*). It documents in text and picture every mythological sarcophagus (and, once it is complete, all non-mythological reliefs too), ordered according to the subjects represented on each, from A for Achilles to U for Underworld. As in the case of *LIMC*, this form of organisation seems in principle to make good sense for a user-friendly publication, such as a work of reference should be. But it cannot be over-looked that the division of the surviving mythological images according to the participating figures, dictated up to a point by practical necessity, has profound effects on analytical research and in so doing, threatens to narrow down the perspective in the way that has just been sketched.

Research on sarcophagi, however, has already from an early stage direc-ted its attention, more emphatically than has so far been true of any other field of research on ancient mythological images, beyond the analysis of individual mythical themes, to the leading impulses that lay behind the choice and design of the materials. The *Recherches sur le symbolisme funéraire des Romains* by Franz Cumont (1942) led the way for research into the interpretation of the meaning of mythological sarcophagi. The merits of this work are not altered by the fact that immediate and vehement criticism was directed at the Belgian scholar's position, that the reliefs manifested a pronounced belief in the afterlife, so that it never had a strong direct impact. Cumont's general grasp of the subject pointed the direction for the future. He looks at the mythological sarcophagi reliefs in their entirety and understands the images as a means of making visible certain abstract concepts. This is a complete reversal in the face of philologically oriented research of the conventional type. According to the prevailing thesis, the producers and addressees of the images were not primarily concerned for this or that myth to be re-told in a faithful image; instead, these narratives are instruments of communication of ideas and therefore to a certain extent interchangeable with each other – the examples discussed below will illustrate this. In the last few decades this way of looking at these images has become the predominant one. With Paul Zanker's recently

published handbook (*Mit Mythen leben. Die Bilderwelt der römischen Sarkophage; Living with Myths: The Imagery of Roman Sarcophagi*) there is now a comprehensive overview of the Roman sarcophagi, which is logically structured according to the assumed intellectual content and not according to the mythical themes of the reliefs.

Three central aspects emerge, in concrete terms, in the discussion of the meaning of the mythological sarcophagi. One is concerned with the area that can summarily be called self-representation: images which spread the fame of the good characteristics of the dead persons or seek to indicate their high social status. The other two aspects are, in the widest sense, psychological in nature. Many representations apparently attempt to alleviate the suffering of those left behind, by reminding them of mythical figures who suffered an equally hard, often an even crueller, fate. Or, on the other hand, the reliefs turn to the other extreme and depict unworldly 'visions of bliss' (*Glücksvisionen*: P. Zanker). This, however, is only an outline of the present discussion. In no way can many sarcophagus reliefs be unequivocally classified under the one aspect or the other; alternatively, they show elements belonging to various levels of content. In the end, when the talk in modern interpretations turns to psychological categories like comfort or happiness, there is at times a great temptation to empathise, only too readily, with the emotions of people in Roman antiquity.

The sarcophagus with the images of Medea in Corinth (Fig. 13), already discussed in the context of the types of visual narrative, is a good example of the possibilities and limitations of the interpretation by content. From left to right, we see the preparations for the wedding of Creusa, Jason's new bride; then three scenes of Medea's revenge on her former husband: the killing of Creusa and her father, brought about by means of magic, then her pondering the murder of her own children, and finally her flight with the serpent-chariot, away from the earth. By modern standards, these images would be called extremely unsuitable for the decoration of a grave monument. But if a strict differentiation is made between Greek mythical narrative and Roman 'application' then, with a view to the group of monuments in its entirety, a number of positive aspects can be named immediately.

On numerous mythological sarcophagi, a death scene is placed conspicuously in the centre, as is the case here too. The basic underlying motif is that of the so-called *mors immatura*, the lament for the death of a still young person who had not entered fully into adult life. But this does not necessarily mean that the Medea sarcophagus was meant for a woman who died young, or for a woman at all. The first scene with the bridal couple, Jason and Creusa, also contains a typical element. Many sarcophagus reliefs show

motifs to do with weddings, be that in narrative contexts or as an isolated representation of the married couple. In both cases, the aim is to invoke the ideal of *concordia*, harmony between the partners. That, in the Medea myth, the young bride is threatened by the mortal danger hidden in the wedding gifts, was for the Roman viewer apparently no obstacle to using the subject for sepulchral purposes.

Medea's fairytale drifting away with the snake-chariot, too, probably gains a positive sense on the symbolic level, even though this is about the flight of a murderess: the sorceress can escape the troubles of common human life as she pleases. On sarcophagi, a snake-chariot is also driven by the immortal Goddess Demeter as she hurries from one place to the next, searching for her lost daughter. Finally, with the two young men who stand, facing each other, exactly in the centre of the image, yet another aspect in the content is addressed. Their central position and the idealised nudity of one of them, as well as the beautifully presented arms, turn the pair into idealised figures who embody, in a dry allegory, Roman *virtus*, that is energy and military prowess. This makes their detachment entirely intelligible. In terms of narrative, and despite their spatial proximity, they have nothing to do with the horrific scene to their right, and so this also renders otiose the speculations, often raised, as to whether the beautiful youth should represent the unsuspecting bridegroom Jason, together with a friend.

Together with the sarcophagus was also found its lid, whose raised frontal side is once again carved in relief. The contrast with the dark events on the chest could not be greater. The reclining female figures embody the four Seasons and the manner of their depiction, with the Erotes cheerfully advancing towards them, puts it beyond doubt that here we are meant to recall, first and foremost, the yearly recurrent rhythm of nature and not anything like the inevitable dissolution at the end of the annual cycle, which would fit the fate of Creusa.

To treat a single sarcophagus in isolation can possibly make the determination of its meaning appear somewhat forced. But it is not a source of any difficulty that we find, on a sarcophagus with a completely different subject, not merely a parallel form of treatment of Greek myth, but also related handling of motifs.

The beauty of Adonis led even the goddess of love, Aphrodite herself, to fall into the dependent state of a woman hopelessly in love. But the youth refused to give up his passion for hunting and was killed by a wild boar. On the sarcophagus, dating from about AD 220, now in the Vatican (Fig. 42), this last episode is shown in the right-hand third of the front side. While his companions are still stabbing at the beast, his kneeling pose and the

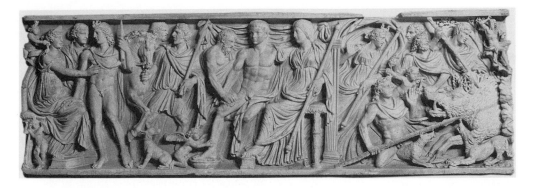

Figure 42 Adonis and Aphrodite. Sarcophagus, Rome, *c.* AD 220

helplessly raised left hand signal Adonis' end. So once again, we have the sudden death of a person still young, that standby scene that will occur many more times on Roman sarcophagi. Penthesilea dies in the arms of Achilles, Actaeon is killed by his own hounds at the behest of Artemis, Alcestis goes to the Underworld on behalf of her husband, the splendid heroes Hippolytus and Meleager die through the intervention of a third party – as the narratives and forms of death vary in detail, so the motif of the *mors immatura*, the premature death not brought about by one's own guilt, the more obviously represents a favourite choice of the scenes shown on sarcophagi. This in fact carries with it the psychological interpretation already mentioned, whereby Roman clients sought to master the personal grief caused by the loss of a family member by presenting to themselves and to the visitors at the grave the misfortunes of great figures from myth.

In the hunt, we are immediately faced with a second favourite motif of this class of monument. The hunting of wild beasts or monsters once again plays an important part in the stories of Hippolytus and Meleager that were so popular on Roman sarcophagi, and in the less frequently represented story of Bellerophon. From a wider context we can clearly infer that hunting, however catastrophic its outcome for Adonis, carried the *positive* significance of a symbol for *virtus*. On the one hand there exists a sarcophagus relief joining the fate of Adonis seamlessly with the representation of a Roman military commander at the sacrifice, and of him and his wife together. On the other, hunting in its own right is a very popular subject for portrayal on sarcophagi, independent of any linkage to a mythical context. So it is not simply a matter of narrative constraint if Adonis, in his leave-taking from Aphrodite (at the left hand edge of the image) seems rather artificially to take up the pose of the hunter.

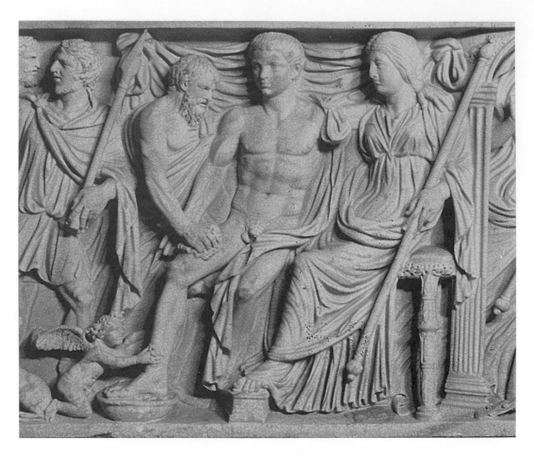

Figure 43 Portrait heads of Adonis and Aphrodite as shown in Fig. 42

But in a much more emphatic way than in the other parts of the relief, the central scene serves to make allegorical statements. Once more the viewer is confronted by Adonis and Aphrodite in a dignified seated pose, suggesting that of a ruling couple. An old man and a small Eros are attending the wounded man whom, according to the course of the narrative, we have to imagine as doomed to die. There are already two departures from the rule of the coherent visual narrative, first, in that the third episode in the sequence of the story is placed in the middle; secondly, by the decision to give both main figures, not the timeless idealised hairstyle common to gods and heroes but, in this single case, one conforming to characteristic contemporary fashion (Fig. 43). The short haircut of Adonis, together with the swept-back hair of Aphrodite, are commonplace in private portraits of the early third century. So the figures of contemporaries have been superimposed in the central place on the front of the sarcophagus, slipping into the role of the divine lovers. In terms of content, this central scene offers nothing that was

Figure 44 Dionysus with his circle and the sleeping Ariadne. Sarcophagus, Rome, *c.* AD 220

not already present in the Medea sarcophagus. Adonis and Aphrodite, precisely because they seem as if cut out from their place in the narrative, stand for the ideal of harmonious partnership, *concordia*; and the relief once again acquires a visionary element, from the utopian conception of proximity to a deity, here granted to a mortal figure.

From this point of view, the substantial differences on the level of the mythical narrative, between the Medea and the Adonis sarcophagi, are far eclipsed by their closeness in content – through the concentration on the elements of comfort and self-representation – and also in their conception, through the process of tying the communication of these messages to a mythical narrative of independent value. The appropriate expression that has been adopted is 'layers of meaning', to be understood as vertically divided levels on which to operate: on the surface, a legendary episode in visual form, below it the 'deeper meaning'. To deal with this combination must have made certain demands even on the ancient viewer. It is no surprise therefore that, from the very start of the diffusion of this class of monument, much simpler and more directly conceived mythological reliefs were also created. Particularly when the emphasis was to be placed on the element of the vision of bliss, so far noted by allusion, compositions were chosen that, by comparison with the two reliefs we have just been discussing, can be reckoned notably easy of access. They include the large group of so-called Dionysiac sarcophagi, which bring together figures of the world of the wine god in varying contexts. Even if these representations point towards the mythical sphere, it is established archaeological practice not to class them among the mythological sarcophagi in the stricter sense, because their narrative element is as a rule only slightly developed, or altogether absent.

An example at Hever Castle in England, belonging like the Adonis sarcophagus to the early third century (Fig. 44), portrays a Dionysiac revel

in typical style, but with a narrative thread woven into it. Satyrs and maenads make music and dance, as many as three musical instruments are being played, and the old man close to the left-hand edge of the relief also seems to be a little carried way by the wildness of the movement. The panther, as well as the tree and the herms at the right-hand edge of the relief, place the setting in the open air, far away from the ordered life of the settlement. In the centre appears the source of all this liberating merriment, the God Dionysus, supported by a dignified representative of his wider retinue. The goat-footed Pan, who stands next to the right, introduces the narrative element of the relief. Pan pulls aside the piece of cloth with which a sleeping woman had covered herself, and thereby exposes to view her naked body. She could be any one of those maenads with whom satyrs like to have their sport (Fig. 15), but in the context of the Dionysiac sarcophagus reliefs, the motif points to a specific mythical event. After Theseus had been able, with the help of the king's daughter Ariadne, to overcome the Minotaur (Figs. 12, 31), he sailed away from Crete with her but then, during a temporary stop at the island of Naxos, abandoned her while she was asleep. Yet she does not remain alone for long. Dionysus finds her and thus a woman abandoned by a mortal becomes the consort of a god – the same fundamental motif on which the story of Adonis and Aphrodite is based. So on our sarcophagus, Pan's raised right arm should not be understood solely as a gesture of surprise, but also as a signal to Dionysus, drawing his attention towards Ariadne.

The legendary scene hinted at here, with the at first abandoned Ariadne, does not at all change the fact that the representation as a whole suggests the image of a carefree world, where people abandon themselves to sensuous pleasures and are freed from the troubles of everyday life. Other large groups of sarcophagi are indebted, though each with its own emphasis, to the same fundamental idea. As the most closely related of these, let me cite just the sarcophagi with sea creatures, of which again some 400 examples survive. Human and half-animal creatures of every kind romp around in a not clearly located marine landscape, and their only interest seems to be to enjoy their existence, making music in the ocean. The musical element, much more strongly characterised on other sarcophagi, gives an indication that even reliefs with an underdeveloped narrative content, like the one on the sarcophagus in Hever Castle (Fig. 44), could still serve the self-representation of the client and his family. Education, which included, along with music and literature, the content of Greek mythology, was not only used for personal self-realisation but was also an important status symbol. Only members of the upper classes could afford such luxury. The

gain in distinction, which the materials and artistic value of the sarcophagi already confer, is further heightened by the subjects represented, whose meaning is not accessible to everyone.

The three categories of content, under which the colourful diversity of themes on the mythological sarcophagi can be grouped – models for comfort, visions of bliss, and also the self-reassurance of giving visual shape to Roman values and norms – represented something like options for the clients. But whether individual preferences played a large part in the choice of subject-matter is doubtful. In the burial chambers used as family vaults, evidently – insofar as the few reliable findings allow us to judge – there normally stood sarcophagi with reliefs of very varied kinds, which called to mind a broad spectrum of aspects instead of giving conspicuous preference to one of them.

Greek vase painting

Discussion of the subjects of the images on Greek vases follows on from our observations on Roman sarcophagi, insofar as here, once again, we are dealing with a field of so-called private representation. Like the decorated stone sarcophagi, painted pots were bought by individuals and, here again, state regimentation played only a very general part, for example through the restriction in law on material display at funeral ceremonies. The term 'private', however, must not lead to misunderstandings. The very objects that form the material for the archaeological interpretation of myth, were frequently used in semi-public contexts. The images on them, for that reason alone, were typically linked with the collective values that prevailed in the social community, rather than giving expression to individual convictions. A further point of comparison between these two cases is the great concentration of surviving material, which allows a systematic engagement with the fundamental questions of interpretation.

Yet despite the comparatively favourable conditions, research into mythological images on Greek vases has so far developed only in a rudimentary way towards a synthesis of the values and ideas that they communicate. Since the 1960s, a group of French researchers around Jean-Paul Vernant, standing in the Structuralist tradition, has demonstrated a very effective approach towards this goal. Their researches are primarily aimed at a systematic anthropology, or history of mentality, of Greek culture. Interest is directed at central fields of life such as the religious festival, the military sphere, the world of Eros or the domain of women. From the start, it was

characteristic of their method here to evaluate thoroughly not only the written sources but also the pictorial representations and in particular the huge corpus of vase paintings, and to understand them as elements of a communicative system complementary to language. It can be reckoned as methodologically progressive when, in so doing, they evaluate together the mythological representations and those that are related by motif but not mythological, without disjunction. We cannot, however, speak of developed Structuralist research on mythological images, because the images with their specific peculiarities of design and potential for conveying messages are not a central focus of interest for the representatives of this school, who are mostly not Classical archaeologists and tend to reduce these to the level of text modules for an alternative 'reading' of Greek culture.

The tabulated listing (see below) constitutes an attempt to identify the most important areas of content, to which the mythological images in their apparently almost endless diversity, and with them a large number of scenes of the real world on Greek vases, can be assigned. This synthesis has been developed primarily with Attic vases of the sixth and fifth centuries in mind but it can, in its basic outlines, also claim validity for other places and regions. The more roughly such a scheme is applied, the more clearly the categories of content stand out but, at the same time, the greater the danger of misleading simplification. In principle, the classification set out corresponds to the interpretative approach to the Roman sarcophagi described above. It seems therefore to make sense, at the outset, to describe in a general way common features and differences in the two large groups of monuments when analysing them.

For vase painting this results in a wider range of subject, in each category of content, than for the sarcophagi, since the latter served a strictly limited purpose, while the vessels by contrast found a use in a diversity of contexts. Further important differences arise from the divergence in cultural conditions. Roman sarcophagi were produced for the inhabitants of a highly centralised empire, which granted relatively few possibilities to the individual for socio-political development, while the vases were for the most part intended for city-state populations with small-scale internal organisation and strong social dynamic. If one sought to cover, in as complete a way as possible, the aspects of content addressed by the mythological images on the painted pottery, this would amount to a comprehensive cultural history of Greece. In this context, therefore, it is possible to address only certain central points. But at least there can be only few classes of motif on the vases which are not covered by the five categories.

Typical motifs of myth	Category of content	Typical motifs from real life
deeds of the gods divine aid to heroes	**religious experience**	cultic activities
deeds of the heroes (Heracles, Theseus etc.)	**ethos of male achievement**	arming scenes athletics
Dionysiac scenes loves of gods and heroes	**male enjoyment of life**	symposium erotic scenes
mythical couples: gods, heroes and mortals	**women's life; couples**	marriage women's quarters
deaths of heroes	**death**	warrior's farewell tending the grave

It is one of the essential conditions of archaeological research into myth, that no clear distinction can be drawn between images of myth and those of the lifeworld (see pp. 50–9). Accordingly, the scheme explicitly connects the one sphere with the other on every level. Scenes of the recovery of a dead warrior, for example, can be found with close correspondence of motif, both with Homeric heroes identified by name-inscriptions (Fig. 16) and with anonymous figures (Fig. 6), where it must remain open whether the viewer, here too, should think of Ajax and Achilles. What is vividly shown here, in a single subject, can be reckoned a firm principle: for each category of content, mythological images as well as those from the real world come into play, according to the message intended in each case. The examples below will explain this more precisely.

Like the diagram of the contextual fields (p. 128), this scheme for the areas of content addressed in Greek vase paintings inevitably has a distinctively model character. Neither should we expect that every vase painting was perceived in its time as a statement about a certain field of life, nor are we capable, from our modern standpoint, of clearly and reliably attributing every image to one or more of these fields. The warrior images just mentioned, for instance, could equally well be classed under male striving for fame, or concern with death, or even both. But these uncertainties which apply to many individual cases do not cast doubt on the justification of the approach here suggested. Great as is the diversity of the subjects and images on the vases, conditioned by the striving for originality of the producers and recipients, there is nevertheless only a manageable number of aspects of human existence from which they take their subjects.

'**Religious experience**' includes a belief in transcendental beings or authorities, notably the gods in human form, as well as participation in cult practices. On the level of myth, all representations must be included here which describe the nature of the gods and identify their relations with mankind. Thus the battle of the gods and giants, frequently depicted on vases, shows that the Olympian gods overcame strong adversaries. By this proof of their power, they win approval for their position. The motif of the assembly of the gods, at times equally favoured, shows the Olympians as a community established in its own world, but one which is not unattainably remote for human kind, as the assumption of Heracles into this circle shows (Fig. 2).

More explicitly, the images showing divine help for heroes revolve round the wishful thinking of divine protection for mortal men. The portrayal of Athena on the amphora from Eleusis (Figs. 20, 21) is an early example from a long chain of comparable scenes. Here the goddess appears as companion to Perseus, who kills the Medusa and in doing so exposes himself to the risk of being turned to stone by the monster's gaze. In the sixth and fifth centuries, pictures of the same goddess as supporter of Heracles gain in popularity (Fig. 7). The need for assistance, even on the part of the greatest heroes in Greek mythology, includes as its opposite the idea of downfall despite, or even directly because of, divine intervention. The image on the interior of the Sosias cup (Fig. 1) broaches the issue of this problematic in a subtle way. Single elements of the picture, like the tripod on the shield as a sign of Apollo, direct the viewer's associations towards the mythical idea according to which this god's intervention had brought about the deaths of the two heroes, Achilles and Patroclus. The picture on the outside of the same vessel (Fig. 2) strengthens this connection by showing Heracles as a figure born mortal, but able to overcome death.

On this last picture, several gods hold bowls for libations in their hand, while a winged divinity pours into them a liquid from a jug. This is a cult practice performed on various occasions in the human domain. It represents, in its most elementary form, a ritual for making contact with the gods (when the gods themselves pour a libation, then according to a widespread opinion they are deriving enjoyment of their own status from the solemnity of the ritual action). The single motif most frequently depicted is probably the libation at the warrior's leave-taking. The departure from the familiar and safe domestic environment is, so to speak, highlighted by a libation while, at the same time, the participants invoke the protection of the gods. Pictures of lavish cult practices, by contrast, are found only relatively rarely, although the great religious festivals were undoubtedly high points in the

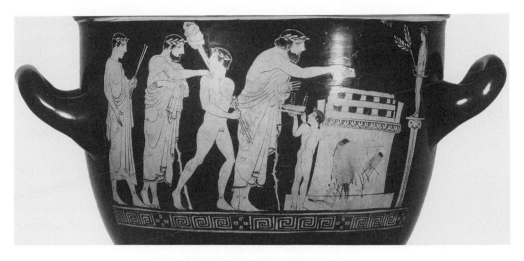

Figure 45 Scene of sacrifice. Attic red-figure bell-krater, *c.* 440 BC

life of the community. Evidently pictures representing the gods in person or, on the other hand, emphasising the role of the individual in the libation or sacrifice, were best suited to express the need for contact with the gods.

An image on an Attic krater in Frankfurt, from the mid-fifth century, is one of the rather unusual scenes depicting the activities at an elaborate animal sacrifice (Fig. 45). The man at the head of the procession is laying pieces of meat on to the flaming altar, whose plinth is smeared with the blood of the animal sacrifices; the naked youth is bringing more sacrificial meat on spits; and a musician holding a double *aulos* in his left hand brings up the rear of the procession. At the far right, a statue of the youthful Apollo stands on a column that serves as its base. His bow in a way leads us back into the world of myth, for the weapon belongs to the God in his role as the active authority who intervenes in the affairs of men, both of the assiduous participants in the cult before him, and of the viewers holding the vessel in their hands.

'Ethos of male achievement' – this expression denotes not the only aspect, but a pivotal one, of the free Greek citizen's definition of his identity. From the earliest historical period, the idea of competition permeates many aspects of Greek society. The Homeric heroes strive, with an enthusiasm that is downright obsessive, to stand out from the generality of their competitors and win the recognition that not only brings them social esteem during their lifetime, but also assures them of posthumous fame as a kind of secular immortality. Military achievement and athletic excellence here form a virtual unity. In Book 23 of the *Iliad*, which describes the funeral games

held in honour of Patroclus, the warriors in the Greek camp line up against each other for the athletic competitions with great eagerness. Here there is already indicated a close reference to the category of content discussed just now, that is religious life: all the great religious festivals also feature in their programmes competitions (*agones*); or, conversely, all major competitions, musical and theatrical ones included, are integrated into a cultic framework. The Olympic Games, held in the sanctuary of Zeus, are only the best-known example of this phenomenon.

The ideal, of excelling by comparison with the others, is reflected in the profusion of vase paintings, almost impossible to survey. Every representation showing the extraordinary deeds of mythical figures can be seen as a variation on this one theme. Whether Achilles and Patroclus are commemorated as outstanding participants in the Trojan War (Fig. 1); or Theseus overcomes the Minotaur (Fig. 12); or Odysseus blinds Polyphemus, or Perseus slays the Gorgon Medusa (Fig. 21), not to mention the thousands of images of Heracles (Fig. 7) – the mere fact that the fame of these heroes is transmitted from one generation to the next affirms the status of their achievement. Even if it is first and foremost the downfall of a figure like Sarpedon that is captured in collective memory (Fig. 17), he is a fitting symbol for the acquisition of honour through military action. The myth makes an explicit point of these ideas by narrating how, by the intervention of Zeus, the two death daemons retrieve the body and thus make possible an honourable burial and enduring memory for this man in his homeland.

This same vessel by the vase painter Euphronios also demonstrates very vividly how blurred is the transition from mythological to non-mythological images, from the aspect of the ethos of male achievement. On the reverse of the krater (Fig. 18) are shown warriors preparing for battle. The name-inscriptions make it clear to us that the men are not meant as giving visual form to a scene of myth, but together act to draw the theme of war across into the sphere of real life (see pp. 57–9). Euphronios also painted on other vessels, with similar attentiveness, athletes in varying poses. The two options, 'myth' and 'real life', were chosen with roughly equal frequency on vases, when it was a question of addressing the ideal of recognition through personal achievement. Depictions of anonymous warriors and athletic competitors make up a very large group in the repertoire of monuments, no less than the images of figures from myth who fight against human adversaries and all manner of fabulous creatures.

Besides the striving for personal recognition, the vase paintings also give us information about a whole set of further components of male self-perception in Archaic and Classical times. Two aspects, closely linked to

the idea of achievement, should be briefly mentioned here. Homer already sees the ability to perform convincingly 'in council' as an important challenge for a man of standing. Given the dominant role of military combat in the *Iliad*, it is easy to overlook this point. Strength is also to be expressed in the capacity of winning over others by argument, and thereby finding a peaceful solution for conflict. Thus Sarpedon is said to have been equally distinguished as warrior and as judge (16, 542). Thoas, by contrast, as a representative figure in the Greek army, is picked out by Homer for his superiority in discussion 'when the young men were vying zealously in debate' (15, 281). Occasionally, there are pictures on the vases which can be seen, with good cause, as referring to this ideal of what we today would call social skills. It is one of the many aspects present, for example, in the scenes of Hector's ransom. The picture by the Brygos Painter (Fig. 25), by the manner of its portrayal, certainly emphasises the conflict between the aged petitioner Priam and the youthful Achilles, in the initial refusal to hand over the fallen son. But, as the viewer knows, it is not the ransom or any kind of power factor that induces Achilles to change his mind. The Trojan king achieves this by his words, and by the thought-processes that they trigger in Achilles. The memory of his own distress at the loss of his father and the news of his friend Patroclus' death moves him to recognise Priam's request as a justified one, and hence to place the value of certain ethical considerations above the right of the stronger (in military terms).

The images, quite popular in the Classical epoch, of Oedipus before the Sphinx can be cited here as a further example (Fig. 8). An important impulse for the creation of these pictures, on one hand, probably originated in the demands of funerary art – the triumph over the homicidal monster served as a symbol for the desire to overcome death. But, without doubt, one of the aspects of the content of the subject is also the capacity of Oedipus to master through intellectual competence a task that could not be discharged by force. The version on the Vatican cup (our illustration), where part of the famous riddling question is included as an inscription and where Oedipus appears, more than is the case with many other pictures, in the pose of the thinker, exhibits this aspect especially clearly. With the destruction of the Sphinx, civilised life can resume in an orderly fashion.

With this half-human figure, part lion and part woman, one enters at the same time an area that again links up with the shaping of identity. Proof of membership of a respected social group can be achieved not only in a positive way, by the demonstration of individual achievement, but also in a negative way, by keeping oneself aloof from all people who stand outside a certain social norm. From the male point of view, this means in concrete

terms separation from non-Greeks, from slaves and from women. Research on 'the Other' has in recent years made an intense effort to evaluate this phenomenon in the light of the literary and visual sources. According to this research, a veritable profusion of images was created to contribute to the definition of one's own identity by calling up the image of the 'Other'. Belonging to the level of real life, therefore, are such things as depictions of people from lower social classes, of Persian and other non-Greek warriors as well as civilian members of other nations. The diversity of mythological images that can be cited in this context is apparently limitless: large groups of 'divergents' like the Amazons who, as combatant women, turn a firm role-pattern upside down; or the half-animal centaurs who violate recognised rules of communal living through lack of control over their urges (compare Fig. 24); but also creatures such as the Sphinx, the Minotaur or Polyphemus, who all practise indiscriminate homicide and who are successfully confronted by a hero, in order thereby to demonstrate the superiority of the normal world.

But whether the majority of the images are really propagating a simple opposition of those figures who defy norms with those who conform to them, has more recently and on good grounds been called into question. At the least, one must reckon with the possibility that, in an epoch as critical of tradition as that of Classical Greece, the idea won favour that in every individual, besides impulses that are supportive of order, there are also hidden drives that seek to renounce civilising constraints. Centaurs and Amazons, seen from this perspective, are by no means merely repellent, but also fascinating figures.

'Male enjoyment of life' should anyway appear as a separate category here because an unusual amount of space on Greek vases is given over to representations of sensuous pleasure – not a surprising result, however, in the light of the function of the vessels on which the images occur, which in many cases was as utensils for the feast (Fig. 29). The heading 'symposium' leads immediately to the question why enjoyment of life should be assigned exclusively to the male domain. In Greek culture, of course, women also experienced satisfaction of the senses in a variety of ways, through their sexuality, but also in the musical sphere and in a collective setting, such as that of the dancing and music performed at religious festivals. They also came to prominence in productive fields: Sappho is merely the best known in the series of Greek poetesses. And yet enjoyment of the senses represents a field of life which, according to the dominant ideas of the time, is a constituent of one's own self-conception only for men. It is no exaggeration to say that the 'ethos of achievement', which we were discussing just now,

extends also to the capacity for enjoyment. Aesthetic expertise and erotic experience are among the areas which complete the formation of a man of high standing, who does not need to earn a living with his own hands.

Besides the literary evidence, countless images demonstrate just this. Already the earliest vases with figural scenes, scenes of the dance and of musicians are found, performing their songs in front of a small circle of listeners. These pictures of the eighth century can be matched with the description of Achilles in the *Iliad* who is skilled, not only in arms but also with the lyre (9, 186–7). From the early sixth century on, a sophisticated culture of the feast develops. Men congregated in a private house to drink wine together, to debate and to amuse themselves. Here women are present only in the role of attendants, as musicians (Fig. 29), as *hetairai* (paid 'escorts'). The popularity of the symposium leads to a heyday in the production of fine drinking vessels which, in turn, sets off a boom in the images which match the object with the occasion. The phenomenon of the fundamental interchangeability of depictions of myth and of real life is more prominent here than in any other of the five categories of content. Satyrs are in search of an erotic adventure when they approach a sleeping maenad (Fig. 15) – on our cup, incidentally, a woman who from her outer appearance alone, with her demure cap and conventional clothes, could pass by implication for a normal fellow-citizen of the viewer of the image. At the same period of Attic vase painting and on the same types of vessel are found a mass of 'normal' erotic images, at times even with a parallel arrangement of figures. A famous cup from the years around 500, whose painter has signed with the name 'Peithinos' which means roughly "the seducer", carries to extremes the play with the change of levels (compare p. 12): on the two outer faces appear, in one case pairs of men and in the other men and women in tender encounters, while on the interior (Fig. 4), by contrast, a mythical pair of lovers are shown, the Goddess Thetis trying to fend off her – mortal – suitor Peleus.

Comparable observations can be made on vase paintings which refer to music, dance and theatre. Portrayals of Athenian citizens who have slipped into the role of a satyr for a theatre performance (Fig. 39), give us an idea of how the two spheres were fused into each other in contemporary stage practice. The reverse side of the krater with the solemn recovery of the Trojan War hero Sarpedon delivers, yet again, a disguised, but also very elegant proof of how closely the serious business of war and the joy of satisfaction in music go together (Fig. 18): a music-making crab decorates the shield of the warrior in the centre of the picture. The close association, by their motifs, between the military and the musical spheres must not be

seen as a mere joke; the same painter often makes this link in a more broadly developed form.

'Women's life; couples'. Here, decidedly more than in the other categories of content, a historical distinction is to be made. It is only from the early fifth century onwards that vase paintings which make express reference to the sphere of women gradually take over a significant place in the repertory of motifs. The question of the background lying behind this leads to a long-debated and controversial topic, the position of women in Greek and especially in Athenian society. The debate as to whether women were, even under democratic constitutions, more or less excluded from public life, or whether the new epoch brought new possibilities for development on a broader front for them too, cannot be retraced here. In addition, this discussion can hardly be brought to a decisive conclusion, because of the extreme lack of first-hand testimony. Precisely for this reason, the vase paintings explicitly dedicated to the life of women represent a valuable enrichment of the source material. In any event they reinforce the impression that, in the course of the debate over the role of the individual member within the social structure, typical of democratically constituted states, the position of women and furthermore the relationship between the sexes, became a topic of discussion in society.

To place 'Women's life' and 'Couples' in one category may at first occasion surprise. But it is the vase paintings which attest to the culture-historical phenomenon that, for a woman, entering into the married state was regarded as an event of paramount importance. It was only through marriage that she achieved, as it were, completeness as a human being – something which does not equally apply to men. So it is that, of the images which indisputably relate to the sphere of women, a very large proportion have to do with the celebration of weddings. On an Attic vessel of the years around 430 BC, which to judge from its basic form was used as a container for the water with which the ritual bathing of the bride was carried out (*loutrophoros*), we can see an episode from the ceremony (Fig. 46). Without attaching great importance to strict fidelity in his picture, the vase painter has portrayed, in the left-hand half of the picture, the procession of the bride from her house to that of the bridegroom. The latter is lifting his future wife on to the chariot; companions frame the couple. A small flying Eros also appears, not as an addition to the scene, but as a purely atmospheric element, holding in his hand a myrtle wreath. But merging of the mythical sphere with experienced reality seems also to apply to the right-hand half of the picture. The two figures can only be meant as the bridegroom's parents, whose house the procession approaches. But the enlarged scale of their

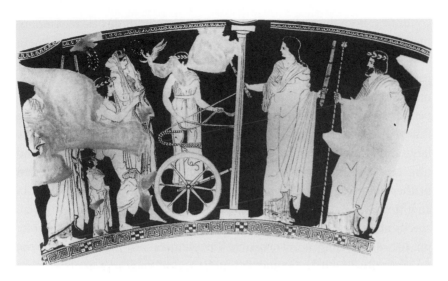

Figure 46 Wedding procession. Attic red-figure loutrophoros (drawing), *c.* 430 BC

bodies, by comparison with all the other figures, as well as the sceptre in the man's hand, are evidently meant to confer on them a status extending above the human scale.

The semi-mythical character thus given to this everyday scene represents one of the arguments for making a connection between a series of images which, insofar as they are securely identifiable, contain solely figures of myth, and the range of themes concerning women's life and couples. The basic motif of 'bringing home the bride' is also seen, for example, of Paris and Helen, or of Heracles and Hebe. These depictions with mythical couples make more explicit what the 'enhanced' features of the vase painting just discussed could only hint at: the wish for the marriage – according to convention, in principle arranged by the parents – to be a happy one.

To the realm of such wishful projections belong also the images showing gods and heroes as lovers of mortal women. Though recent research has rightly pointed out that to speak of 'the amours of Zeus' has something trivialising about it, in view of the force and trickery involved in these, the buyers and viewers of the vase paintings would presumably not have understood this objection. For them, the accolade expressed by the loving desire of a god for a mortal woman was the only important element in these myths. This aspect made the vase paintings into suitable images of wish-fulfilment in connection with weddings and marriage.

The confrontation with '**death**' represents one of the great themes of Greek vase painting, and is undoubtedly the one with the strongest

continuity. Both the earliest and the latest flowerings of this class of monu-
ment – in the eighth century BC at Athens and in the fourth in southern
Italy – are alike in being beholden to the highly developed demand for
painted pottery in burial cult, whether as grave gifts, as grave markers or as
utensils in the context of the funeral ceremonies. In the long intervening
periods too, vessels decorated with figural scenes play a large part in the
funerary culture of certain regions. Particularly in the interpretation of the
large and extremely diverse corpus of Attic vase paintings of the sixth and
fifth centuries, however, research has had to face a technical difficulty:
neither the motifs nor the contexts of production and discovery allow, in
anything like all the instances, a reliable statement as to which vessels were
specifically destined by the painters for use in the funerary context (see
pp. 101–3). Certainty is only possible with pictures showing scenes from the
funerary ritual itself. In Geometric times, the dominant representations are
those of the lying in state of the deceased person in their house, while in
Classical times, it is the visit to the grave that is often portrayed; in rare cases,
at Athens and in southern Italy alike, the procession to the grave is also
shown.

A second group of vase paintings holds an intermediate position, in two
respects. The scenes, very popular for a time in Attic vase painting, of a
warrior in the process of taking his leave before going into action (Fig. 5)
and, even more so, the motif of the carrying home of a fallen warrior by a
comrade (Fig. 6), have been identified by researchers both as mythological
scenes and as ones from real life. This uncertainty may indeed be well
founded in individual cases, since it is very possible that the aim of the
vase painters was to allow the viewers a certain leeway for associations.
There is also, however, a probable ambivalence on the level of content as
well. Images like the two just cited have been brought into association with
the ancient concept of the 'beautiful death': that is, with the notion that there
is something honourable in dying on the battlefield for a good cause, if
possible still in one's younger years, as a man who has just entered adult-
hood. If one were to confine oneself more strictly to the literal message of the
two images on the amphora, then there is nothing there but warriors and
their families, on one side in an anxious leave-taking, on the other in the
lament for the fallen. But the two aspects, the ethical and the emotional, are
by no means mutually exclusive. To speak of ambivalence does not carry the
insinuation of factual 'uncertainty', but refers to the 'confrontation with
death' already suggested in our initial heading: grief may find compensation
in the consciousness that the dead man has won great posthumous fame
through his military achievement.

With the explicitly mythological images, there are numerous good reasons for recognising just such an ambivalent trait in the handling of death. The death of Sarpedon on the krater of Euphronios (Fig. 17) gives an especially instructive example of this, because his dying is brought home to us by the gaping wounds, yet the same is also true of the need for honourable burial, through the intervention of the divine figures. The favourite motif of the destruction of a monster at the hands of a hero (Figs. 8, 12, 20, 21) can also be cited in this context, since it always carries an implicit suggestion of the possibility of failure, especially when the presence of Athena or another female helper reminds us that the deed could only be accomplished with external support. In every case, only a careful analysis of the context, such as was conducted in abbreviated form for the Sosias cup (Fig. 1) in our introductory chapter, will allow of a conclusion as to how an image, conceived as a tribute to the virtue of the warrior, was also meant as a confrontation with death. In the final section, yet another prominent pictorial design will be investigated with a view to this aspect, in the shape of the scene of Achilles and Ajax playing a board game (Fig. 48).

Greek architectural sculpture

Among the classes of monument employed to give visual form to Greek myths, pre-eminence in terms of numbers belongs to Greek vases and Roman sarcophagi; but in their level of effect, the sculptures incorporated in public buildings (see pp. 106–8) come first. It is a commonplace that, in Greek as well as in Roman antiquity, the boundary between public and private cannot be drawn as it is in the contemporary western world; that even the use of these modern terms can, on its own, lead to misunderstandings. But on the other hand, one would miss the point of the specific nature of the images if their differences, at the level of the relationship between object and viewer, were not taken into account. Images on vases and sarcophagi are addressed, in the first instance, to individuals, to separate or restricted groups of people, such as the participants in the circle of a symposium, or the community of mourners coming together to attend the ceremony. The buildings, by contrast – these are primarily temples and other sacred structures – have a collective both as their agency and also as their addressees, namely the entirety of the visitors to a sanctuary or a city.

Correspondingly, it is to the values of the collective, once again, and not those of the individual that the mythological images on public buildings relate. Of the five categories of content cited in the previous section, only the

first two are of importance here, religious experience and the ethos of achievement. Other factors enter the picture, especially – as the examples which follow will demonstrate – the use of the images to form a collective identity. This last, together with the first item mentioned, in general form a constant factor for the images of myth that are incorporated in architecture. In numerous cases, the outcome of the interpretation is that the religious and the political content balance each other or, better, form an indissoluble unity, which presents itself in ever-changing forms, according to the conditions of the time.

Measured against the almost overwhelming profusion of the surviving mythological images on Greek vases, the results that pedimental groups and the other ensembles of Greek architectural sculpture exhibit are few and far between. The pedimental sculptures of the Temple of Artemis on Corfu (Figs. 22, 23) stand more or less alone for their time, not unlike the statues from the pediment of the Temple of Zeus at Olympia. For several ensembles to survive, or even to be created, at one and the same place in quick succession was doubtless the exception and not the rule. As with all monuments standing in relative isolation, so too for the images of myth incorporated in architecture the consequence is that their context can only be brought very imperfectly to light and a satisfactory interpretation, even for monuments long familiar, cannot be achieved. So, for example, for the west pediment of the Temple of Zeus at Olympia showing the Centauromachy (Fig. 24), the interpretation as an allegory of inter-Greek conflict can only stand as one approach among others to an explanation. Accordingly, two buildings whose history is well known will serve to illustrate the possibilities of interpretation.

The Parthenon on the Acropolis at Athens, the Temple of the Goddess Athena in her quality of *Parthenos* (Virgin), was built in the years between 447 and 432 BC. Its construction coincides with a phase of intense debate in society about the concept of democracy. Powerful forces strove, in a well-nigh obsessive way, to put the collective idea into practice and to involve the (male) citizenry, as comprehensively as was technically possible, in the processes of political and juridical decision-making. With this political factor must be associated the fact that, on the Parthenon, the notably unusual motif of a cultic procession comprising some 200 people was given shape in a relief frieze. On the surface, admittedly, the choice of theme for the *c.* 160-metre-long frieze is explained as homage to the goddess, in whose honour the procession takes place. But a considerable impulse is undoubtedly also represented by the need to make the sacred building into a kind of monument for the Athenian citizenry

which appears here, and for the form of constitution which it has so proudly generated.

That the frieze is to be understood not as a reproduction, but rather as a symbol, is shown by the scene at the head of the procession. There, the portrayal of a procession passes almost seamlessly into that of an assembly of the Olympian gods. In the relief, the gods are spatially very close to the people taking part in the ceremony, but a series of artistic devices makes sure that they are perceived as inhabitants of a separate world. This formal interlocking follows a well-tried procedure to give the impression that there is a causal effect too: the gods appear as the authorities, to whom the human performers of the ritual subject themselves, but in awareness of thereby obtaining protection and a privileged attention to their affairs.

This dualism, of gaining recognition for oneself by honouring the gods, comes to the fore, in a different way again, in the two pedimental groups. They are centred on events from the life of Athena. The birth of the Athenian city goddess is the theme of the pediment over the main entrance on the east. The ensemble of figures is too poorly preserved for us to make any far-reaching statements. What was shown was not the bizarre process of the birth itself, whereby Athena enters life fully formed from the head of Zeus, but a simple array of divine figures, whose composition revealed the mythical event to the knowledgeable viewer.

More important for our purposes is the west pediment with its very unusual motif. There was to be seen a more dynamic episode, the contest of Athena and Poseidon for the role of protector of the land of Attica (Fig. 9); the figures on either side of the central scene presumably play the part of witnesses to this event. The story of the contest of the two gods, as discussed earlier (pp. 25–7), seems not to have been a traditional subject of myth in the strict sense, but a cult legend created only a few decades earlier. Like any new creation of a myth, it must therefore be understood as a reaction to an issue which had become topical in those years. The following point is important here: it is not the factor of the quarrel, as to which of the two deities is capable of achieving the greater miracle, that is of interest in the contest between the two. Instead, it is about an underlying element, that is the propagation of the flattering fiction that Athens and the contemporary Athenian state merit a competition between two gods, to take over the role of a protecting authority. So the designers of the temple, with some self-confidence, combined a respect for the gods displayed on the temple with a claim to take up a leading position in their own world.

There is nothing surprising about such an attitude, for the Athens of the thirties of the fifth century BC. While in internal affairs the shaping of

democracy, carried out with ideological fervour, held a high priority, Athens at the same time pursued a policy of aggressive expansion towards her Greek neighbours. Federal partners were treated like vassal-states, in order to impose, at will, her own ideas of imperialism. The completion of the Parthenon virtually coincided with the outbreak of the Peloponnesian War, to end some thirty years later in military and economic defeat for Athens. The motif in the pediment, so prominently displayed to the visitor who could only gain access to the Acropolis from the west, thereafter plays almost no further role in the visual arts. The 'religious' idea, that gods would dispute the right to protect Athens, had lost its value as a political statement.

Three hundred years later, at Pergamon on the west coast of Asia Minor which had been settled by Greeks, different political conditions prevailed. The word 'political' has its root in that untranslatable term, *polis*. The expression 'city state' is what comes closest to accuracy, in so far as a *polis*, like Athens or Corinth for example, frequently possessed a rather large urban centre and in any case represented an independent state structure, even when its population amounted to only a few thousands. Whereas in the Archaic and Classical periods the city state was the dominant model for a social community in the Greek world, the political map in the Hellenistic age was defined by large territorial states with autocratic governments. The political decisions were taken, not by parliamentary committees but by kings and the administrations dependent on them, in many of the areas ruled by Greeks.

The kingdom of Pergamon arose in the third century BC and, in the following century, enjoyed the heyday of its brief but eventful history. The city of Pergamon developed, in the course of time, from a ruler's citadel to a densely built-up urban centre. Within it, a decisive element was represented by buildings and other monuments that served for the self-presentation of the ruling house. Prominent amongst these is the so-called Pergamon Altar, which King Eumenes II (who ruled 197–159 BC) commissioned, probably in the years after 180. What the excavations of the late nineteenth century could recover of the building today constitutes the most precious possession of the *Antikensammlung* in Berlin. The actual place of sacrifice takes up only a small part of the structure. The traditional building form of the altar was taken, so to speak, as a pretext for the erection of a grandiose building which, not least, fulfils the task of supporting a relief frieze, about 110 m. long and 2.30 m. high (Fig. 47). As an expression of the difference in the political systems, it is now the ruler himself who is given prominence as the founder of grand public buildings, rather than a collective group. The inscription – preserved only in fragments – named the royal patron and, in a formulaic

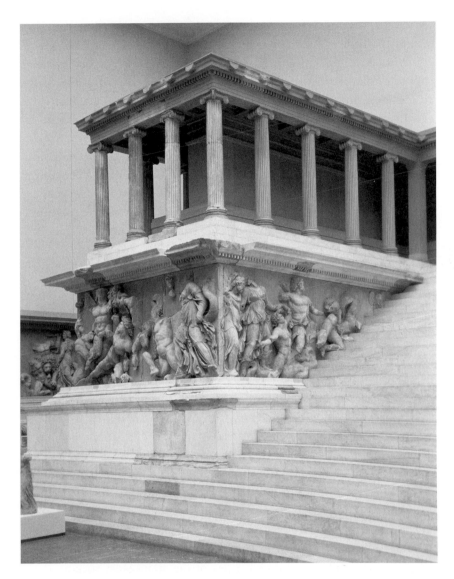

Figure 47 The battle of the gods and giants (Gigantomachy). Great Altar of Pergamon, *c*. 170 BC

acknowledgement, voiced respect for the gods who had made possible the rise of the state of Pergamon to the greatness that it had reached under Eumenes.

This is where the colossal figural frieze fits in, showing in a single simultaneous scene the battle of the Olympian gods against the giants (see cover picture). According to the immediate content of the representation, this is an eminently religious subject. Through their victory over the giants,

who were descended from the earth goddess Gaia, the Olympian gods display the scale of their power and legitimise themselves as recipients of cultic honours from mankind. The character of the forms on the frieze supports this view, with the almost brutal physicality of many of the combatants, both on the side of the gods and on that of the giants. On every side of the building, the viewer sees battle-scenes in their dramatic climaxes. Giants of purely human form fight alongside monstrous creatures with snakes for legs, or with wings – we cannot rate too highly the scale of the feat accomplished by the gods. Our illustration shows an extract from the north frieze, with a figure probably to be identified as a goddess of Fate, over whom the scaly snake-tail of a giant creeps up. The scene communicates well the vital energy that myth and myth-representation could still deploy in this epoch.

As in the case of the portrayal of Athena and Poseidon on the Parthenon (Fig. 9), into the reverence towards the gods there is woven a topical political element. The designers faced the task of distributing a large number of divine figures whose names, now mostly lost, were all inscribed on the cornice above, over the length of the frieze that ran round all the outer sides of the structure and also flanked the open-air staircase on the west side. In this process, they applied various criteria, among them the kin relationships between deities or the common link of particular groups of gods with certain areas of life. Thus the clan of the Sea-God Poseidon is gathered around the north-west corner of the altar (Fig. 47). This principle of organisation, developed out of traditional ideas of the genealogy of the gods and their 'competences', was used in combination with a genuinely Pergamene view of the world of the gods. In certain prominent positions appear the gods that have exceptional standing in the cultic calendar of the city and its ruling dynasty. Among them are, most notably, the two deities Zeus and Athena, as well as Apollo, all of whom are prominent on the east side, that is one of the two main sides of the altar. Most striking is the singling out, by his position, of Dionysus who, with his mother Semele, occupies the short but highly visible sector of the frieze on the face of the south return of the side of entry, the west. No warrior deity, but Dionysus, the god of ecstasy and transformation and thus a liberator of mankind, had been given the function of personal protecting deity for the royal dynasty of Pergamon. Anyone standing before the great open-air staircase of the altar was automatically reminded, by this view of the fighting Dionysus, of the king and his successes as military commander and ruler.

In the founder-inscription attached to the Altar, Eumenes II's mother Olympias is also named, with her title of 'Queen'. Behind this there stands

no mere empty formality of protocol but the concept, found also in other kingdoms of this epoch, of presenting the outward appearance of a ruling house in the fullest sense and at times of also linking the women into the exercise of power. This had long been the tradition in the dynasty of the Greek rulers of Egypt, down to the legendary Cleopatra VII. So if, on the great frieze of the Pergamon altar, a male god is conspicuously often shown fighting alongside his mother against the giants, this must be seen as reflecting political relations in Pergamon. Dionysus and Semele represent one of these pairings; in a matching and no less prominent position to the north of the staircase, the sea-creature Triton and his mother Amphitrite are the only gods fighting (Fig. 47). The representation of the deities in the frieze with the giants is thus intercut with elements of self-presentation on the part of the royal house of Pergamon.

The manner of employment of mythological images on public buildings has not fundamentally changed from the solution adopted on the Parthenon in Athens, for all the long gap in time and the difference in political culture. Monuments like the great frieze derive their effect from the fact that different categories of content are indissolubly interwoven: religious declaration (acknowledgement of the gods as guarantors of success) and political allegory (the positive self-image of the ruling Pergamene dynasty). The viewer's perception and intellectual assimilation of the images inevitably oscillate between the fields of meaning that have been mentioned, and the outcome of the process will always contain elements of all of them. Any attempt to privilege strongly one or another of them, and thus to interpret the Pergamon altar as an exclusively religious, or as a primarily secular, monument – a victory memorial, for instance – would mean disregarding the programme of effects that is inherent in the mythological image.

Affirmation and reflection

The first three sections of this chapter have outlined the range of areas, to one or other of which the major classes of mythological image can in most cases be assigned. In the course of this, as also with many of the images discussed earlier, a question that came up for preliminary discussion was that of the effect of the images on the viewers. Before undertaking a detailed treatment of this matter, let us recall a fundamental peculiarity of communication, on the part of images in general, and mythological images in particular (see pp. 59–63). As a mute medium, the image is incapable

of stating its subject, much less the meaning that this is meant to communicate. This statement may seem trivial, especially when it is some simple object, or even a mythical figure which the viewer can easily identify. Yet as soon as an action has taken shape visually, and the visual artist also makes sophisticated use of the means at his disposal, then the viewer has to have specific knowledge and experience at his command, in order to unlock the full intellectual potential of the mythological representation. A further corollary, however, consists in the fact that the producers were often able to turn the disadvantage of imagery, that it cannot convey clearly defined messages, into an advantage by comparison with versions in language: they used the openness of their medium to set off targeted associations in the viewer. The question how, in individual cases, this associative potential was directed within a certain framework, poses a central challenge for the practice of interpretation.

It seems of little help to speak of 'polysemic' depictions, as happens frequently in the current debate on the ancient world of images. For only in the rarest cases are the images multivalent, in the general sense that they are to take on different meanings, according to the viewer and the viewer's prior assumptions, as the case may be. In most cases the apparently elegant finding based on a polysemic image represents only a projection of the insecurities of the modern interpreter on to the world of antiquity: where the analysis of the context provides no adequate basis for a well-founded interpretation, there is a temptation to present, simultaneously, several approaches as equally valid.

To speak of the associative character of mythological images refers, in the first instance, to the ways in which contents and meanings are communicated. In this connection, individual interpretations, in all their diversity of presentation and variety of topics, can be distributed between two poles, affirmation and reflection. Affirmation, literally 'strengthening', means the deployment of images with the intention, or at any rate the effect, of propagating or corroborating certain values, norms and ideas for the addressees. The spectrum of 'values' in this case covers, in principle, all aspects of life, from the assignment of roles between the sexes to the ideological attitudes of a state – to name only two fields. Hence every mythological image that can be understood as 'affirming' inevitably relates to something that had already taken shape outside the visual sphere. Representations of the fight between the Greek tribe of the Lapiths and the half-animal, and therefore abnormal, centaurs represent a prime example for affirmative readings. The most widely adopted interpretation of the ensemble in the west pediment of the Temple of Zeus at Olympia (Fig. 24)

boils down to the view that it is a symbol of the superiority of one's own, Greek, civilisation over every kind of alien one. This interpretation invokes a debate that was conducted at the time, in which ideological self-distancing from the Persian Empire played an especially important part. In the ensemble of sculptures, thus understood, there is expressed a need for drawing boundaries which was otherwise satisfied predominantly by means of language. Not a few authors believe that they can spell out the visual image; that the centaurs were, so to speak, standing in for the Persians who had been defeated a few decades earlier, and the Lapiths, successful in the myth, for the victorious Greek armies – even though the mythical human-equines have nothing to do with the Orient. Another interpretation finds in the pedimental sculptures an affirmative intent of a different kind: that it reminds the visitor to the sanctuary of the permanent strife between Greek states – in the myth, centaurs and Lapiths are good friends, or even related, to each other – and at the same time invites them to overcome these disputes.

To see mythological images as instruments for reflection, literally 'mirroring', is by contrast to understand them as stimuli for one's own intellectual processes and not as confirmation of already existing attitudes. To stay with the example just used: do not the wild centaurs, it has been asked, in the final analysis represent the impulsive and uncontrollable element that is also part of human nature? The portrayal of the Centauromachy cannot then be reduced to the simple equation, 'We against you' or 'The standard and good against the non-standard and bad'. Rather, it appears as an allegory of characteristics that all form part of the viewers themselves and present them with a mirror – a mirror, admittedly, that does not reflect the surface of things, but makes visible the deeper levels.

In archaeological research on myth, the dominant attitude has until very recently been one ascribing an affirmative function to mythological images. An incalculable number of interpretations of individual images or motifs conclude by finding, in the representations, a sort of guide to conduct, an admonition to do certain things or a warning not to do certain others. On this view the images, judging by their effects, turn out to be something close to moralising *logoi*, that is comments, expressed in words, designed to win over the recipients to a specific viewpoint. The idea of the 'beautiful death' on the battlefield is one example among many. Its most conspicuous formulation in words is preserved in the form of Pericles' funeral speech as reported by Thucydides. In a public address, the politician honours those Athenians who had fallen in the first year of the Peloponnesian War (431 BC) and dispenses comfort to the bereaved. Thus he speaks of how

'it is to be accounted good fortune when men win, even as these now, a most glorious death' (*History of the Peloponnesian War* 2, 44; trans. C. F. Smith). By making reference to this *topos*, widespread among contemporaries, one can argue that the numerous images of myth and real life that relate to death in battle, are to be interpreted as translation of the idea, initially fixed in language, of the beautiful death in war into the other medium. If so, representations of the type of the Exekias amphora with the recovery of a fallen warrior (Fig. 6) or the portrayal of the wounded Patroclus (Fig. 1) acquire the character of a call to arms: 'Off to the war and emulate Achilles and the other famous heroes!'. Plausible as this may seem from a cursory examination, it is also very obvious to what degree this interpretation has been imported from outside. As the analysis of the Achilles-Patroclus picture in the first chapter has shown, the images themselves, with their context, precisely do not support an affirmative reading.

But the element that enjoys the greatest popularity in affirmative inter-pretations of Greek mythological images is that of *hybris*. The expression denotes, in Greek thought, the – mostly improper – transgression of boundaries. Thus even personal overestimation of oneself is a form of *hybris*. But the term reserves its sharpest application for denunciations of the transgressing of ethical norms. This is the starting point, too, from which innumerable interpretations of Greek mythological images have been developed. From Classical and Hellenistic times in particular, whole series of Amazon, centaur, giant and satyr images are seen as denunciations of *hybris*. By way of deterrent examples, so the prevalent view runs, they are meant to advertise specific positive values. Thus there are powerful scholarly voices advocating the view that, in the battle of the gods and giants on the great frieze of Pergamon (Fig. 47 and cover picture), we should see a propagandist measure, in the sense of the disparagement of the non-Greek tribe of the Celts who had dared to attack the kingdom of Eumenes II. The centaurs running riot in the west pediment of the Temple of Zeus at Olympia (Fig. 24) are interpreted as the embodiment of impulse-driven, lawless behaviour, against which the Greek ideal of moderation and observ-ance of social rules stood out even more clearly. Contemporaries would have had the music-maker Marsyas in Myron's sculptural group (Figs. 36, 37), later to meet such a horrific death, brought home to them as a warning to be on their guard against unbridled sensuality.

But should we really believe that such an explicit educational programme existed, with hundreds of visual 'warning notices', and that the Greeks were afflicted by a veritable *hybris*-obsession? Many of the individual findings to which the affirmative model of interpretation has been applied turn out, on

closer examination, to resist such a moralising reading. A separate question is why the problematic hypothesis, that mythological images would have served in large part as educational commands and prohibitions, has won such wide approval. An important role in this was presumably played by the long-dominant view of Greek art, and beyond it the whole of Classical culture, as a normative one. From the eighteenth century onwards, works of art from this epoch were seen as unsurpassed in aesthetic terms and as examples for contemporary artists to follow. From this point, it is only a small step to assigning a model character to these images in respect of ethics and morality too.

The hypothesis of an educational function for mythological images can, however, be perfectly justified if it is given a different emphasis. Instead of exhibiting a primarily affirmative and merely reinforcing effect, many images contributed to reflection on the subjects with which they dealt. A primary reason for the soundness of this assumption lies in an important characteristic of the myths as narrative material (regardless of whether they are in visual form). They are a medium for engagement with the world around us, whichever individual figures they involve. They are, as the chapter on 'Definitions' sets out, 'of importance' in that they explain, or at any rate give shape to, contexts that cannot be exhaustively analysed by the route of rational argumentation. Greek myths have, with some justification, been understood as a means of discussing problems that are insoluble. They guide us, as is most clearly expressed in Athenian tragedy, not normally towards clear answers but to the intensification of questions, and certainly in no way aim at a succinct identification of 'good' and 'bad'.

This trait is heightened, rather than reduced, when myths are presented in a visual form, because of the characteristics of the medium. To the openness of meaning of the content, as part of mythical narrative, is added the fact that the image depends on the viewer's foreknowledge of the story. We have presented in detail the way in which the visual artists counteract these factors; how they steer the viewer, by the inclusion of elements external to the narrative, towards a certain understanding of the scene. Close analysis leads to essentially the same conclusion for the myths in visual, as for those in literary form. It is not a firm rule, but a widespread principle that the images invite intellectual engagement, by calling to mind two or more simultaneously effective forces, or co-existing aspects. The case studies so far discussed have led us back to this point again and again. If the pictures show that Perseus is in need of support while conquering the Gorgon Medusa (Fig. 21), or if Theseus receives help for the killing of the Minotaur (Fig. 12), then they combine the display of heroic commitment

with the additional element of potential downfall. The depiction of Menelaus storming up to Helen (Fig. 26) feeds on the balance between two emotional impulses, his need for revenge on the unfaithful wife and his sensual overwhelming by the woman's beauty. Even if the figures of Aphrodite, and especially of Peitho, bring out the element of persuasion and seduction, this does not inevitably lead to judgemental partisanship – for the woman's weapons against those of the man. The primary effect of the (only imagined) presence of the two female figures is as a culmination of the collision between the two forces here present.

How affirmation and reflection are pitted against each other, as opposing approaches to – and expectations of! – interpretation can finally be illustrated by rather more extensive discussion of a model example. The final piece falls into place with the well-known motif, very popular for some decades in Attic vase painting, known as the 'Heroes at the board game'. As in the first chapter, we are once again faced with Achilles before Troy, and the link between the pursuit of fame and the nearness of death. There is a close parallel in methodological terms too, for once again literary sources for the scene depicted are completely absent; the analysis therefore has to start from the image itself – and, at the end, also to prove itself against it.

The inventor of the motif is presumably the Attic vase painter Exekias, active around 530 BC – at all events, his formulation of the subject represents the most ambitious of the more than 150 versions so far known (Fig. 48). The image is on a large amphora, 61 cm. high, today located in the Vatican collections. We have already become familiar with a slightly differently shaped example of this type of vessel, also painted by Exekias (Figs. 5, 6). Our projected version cancels out the cramping effect of the vessel's body, yet brings out clearly all the details of the drawing. Among these are the inscriptions. They name the seated man on the left as Achilles, the one on the right as Ajax. A further part of the explanation of the scene are the two numerical scores, ascribed to the men as are the speech-bubbles in a comic: they are just throwing the dice; Achilles has thrown a four, the highest value, and Ajax a three. It is made unambiguously clear to any viewer of the scene that the two men are utterly absorbed in the progress of the game. This emerges from the hand movements and the tense posture of the bodies, and the severity of the composition only goes to support it. The direction of their gazes, the diagonally outstretched arms and the crossing lines of the pairs of spears, all act to make the surface on which the gaming pieces are being moved into the focus of the whole picture.

The basic idea behind the composition is so obvious that it has long enjoyed a consensus in research. Two great heroes, in the course of the

Figure 48 Achilles and Ajax playing board game. Attic black-figure amphora, signed by the painter Exekias (drawing), *c.* 530 BC

Greek expedition against Troy, are playing a board game during a break in the fighting, and are thus involved in a thoroughly unwarlike activity. The game combined the luck of the dice with tactical skill. The picture thus derives its tension from the sharp contrast between the spheres of game and battle. Achilles and Ajax dedicate themselves, with full concentration, to the board game and are just at the point of moving their pieces. Yet battle is a no less present factor. It is not just that both of them are fully armed; they even keep their spears in their hands during the game as if they intended to return to battle at the very next moment.

But on the question of how this exceptionally effective pictorial motif should be interpreted, opinion among researchers is widely divided. For a long time, a distinctly affirmative reading dominated the discussion. According to this, the two men had become all too absorbed in their game and thus in an idle pastime, while all around them rages the battle for which, after all, they have also prepared themselves. Achilles and Ajax are therefore, as has been stated, 'neglectful' or 'dilatory' heroes. Instead of living up to their role as models of military prowess, they bring their comrades and themselves into the greatest peril through their passion for gaming. In slightly later versions of the motif, the figure of the Goddess Athena appears

in the centre of the picture, apparently urging Achilles and Ajax back into battle.

But a weighty objection nevertheless stands in the way of this explanatory approach: could the central motif of the scene, that is the throwing of the dice, really have been selected, as a randomly chosen and therefore inter-changeable symbol for whiling the time away? The portrayal of Achilles and Ajax as game-players throwing the dice is such a specific, because novel and highly distinctive, motif that we must insist on giving it a specific meaning. One thesis which does away with this defect of the traditional interpretation is that which takes as its starting-point the very peculiarities of the board game: the game, in which much but not all depends on chance, would serve as a metaphor for the heavy dependence of individual fate on external factors. Even the best-trained and most skilled warrior can lose his life if, in the course of battle, a configuration arises that is unlucky for him or if, seen from the Archaic Greek perspective, the gods withdraw their protec-tion from him. Accordingly the motif of the board game, instead of being an admonition to appropriate behaviour, represents a philosophical reflection transposed on to the plane of a mythological image. The result in essence corresponds exactly with what we have established for the picture of Achilles and Patroclus (Fig. 1), originating around three decades later. The guiding idea is the opposition between the gaining of honour through military achievement and the high risk of death which has to be accepted for it.

The wider context of the image yields a whole series of arguments to support this interpretation. Mention should first be made of the custom, attested in Athens at various times, of putting dice in the grave for the dead to take with them. To see a metaphorical element in this game is thus not a modern thesis, but something that corresponds to contemporary ideas. A more specific picture of the meaning of the board game scene is given by the combination of characters. There is something surprising in the fact that it is precisely Achilles and Ajax who sit together during the lull in the fighting. Contrary to what the picture suggests, there were no bonds of friendship between Achilles and Ajax: according to the traditional form of the narra-tive, they were fellow-combatants at Troy without being companions. Especially with a leisure pursuit like the board game, a contemporary viewer would, on the contrary, expect Achilles' companion to be someone with whom, away from their military mission, he had friendly ties – Patroclus before all others. Since it is Ajax who takes on this role, the design of the image shows itself as something dependent, above all, on an intellectual structure.

There are two factors which, over and above its direct narrative plausibility, give credibility to the design of the picture. In the *Iliad*, Achilles and Ajax were considered not merely great warriors, but the two greatest of all. It is beyond dispute that they are the ones who, as warriors, rank above all others in the Greek army because of their fighting abilities. So no one is better suited than these two heroes for the visual presentation, in heightened form, of the opposition between exceptional fighting prowess and life's dependence on the play of chance. On this there directly follows another aspect, this time a biographical one. For the ancient viewers looking at these two men, the element of mortal danger was no remote, abstract thought. They knew that Achilles and Ajax were closely linked together not in their lives but, to a degree, in their deaths. Ajax will rescue Achilles' body from the battlefield and so save it from being despoiled and mutilated by the enemy, an episode of legend that had often, already before Exekias' time, been represented in art (Fig. 16).

But it is not Achilles only, but Ajax too who dies young, again even before the capture of Troy. When the arms of Achilles are awarded by drawing lots, Ajax is left empty-handed, declines into madness and finally kills himself out of shame. Achilles alone, however, has foreknowledge of his approaching death. It is several times discussed in the *Iliad* and he himself explicitly refers to the two perspectives on life that are offered to him: a long but undistinguished domestic existence, or a short life and lasting fame. It is the capacity to withstand the stress of this that, more than anything else, distinguishes his personality. He secures his singular 'metaphysical immortality' precisely by his acceptance of his physical mortality and of the combination of factors which allows him only a short life. It was this balance between the closeness of death and the energetic striving to win honour which, for the contemporaries of Exekias, made the picture of Achilles and Ajax, throwing dice yet ready for battle, into a convincing allegory. By abstaining from making a judgement between these two categories, which is what you would expect of an affirmative conception, the image all the more effectively invites the viewers to reflection. They have to absorb the stimuli given by the image and work out an answer for themselves.

Both these effects, affirmation and reflection, are undoubtedly functions that Greek mythological images fulfil, and that are not separated by a deep gulf from each other. Analysis involves not only discovering whether an image serves for the dissemination of certain values and behaviours, or whether it is meant to contribute to dealing intellectually with fundamental issues. One must also be aware that mythological representations gain a different value as evidence, depending on the interpretative approach.

Every kind of moralistic admonition or reinforcement of prevailing social norms has something about it that is conditional on its period: if the conditions to which the image refers have changed, it has to a certain extent become historical, and can be processed as nothing but a historical document. Those mythological representations, by contrast, which call for philosophical reflection – in the widest sense – concern us in a very immediate way, to this day.

Guide to further reading

Abbreviations

Giuliani, *Bild*	L. Giuliani, *Bild und Mythos. Geschichte der Bilderzählung in der griechischen Kunst* (Munich 2003; English edition forthcoming: Chicago University Press)
Zanker, *Mythen*	P. Zanker, *Mit Mythen leben. Die Bilderwelt der römischen Sarkophage* (Munich 2004; English edition *Living with Myths: The Imagery of Roman Sarcophagi* (Oxford 2012))

Handbooks and Compendia

Compendia on Greek myths

R. Graves, *The Greek Myths* (New York 1955 and many later editions)

R. Buxton, *The Complete World of Greek Mythology* (London 2004)

S. Price and E. Kearns (eds.), *Oxford Dictionary of Classical Myth and Religion* (New York 2004)

M. P. O. Morford and R. J. Lenardon, *Greek Mythology* (New York etc. 2007)

R. Hard, *The Routledge Book of Greek Mythology: Based on H. J. Rose's Handbook of Greek Mythology* (London 2008)

Greek myths: scholarly syntheses

K. Kerényi, *The Gods of the Greeks* (London 1974)
 The Heroes of the Greeks (London 1978)

T. Gantz, *Early Greek Myth. A Guide to Literary and Artistic Sources* (Baltimore, Md./London 1993)

Images of Greek Myths: Compendia

(see also chapter 2)

 LIMC = *Lexicon Iconographicum Mythologiae Classicae*. 8 double vols. (text/plates), 2 index vols. (Zurich/Munich 1981–97)

The *LIMC*, which comprises more than 7000 text pages in German, English, French, and Italian, includes articles, some of them reaching book length, which deal with all figures of Greek and Roman mythology. Besides the preferentially documented and

annotated pictorial tradition, it also contains detailed notes on the written sources. These features make it an indispensable tool for all kinds of archeological research on ancient myths.

K. Schefold and A. Griffiths, *Gods and Heroes in Late Archaic Greek Art* (Cambridge 1992)

The lavishly illustrated books by Karl Schefold are conceived mainly as documentation of the pictorial tradition but deal also with questions of interpretation.

K. Schefold, *Die Göttersage in der klassischen und hellenistischen Kunst* (Munich 1981)
 Götter- und Heldensagen der Griechen in der früh- und hocharchaischen Kunst (Munich 1993)
K. Schefold and F. Jung, *Die Urkönige Perseus, Bellerophon, Herakles und Theseus in der klassischen und hellenistischen Kunst* (Munich 1988)
 Die Sagen von den Argonauten, von Theben und Troia in der klassischen und hellenistischen Kunst (Munich 1989)

T. H. Carpenter, *Art and Myth in Ancient Greece. A Handbook* (London 1991) Handbook on images of Greek myths from the beginnings to the 4th century B.C. arranged according to mythical characters and cycles.

H. A. Shapiro, *Myth into Art. Poet and Painter in Classical Greece* (London 1994) Handbook on images of Greek myths arranged according to literary genres.

Exhibition catalogues on individual mythical topics

B. Andreae, Odysseus. *Mythos und Erinnerung* (Mainz 1999)
The Odyssey *and Ancient Art. An Epic in Word and Image* (Annandale-on-Hudson 1992)
E. D. Reeder, *Pandora. Women in Classical Greece* (Baltimore 1995)
Ulisse. Il mito e la memoria (Rome 1996)
R. Wünsche (ed.), *Herakles–Hercules* (Munich 2003)

Note: Literature on individual mythical characters

The following list of specialised literature does not provide many references for individual mythical characters, as the *LIMC* offers an enormous amount of annotations on the literary as well as on the pictorial tradition for all figures of Greek mythology. See also the books by Carpenter, Shapiro, and Schefold and the detailed secondary literature listed in the *LIMC*.

 Example: On the depiction of Achilles and Patroclus (chapter 1, Fig. 1) see T. H. Carpenter, *Art and Myth in Ancient Greece. A Handbook* (London 1991) 201 fig. 301; K. Schefold and A. Griffiths, *Gods and Heroes in Late*

Archaic Greek Art (Cambridge 1992) 224–5 fig. 277; *LIMC* I (1981) 115 no. 468 (with illustration in the plate volume) under the entry 'Achilleus' (chapter XIII 'Achilleus und Patroklos'); *LIMC* VIII (1997) 949 no. 4 under the entry 'Patroklos'.

Further, see the recently completed lexicon *Brill's New Pauly* (Leiden 2002–7) as a general scholarly compendium: 20 volumes, 5 of which are devoted to the Classical tradition (translation of the German edition, Stuttgart 1996–2003).

Chapter 1

The Sosias Painter and his cup

A. Furtwängler and K. Reichhold, *Griechische Vasenmalerei. Auswahl hervorragen-der Vasenbilder*, vol. III (Munich 1932) 13–22 pl. 123 (F. Hauser)

N. Himmelmann, 'Die Götterversammlung der Sosias-Schale', *Marburger Winckelmann-Programm* 1960, 41–8

St. Lowenstam, 'The Uses of Vase-Depictions in Homeric Studies', *Transactions of the American Philological Association* 122, 1992, 184–5.

I. Wehgartner in: *Euphronios der Maler*. Exhibition catalogue (Berlin 1991) 244–9

M. Robertson, *The Art of Vase-Painting in Classical Athens* (Cambridge 1992) 58–9.

K. Junker, *Pseudo-Homerica. Kunst und Epos im spätarchaischen Athen* (Berlin 2003) 2–8

Medicine and healing in Classical Antiquity

G. Majno, *The Healing Hand. Man and Wound in the Ancient World* (Cambridge, Ma. 1975)

S. Geroulanos and R. Bridler, *Injury. Cause and Care of the Wound in Ancient Greece* (Athens 1998; Mainz 1994: *Trauma. Wund-Entstehung und Wund-Pflege im antiken Griechenland*)

Martha L. Rose, *The Staff of Oedipus. Transforming Disability in Ancient Greece* (Ann Arbor 2003)

Achilles in the Iliad

K. C. King, *Achilles. Paradigms of the War Hero from Homer to the Middle Ages* (Berkeley etc. 1987) 1–49

L. Balensiefen, 'Achills verwundbare Ferse. Zum Wandel der Gestalt des Achill in nacharchaischer Zeit', *Jahrbuch des Deutschen Archäologischen Instituts* 111, 1996, 75–103

'Talking' shield devices

G. H. Chase, *The Shield Devices of the Greeks in Art and Literature* (Cambridge, Mass. 1902; Repr. Chicago 1979)

F. Lissarrague, 'Looking at Shield Devices. Tragedy and Vase Painting', in C. Kraus *et al.* (eds.), *Visualizing the Tragic. Drama, Myth, and Ritual in Greek Art and Literature* (Oxford 2007) 151–64

Cup by the painter 'Peithinos'

H. A. Shapiro, 'Courtship Scenes in Attic Vase-Painting', *American Journal of Archaeology* 85, 1981, 133–43

E. D. Reeder, *Pandora. Women in Classical Greece* (Baltimore 1995) 340–343 No. 106

Ajax carrying the body of Achilles

S. Woodford and M. Loudon, 'Two Trojan Themes. The Iconography of Ajax Carrying the Body of Achilles and of Aeneas Carrying Anchises in Black Figure Vase Painting', *American Journal of Archaeology* 84, 1980, 25–40

M. B. Moore, 'Exekias and Telamonian Ajax', *American Journal of Archaeology* 84, 1980, 417–34

F. Lissarrague, *L'autre guerrier. Archers, peltastes, cavaliers dans l'imagerie attique* (Paris 1990) 35–53, 71–96

Giuliani, *Bild* 133–43

Heracles as symposiast

LIMC IV (1988) 817–21 s.v. Herakles/Herakles symposiastes (J. Boardman)

S. R. Wolf, *Herakles beim Gelage* (Cologne/Weimar/Vienna 1993)

A. Steiner, 'The Alkmene Hydrias and Vase-Painting in Late-Sixth-Century Athens', *Hesperia* 73, 2004, 427–63; here: 444–7

Heracles and the Nemean lion

K. Schefold and F. Jung, *Die Urkönige, Perseus, Bellerophon, Herakles und Theseus in der klassischen und hellenistischen Kunst* (Munich 1988) 135–42

R. Vollkommer, *Herakles in the Art of Classical Greece* (Oxford 1988) 1–5

LIMC V (1990) 16–34 s.v. Herakles/Herakles and the Nemean Lion (W. Felten)

B. Kaeser, 'Erste Tat. Der Löwe von Nemea', in R. Wünsche (ed.), *Herakles – Hercules* (Munich 2003) 68–90

Chapter 2

Greek myth: definiton and historical context

G. S. Kirk, *The Nature of Greek Myth* (Woodstock, N.Y. 1974; Harmondsworth 1976)

W. Burkert, *Structure and History in Greek Mythology and Ritual* (Berkeley 1979)

R. L. Gordon (ed.), *Myth, Ritual and Society. Structuralist Essays by M. Detienne, L. Gernet, J.-P. Vernant, and P. Vidal-Naquet* (Cambridge/Paris 1981)

P. Veyne, *Did the Greeks Believe in Their Myths?* (Chicago 1988; Paris 1983)

J. Bremmer, 'What is a Greek Myth?', in J. Bremmer (ed.), *Interpretations of Greek Mythology* (London 1987; Repr. 1994) 1–9

H. S. Versnel, 'What's Sauce for the Goose Is Sauce for the Gander. Myth and Ritual, Old and New', in L. Edmunds (ed.), *Approaches to Greek Myth* (Baltimore/ London 1990) 25–90

F. Graf, *Greek Mythology. An Introduction* (Baltimore 1993; Munich 1985). Masterly survey with an excellent outline of the history of scholarship.

K. Dowden, *The Uses of Greek Mythology* (London 1992)

R. Buxton, *Imaginary Greece. The Contexts of Mythology* (Cambridge 1994)

Oedipus

J.-M. Moret, *Oedipe, la Sphinx et les Thébains. Essai de mythologie iconographique* (Rome 1984)

K. Schefold and F. Jung, *Die Sagen von den Argonauten, von Theben und Troia in der klassischen und hellenistischen Kunst* (Munich 1989) 58–68

T. H. Carpenter, *Art and Myth in Ancient Greece* (London 1991) 164–5 figs. 261, 264

LIMC VII (1994) 81–105 s. v. Orpheus (M.-X. Garezou)

Contest between Athena and Poseidon over the patronage of Attica

E. Simon, 'Die Mittelgruppe im Westgiebel des Parthenon', in *Tainia. Festschrift R. Hampe* (Mainz 1980) 239–55

J. Binder, 'The West Pediment of the Parthenon. Poseidon', in *Studies Presented to Sterling Dow on His Eightieth Birthday* (Durham 1984) 15–22

H. A. Shapiro, *Art and Cult Under the Tyrants in Athens* (Mainz 1989) 101–8

O. Palagia, *The Pediments of the Parthenon* (Leiden 1993) 40–61

J. J. Pollitt, 'Patriotism and the West Pediment of the Parthenon', in G. R. Tsetskhladze et al. (eds.), *Periplous. Papers on Classical Art and Archaeology Presented to Sir J. Boardman* (London 2000) 220–7

*Plato as mythographer (*hyponoia, mythopoioi*)*

hyponoia: Plato, Republic 378d; *mythopoioi*: Plato, Republic 377c

J. Pépin, *Mythe et allégorie* (Paris 1958) 85–7 (on *hyponoia*)

K. Morgan, *Myth and Philosophy from the Presocratics to Plato* (Cambridge 2000)

D. Clay, 'Plato Philomythos', in R. D. Woodard (ed.), *The Cambridge Companion to Greek Mythology* (Cambridge 2007) 210–36

John Flaxman

R. Essick and J. La Belle (eds.), *Flaxman's Illustrations to Homer* (New York 1977)

J. M. Symmons, *Flaxman and Europe. The Outline Illustrations and their Influence* (New York 1984)

L. Giuliani, *Bilder nach Homer. Vom Nutzen und Nachteil der Lektüre für die Malerei* (Freiburg 1998)

Knowledge of myths in the fifth century BC

A. M. van Erp Taalman Kip, *Reader and Spectator. Problems in the Interpretation of Greek Tragedy* (Amsterdam 1990) 21–41

Aeschylus' Oresteia *as 'political' drama*

C. Meier, *The Political Art of Greek Tragedy* (Baltimore 1993; Munich 1988)

P. J. Rhodes, 'Nothing to Do With Democracy. Athenian Drama and the Polis', *Journal of Hellenic Studies* 123, 2003, 104–19

Principles of visualisation of Greek myths

A. Snodgrass, *Narration and Allusion in Archaic Greek Art. The 11th J. L. Myres Memorial Lecture* (London 1982)

H. Froning, 'Anfänge der kontinuierlichen Bilderzählung in der griechischen Kunst', *Jahrbuch des Deutschen Archäologischen Instituts* 103, 1988, 169–99

W. Raeck, 'Zur Erzählweise archaischer und klassischer Mythenbilder', *Jahrbuch des Deutschen Archäologischen Instituts* 99, 1984, 1–25

N. Himmelmann, *Reading Greek Art* (Princeton 1998); see chapter 'Archaic Narrative and Figure' (German edition, Mainz 1967: 'Erzählung und Figur in der archaischen Kunst')

J. P. Small, 'Time *in* Space. Narrative in Classical Art', *Art Bulletin* 81, 1999, 562–75

M. Stansbury-O'Donnell, *Pictorial Narrative in Ancient Greek Art* (Cambridge 1999)

J. P. Small, *The Parallel Worlds of Classical Art and Text* (Cambridge 2003)

S. Woodford, *Images of Myths in Classical Antiquity* (Cambridge 2003)

Giuliani, *Bild* (fundamental)

Achilles and Priam (The ransom of Hector)

LIMC III (1986) 492–4 s. v. Hektor/Le rançon de Hektor (O. Touchefeu)

K. Junker, 'Symposiongeschirr oder Totengefäße? Überlegungen zur Funktion attischer Vasen des 6. und 5. Jahrhunderts v. Chr.', *Antike Kunst* 45, 2002, 19–25

Giuliani, *Bild*, chapter 5

B. A. Sparkes, 'The Ransom of Hektor Illustrated', *Hyperboreus* 12, 2006, 5–20

Visual impact of Athenian drama

O. Taplin, *Greek Tragedy in Action* (London 1978)

A. Bierl, *Die Orestie des Aischylos auf der modernen Bühne. Theoretische Konzeptionen und ihre szenische Realisierung* (Stuttgart/Weimar 1996)

E. Fischer-Lichte, 'Thinking about the Origins of Theatre in the 1970s', in E. Hall, F. Macintosh and A. Wrigley (eds.), *Dionysus Since 69. Greek Tragedy at the Dawn of the Third Millenium* (Oxford 2004) 329–60; here: 344–52

Theseus and the Minotaur

F. Brommer, Theseus. *Die Taten des griechischen Helden in der antiken Kunst und Literatur* (Mainz 1982) 35–64

J. Neils, *The Youthful Deeds of Theseus* (Rome 1987)

H. A. Shapiro, *Myth into Art. Poet and Painter in Classical Greece* (London 1994) 109–17

Medea on Roman sarcophagi

M. Schmidt, *Der Basler Medea-Sarkophag* (Tübingen 1968)

K. Fittschen, 'Der Tod der Kreusa und der Niobiden. Überlegungen zur Deutung griechischer Mythen auf römischen Sarkophagen', *Studi italiani di filologia classica* 10, 1992, 1046–59

V. Gaggadis-Robin, *Jason et Médée sur les sarcophages d'époque impériale* (Rome 1994)

G. Gessert, 'Myth as Consolatio. Medea on Roman sarcophagi', *Greece and Rome* 51, 2004, 217–49

Zanker, *Mythen* 82–4, 336–41

For Roman sarcophagi depicting Greek myths, see also chapter 6

Statues of Heracles

S. Kansteiner, *Herakles. Die Darstellungen in der Großplastik der Antike* (Cologne 2000)

S. Lorenz, 'Verehrt als Heros und Gott – Statuen und Statuetten als Zeugnisse', in R. Wünsche (ed.), *Herakles – Hercules* (Munich 2003) 312–27

H. Schulze, 'Vorbild der Herrschenden – Herakles und die Politik', in R. Wünsche (ed.), *Herakles–Hercules* (Munich 2003) 344–65

Barberini Faun (see also chapter 5)

B. S. Ridgway, *Hellenistic Sculpture I* (Bristol 1990) 313–16 pl. 157a–b

C. Kunze, 'Die Konstruktion einer realen Begegnung. Zur Statue des Barberinischen Fauns', in G. Zimmer (ed.), *Neue Forschungen zur hellenistischen Plastik. Kolloquium zum 70. Geburtstag von Georg Daltrop* (Eichstätt 2004) 9–47

R. Wünsche, *Glyptothek Munich. Masterpieces of Greek and Roman Sculpture* (Munich 2007) 108–11

Satyrs and sleeping maenads

L. D. Caskey and J. D. Beazley, *Attic Vase Paintings in the Museum of Fine Arts, Boston II* (London 1954) 95–9

A. Stähli, *Die Verweigerung der Lüste. Erotische Gruppen in der antiken Plastik* (Berlin 1999) 161–201

F. Lissarrague, 'A Sun-Struck Satyr in Malibu', in G. R. Tsetskhladze *et al.* (eds.), *Periplous. Papers on Classical Art and Archaeology presented to Sir John Boardman* (London 2000) 191–7

Death of Sarpedon

Euphronios der Maler. Exhibition Catalogue, Berlin 1991, 93–105 no. 4; pp. 182–6 no. 34

H. A. Shapiro, *Personifications in Greek Art* (Kilchberg 1993) 132–65, 246–50

K. Junker, *Pseudo-Homerica. Kunst und Epos im spätarchaischen Athen* (Berlin 2003) 16–28

M. Turner, 'Iconology versus Iconography. The Influence of Dionysos and the Imagery of Sarpedon', *Hephaistos* 21/22, 2003/4, 53–79

'On-lookers' on Greek vases

B. Kaeser, 'Zuschauerfiguren', in K. Vierneisel and B. Kaeser (eds.), *Kunst der Schale. Kultur des Trinkens* (Munich 1990) 151–6

M. D. Stansbury-O'Donnell, *Vase-Painting, Gender, and Social Identity in Archaic Athens* (Cambridge 2006)

Chapter 3

On the literary production of Greek myths see, in addition to the secondary literature cited below, the references given to chapter 2, especially F. Graf, *Greek Mythology. An Introduction* (Baltimore 1993; Munich 1985).

Homer, Hesiod and the early epic

H. Maehler, *Die Auffassung des Dichterberufs im frühen Griechentum bis zur Zeit Pindars* (Göttingen 1965)

I. Morris and B. Powell (eds.), *A New Companion to Homer* (Leiden 1997)

J. Latacz, *Homer. His Art and His World* (Ann Arbor 1998; Munich ⁴2003)

J. L. Ready, 'Homer, Hesiod, and the Epic Tradition', in H. A. Shapiro (ed.), *The Cambridge Companion to Archaic Greece* (Cambridge 2007) 111–40

G. Nagy, 'Homer and Greek Myth', in R. D. Woodard (ed.), *The Cambridge Companion to Greek Mythology* (Cambridge 2007) 52–82

R. D. Woodard, 'Hesiod and Greek Myth', in R. D. Woodard (ed.), *The Cambridge Companion to Greek Mythology* (Cambridge 2007) 83–165

Pandora

E. D. Reeder, *Pandora. Women in Classical Greece* (Baltimore 1995) 277–86

F. Zeitlin, 'The Economics of Hesiod's Pandora', in Reeder, *Pandora* 49–56

J. P. Zarecki, 'Pandora and Strife in Hesiod', *Greek, Roman and Byzantine Studies* 47 (2007) 5–29

Myth versus logos

W. Nestle, *Vom Mythos zum Logos. Die Selbstentfaltung des griechischen Denkens von Homer bis auf die Sophisten und Sokrates* (Stuttgart 1940)

P. Veyne, *Did the Greeks Believe in Their Myths?* (Chicago 1988; Paris 1983)

K. Dowden, *The Uses of Greek Mythology* (London 1992) 39–53

F. Graf, *Greek Mythology. An Introduction* (Baltimore 1993; Munich 1985) 176–98

R. Buxton (ed.), *From Myth to Reason? Studies in the Development of Greek Thought* (Oxford 1999)

K. Morgan, *Myth and Philosophy from the Presocratics to Plato* (Cambridge 2000) 30–7

D. Clay, 'Plato Philomythos', in Roger D. Woodard (ed.), *The Cambridge Companion to Greek Mythology* (Cambridge 2007) 210–36; here: 210–15 ('The Myth of *Logos vs. Mythos*')

Xenophanes of Colophon

W. K. C. Guthrie, *A History of Greek Philosophy*, vol. I (Cambridge 1962) 360–402

K. Morgan, *Myth and Philosophy from the Presocratics to Plato* (Cambridge 2000) 46–53

R. D. McKirahan, *Philosophy before Socrates. An Introduction with Text and Commentary* (Indianapolis ²2010) 58–69

Myth and history in Herodotus

C. Sourvinou-Inwood, *'Reading' Greek Culture. Texts and Images, Rituals and Myths* (Oxford 1991) 244–84

P. Bietenholz, *Historia and Fabula. Myths and Legends in Historical Thought from Antiquity to the Modern Age* (Leiden 1994) 23–9

H.-J. Gehrke, 'Myth, History, and Collective Identity. Uses of the Past in Ancient Greece and Beyond', in N. Luraghi (ed.), *The Historian's Craft in the Age of Herodotos* (Oxford 2001) 286–313

D. Boedeker, 'Epic Heritage and Mythical Pattern in Herodotus', in E. J. Bakker, I. J. F. de Jong and H. van Wees (eds.), *Brill's Companion to Herodotus* (Leiden 2002) 97–116

Euhemeros, euhemerism

R. J. Müller, 'Überlegungen zur *hiera anagraphe* des Euhemeros von Messene', *Hermes* 121, 1993, 276–300

P. Bietenholz, *Historia and Fabula. Myths and Legends in Historical Thought from Antiquity to the Modern Age* (Leiden 1994) 39–40

Bernard de Fontenelle

W. Krauss, *Fontenelle und die Aufklärung* (Munich 1969)

B. Feldman and R. D. Richardson, *The Rise of Modern Mythology (1680–1860)* (Bloomington/London 1972) 7–18 (text and commentary)

Pindar as mythographer and the 1st Olympian Ode

A. Köhnken, *Die Funktion des Mythos bei Pindar. Interpretationen zu sechs Pindargedichten* (Berlin 1971)

G. Nagy, '*Pindar's Olympian I* and the Aetiology of the Olympic Games', *Transactions of the American Philological Association* 116, 1986, 71–88

G. Nagy, 'Homer and Greek Myth', in R. D. Woodard (ed.), *The Cambridge Companion to Greek Mythology* (Cambridge 2007) 57–60

Prodicus: Heracles at the Crossroads

W. K. C. Guthrie, *A History of Greek Philosophy*, vol. III (Cambridge 1969) 274–80

K. Morgan, *Myth and Philosophy from the Presocratics to Plato* (Cambridge 2000) 106–9

The earliest images of Greek myths

K. Schefold, *Myth and Legend in Early Greek Art* (New York 1966; Munich 1964)

K. Friis Johansen, *The Iliad in Early Greek Art* (Copenhagen 1967)

K. Fittschen, *Untersuchungen zum Beginn der Sagendarstellungen bei den Griechen* (Berlin 1969)

R. M. Cook, 'Art and Epic in Archaic Greece', *Bulletin Antieke Beschaving* 58, 1983, 1–10

G. Ahlberg-Cornell, *Myth in Early Greek Art. Representation and Interpretation* (Jonsered 1992)

St. Lowenstam, 'Talking Vases. The Relationship between the Homeric Poems and the Archaic Representations of Epic Myth', *Transactions of the American Philological Association* 127, 1997, 21–76

A. Snodgrass, *Homer and the Artists. Text and Picture in Early Greek Art* (Cambridge 1998)

Giuliani, *Bild* 39–114

L. Giuliani, 'Odysseus and Kirke. Iconography in a Pre-literate Society', in C. Marconi (ed.), *Greek Vases. Images, Contexts and Controversies* (Leiden 2004) 85–96

Perseus and Medusa; Odysseus and Polyphemus: The Eleusis amphora

G. E. Mylonas, *O protoattikos amphoreus tes Eleusinos* (Athens 1957)

A. Snodgrass, *Homer and the Artists. Text and Picture in Early Greek Art* (Cambridge 1998) 90–100

Giuliani, *Bild* 96–105, 159–67

Greek renaissance of the eighth century BC

R. Hägg (ed.), *The Greek Renaissance of the Eighth Century BC* (Stockholm 1983)

Early images of men fighting lions

K. Fittschen, *Untersuchungen zum Beginn der Sagendarstellungen bei den Griechen* (Berlin 1969) 76–88

T. Rombos, *The Iconography of Attic Late Geometric II pottery* (Jonsered 1988) 185–208

Mythical and non-mythical shipwrecks

A. Snodgrass, *Homer and the Artists. Text and Picture in Early Greek Art* (Cambridge 1998) 35–6 fig. 14

Giuliani, *Bild* 73–5

J. M. Hurwit, 'The Shipwreck of Odysseus: Strong and Weak Imagery in Late Geometric Art', *American Jouurnal of Archaeology* 115, 2011, 1–18

Subjects from the Odyssey *in early Greek art*

R. M. Cook, 'Art and Epic in Archaic Greece', *Bulletin Antieke Beschaving*, 58, 1983, 1–10

B. B. Powell, 'Writing, Oral Poetry, and the Invention of the Narrative Style in Greek Art', in *The* Odyssey *and Ancient Art. An Epic in Word and Image*. Exhibition catalogue (Annandale-on-Hudson 1992) 180–5

J. P. Small, *The Parallel Worlds of Classical Art and Text* (Cambridge 2003) 8–36

Corfu, Temple of Artemis, pediment

G. Rodenwaldt, *Korkyra II. Die Bildwerke des Artemistempels in Korkyra* (Berlin 1939)

H. Knell, *Mythos und Polis. Bildprogramme griechischer Bauskulptur* (Darmstadt 1990) 10–17

B. S. Ridgway, *The Archaic Style in Greek Sculpture* (Princeton ²1993) 276–81

C. Marconi, *Temple Decoration and Cultural Identity in the Archaic Greek World. The Metopes of Selinus* (Cambridge 2007) 11–14

Olympia, Temple of Zeus, Centauromachy in the west pediment

B. Ashmole and N. Yalouris, Olympia. *The Sculptures of the Temple of Zeus* (London 1967)

R. Osborne, 'Framing the Centaur. Reading Fifth-Century Architectural Sculpture', in S. Goldhill and R. Osborne (eds.), *Art and Text in Ancient Greek Culture* (Cambridge 1994) 57–62

C. Rolley, *La sculpture grecque I. Des origines au milieu du Vᵉ siècle* (Paris 1994) 363–6, 371–7

A. Heiden, 'Thessalische Lapithen in Elis. Zur Deutung des Westgiebels von Olympia, und die Kentauromachie im Westgiebel des Zeustempels in Olympia', *Archäologischer Anzeiger* 2003, 183–90

K. Junker, 'Geschlechteropposition und Gewaltdarstellung in der klassischen Bauplastik', in G. Fischer and S. Moraw (eds.), *Die andere Seite der Klassik. Gewalt im 5. und 4. Jahrhundert v. Chr.* (Stuttgart 2005) 287–304

H. Westervelt, 'Herakles. The Sculptural Program of the Temple of Zeus at Olympia', in P. Schultz and R. von den Hoff (eds.), *Structure, Image, Ornament. Architectural Sculpture in the Greek World* (Oxford 2009) 133–52

Ilioupersis/Fall of Troy ('Vivenzio hydria')

S. Woodford, *The Trojan War in Ancient Art* (Ithaca, N.Y. 1993)

M. J. Anderson, *The Fall of Troy in Early Greek Poetry and Art* (Oxford 1997) 179–265

M. Mangold, *Kassandra in Athen. Die Eroberung Troias auf attischen Vasenbildern* (Berlin 2000)

G. Hedreen, *Capturing Troy. The Narrative Function of Landscape in Archaic and Classical Greek Art* (Ann Arbor 2001)

Giuliani, *Bild*, chapter 5

Personifications

H. A. Shapiro, 'The Origins of Allegory in Greek Art', *Boreas* 9, 1986, 4–23

Personifications in Greek Art. The Representation of Abstract Concepts 600–400 B.C. (Kilchberg 1993)

A. C. Smith, 'Political Personifications in Classical Athenian Art' (Diss. Yale University 1997)

Menelaus and Helen

G. Hedreen, 'Image, Text, and Story in the Recovery of Helen', *Classical Antiquity* 15, 1996, 152–84

A. Dipla, 'Helen, the Seductress?', in O. Palagia (ed.), *Greek Offerings. Essays on Greek Art in Honour of John Boardman* (Oxford 1997) 119–30

Selinous, Temple of Hera, relief metopes

E. Langlotz, *The Art of Magna Grecia* (London 1965) pl. 100–13

C. Marconi, *Selinunte. Le metope dell'Heraion* (Modena 1994)

K. Junker, 'Die Reliefmetopen des Heratempels in Selinunt', *Mitteilungen des Deutschen Archäologischen Instituts, Römische Abteilung* 110, 2003, 227–61

E. Østby, 'The Relief Metopes from Selinus. Programs and Messages', in P. Schultz and R. von den Hoff (eds.), *Structure, Image, Ornament. Architectural Sculpture in the Greek World* (Oxford 2009) 154–73

Actaeon and Artemis

L. R. Lacy, 'Aktaion and a "Lost Bath of Artemis"', *Journal of Hellenic Studies* 110, 1990, 26–42

P. M. C. Forbes Irving, *Metamorphosis in Greek Myths* (Oxford 1990) 80–90, 197–201

E. D. Reeder, *Pandora. Women in Classical Greece* (Baltimore 1995) 314–21

B. Cohen, 'Man-killers and Their Victims. Inversions of the Heroic Ideal in Classical Art', in B. Cohen (ed.), *Not the Classical Ideal. Athens and the Construction of the Other in Greek Art* (Leiden 2000) 115–23

Ovid's Metamorphoses

P. Hardie (ed.), *The Cambridge Companion to Ovid* (Cambridge 2002)

A. J. Boyle, 'Ovid and Greek Myth', in R. D. Woodard (ed.), *The Cambridge Companion to Greek Mythology* (Cambridge 2007) 355–81

Chapter 4

Greek vase painting: general introductions

P. E. Arias, *A History of Greek Vase Painting* (London 1962)

E. Simon, *Die griechischen Vasen* (Munich 1976)

B. A. Sparkes, *Greek Pottery. An Introduction* (Manchester 1991)

R. M. Cook, *Greek Painted Pottery* (London ³1997)

J. Boardman, *The History of Greek Vases. Potters, Painters and Pictures* (London 2001)

Greek vase painting: Athens

J. D. Beazley, *The Development of Attic Black-figure* (Berkeley 1951; Berkeley ²1986)

J. Boardman, *Athenian Black Figure Vases* (New York and London 1974)
 Athenian Red Figure Vases. The Archaic Period (London 1975)
 Athenian Red Figure Vases. The Classical Period (London 1989)

M. Robertson, *The Art of Vase-painting in Classical Athens* (Cambridge 1992)

F. Lissarrague, *Greek Vases. The Athenians and their images* (New York 2001; Paris 1999)

Greek vase painting: schools and epochs

G. M. A. Richter and M. J. Milne, *Shapes and Names of Athenian Vases* (New York 1935)

A. D. Trendall, *The Red-figured Vases of Lucania, Campania and Sicily* (Oxford 1967; several supplements)

J. N. Coldstream, *Greek Geometric Pottery* (Munich 1968)

C. M. Stibbe, *Lakonische Vasenmaler des 6. Jahrhunderts v.Chr.* (Amsterdam 1972)

A. D. Trendall, *The Red-figured Vases of Apulia* (London 1978/1982; several supplements)
 The Red-figured Vases of Paestum (Rome 1987)

D. A. Amyx, *Corinthian Vase-painting of the Archaic Period* (Berkeley 1988); Supplement by C. W. Neeft (Amsterdam 1991)

A. D. Trendall, *Red Figure Vases of South Italy and Sicily. A Handbook* (London/New York 1989)

J. Boardman, *Early Greek Vase Painting. 11th – 6th centuries BC* (London 1998)

Greek vases: functions and context

T. B. L. Webster, *Patron and Painter in Classical Athens* (London 1971)

O. Murray (ed.), *Sympotica. A Symposium on the Symposion* (Oxford 1990)

K. Vierneisel and B. Kaeser (eds.), *Kunst der Schale. Kultur des Trinkens* (Munich 1990)

B. A. Sparkes, *Greek Pottery. An Introduction* (Manchester 1991) 60–92

K. Arafat and C. Morgan, 'Athens, Etruria and the Heuneburg. Mutual Misconceptions in the Study of Greek-Barbarian Relations', in I. Morris (ed.), *Classical Greece. Ancient Histories and Modern Archaeologies* (1994) 108–34

M. Vickers and D. Gill, *Artful Crafts. Ancient Greek Silverware and Pottery* (Oxford 1994)

L. Giuliani, *Tragik, Trauer und Trost. Bildervasen für eine apulische Totenfeier* (Berlin 1995) 143–58

I. Scheibler *Griechische Töpferkunst* (Munich ²1995) 16–58

M.-C. Villanueva Puig *et al.* (eds.), *Céramique et peinture grecques. Modes d'emploi* (Paris 1999)

C. Reusser, *Vasen für Etrurien. Verbreitung und Funktionen attischer Keramik im Etrurien des 6. und 5. Jahrhundert v. Chr.* (Kilchberg 2002)

K. Junker, 'Symposiongeschirr oder Totengefäße? Überlegungen zur Funktion attischer Vasen des 6. und 5. Jahrhunderts v. Chr.', *Antike Kunst* 45, 2002, 3–25

B. Schmaltz and M. Söldner (eds.), *Griechische Keramik im kulturellen Kontext* (Münster 2003)

C. Marconi, *Greek Vases. Images, Contexts and Controversies* (Leiden 2004)

Greek funerary legislation

R. Garland, 'The Well-Ordered Corpse. An Investigation into the Motives Behind Greek Funerary Legislation', *Bulletin of the Institute of Classical Studies* 36, 1989, 1–15

J. Engels, *Funerum sepulcrorumque magnificentia. Begräbnis- und Grabluxusgesetze in der griechisch-römischen Welt* (Stuttgart 1998)

Greek sculpture: handbooks

B. S. Ridgway, *The Severe Style in Greek Sculpture* (Princeton 1970)

J. Boardman, *Greek Sculpture. The Archaic Period* (New York/London 1978)

R. Lullies, *Die griechische Plastik* (Munich ⁴1979)

B. S. Ridgway, *Fifth Century Styles in Greek Sculpture* (Princeton 1981)

J. Boardman, *Greek Sculpture. The Classical Period* (New York/London 1985)

B. S. Ridgway, *Hellenistic Sculpture* I (Bristol 1990). II (Madison 2000). III (Madison 2002)

W. Martini, *Die archaische Plastik der Griechen* (Darmstadt 1990)

A. Stewart, *Greek Sculpture. An Exploration* (New Haven 1990)

R. R. R. Smith, *Hellenistic Sculpture. A Handbook* (London 1991)

B. S. Ridgway, *The Archaic Style in Greek Sculpture* (Princeton ²1993)

J. Boardman, *Greek Sculpture. The Late Classical Period and Sculpture in Colonies and Overseas* (London 1995)

B. S. Ridgway, *Fourth Century Styles in Greek Sculpture* (Madison 1997)

C. Rolley, *La sculpture grecque I. Des origines au milieu du V^e siècle* (Paris 1994). II. La période classique (Paris 1999)

B. Andreae, *Skulptur des Hellenismus* (Munich 2001)

Function of Greek temples

G. Roux, 'Trésors, temples, tholos', in *Temples et sanctuaires. Travaux de la Maison de l'Orient* 7, 1984, 153–71

W. Burkert, 'The Meaning and Function of the Temple in Classical Greece', in M. V. Fox (ed.), *Temple in Society* (Winona Lake 1988) 27–47

Greek architectural sculpture

B. Ashmole, *Architect and Sculptor in Classical Greece* (London 1972)

H. Knell, *Mythos und Polis. Bildprogramme griechischer Bauskulptur* (Darmstadt 1990)

P. A. Webb, *Hellenistic Architectural Sculpture* (Madison, Wi. 1996)

D. Buitron-Oliver (ed.), 'The Interpretation of Architectural Sculpture in Greece and Rome', *Studies in the History of Art* 49 (Washington 1997)

B. S. Ridgway, *Prayers in Stone. Greek Architectural Sculpture 600–100 B.C.E.* (Berkeley 1999)

C. Marconi, *Temple Decoration and Cultural Identity in the Archaic Greek World. The Metopes of Selinus* (Cambridge 2007) 1–28

P. Schultz and R. von den Hoff (eds.), *Structure, Image, Ornament. Architectural Sculpture in the Greek World* (Oxford 2009)

Mythological representations on coins, gems and metal reliefs

C. M. Kraay, *Archaic and Classical Greek Coins* (London 1976)

P. Zazoff, *Die antiken Gemmen* (Munich 1983)

P. C. Bol, *Argivische Schilde* (Berlin 1989)

A. Schwarzmaier, *Griechische Klappspiegel* (Mainz 1997)

J. Boardman, *Greek Gems and Finger Rings. Early Bronze Age to Late Classical* (London ²2001)

Mythological representations on Greek wall paintings

D. Castriota, *Myth, Ethos, and Actuality. Official Art in Fifth-Century B.C. Athens* (Madison 1992) 33–63 [Paintings in the district of Theseus]

I. Scheibler, *Griechische Malerei der Antike* (Munich 1994)

Mythological representations on Roman wall paintings and mosaics

P. H. v. Blanckenhagen, 'The *Odyssey* Frieze', *Mitteilungen des Deutschen Archäologischen Instituts, Römische Abteilung* 70, 1963, 100–46

R. Ling, *Roman Painting* (Cambridge 1991) 101–41

W. Raeck, *Modernisierte Mythen. Zum Umgang der Spätantike mit klassischen Bildthemen* (Stuttgart 1992)

St. Lowenstam. 'The Sources of the *Odyssey* Landscapes', *Echos du Monde Classique* 39, n.s. 14, 1995, 193–226

R. Biering, *Die Odysseefresken vom Esquilin* (Munich 1995)

K. M. D. Dunbabin, *Mosaics of the Greek and Roman World* (Cambridge 1999)

P. Zanker, 'Mythenbilder im Haus', in *Proceedings of the XVth International Congress of Classical Archaeology, Amsterdam* 1998 (Amsterdam 1999) 40–8

B. Bergmann, 'Rhythms of Recognition. Mythological Encounters in Roman Landscape Painting', in F. de Angelis and S. Muth (eds.), *Im Spiegel des Mythos. Bilderwelt und Lebenswelt* (Wiesbaden 1999) 81–107

P. M. Allison and F. B. Sear, *Casa della Caccia Antica*. Häuser in Pompeji 11 (Munich 2002)

E. W. Leach, *The Social Life of Painting in Ancient Rome and on the Bay of Naples* (Cambridge 2004) 271–81

Mythological representations on Roman sarcophagi: handbooks and catalogues

H. Sichtermann and G. Koch, *Griechische Mythen auf römischen Sarkophagen* (Tübingen 1975)

A. M. McCann, *Roman Sarcophagi in the Metropolitan Museum of Art* (New York 1978)

G. Koch and H. Sichtermann, *Römische Sarkophage* (Munich 1982) 127–90

S. Walker, *Catalogue of the Roman Sarcophagi in the British Museum* (London 1990)

B. C. Ewald, 'Dokumentation zu Mythos und Ikonographie', in Zanker, *Mythen*, 279–381

Mythological representations on Roman sarcophagi: interpretation

F. Cumont, *Recherches sur le symbolisme funéraire des Romains* (Paris 1942)

A. D. Nock, 'Sarcophagi and Symbolism', *American Journal of Archaeology* 50, 1946, 140–70; reprinted in A. D. Nock, *Essays on Religion and the Ancient World* II (Oxford 1972) 607–41

S. Wood, 'Alcestis on Roman Sarcophagi', *American Journal of Archaeology* 82, 1978, 499–510; reprinted in E. d'Ambra (ed.), *Roman Art in Context* (Englewood Cliffs 1993) 84–103

R. Brilliant, *Visual Narratives. Storytelling in Etruscan and Roman Art* (Ithaca and London 1984) 124–65

D. Grassinger 'The Meanings of Myth on Roman Sarcophagi', in *Myth and Allusion. Meanings and Uses of Myth in Ancient Greek and Roman Society* (Boston 1994) 91–107

F. G. J. M. Müller, *The So-Called Peleus and Thetis Sarcophagus in the Villa Albani* (Amsterdam 1994)

M. Koortbojian, *Myth, Meaning, and Memory on Roman Sarcophagi* (Berkeley 1995)

P. Zanker, *Die mythologischen Sarkophagreliefs und ihre Betrachter* (Munich 2000)

Zanker, *Mythen* (fundamental)

J. Elsner and J. Huskinson (eds.), *Life, Death and Representation. Some New Work on Roman Sarcophagi* (Berlin 2010)

Portraits on mythological sarcophagi

B. Andreae, 'Bossierte Porträts auf römischen Sarkophagen – ein ungelöstes Problem', *Marburger Winckelmann-Programm 1984*, 109–28

K. Fittschen, 'Über Sarkophage mit Porträts verschiedener Personen', *Marburger Winckelmann-Programm 1984*, 129–61

Zanker, *Mythen*, 185–8

Z. Newby, 'In the Guise of Gods and Heroes. Portrait Heads on Roman Mythological Sarcophagi', in J. Elsner and J. Huskinson (eds.), *Life, Death and Representation. Some New Work on Roman Sarcophagi* (Berlin 2010) 189–227

Endymion on Roman sarcophagi

H. Sichtermann, *Späte Endymion-Sarkophage. Methodisches zur Interpretation* (Baden-Baden 1966)

H. Sichtermann, *Die mythologischen Sarkophage: Apollon bis Grazien*. Die antiken Sarkophagreliefs XII 2 (Berlin 1992) 32–58

M. Koortbojian, *Myth, Meaning, and Memory on Roman Sarcophagi* (Berkeley 1995)

Zanker, *Mythen*, 102–9

Mythological representations on other Roman funerary monuments

S. Walker, *Memorials to the Roman Dead* (London 1985)

D. Boschung, *Antike Grabaltäre aus den Nekropolen Roms* (Bern 1987)

F. Sinn, *Stadtrömische Marmorurnen* (Mainz 1987)

F. Feraudi-Gruénais, *Ubi diutius nobis habitandum est. Die Innendendekoration der kaiserzeitlichen Gräber Roms* (Wiesbaden 2001)

Chapter 5

The hermeneutic approach and its application in Classical archaeology

E. Panofsky, *Meaning in the Visual Arts* (New York 1955; reprinted New York 1974)

E. Gombrich, *Aby Warburg. An Intellectual Biography* (London 1970; Chicago 1986)

T. Hölscher, 'Bildwerke. Darstellungen, Funktionen, Botschaften', in A. H. Borbein, T. Hölscher and P. Zanker (eds.), *Klassische Archäologie. Eine Einführung* (Berlin 2000) 147–65

I. Hodder and S. Hutson, *Reading the Past. Current Approaches to Interpretation in Archaeology* (Cambridge ³2003)

M. Young, *Malinowski. Odyssey of an Anthropologist, 1884–1920* (New Haven 2004)

M. Hatt and C. Klonk, *Art History. A Critical Introduction* (Manchester 2006) 96–119

The Vatican Laocöon

G. Daltrop, *Die Laokoongruppe im Vatikan* (Konstanz 1982)

C. Kunze, 'Zur Datierung des Laokoon und der Skyllagruppe aus Sperlonga', *Jahrbuch des Deutschen Archäologischen Instituts* 111, 1996, 139–223

R. Brilliant, *My Laokoon. Alternative Claims in the Interpretation of Artworks* (Berkeley 2000)

B. Andreae, *Skulptur des Hellenismus* (Munich 2001) 188–94

B. S. Ridgway, *Hellenistic Sculpture III. The Styles of ca. 100–0 B.C.* (Madison, Wis. 2002) 87–90

Myron's Athena-Marsyas group: myth, reconstruction, interpretation, comparisons, context

W. Déonna, 'Les prototypes du groupe d'Athéna et de Marsyas', *Revue Archéologique* 1926, 2, 188–209

A. Weis, 'The Marsyas of Myron. Old Problems and New Evidence', *American Journal of Archaeology* 83, 1979, 214–19

G. Daltrop and P. C. Bol, 'Athena des Myron'. *Liebieghaus Monographie* 8 (Frankfurt 1983)

B. Leclerq-Neveu, 'Marsyas, le martyr d'aulos', *Métis* 4, 1989, 251–68

LIMC VI (1992) 366–78 s.v. Marsyas I (A. Weis)

R. Wünsche, 'Marsyas in der antiken Kunst', in R. Baumstark and P. Volk (eds.), *Apoll schindet Marsyas. Über das Schreckliche in der Kunst* (Munich 1995) 19–47

J. G. Landels, *Music in Ancient Greece and Rome* (London/New York 1999) 153–6

K. Junker, 'Die Athena-Marsyas-Gruppe des Myron', *Jahrbuch des Deutschen Archäologischen Instituts* 117, 2002, 127–84

S. D. Bundrick, *Music and Image in Classical Greece* (Cambridge 2005) 131–9

Divine inventions and their transmission

A. Kleingünther, *Protos heuretes. Untersuchungen zur Geschichte einer Fragestellung* (Leipsig 1933)

G. Schwarz, Triptolemos. *Ikonographie einer Agrar- und Mysteriengottheit* (Horn 1987)

Aulos music in Classical Greece

M. L. West, *Ancient Greek Music* (Oxford 1992) 13–38, 81–109, 327–85

W. D. Anderson, *Music and Musicians in Ancient Greece* (Ithaca, N.Y. 1994)

A. Bélis, 'La fabrication d'auloi en Grèce', *Topoi* 8, 1998, 777–90

J. G. Landels, *Music in Ancient Greece and Rome* (London and New York 1999) 24–46

P. Wilson, 'The *Aulos* in Athens', in S. Goldhill and R. Osborne (eds.), *Performance Culture and Athenian Democracy* (Cambridge 1999) 58–95

A. Zschätzsch, *Verwendung und Bedeutung griechischer Musikinstrumente in Mythos und Kult* (Rahden 2002)

E. Csapo, 'The Politics of the New Music', in P. Murray and P. Wilson (eds.), *Music and the Muses. The Culture of 'Mousike' in the Classical Athenian City* (Oxford 2004) 207–48

Pindar's 12th Pythian Ode

[on Pindar as mythographer see chapter 3]

R. W. B. Burton, *Pindar's Pythian Odes. Essays in Interpretation* (Oxford 1962) 25–31

A. Köhnken, *Die Funktion des Mythos bei Pindar* (Berlin 1971) 117–53

J. S. Clay, 'Pindar's Twelfth *Pythian*. Reed and Bronze', *The American Journal of Philology* 113, 1992, 519–25

F. Frontisi-Ducroux, 'Athéna et l'invention de la flûte', *Musica e storia* 2, 1994, 239–64

Z. Papadopoulou and V. Pirenne-Delforge, 'Inventer et réinventer l'aulos. Autour de la XIIᵉ Pythique de Pindare', in P. Brulé and Chr. Vendries (eds.), *Chanter les dieux. Musique et religion dans l'antiquité grecque et romaine* (Rennes 2001) 37–58

Barberini Faun: Modern Interpretations

[see also chapter 2]

J. J. Winckelmann, *Geschichte der Kunst des Altertums* (Dresden 1764) 158; English edition: New York 1966

A. Furtwängler, *Beschreibung der Glyptothek König Ludwigs I.* (Munich 1900) 205

L. Alscher, *Griechische Plastik IV. Hellenismus* (Berlin 1957) 61

Chapter 6

Lexicon Iconographicum Mythologiae Classicae: Reviews

B. S. Ridgway, Review of vol. II (1984): *American Journal of Archaeology* 91, 1987, 150–1

M. Robertson, Review of vol. II (1984): *Journal of Hellenic Studies* 106, 1986, 259

Adonis on Roman sarcophagi

G. Koch and H. Sichtermann, *Römische Sarkophage* (Munich 1982) 131–3

M. Koortbojian, *Myth, Meaning, and Memory on Roman Sarcophagi* (Berkeley 1995) 23–62

D. Grassinger, *Die mythologischen Sarkophage: Achill bis Amazonen. Die antiken Sarkophagreliefs* XII 1 (Berlin 1999) 70–90 (sarcophagus in the Vatican: no. 65)

Zanker, *Mythen* 208–13. 288–94 (sarcophagus in the Vatican: no. 5)

Recovery of Ariadne on Roman Sarcophagi

K. Lehmann-Hartleben and E. C. Olsen, *Dionysiac Sarcophagi in Baltimore* (Baltimore, Md. 1942)

F. Matz, *Die dionysischen Sarkophage*. Die antiken Sarkophagreliefs, IV 3 (Berlin 1969) 360–404 (sarcophagus in Hever Castle: no. 214)

Zanker, *Mythen* 162–7. 306–12

Structuralist analysis of vase paintings

F. Lissarrague and F. Thélamon (eds.), *Image et céramique grecque* (Rouen 1983)

C. Bérard, C. Bron and A. Pomari (eds.), Images et société en Grèce ancienne. *L'iconographie comme méthode d'analyse* (Lausanne 1987)

C. Bérard (ed.), *A City of Images. Iconography and Society in Ancient Greece* (Princeton 1989; Paris 1984)

F. Lissarrague, *Greek Vases. The Athenians and their images* (New York 2001; Paris 1999)

Images on Greek vases

As explained in the text, a comparativist discussion of mythological and non-mythological images on Greek vases has only begun to emerge in recent years. The references given below thus cannot claim to cover the field exhaustively. See also the literature on Greek vases in general (chapter 4) and on individual subjects (such as 'Ajax carrying the body of Achilles'). The following two titles are relevant for all five fields dealt with in this section:

B. Cohen (ed.), *Not the Classical Ideal. Athens and the Construction of the Other in Greek Art* (Leiden 2000)

S. Albersmeier (ed.), *Heroes. Mortals and Myths in Ancient Greece*. Exhibition Catalogue (Baltimore 2009)

Religious experience

E. Simon, *Festivals of Attica. An Archaeological Commentary* (Madison 1983)

J. Neils, *Goddess and Polis. The Panathenaic Festival in Ancient Athens* (Hanover/ Princeton 1992)

F. van Straten, *Hiera kala. Images of Animal Sacrifices in Archaic and Classical Greece* (Leiden 1995)

N. Himmelmann, *Tieropfer in der griechischen Kunst* (Opladen 1997)

J. Gebauer, *Pompe und Thysia. Attische Tieropferdarstellungen auf schwarz- und rotfigurigen Vasen* (Münster 2002)

Ethos of male achievement

Mind and Body. Athletic Contests in Ancient Greece. Exhibition Catalogue (Athens 1989)

D. Vanhove, *Le sport dans la Grèce antique. Du jeu au compétition*. Exhibition Catalogue (Brussels 1992)

D. Castriota, *Myth, Ethos, and Actuality. Official Art in Fifth-Century B.C. Athens* (Madison 1992)

B. Knittlmayer, *Die attische Demokratie und ihre Helden. Darstellungen des trojanischen Sagenkreises im 6. und frühen 5. Jahrhundert v. Chr.* (Heidelberg 1997)

A. Schnapp, *Le chasseur et la cité. Chasse et érotique dans la Grèce antique* (Paris 1997)

F. Lissarrague, 'The Athenian Image of Foreigners', in Th. Harrison (ed.), *Greeks and Barbarians* (Edinburgh 2002) 101–24

R. Wünsche (ed.), *Lockender Lorbeer. Sport und Spiel in der Antike* (Munich 2004)

B. Kratzmüller et al. (eds.), *Sport and the Construction of Identities. Proceedings of the XIth International CESH-Congress. Vienna, September 17th–20th 2006* (Vienna 2007)

Male enjoyment of life

G. Koch-Harnack, *Knabenliebe und Tiergeschenke. Ihre Bedeutung im päderastischen Erziehungssystem Athens* (Berlin 1983)

E. C. Keuls, *The Reign of the Phallos. Sexual Politics in Ancient Athens* (New York 1985)

Th. H. Carpenter, *Dionysian Imagery in Archaic Greek Art. Its Development in Black-Figure Vase Painting* (Oxford 1986)

O. Murray (ed.), *Sympotica. A Symposium on the Symposion* (Oxford 1990)

G. Hedreen, *Silens in Attic Black-Figure Vase Painting. Myth and Performance* (Ann Arbor 1992)

M. F. Kilmer, *Greek Erotica on Attic Red-Figured Pottery* (London 1993)

C. Reinsberg, *Ehe, Hetärentum und Knabenliebe im antiken Griechenland* (Munich ²1993)

N. B. Kampen (ed.), *Sexuality in Ancient Greek Art. Near East, Egypt, Greece, and Italy* (Cambridge 1996)

Th. H. Carpenter, *Dionysian Imagery in Fifth-Century Athens* (Oxford 1997)

A. Schäfer, *Unterhaltung beim griechischen Symposion. Darbietungen, Spiele und Wettkämpfe von homerischer bis in spätklassischer Zeit* (Mainz 1997)

A. F. Stewart, *Art, Desire, and the Body in Ancient Greece* (Cambridge 1997)

Th. F. Scanlon, *Eros and Greek Athletics* (Oxford 2002)

Women's life – couples

S. Kaempf-Dimitriadou, *Die Liebe der Götter in der attischen Kunst des 5. Jahrhunderts v. Chr. Beiheft Antike Kunst 11* (Bern 1979)

C. Sourvinou-Inwood, *'Reading' Greek Culture. Texts and Images, Rituals and Myths* (Oxford 1991) 27–143 [contains three papers on 'Images of Greek Maidens']

J. H. Oakley and R. H. Sinos, *The Wedding in Ancient Athens* (Madison 1993)

E. D. Reeder, *Pandora. Women in Classical Greece* (Baltimore 1995)

A. O. Koloski-Ostrow and C. L. Lyons (eds.), *Naked Truths. Women, Sexuality, and Gender in Classical Art and Archaeology* (London 1997)

S. Lewis, *The Athenian Woman. An Iconographic Handbook* (London 2002)

Confrontation with death

D. C. Kurtz and J. Boardman, *Greek Burial Customs* (London 1971)

H. A. Shapiro, 'The Iconography of Mourning in Athenian Art', *American Journal of Archaeology* 95, 1991, 629–56

I. Huber, *Die Ikonographie der Trauer in der griechischen Kunst* (Möhnesee 2001)

J.-P. Vernant, 'A "Beautiful Death" and the Disfigured Corpse in Homeric Epic', in D. L. Cairns (ed.), *Oxford Readings in Homer's Iliad* (Oxford 2001; franz. 1982) 311–41

J. H. Oakley, *Picturing Death in Classical Athens. The Evidence of the White Lekythoi* (Cambridge 2004)

Mythological representations in the Parthenon in Athens

(on the west pediment see also chapter 2)

F. Brommer, *Die Parthenon-Skulpturen. Metopen, Fries, Giebel, Kultbild* (Mainz 1979)

H. Knell, *Mythos und Polis. Bildprogramme griechischer Bauskulptur* (Darmstadt 1990) 95–126

I. Jenkins, *The Parthenon Frieze* (London 1994)

P. Tournikiotis (ed.), *The Parthenon and its Impact in Modern Times* (Athens 1994)

M. B. Cosmopoulos (ed.), *The Parthenon and its Sculptures* (Cambridge 2004)

J. Hurwit, *The Acropolis in the Age of Pericles* (Cambridge 2004) 106–54

J. Neils (ed.), *The Parthenon. From Antiquity to the Present* (Cambridge 2005)

Pergamon and the Great Altar

H.-J. Schalles, *Der Pergamonaltar. Zwischen Bewertung und Verwertbarkeit* (Frankfurt 1986)

M. Kunze, *The Pergamon Altar. Its Rediscovery, History and Reconstruction* (Mainz 1995)

R. Dreyfus and E. Schraudolph (eds.), *Pergamon. The Telephos Frieze from the Great Altar* (San Francisco 1996)

H. Koester (ed.), *Pergamon, Citadel of the Gods. Archaeological Record, Literary Description, and Religious Development* (Harrisburg/Pa. 1998)

W. Radt, *Pergamon. Geschichte und Bauten einer antiken Metropole* (Cologne 1999)

A. Stewart, 'On the Date, Reconstruction, and Functions of the Great Altar of Pergamon', in N. de Grummond and B. S. Ridgway (eds.), *From Pergamon to Sperlonga. Sculpture and Context* (Berkeley [etc.] 2000) 32–57

K. Junker, 'Meerwesen in Pergamon. Zur Deutung des Großen Frieses', *Istanbuler Mitteilungen* 53, 2003, 209–27

F. Queyrel, *L'autel de Pergame. Image et pouvoir en Grèce d'Asie* (Paris 2005)

'Hybris'

N. R. E. Fisher, *Hybris. A Study in the Values of Honour and Shame in Ancient Greece* (Warminster 1992)

D. L. Cairns, '*Hybris*, Dishonour, and Thinking Big', *Journal of Hellenic Studies* 116, 1996, 1–32

Motif of the heroes playing board games (Achilles and Ajax)

H. Mommsen, 'Aias und Achill pflichtvergessen?', in H. A. Cahn and E. Simon (eds.), *Taenia. Festschrift für R. Hampe* (Mainz 1980) 139–52

S. Woodford, 'Ajax and Achilles Playing a Game', *Journal of Hellenic Studies* 102, 1982, 173–85

H.-G. Buchholz, 'Brettspielende Helden', in S. Laser, *Sport und Spiel. Archaeologia Homerica, Teil T* (Göttingen 1987) 126–84

L. Kurke, *Coins, Bodies, Games, and Gold. The Politics of Meaning in Archaic Greece* (Princeton 1999) 270–4

K. Junker, *Pseudo-Homerica. Kunst und Epos im spätarchaischen Athen* (Berlin 2003) 8–16

Index

Achilles 18, 19, 34–5, 54–6, 65, 66, 86, 105,
 124–5, 145, 165, 172, 175, 177, 192–5
Actaeon 90–4, 135, 165
Adonis 164–7, 168
Aegisthus 32
Aeneas 86, 90, 130
Aeschylus 31–3, 37–8
Aëtes 43
Afyon 116
Agamemnon 6, 32, 66
Aithra 86
Ajax 54–5, 105, 192–5
Ajax (the Lesser) 86–7
Alcestis 165
Alcmene 11
allegory 28–9, 78, 88, 126, 164, 166, 182, 187,
 189, 195
Alscher, Ludger 152
Amazons 84, 92, 108, 113, 176, 190
Amphitrite 187
Antiphanes 24
Aphrodite 89–90, 114, 164–7, 168, 192
Apollo 6–7, 10, 56, 92, 108, 142, 146, 172,
 173, 186
apperception 61
arete 73
Ariadne 40–2, 61, 114, 116, 168
Aristotle 24, 158
Artemis 92–4, 135, 165
Asia Minor 69, 184
Astyanax 86
Athena 8, 22, 25–7, 30, 67, 75, 83, 86,
 92, 108, 109, 131–58, 172, 181,
 182–4, 186
Athena-Marsyas group 109, 131–58, 190
Athens 5, 10, 32, 58, 97, 102, 116, 146, 178, 180,
 183–4
 Acropolis 25, 132, 147, 152–3
 Erechtheion 27
 Parthenon 26–7, 83, 106, 108, 146, 148, 152,
 182–4, 186, 187
 Theseion 113
Attica 25–7

Augustus 90
aulos 134–47, 150, 155–8

'beautiful death' 180, 189
Bellerophon 165
Berlin, Staatliche Museen, Antikensammlung
 1993–243 Lucanian krater 42, 44, 45–6, 61, 104
 F 1718 Attic black-figure amphora by Exekias
 (war loss) 15–17, 52–5, 58, 75, 85, 105–6,
 127, 190
 F 2278 Attic red-figure cup by the Sosias
 Painter 1–18, 29, 62, 95, 121–2, 124–5, 126,
 128–9, 141, 154–5, 172–3, 190, 194
 F 2279 Attic red-figure cup by Peithinus
 12, 177
 F 2372 Attic red-figure loutrophorus 178–9
Bible 21, 31, 125
Boston, Museum of Fine Arts
 00.348 Apulian bell-krater 155–8
Bowdoin College, Museum of Art
 1984.023 Attic black-figure jug 102–3
Burkert, Walter 19, 28, 30

Cassandra 86–7, 88
Caucasus 143
Celts 97, 190
centaurs 6, 84, 108, 113, 176, 182, 188–9, 190
Chalcis 8
Chiron 6
Cleopatra VII of Egypt 187
Clytaemnestra 67–8
Colchis 43
comics 42
concordia 164, 167
context (definition) 2–3, 121–3
Corfu, Temple of Artemis 81–2, 182
Corinth 43, 97
Corpus der antiken Sarkophagreliefs
 (*ASR*) 162
Crete 41, 97, 113
Creusa 87–90, 208–9
Cumont, Franz 162
Cyclopes 70

222

Delphi 37
Demeter 146, 164
Diomedes 8–9, 109, 154
Dionysus 47, 48, 110, 114, 116, 132, 139, 142,
 143, 146, 152, 168, 186–7
discourse analysis 124, 137
divinatio 126
Dokimeion 116
double *aulos*, double flute *see aulos*
drama *see* theatre

Eleusis, Archaeological museum
 Proto-Attic amphora 75, 79–80, 81, 82,
 104, 172
Elysium 118
Endymion 119
Epic cycle 66–7
Erinyes (Furies) 38
Eros 89–90, 166, 169, 178
Euhemerus of Messene, euhemerism 70
Eumenes II of Pergamon 107, 184–5,
 186, 190
Euphorbus 10
Euphronios 55–9, 98, 174
Euripides 31, 60, 70
Exekias 15, 52, 55, 58, 98, 192

fairytale xi, 19, 22, 25, 164
Fate, Goddess of 186
film 19–21, 32, 64, 96, 119
Flaxman, John 30, 40, 79
Florence, Museo Archeologico
 4209 Attic black-figure krater by Kleitias and
 Ergotimos 54, 195
Fontenelle, Bernard de 70
forms of visual narrative 38–50
 complementary 42, 45
 continuous 44, 45, 139
 hieroglyphic 46
 synoptic 42
Foucault, Michel 124
Frankfurt, Archäologisches Museum
 VF b 413 Attic red-figure bell-krater 173
funeral 4, 77, 101, 103, 106, 145, 169, 173,
 180, 189
Furtwängler, Adolf 152

Gaia 186
Ganymede 109
genre (genre scene) 51
giants 10, 81, 84, 92, 172, 185–7, 190
Goethe, Johann Wolfgang von 32
Golden fleece 43

Gorgons 38
Graf, Fritz 30, 71

Hebe 179
Hector 10, 34–5, 66, 175
Helen 86, 90, 179, 192
Hephaestus 67
Hera 90–4
Heracles 11–18, 19, 22, 46, 66, 70, 71, 73, 80,
 92–3, 98, 107, 172, 179
Herculaneum 113
Hercules *see* Heracles
hermeneutic circle 127
hermeneutic spiral 126–8, 132
Hermes 34, 56, 67, 141, 146
Herodotus 26, 69–70, 142
Hesiod 25, 67–8, 90–1
Hever Castle
 Dionysiac sarcophagus 116, 167–8
Hieron of Syracuse 71–2, 74
Himmelmann, Nikolaus 46
Hippodameia 72, 84
Hippolytus 165
Homer 21, 25, 32, 60, 64–9, 70, 71, 72, 77, 90,
 110, 131, 147
 Iliad 1–11, 34–7, 55–6, 58, 64–6, 74, 80–1, 88,
 146, 173, 175, 177, 195
 Odyssey 33, 64–6, 78–9, 80–1, 114
 recitations of his epics 10, 14, 19, 70, 122
 similes 36–7, 56, 68, 78
Husserl, Edmund 51
hybris 190–1
Hypnos 56–7, 74, 88
hyponoia 28

Icarius 143
iconography 1, 124–6
iconology 124–6
Ilioupersis 86–8, 95
illustration 33–40, 52, 59
interpicturality 148
intertextuality 148
Ithaca 66

Jason 43–5, 119, 163
Jocasta 23–4

kakia 73
Kleophrades Painter 86, 98

Laius 22–4
Laocoön 129–31; *see also* Vatican museums,
 1059, 1064, 1067 Vatican Laocoön

Lapiths 84, 108, 113, 188–9
layers of meaning (*Sinnschichten*) 167
Leto 92
Lexicon Iconographicum Mythologiae Classicae
 (*LIMC*) 161–75
lifeworld (*Lebenswelt*) 50–8, 63, 72, 171

maenads 49–50, 155, 168, 177
Mainz, University
 104 Attic red-figure cup 49–50, 177
Malinowski, Bronislaw 123–4
Manga 42
Marsyas 92, 131–58
martyrs 143
Medea 43–5, 60, 115, 118–19, 163–4
Medusa 75, 81, 104, 172, 191
Meleager 165
Menelaus 1, 88–90, 192
Minos 40–2
Minotaur 40–2, 104, 168, 176, 191
mors immatura 163, 165
Munich, Staatliche Antikensammlung und
 Glyptothek
 218 Statue of the so-called Barberini Faun
 46–50, 95, 109, 110, 142, 152, 155
 2410 Attic red-figure stamnos 100
 8696 Attic Geometric jug 78–9
Muses 68, 142
Myron 132, 136
myth
 and religion 21–2, 68, 107–8
 as application 28, 30, 72, 111, 163
 changeability 30–3, 135–6, 148
 didactic use 71, 73
 mythical thinking 29, 33, 78, 159
 mythos 19, 69
 non-dogmatic character 125
mythologeme 143, 146, 161
mythological group 109
mythological image
 associative potential 79, 94, 95, 125–6, 138,
 160, 180, 188
 emphases and deviations 32, 62, 79, 138
mythology as a system 67, 161
mythopoioi 28

Naples, Museo Archeologico Nazionale
 2242 Attic red-figure hydria (Vivenzio-
 Hydria) 85–8, 95
Natural philosophers 68–9
Naxos 168
Nemean lion 11, 46
Neoptolemus 86

Nestle, Wilhelm 68
Niobe 92, 117

Odysseus 19, 40, 66, 70, 77, 78–9, 81, 86, 114–15
Oedipus 22–4, 39–40, 60, 66, 69, 90, 175
Olympia 71–2, 77, 174
 Temple of Zeus 18, 84–5, 106, 107, 108, 182,
 188–9
Olympia, Museum
 T2, Tc 1049 Terracotta statue of Zeus with
 Ganymede 109
Olympias 186
Olympus 19, 93
Orestes 32–3, 38, 117
'otherness' 175–6
Ovid 66, 90–2

Palladion 109
Pan 168
Pandora 67–8
Panofsky, Erwin 124–6, 140
Paris 7, 88, 179
 judgement of 73, 80
Pasiphaë 114
Patroclus 56, 66, 124–5, 141, 172, 174,
 175, 194
Pausanias 113, 132, 135, 136
Peirithoos 84
Peithinos 12, 177
Peitho 89–90, 94, 192
Peleus 12, 177
Peloponnesian War 184, 189
Pelops 72–3
Pembroke Hope collection (formerly)
 'Chalcidian' amphora 8–9, 17
Penelope 66
Penthesilea 165
Pergamon, Great Altar 107, 184–7, 190
Pericles 189
Perseus 75, 80, 81, 172, 191
Persian Wars 5, 27, 108
personifications 88–90, 112
Petersen, Wolfgang 32
Phaeaceans 66
Pheidias 152–3
Phineus 38
photography 40, 45
Phrygia 116
Pindar 71–3, 74, 89, 147
Plato 28, 71
Pliny the Elder 129, 132
Polyphemus 40, 77, 79–80, 104, 176
Pompeii 113

Casa della Caccia Antica 42, 114
portrait 51–2, 119, 166
Poseidon 25–7, 30, 72, 83, 108, 146, 152,
 183, 186
Priam 7, 34–5, 81, 86–7, 175
Prodicus 71, 73–4
Prometheus 143

Rhegion 8
Rhodes 129
Rome 47, 90–1, 109, 110–12, 116, 129–31
 Tomba della Medusa 117
Rome, Museo di Villa Giulia
 Attic red-figure krater by Euphronios 55–9,
 61, 62, 72, 85, 101, 141, 151–2, 174,
 177–8, 181
Rome, Museo Nazionale Romano 43–5,
 118–19, 163–4
 75248 Roman sarcophagus (Medea in
 Corinth) 43–5, 62, 95, 118–19, 163–4,
 166–7
Roscher, Wilhem Heinrich 161

Saint Catherine 125
Sappho 176
Sarpedon 36, 37, 55–9, 60, 72, 74, 85, 141, 174,
 175, 181
satyr play 149–50, 153
satyrs 48–50, 132, 139, 144, 168, 190; *see also*
 Marsyas; Munich, Staatliche
 Antikensammlung und Glyptothek 218
 Statue of the so-called Barberini Faun
Schwab, Gustav 30–1
Selene 119
Selinous, Temple of Hera 90–4
Semele 186, 187
Shakespeare, William 32
shield device 10, 53, 177
Sicily 77, 90, 97, 104
Socrates 73
Sophocles 31, 70
Sosias 3–4
South Italy 77, 97, 104, 180
Sphinx 23–4, 39–40, 175, 176
Sthenelos 8–9
structuralism 137, 169
symposium 4, 100–1, 105, 151, 176–7, 181
synthetic intuition 126, 140

Tantalus 72
television 20, 64
Thanatos 56–7, 74, 88

theatre 20, 39, 70–1, 145, 146, 148, 149–50, 159,
 177, 191
Thebes 22, 90
Theseus 40–2, 61, 66, 86, 104, 114, 116,
 168, 191
Thessaly 84
Thetis 12, 54, 65, 177
Thoas 175
Thucydides 70, 189
Titus 129
tragedy *see* theatre
Triptolemus 146
Triton 187
Trojan War 1–18, 32, 34–5, 54, 55, 59, 65, 66,
 80, 81, 86, 109, 115, 122, 123, 129–31,
 146, 192–5

vase painting 96–106, 169–81
 name-inscriptions 5, 35, 53, 54, 58, 124,
 171, 174
 shapes and functions 99
 substitute for metal vessels 98
 term 'vase' 3, 99, 151–2
Vatican museums
 10409 Roman sarcophagus (Adonis and
 Aphrodite) 119, 164–7
 1059, 1064, 1067 Vatican Laocoön 109, 110,
 129–31
 16535 Attic red-figure jug 88–90, 192
 16541 Attic red-figure cup 23, 40, 44, 50, 175
 344 Attic black-figure amphora by Exekias
 18, 54, 192–5
 Odyssey landscapes 115
Vernant, Jean-Paul 169
Veyne, Paul 68
Vienna, Kunsthistorisches Museum
 8710 Attic red-figure skyphos 34–6,
 66, 175
Virgil 66, 90, 129
virtus 164, 165
Vulci 55

Warburg, Aby 123
Winckelmann, Johann Joachim 152
wooden horse 129

Xenophanes 69, 70, 91
Xenophon 73

Zanker, Paul 162, 163
Zeus 11, 12, 67, 69, 70, 81, 92–4, 108, 109, 144,
 152, 179, 186